Romance

of the
Taj Mahal

Pratapaditya Pal
Janice Leoshko
Joseph M. Dye, III
Stephen Markel

with 262 illustrations, 96 in colour

Thames and Hudson
Los Angeles County Museum of Art

NOTE The exhibition *Romance of the Taj Mahal* was organized
by the Los Angeles County Museum of Art. In the captions, a
dagger (†) indicates that an item did not form part of the
exhibition.

Copublished by
Los Angeles County Museum of Art
5905 Wilshire Boulevard
Los Angeles, California 90036
and
Thames and Hudson Ltd
30–34 Bloomsbury Street
London WC1B 3QP

Main text set in Monophoto 11/12pt. Bembo

Printed and bound in Hong Kong by Toppan Printing Co.

Romance

of the

Taj Mahal

Contents

Foreword

Certainly the Taj Mahal is the image that comes most readily to mind when people the world over think of India and its arts. It was built in the seventeenth century as a tomb for a beloved Mogul empress, but its funerary nature has been overshadowed by its perfection and romance. Although better remembered for his architectural achievements, Shah Jahan, the Mogul emperor who commissioned the Taj Mahal, was actually a discerning patron of paintings, decorative objects, and textiles. By examining the record of his wide-ranging connoisseurship, *Romance of the Taj Mahal* seeks to establish a fuller context for understanding the unique fame of this magnificent monument.

There has not previously been an exhibition or book that surveys all the arts created during the reign of Shah Jahan. Thus *Romance of the Taj Mahal* affords a special opportunity to explore the extraordinary character of the arts from Shah Jahan's reign (1628–58) and their interrelated nature. The Los Angeles County Museum of Art, which houses one of the most comprehensive collections of Indian art in the world, has long been committed to demonstrating the importance and richness of Indian artistic traditions. This goal has been particularly well served by this multifaceted investigation of an extraordinary period of Indian culture. By including material as varied as drawings by Rembrandt and paintings and photographs by contemporary artists, *Romance of the Taj Mahal* also provides valuable insight into the ways in which Shah Jahan and the Taj Mahal influenced subsequent generations throughout the world, a fascinating demonstration of the far-ranging power of art.

Romance of the Taj Mahal was organized by Pratapaditya Pal, the museum's senior curator of Indian and Southeast Asian art, with the assistance of Janice Leoshko and Stephen Markel, the museum's associate and assistant curators of Indian and Southeast Asian art, and Joseph M. Dye, III, curator of Asiatic Art at the Virginia Museum of Fine Arts. We are very grateful to them for this excellent exhibition and the thoughtful book that accompanies it. We are pleased to circulate the exhibition to the Toledo Museum of Art, the Virginia Museum of Fine Arts, Richmond, and the Asia Society, New York. Their enthusiastic support of this project is gratefully appreciated.

Earl A. Powell III
Director
Los Angeles County Museum of Art

Preface and Acknowledgments

It would not be an exaggeration to say that more books have been published about the Taj Mahal than any other monument in India. This book, however, is not meant to be another pretty coffee-table book about this universally admired mausoleum. Rather, with the Taj as its focus, it attempts to provide an overview of the various aesthetic achievements of the age in which the building was created. It is also the first book to offer a critical analysis of the art and architecture of the Mogul Emperor Shah Jahan's reign.

Readers should remember that although written as a book by four different authors, each expressing his or her own views, it is also meant to serve as the catalogue of an exhibition. In the main, therefore, the illustrations, especially of the objects and paintings, are of those items that could be borrowed. Hence the selection is limited and many familiar objects regarded as landmarks of the Shah Jahan period, such as the famous *Padshah-nama* pictures in the Queen's Collection at Windsor Castle, were not used as they were not available for the exhibition. Indeed, organizing this particular exhibition was not easy, as many delicate and fragile works could not be borrowed at all. Nevertheless, thanks to the relentless persistence and enthusiasm of my three co-curators—Joseph M. Dye, III, Janice Leoshko, and Stephen Markel—and the extraordinarily generous cooperation of all lenders (listed on p. 252), we have succeeded in assembling a large selection of art works that make the exhibition a significant cultural event and the book a fascinating art historical document. A special word of appreciation must be added for Janice Leoshko's smooth and efficient management of this entire project. In addition, the section on photography and the Taj incorporated in the final chapter of the book was written entirely by her.

We have benefited immensely from all previous authors who have written on the subject, and especially from Catherine Asher, Simon Digby, and Robert Skelton. Catherine Asher has been particularly helpful with the chapter on the architecture of the Taj, and

Robert Skelton with that on the decorative arts. Simon Digby was kind enough to read the entire manuscript, suggest many improvements, and interpret all inscriptions. We also thank our editor at Thames and Hudson.

As is the case with all exhibitions, almost the entire staff of the museum has been actively involved and has contributed toward its success; while a few individuals have been acknowledged below, my colleagues join with me in thanking the many not mentioned for their ungrudging support. A special word of appreciation, however, must be said for Dr. Earl A. Powell III, the director, for his constant enthusiasm and encouragement.

I would also like to thank the following individuals for their assistance: in West Berlin, Joachim Bautze and, from the Museum für Indische Kunst, Gouriswar Bhattacharya and Marianne Yaldiz; at the Boston Museum of Fine Arts, Vishakha Desai; at the Brooklyn Museum, Amy G. Poster; at Harvard University, Julia Bailey and Stuart Cary Welch; at the Art Institute of Chicago, Jack Sewell; at the Cleveland Museum of Art, Stanislaw Czuma; in Gainesville, Roy C. Craven, Jr.; at the Honolulu Academy of Arts, Sanna Saks Deutsch and George Ellis; in Iowa City, Wayne E. Begley; in Jerusalem at the Israel Museum, Na'ama Brosh; in Kuwait at the Dar al-Athar al-Islamiyyah, Ghada Qaddumi and Sheikha Hussa al-Sabah; in London, Mildred Archer, Chris Beetles, Anthony Gardner, Michael Goedhuis, Niall Hobhouse, Brendan Lynch, Michael Spink, Mark Zebrowski, at the British Library, Annabel Teh Gallop, at the India Office Library, J. P. Losty, at the Royal Asiatic Society, D. J. Duncanson, and, at the Victoria and Albert Museum, Rosemary Crill, John Guy, Susan Stronge, and Betty Tyres; at the Los Angeles County Museum of Art, Mary Katherine Aldin, Victoria Blyth-Hill, Anne Diederick, Ethel Heyer, Tom Jacobson, Thomas Lentz, Catherine McLean, Steve Oliver, John Passi, Sharon Slanovec, Mitch Tuchman, and Rosanna Zubiate; in New York, Terence McInerney, Elizabeth Rosen, Doris Wiener, at

the Asia Society, Mary Linda and Andrew Pekarik, at the Metropolitan Museum of Art, Marilyn Jenkins, Richard Stone, and Daniel Walker; in Oxford, Raymond Head; in Paris at the Bibliothèque Nationale, Cecile Morrisson, at the Musée Guimet, Amina Okada; in Richmond at the Virginia Museum of Fine Arts, Diana Dougherty, Carol Moon, Pinkey L. Near, and Paul N. Perrot; at the San Diego Museum of Art, Steven L. Brezzo and Sung Yu; at the Santa Barbara Museum of Art, Barry Heisler; and in Washington, D.C., at the Arthur M. Sackler Art Gallery, Smithsonian Institution, Milo C. Beach and Glenn D. Lowry.

In addition, research in India was supported by the Indo–U.S. Subcommission on Education and Culture.

Pratapaditya Pal
Senior Curator
Indian and Southeast Asian Art

Introduction

Pratapaditya Pal

Though emeralds, rubies, pearls are all
But as the glitter of a rainbow tricking out empty air
And must pass away,
Yet still one solitary tear
Would hang on the cheek of time
In the form
Of this white and gleaming Taj Mahal.

<div align="right">Rabindranath Tagore</div>

The celebrated Bengali writer Rabindranath Tagore's poem entitled "Shah-Jahan" is only one of several that have the Taj Mahal as their subject. An earlier English poem composed by Sir Edwin Arnold is no less eloquent.

Not architecture! as all others are,
But the proud passion of an Emperor's love
Wrought into living stone, which gleams and soars
With body and beauty shrinking soul and thought.

Poets, however, are not the only ones to have been inspired by the Taj Mahal. The following folk song from Bengal will demonstrate how widely the seventeenth-century mausoleum of an empress has carved a niche in the popular consciousness and collective memory of a people.

The rites of spring
Have burst in the Taj Mahal.
The meaning[s] of the words
Right and wrong
Are cast away into the empty space
Of meaninglessness.
The rites of spring
Have entered the Taj Mahal.
Little sons of pigs
Who are ruled by the powerful king
Have taken charge of all.
The rites of spring
Have burst in the Taj Mahal.

This is only a sampling of the literary response to the Taj Mahal ever since it was "discovered" by the British some two centuries ago. Other literary allusions to the Taj by both the great and the small will be discussed throughout this book.

The Taj Mahal (Crown of the Palace) was built in the city of Agra by the Mogul emperor Shah Jahan to commemorate his wife Mumtaz Mahal (Exalted One of the Palace), who died in 1631 during childbirth, which in itself was not an uncommon occurrence. Nor was the lady whose memory has been so spectacularly enshrined his only wife. And yet the Taj has become the symbol *par excellence* of one man's love for a woman.

In the history of mankind's architecture the Taj Mahal is rather a young building. Nor is it the most impressive of man's civil engineering achievements. Egypt has its mysterious pyramids, the Greeks their ruined Parthenon in Athens, and the Chinese their Great Wall. There are several cathedrals in Europe that are more monumental buildings, as are the temple complexes of Angkor Vat in Kampuchea and Borobudur in Central Java. Among more recent creations, St. Peter's in Rome, the Eiffel Tower in Paris, and the Statue of Liberty in New York Harbor have perhaps been seen by more people. But it would not be an exaggeration to state that no other building in the world has captured the romantic imagination of mankind as has the Taj Mahal. As Edwin Arnold said, it is "not architecture." Rather it is a fad, a cliché, a concept, an image, a symbol, the focus of a cult, and a state of mind.

It is certainly the most familiar building in the world, thanks to its pervasive exploitation for commercial purposes both in India and abroad. That it should be used by airlines and travel agencies to lure tourists to India is understandable. But it is encountered in advertisements far more frequently than any other building, to sell all sorts of products. Most simply exploit the cliché, but a few are both imaginative and amusing.

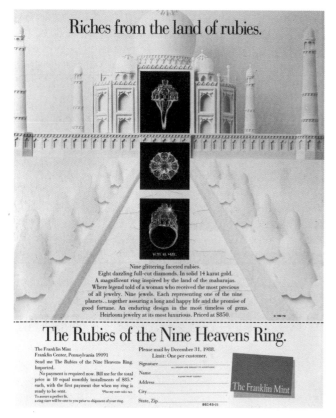

1 Advertisement for the Franklin Mint

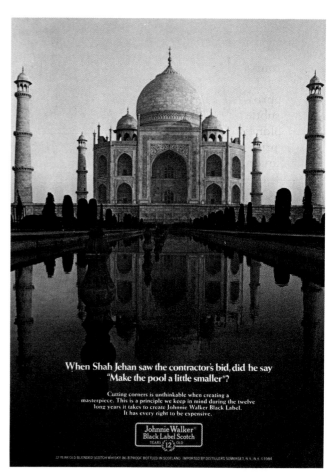

2 Advertisement for Johnnie Walker Black Label Scotch

One of the most frequently repeated images in connection with the Taj is that of jewelry: it is said to be "jewel-like," or a "jewel-box," or that the building was "finished by jewelers." And yet, to the best of our knowledge, unlike restaurant and hotel owners, no jeweler has ever named his or her shop after the monument. However, Mogul jewelry in general and the Taj Mahal in particular have inspired such well-known jewelry manufacturers as Tiffany and Cartier, and a picture of the Taj has been frequently used in advertisements. One of the latest is that of the Franklin Mint to advertise rubies, which are shown against a background of what appears to be a plastic model of the Taj [Fig. 1]. The principal source of the ruby in that part of the world is Burma, followed by Sri Lanka—not India. The point of the advertisement, however, is to suggest that these rubies are as perfect and flawless as the Taj Mahal.

When the founder of the powerful industrial house in India, the Tatas, built a hotel in Bombay at the turn of the century because he was not allowed to enter a whites-only establishment, he named it the Taj Mahal, and the modern tourist in India can now stay at a string of Taj hotels including one in Agra. It did not occur to the patrician builder of the first such hotel that the Taj is a tomb where Shah Jahan and his beloved sleep eternally, though not on a spring mattress. And so in the 1980s in New York City we find the Helmsley group of hotels unhesitatingly comparing one of its hostelries with the Taj and adding, "service and appointments fit for royalty—you—our guests." The comparison is carried even further when we are reassured that it is "the only palace in the world where the queen stands guard." An inset picture of Leona M. Helmsley is strangely reminiscent of the oval miniatures of Mumtaz Mahal that became a commonplace of the nineteenth-

century tourist trade at the site of the monument itself [Fig. 14].

The approach of the manufacturers of Scotch whisky is more subtle and amusing [Fig. 2]. With tongue-in-cheek boldness the company anticipates criticism for the high price of the particular brand by pointing out to Scotch lovers that Shah Jahan would never have scrimped on expenses when he wanted a quality product. One wonders how Shah Jahan, who hardly touched alcohol, would have felt if he knew that the shrine he built over the mortal remains of his beloved was helping to sell whisky.

Hotels and alcoholic beverages are not the only commercial products that rely on the concept of the Taj Mahal to convey the message about the superlative quality of their product. One popular musician in America saw nothing incongruous in usurping the title of an empress and a building as his personal name [Fig. 3]. When Henry St. Clair Fredericks, a rock-blues musician from Massachusetts, decided to adopt a stage name, his choice was "Taj Mahal." His friends now address him as "Hi, Taj," while he is greeted more formally in restaurants by fawning maitre d's with "Nice to see you again, Mr. Mahal." The blurb on the jacket of one of his albums tells us, "Just count yourself lucky to own this volume by young Taj, the *real* master of space and time." Shah Jahan loved music and certainly intended his own creation to transcend both space and time.

An outlandish though amusing example of the visual exploitation of the Taj may be seen in a 1989 calendar intended evidently for keen golfers [Fig. 4]. The calendar attempts to illustrate twelve of the world's toughest golf courses, albeit imaginary. What else should appear on the cover but the stereotyped picture of the Taj, with its famous pool lampooned as a putting green. The imaginative creator of this cover did not miss a trick, for at the bottom the green is annotated as "Agra-vation 80 yards by 6 yards."

It is clear therefore that the Taj Mahal is no longer just a building to admire, whether for aesthetic reasons or for its romantic appeal. Even though the definitions in most dictionaries have not yet quite caught up, to most people around the world the expression "Taj Mahal" means a standard of excellence. But this is not the only meaning that has been superimposed on this monument. When real estate companies in Southern California invite us to build our own Taj Mahals, they are clearly

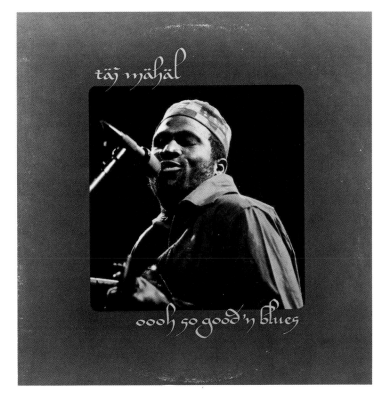

3 Cover of a record album by blues singer Taj Mahal

4 From *The World's Toughest Golf Courses 1989 Calendar*, copyright by Tom Hepburn and Selwyn Jacobson. By permission of Price Stern Sloan Inc.

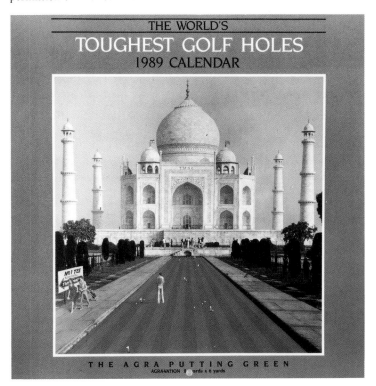

implying the fulfillment of each young American couple's dream, to own one's own house. Here again it is rather curious that a tomb is being compared to a home. It is remarkable how from the very moment of its discovery the Taj has transcended all associations with death. As early as the eighteenth century Europeans freely used the Taj for moonlight picnics and as a "honeymoon hotel." It is for sociologists and psychologists to probe how a building that houses the dead should become the metaphor for excellence for the homes of the living.

The words "mogul" and "Taj Mahal" have now become familiar metaphors, particularly in American parlance. "Mogul" was first used in the 1920s to describe the megalomaniacal giants of the Hollywood movie industry. While the actors and actresses became stars, the great studio bosses were referred to as "movie moguls." Since then the word has had much wider usage, and constantly we read or hear about "TV moguls," "media moguls," or "corporate moguls." Similarly, "Taj Mahal" too has been and continues to be employed as a metaphor in all sorts of strange ways.

Ever since the Administration Building at Randolph Air Force Base in Texas, designed by the architect Atlee Ayres, was built in 1935, it has been called the Taj Mahal. Not too long ago an article on the Brand Library in Glendale, California, described the building as "the Taj Mahal of Glendale," even though the edifice has little in common with the Taj. A recent application of both "mogul" and "Taj Mahal" as metaphors occurred in an article in *Time* magazine. The story is about the refurbished Cineplex Odeon Theater in New York and predictably the new owner, Garth Drabinsky, is characterized as a mogul while the title of the article reads, "Master of the Movies' Taj Mahals." One of the earliest and strangest uses of the Taj Mahal as a metaphor may be found in the following sentence: "the late poet had built a Taj Mahal mausoleum while bilking his benefactors." The deceased poet was Walt Whitman, and the creator of the metaphor was Thomas Wentworth Higginson, who was battling William Sloane Kennedy over the great American poet's debts. And how would Shah Jahan react, if he could, if he woke up one morning and came across the following headline for an article in his *Wall Street Journal* (19 August 1987): "GE Unit, Expanding Auction Role, Opens Taj Mahal of Used Car Lots"? In the article a wholesale dealer from Ellwood, Kansas, is quoted as

calling GE's Denver Auto Auction "really the Taj Mahal of the industry, for service and convenience." Would Shah Jahan have thought that this was carrying the metaphor a bit too far?

In the mid-sixties while visiting Norway I met a group of tourists from Texas. During a pleasant conversation with two elderly Texans, I mentioned that I was a student of Himalayan architecture. Neither knew what the Himalayas were, but the minute I mentioned India, their immediate response was, "Ah! The Taj Mahal!" Indeed, the Taj Mahal today is the most familiar symbol of India, even though it is a Muslim mausoleum and there are many older monuments in the country that are more impressive and more characteristic of India's older civilization. That the Taj Mahal should have become the visible image of India under British rule is not surprising, as will be discussed in the final chapter of this book. But that it should have continued to represent India after the creation of Pakistan, an Islamic state, in 1947, is of considerable cultural and psychological interest. Not only is it an Islamic monument, but it is a sepulchral building. Moreover, it was raised to commemorate a lady of Persian rather than Indian origins. Thus, the most identifiable visual symbol of India, its "place of memories," is a tomb built by a member of a minority community as an emblem of his love for his Persian wife. Furthermore, another foreign people, the British, were responsible for cultivating the image that now looms so large in the collective consciousness of the country. In the long history of the nation the building is of no particular historical significance, it does not commemorate a major victory, nor does it signify a national cathartic experience. It does not embody any lofty principle or institution, as other buildings in other countries do. It symbolizes the intensely personal tragedy of one man, at the same time expressing one of the most powerful impulses of the human species, "the struggle to stave off oblivion." Although the literature of the time when it was built has little to say about the Taj, that it was meant to represent an earthly paradise is clear. The setting of the monument is in keeping with the paradisiacal symbolism of the garden in Islamic civilization. While Mumtaz's soul traveled to the real paradise, it was inconceivable that her mortal remains should be interred anywhere but in a terrestrial replica. A nineteenth-century Persian text on the tomb quotes the following verse:

When Mumtaz-i-Mahall left this world, the Virgins of Paradise opened the gate to admit her. On account of the date of her death the angels said, "Paradise be ever the abode of Mumtaz-i-Mahall."

Taking the paradise concept a step further, it has been suggested that the Taj represents the Throne of Heaven as well. To the followers of Islam, it is a sacred site, richly adorned as it is with verses from the Koran, the Bible of the Muslims, and flanked on one side by a mosque and on the other by a hospice for visiting pilgrims. And as every visitor to the Taj Mahal is aware, throughout the day within the building one can hear sonorous chanting of litanies from the sacred book, so that what on the outside is essentially an aesthetic sensation becomes on the inside a spiritual experience. As in the Hindu temple or the Muslim mosque, one must remove one's shoes to enter the shrine. Thus, although to most visitors the Taj is an embodiment of human love, it is not simply a secular building. Shah Jahan himself is said to have composed the following verses:

Prayers are here answered, it is in fact the very spot where worship meets with a favorable reception. The "roses of pardon" bloom throughout the gardens, the perfume of which intoxicates the brains of the pure. . . . Should a sinner enter this mansion, he will be cleansed from his sins.

The nineteenth-century British artist and poet Edward Lear concluded his comments on the Taj by writing, "Henceforth, let the inhabitants of the world be divided into two classes—them as has seen the Taj Mahal; and them as hasn't." This book is primarily for the latter group. Although the focus is the story of the gradual development of the romance of the Taj Mahal over the last two centuries through both literary and visual allusions, it casts a much wider net. Apart from discussing the myth and the image of the Taj, it also provides a description of the monument, its place in the context of Shah Jahan's architectural programme in particular and Mogul architecture in general, and its symbolic significance. Both the myth and the reality of the Taj are also reviewed in the context of the emperor's overall aesthetic attitude and the state of the arts during his reign. Although Shah Jahan is generally remembered for his obsession with architecture, he was in fact a multifaceted aesthete who was passionately interested in gems and jewels, textiles and carpets, as well as paintings. Thus, while the Taj Mahal remains the crowning glory of his aesthetic adventures, this book for the first time provides the reader with a broad overview of Shah Jahan's extraordinarily varied interest in the arts and his remarkably eclectic taste, which was almost unparalleled among the many kings and emperors before and after him who patronized the arts and architecture. And as the noted American author Lowell Thomas has written,

He gave his life to art. They [the Moguls] spilt much blood and no little wine in their time, yet loot and lust did not dim their artistic sense. Through all the Moghuls ran a love of beauty, which came to its fullness in the time of Shah Jahan. . . . Their empire has vanished but the monuments and the deeds of the Moghuls remain, to challenge comparison with any landmarks of history.

Not only does the Taj Mahal epitomize the Moguls' love of beauty: it remains the clearest expression of a man's perennial quest for immortality as well as his love for a woman. As long as there is romance in this world the cult of the Taj Mahal will continue to grow. When all is said and done, however, the Taj will always remain a mystery, which is the essence of all great art.

CHAPTER ONE

Ruler of the World

Pratapaditya Pal

He has immortalized—if he could not preserve alive for one brief day—his peerless wife; yet the pathetic moral of it all is written in a verse hereabouts from the Hudees, or "traditions." It runs—after reciting the styles and titles of "His Majesty, King of Kings, Shadow of Allah, Whose Court is as Heaven":—*"Saith Jesus (on whom be peace), This world is a bridge! Pass thou over it, but build not upon it! This world is one hour, give its minutes to thy prayers, for the rest is unseen."*

<div align="right">

Sir Edwin Arnold
India Revisited, 1886

</div>

THE FORMATIVE YEARS

The builder of the Taj was born on 5 January 1592. His father was the heir apparent, Prince Salim, who later became the Emperor Jahangir (1569–1627). At the time of his birth his grandfather Akbar (1542–1605) was presiding over the greatest empire that had flourished on the subcontinent prior to British rule in the nineteenth century. The newborn infant's mother, known as Jodh Bai, was a Hindu princess of Jodhpur, a Rajput state in Rajasthan.

A little over half a century before Shah Jahan's birth, his great-great-grandfather Babur (1483–1530) had come from Central Asia like other Muslim adventurers before him to seek his fortune in India. He won a decisive victory on the plains of Panipat, somewhat west of Delhi, in the year 1526, and by the time he died four years later he had carved out a kingdom larger and more prosperous than the principality he had lost in Central Asia. On his father's side Babur was descended from Timur, better known as Tamerlane, and on his mother's side from the Mongol emperor Chingiz or Genghis Khan [Fig. 19]. It was the name of the latter's tribe that stuck to the dynasty, in the altered form of "Mogul" or "Mughal," although throughout their history the dynasty took greater pride in their Timurid

heritage than in their Mongol connection [Fig. 5]. Like other Timurid princes before him Babur wielded the sword and the pen with equal facility, and most of his eminent successors, until the Mogul sun began to set after the mid-eighteenth century, continued the Timurid tradition of pursuing policies of political and cultural expansion simultaneously. Apart from laying the foundation of the Mogul empire, Babur was also a great naturalist and, in his native Turki, wrote his memoirs, which remain one of the finest literary creations of the genre in any language.

No less sensitive than Babur, his son and successor Humayun (1507–56) was, however, politically less fortunate. Within ten years of his accession to the throne he lost the kingdom to Sher Khan, a brilliant adventurer from Bihar in Eastern India. Humayun fled to Sind with his family, and it was during this period of misery that his wife Hamida Banu Begum gave birth to Akbar at Umarkot in 1542. Fleeing further west, Humayun took shelter at the court of the ruler of Iran, Shah Tahmasp. With military aid from the shah, Humayun conquered Kabul in 1545 but had to wait another ten years before regaining his throne at Delhi. Less than a year later he died by accidentally falling down the staircase of his library. In the long run his exile in Iran and Afghanistan was of momentous significance for both the administrative and cultural history of the dynasty. During his sojourn abroad he was able to reacquaint himself with his Timurid heritage and with the culture of the rising Safavid court, which contributed considerably to the cultural synthesis achieved later in Mogul India.

Akbar was only fourteen years old and had no formal education when he became king. Yet by 1592, when Shah Jahan was born, Akbar had conquered the whole of Northern India and ensured the empire's continuance by providing a solid administrative infrastructure. He had also become the first Muslim ruler in the country to inspire confidence and loyalty among the majority of his subjects, who were Hindus. Apart from

5 *A Mogul Tree of Descent*
Mogul, c. 1630
Opaque watercolor on paper
$14\frac{3}{16} \times 9\frac{9}{16}$ in. (36.1 × 24.3 cm.)
Collection Prince Sadruddin Aga Khan

This work, composed of reassembled fragments, shows Jahangir surrounded by his descendants above Mirza Miran Shah, who was a son of Timur.

6 *Shah Jahan and Akbar*
Mogul, c. 1645
Opaque watercolor on paper
$14\frac{5}{8} \times 9\frac{7}{8}$ in. (37 × 25.1 cm.)
Musée National des Arts Asiatiques—Guimet, Paris (MA 3542)

marrying into Hindu royal families, he appointed Hindus to high offices, abolished sectarian taxes imposed only on Hindus, had Hindu epics translated, participated in Hindu festivals, and even attempted to establish a new religion that encouraged universal tolerance. This is not to say that he neglected his own faith, but he was obviously a liberal with an insatiable intellectual curiosity. At once a pragmatist and a visionary, he was not only the real founder of the Mogul empire but the creator of what is known as Mogul culture, which was to remain synonymous with

Indian culture in Northern India until the British dominance in the nineteenth century.

It was this man, rather than Shah Jahan's own father Jahangir, who made the greatest impression on the prince during the formative years of his childhood and remained his ideal later on. As an emperor, Shah Jahan would have numerous portraits painted emphasizing their close relationship [Fig. 6; see also Fig. 19].

Akbar's joy at the birth of this third grandson appears to have been boundless. As Jahangir observed in his memoirs, the *Tuzuk-i-Jahangiri,*

His advent made the world joyous (khurram), and gradually, as his years increased, so did his excellencies, and he was more attentive to my father than all (my) other children, who was exceedingly pleased with and grateful for his services, and always recommended him to me and frequently told me there was no comparison between him and my other children. He recognized him as his real child.[1]

It was Akbar who named the newborn infant Khurram and took charge of him from the moment of his birth. He was taken away from his mother and given to Ruqayyah Sultan Begum, one of Akbar's childless wives, who adopted the boy. It is unlikely that this immediate separation from his mother left any psychological scars on the young prince, for it is not uncommon in Indian joint-families for a child to be brought up by an elderly aunt or a grandmother. If anything the child was likely to be thoroughly spoiled, but there is no indication that Khurram was, despite a doting grandfather and foster-mother. For her part, Khurram's mother Jodh Bai was consoled with a priceless set of rubies and pearls.

Akbar's instant affection for this child may have been influenced partly by his dissatisfaction with the two elder grandsons, but more likely astrology played a large part. Even before his birth, the court astrologers had predicted the auspiciousness of the occasion by characterizing the child to be "more resplendent than the sun."[2] It would appear that Shah Jahan himself could not have chosen a more momentous time of birth if he had been able to manipulate destiny. He was born under the same conjunction of the planets that had prevailed at the time of the birth of his illustrious ancestor Timur. Even more significantly, Khurram was born on 30 Rabi-ul-Awwal of the year 1000 according to the Islamic calendar. It was the month when his father was born, as well as the prophet Muhammad, and the year was the first of the second millennium. The court astrologers and chronographers were in their element, and came up with such exuberant epithets and predictions as "The citadels of glory the newborn is destined to conquer," "A very riband in the cap of royalty," and "He combines in himself the virtues of Alexander the Great and Nausherwan the Just."

So carefully was his upbringing planned that he rarely saw his elder brothers—Khusrau, who was seven when Khurram was born, and Parviz, who was three. They met only on festive occasions, and we are told by contemporary historians that Khurram invariably outshone the others both for his ebullience and for his wit. Obviously Khurram was the chosen one, and this blatant favoritism on the part of his relatives as well as sycophantic courtiers could not have contributed to encouraging an affectionate relationship among the siblings. Akbar always called him "Shah Baba." Generally the title *shah* was reserved for the ruler himself, while *baba*—father—is a very special term of endearment in Northern India. Significantly, in his memoirs Jahangir also constantly refers to him as "Baba Khurram," whereas Khusrau and Parviz are mentioned without a prefix. Later on Khusrau would be blinded for his rebellion against his father, whereas Parviz was poisoned, perhaps at the instigation of Khurram.

Akbar himself escorted Khurram to school when he reached the age of four years, four months, and four days. The school of course was the royal mosque, where a team of mullas or religious teachers headed by the venerable Qasim Beg Tabrizi had assembled [Fig. 7]. The auspicious time was fixed by the favorite Hindu astrologer, Govind Rai. Among the presents the prince received on the occasion from Mulla Qasim was a miniature Koran of the fourteenth century which had once belonged to the well-known Sufi family of Qasim's spiritual teacher, Mirza Jan Tabrizi.

The fact that his first tutor was a liberal Sufi did not sit well with the orthodox members of the court. They were successful in persuading his father to install Hakim Ali Gilani, a more orthodox Muslim, as one of Khurram's tutors. Although Khurram studied languages and cultivated the art of writing for two hours every morning, he was essentially an outdoor person who preferred to learn shooting, riding, and fencing. He made this quite evident during his circumcision ceremony when he was six years, six months, and six days old. Among the gifts he received on this occasion, the most precious was a collection of writings by the celebrated Indian Amir Khusrau (who wrote poetry in Persian), beautifully copied in gold by master calligraphers. Khurram, however, was much more excited by a set of arms presented by his foster-mother. They were not ordinary arms but were sumptuously embellished and bejewelled, and so, early in his life, he displayed the penchant for precious stones that remained his lifelong obsession.

His real tutor, however, was his grandfather, from whom he loved to hear stories of the ancient heroes, as

7 *Instructing Princesses*
Mogul, c. 1675
Opaque watercolor on paper
Robert Hatfield Ellsworth

righteous monarch can be of much avail." But, he added, "Prayers without works are dead. Allah answers only deeds, not words."[3]

So fond was the emperor of his grandson that as early as 1598, when the child was only six years old, Akbar took him along on an expedition to the Deccan. Raja Salivahan, an expert rider, swordsman, and marksman with a gun, was made one of his tutors during the trip. On the way from Lahore to Agra, Khurram took his first shot at a leopard and wounded the animal. When the journey towards the south continued, after a long break at Agra where Khurram recovered from an attack of smallpox which caused Akbar much anxiety, the prince was considered old enough to have his own tent. Both Hakim Ali and Raja Salivahan continued to be his tutors, and it was at the latter's suggestion that Akbar invited Shah Baba at the ripe age of nine to sit with the War Council to plan the strategy for the capture of Asirgarh.

Two other incidents of his early childhood must have made a strong impression on the young prince. Before leaving for the south, while they were in Agra news came from Burhanpur that his uncle Prince Murad had died. Akbar did not hide the truth from his grandson, and told him that his uncle "did not die a natural death, he killed himself by excessive use of lethal, alcoholic beverages." Khurram hardly knew his uncle, just as he was equally unfamiliar with his father. He must have known, however, that his father too was an alcoholic. Both that fact and the death of his uncle made a lasting impression on the boy: until the age of thirty he hardly touched any liquor, and thereafter he drank only occasionally. Even his father remarked upon Khurram's aversion to liquor and wrote in his memoirs, "On the 25th, Friday, the weighing of my son Khurram took place. Up to the present year, when he is 24 years old, and is married and has children, he has never defiled himself with drinking wine."[4] Apparently Jahangir had great difficulty in persuading his son to have a drink on that occasion. Nevertheless, he advised him to drink only in moderation, and quoted the following quatrain of Avicenna, which Shah Jahan seems to have remembered all his life:

> Wine is a raging enemy, a prudent friend;
> A little is an antidote, but much a snake's poison.
> In much there is no little injury,
> In a little there is much profit.[5]

indeed Akbar himself did all his life. They held long discussions about guns, horses, and elephants, but Akbar was remarkably reticent about his own achievements. Once when pressed to talk about one of his famous battles, Akbar replied, "I did not win it, the great Lord gave it to me." Khurram never forgot that answer. On another occasion Akbar told his grandson: "My dear son, the effectual and fervent prayers of a

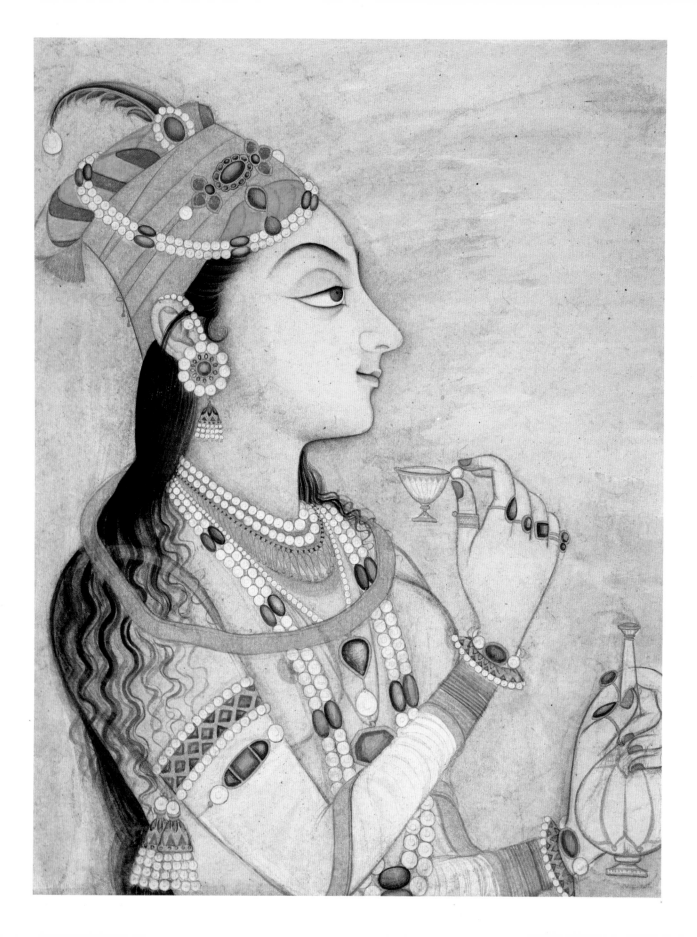

8 *Nur Jahan [?] Drinking Wine*
Rajasthan, Kishangarh, c. 1750
Opaque watercolor on paper
$11\frac{3}{4} \times 8\frac{1}{2}$ in. (29.8 × 21.6 cm.)
Los Angeles County Museum of Art, Gift of
Mr. and Mrs. Michael Douglas (M.81.271.7)

9 Bichitr, *Itimad-ud-daula*
Mogul, c. 1635
Opaque watercolor on paper
$1\frac{3}{4} \times 1\frac{1}{2}$ in. (4.4 × 3.8 cm.)—actual size
Navin Kumar, New York

The second memorable incident was his father's rebellion against his grandfather while they were on their way to the south. Akbar had to rush back to Agra and brought Khurram with him. We do not know how Khurram reacted, but he must have been disturbed even though he was not yet ten years old. Although Salim's rebellion was short-lived—he may not have had the courage to go through with it, or may have belatedly realized the futility of his action—a faction of the court regarded him as unworthy to succeed Akbar and advised the emperor to select Khusrau, the older brother of Khurram, as his successor. Despite Salim's inadequacies, Akbar loved his son and so he is said to have solved the problem by resorting to an omen. He arranged for a fight between two elephants owned by Salim and Khusrau: the owner of the victorious animal would wear the crown. It was a measure of Akbar's confidence in his favorite grandson's judgment that Khurram was made the referee. Soon after the contest began, Salim's elephant was mercilessly mauled by Khusrau's animal. Khurram immediately dispatched a standby elephant into the arena, which created much confusion. Rockets were fired to separate the beasts and Khusrau's elephant decided to bolt. Salim was declared the victor and Akbar breathed a sigh of relief. If this is a true story, the incident must also have endeared Khurram to his father, and may have contributed to Jahangir's blatant display of affection for this son until Shah Jahan's own rebellion many years later.

Although he was shaken by his young uncle Murad's demise, Khurram's second encounter with death, when he was a little over thirteen, was much more traumatic. On 17 October 1605 his beloved grandfather passed away after an illness. For days Khurram had kept vigil at the emperor's bedside. When Akbar was officially pronounced dead, Khurram was both incredulous and disconsolate. He was certain that his Baba would not desert him and leave him alone in this world. He refused to leave the royal chamber, and did not stir until the body was taken away. Not until his beloved wife Mumtaz Mahal died prematurely in 1631 would he be so moved by death again.

THE WAY TO THE THRONE

Shah Jahan's official histories begin only in 1628, the year he ascended the throne. Much information may be gleaned, however, from other contemporary sources,

10 *Portrait of the Emperor Jahangir*
Mogul, c. 1800
Opaque watercolor on paper
$12\frac{3}{8} \times 8\frac{1}{4}$ in. (31.4 × 21 cm.)
The Art Institute of Chicago, The Buckingham Collection (1981.249)

This is a copy of a 1623 painting by Abul Hasan now in the Metropolitan Museum of Art, New York. (See S. C. Welch, 1987, pp. 104–05.)

not the least of which is his father's memoirs. There is no doubt that after his grandfather's death Khurram developed a close relationship with Jahangir [Fig. 10], until he fell out with his stepmother Nur Jahan, who was also his wife Mumtaz Mahal's paternal aunt. In fact, the memoirs make it abundantly clear that not only was Khurram Jahangir's favorite son, but until around 1623 he was also his father's right-hand man and most trusted adviser. He is always referred to in highly flattering terms of endearment, while his brothers are hardly ever

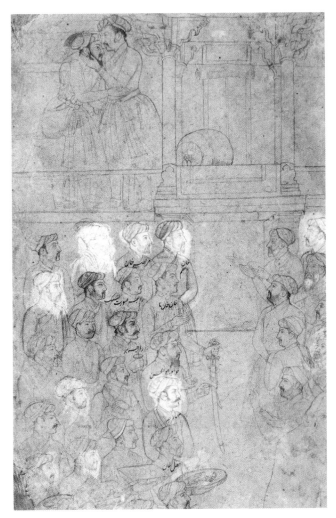

11 *Jahangir Bids Farewell to His Son Prince Khurram*
Mogul, c. 1620–25
Opaque watercolor on paper
$9\frac{5}{8} \times 6\frac{5}{8}$ in. (24.4 × 16.8 cm.)
San Diego Museum of Art, Edwin Binney, 3rd, Collection

mentioned. The extent of Jahangir's love and admiration for his son can be judged from the fact that in 1616, in recognition of the prince's services in the Deccan, the emperor issued an order that henceforth Khurram was to be addressed as "Shah Sultan Khurram." A year later he was honored further, as Jahangir recorded:

When he [Khurram] had hastened to the capture of the Deccan he had obtained the title of Shah, and now, in reward

for this distinguished service, I gave him a mansab [rank] of 30,000 personal and 20,000 horse and bestowed on him the title of Shah Jahan [Ruler of the World]. An order was given that henceforth they should place a chair in the paradise-resembling assemblies near my throne for my son to sit upon. This was a special favour for my son, as it had never been the custom heretofore.[6]

In 1618 when the first copy of the *Jahangir-nama* (The History of Jahangir) was ready he presented it to Shah Jahan, "whom I consider to be in all respects the first of my sons." He continued,

On the back of it I wrote with my own hand that I had given it him on a certain day and at a certain place. I hope that the favour of the receipt of those writings which are intended for the satisfaction of the creature and for supplication to the Creator may be a cause of good fortune.[7]

Throughout Jahangir's reign Shah Jahan remained involved in his father's military ventures. A drawing in the Binney Collection [Fig. 11] illustrates a touching moment when Jahangir embraces his son after his return from a successful campaign against Mewar. Although Jahangir lost Qandahar in the northwest, he did contribute to the expansion of the empire by consolidating Mogul rule in Bengal, including the subjugation of Cooch Behar (1609) and Kamrup (1612) east of Bengal, by a decisive victory over the Rajputs in Mewar in 1615, by reasserting his authority in the Deccan and by the capture of the Kangra fort in 1620. These major military events of his life were due largely to Shah Jahan's leadership.

In 1611 Jahangir married a forty-year-old widow of a minor official who has become famous as Nur Jahan [Fig. 8; and see Figs. 16, 30, 240]. She was the daughter of Mirza Ghiyas Beg, from Iran, who had joined and risen in Akbar's court and became the most powerful official of the realm under Jahangir, when he was better known as Itimad-ud-daula [Fig. 9]. After his death in 1622 the position was held by his son, Nur Jahan's brother, Asaf Khan [Fig. 15], whose daughter was Mumtaz. Apart from the fact that he was Shah Jahan's father-in-law, Asaf Khan also helped the prince to seize the crown, and was rewarded by a grateful son-in-law with the position of *wazir* or prime minister of the empire. There is no doubt that until Asaf Khan's death in 1641, for over three decades this obscure family from Iran wielded enormous power in the Mogul empire and

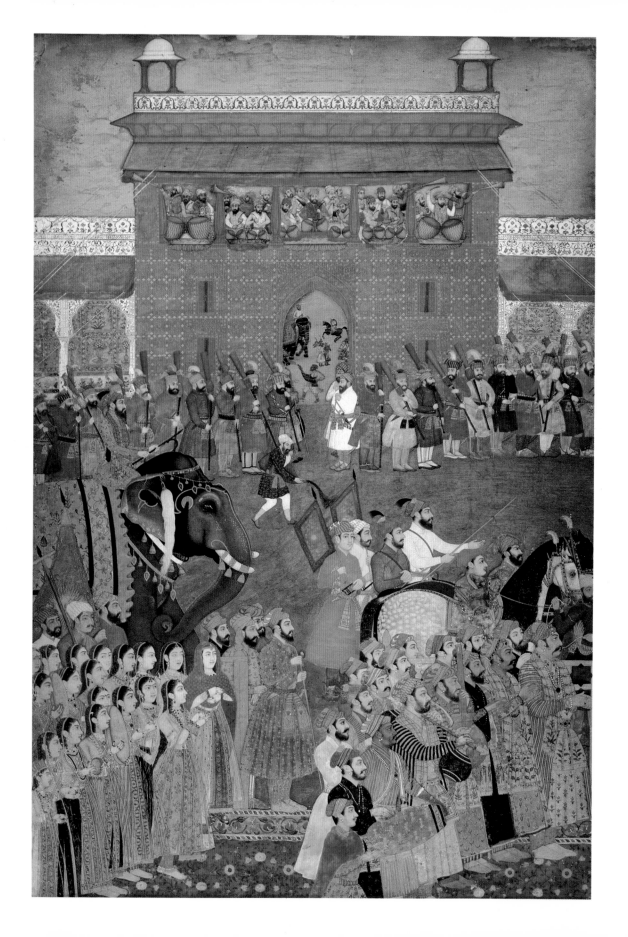

12 *Procession Scene*
Page from a manuscript of the *Padshah-nama*
Mogul, mid-17th C.
Opaque watercolor on paper
14¾ × 8⅝ in. (27.5 × 22 cm.)
The Art Institute of Chicago, Kate S.
Buckingham Fund (1975.555)

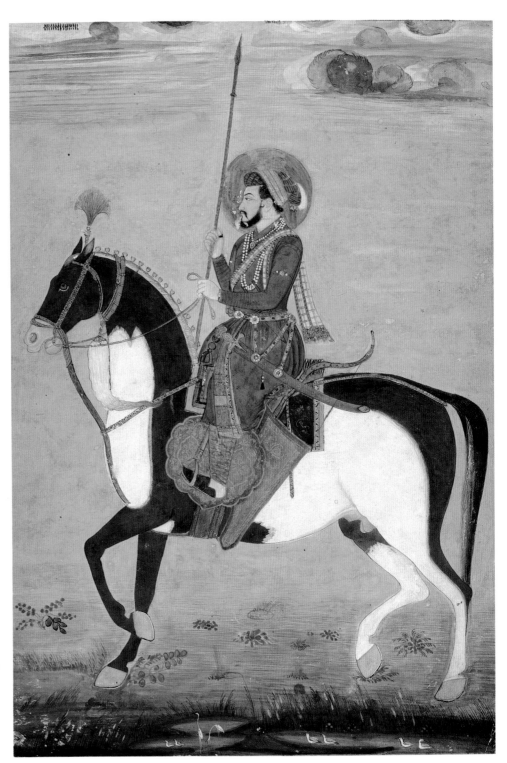

13 *Shah Jahan on Horseback*
Golconda, c. 1670
Opaque watercolor, gold, and ink on paper
11⅜ × 7¾ in. (28.9 × 19.7 cm.)
Dorothea H. Swope

This is another version of a picture in the
Kevorkian Album in the Metropolitan
Museum of Art, New York. (See
S. C. Welch, 1987, pp. 202–03, fig. 59.)

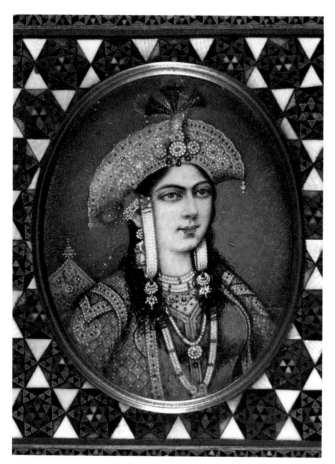

14 *Mumtaz Mahal* (detail of box, Fig. 255)
North India, c. 1900
Opaque watercolor on ivory
Charles Wolfe Masters, Jr., and Family Trusts

year-old Mumtaz Mahal at the Meena Bazaar. This was a private marketplace within the royal enclosure where the ladies of the royal harem and the aristocratic ladies of the court would have stalls and sell their fancy merchandise at exorbitant prices to royalty and the nobility. It may appropriately be characterized as a vanity fair where the normally secluded women enjoyed freedom for a few brief hours. Naturally we are told it was love at first sight, but they had to wait another four years to get married. In the meantime, for state reasons Shah Jahan would have to marry a princess from Iran.

We will never know for certain whether this popular tradition is true or not. What is certain is that in his memoirs Jahangir claims to have arranged the marriage with Mumtaz Mahal when the prince was fifteen years old, which is corroborated by Shah Jahan's official history. Jahangir recorded the occasion by noting, "As I had sought the daughter of Itiqad Khan [Asaf Khan], son of Itimad-ud-daula, in marriage for Khurram, and the marriage festival had been arranged for, I went on Thursday 18th Khurdad to his house, and stayed there one day and one night."[8]

Both Nur Jahan and Shah Jahan were ambitious, and it was inevitable that one day their stars would collide. In 1617, after one of Shah Jahan's successes in the Deccan, Nur Jahan gave a victory party [Fig. 16] for the prince at which she presented him with

dresses of honor of great price, with a *nadiri* of embroidered flowers, adorned with rare pearls, a *sarpich* (turban ornament) decorated with rare gems, a turban with a fringe of pearls, a waistbelt studded with pearls, a sword with jewelled *pardala* (belt), a *phul katara* (dagger), a *sada* (?) of pearls with two horses, one of which had a jewelled saddle, and a special elephant with two females.[9]

exerted significant influence on the politics and culture of their time. The family in general and Nur Jahan in particular also contributed to the extravagant lifestyle of both Jahangir and Shah Jahan—which inspired the subsequent use of the word "Mogul" in the English language.

A year after Nur Jahan's marriage to Jahangir, her niece, Arjumand Banu, was married to Shah Jahan and given the title of "Mumtaz Mahal" [Figs. 14, 28]. Although Nur Jahan encouraged the match she had little to do with its initiation. Tradition has it that when he was sixteen years old Shah Jahan met the fifteen-

Three years later, however, when Jahangir was recuperating in Kashmir, the situation had changed dramatically. By then Nur Jahan had become the *de facto* ruler of the empire. Her aging husband was increasingly showing the consequences of his lifelong indulgence in alcohol and drugs, and the empress had begun to enjoy the enormous power she came to wield. The idea of Shah Jahan succeeding his father now held much less appeal for her and by 1622, when the prince was thirty years old, she began to conspire to place Shahriyar, her son-in-law, on the throne.

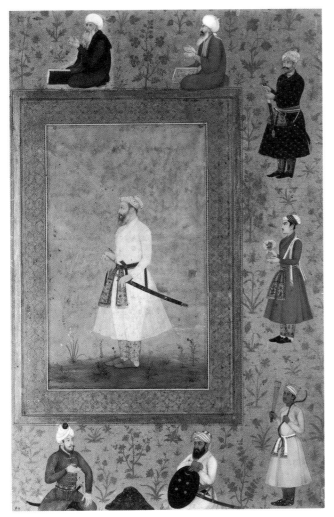

15 *Portrait of Asaf Khan*
Mogul, c. 1650
Opaque watercolor on paper
15 × 9¾ in. (38 × 24.8 cm.) with borders
The Cleveland Museum of Art, Purchase from the J. H. Wade Fund (45.168)

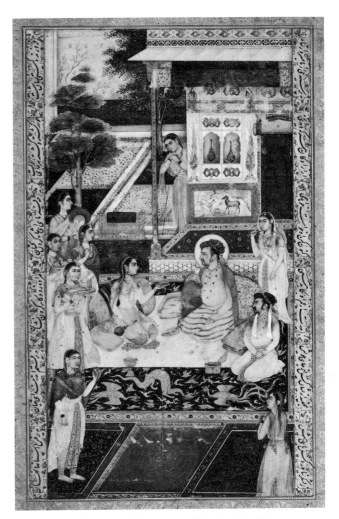

16 *Jahangir and Prince Khurram Feasted by Nur Jahan†*
Mogul, c. 1617
Opaque watercolor on paper
9¹⁵⁄₁₆ × 5⅝ in. (25.2 × 14.2 cm.)
Courtesy of the Freer Gallery of Art, Smithsonian Institution, Washington, D.C.

By the time Jahangir returned to Agra on 11 April 1623 after a pleasant visit to Kashmir, Shah Jahan had already rebelled and taken to flight. On the advice of Nur Jahan, Jahangir sent a large army to pursue the fleeing prince. Thereafter Shah Jahan was constantly on the move but was never able to defeat the imperial forces. In 1627, however, his hopes were rekindled when the general of the imperial army, Mahabat Khan, unable to accept any longer the machinations of Nur Jahan, offered his services to Shah Jahan. Although his motive was uncertain, he may well have been influenced by Asaf Khan, Shah Jahan's father-in-law.

Events moved swiftly upon Jahangir's death on 29 October 1627. Before she could recover from the shock Asaf Khan took his sister, the empress, into custody and proclaimed Dawar Bakhsh, the son of Khusrau, as the new emperor, evidently to allay public fears since Shah Jahan was in the distant south. While a message was being carried to Shah Jahan, Shahriyar, who was then in Lahore, advanced with an army against Dawar Bakhsh and was soundly defeated. Taking shelter in the fort, he was discovered hiding under a heap of carpets in the women's quarters. Asaf Khan lost no time in blinding him and throwing him into a dungeon. Later, on the

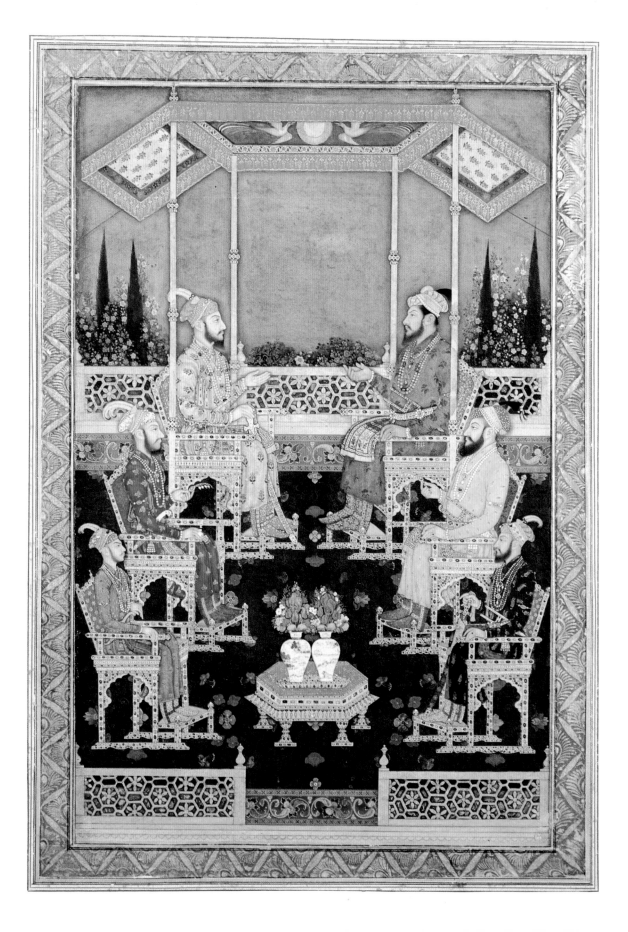

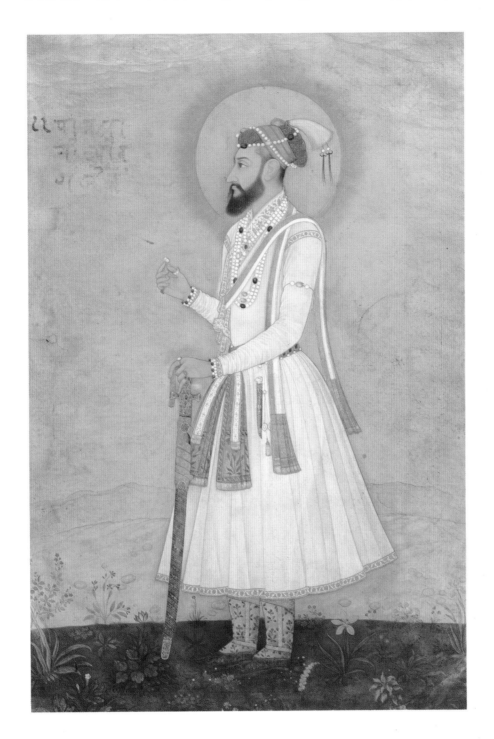

17 Amal-i-Bhawani Das (inscr.), *The Sons of Shah Jahan Enthroned: Shah Shuja, Dara Shikoh, Murad Bakhsh, Aurangzeb, and Azam Shah*
Mogul, late 17th C.
Opaque watercolor on paper
$19\frac{1}{4} \times 13\frac{3}{8}$ in. (48.9 × 34 cm.)
San Diego Museum of Art, Edwin Binney, 3rd, Collection

Azam Shah was one of Aurangzeb's sons. The sixth figure is not identified but may be another son of Aurangzeb.

18 *Aurangzeb*
Mogul, 17th C.
Opaque watercolor on paper
$7 \times 4\frac{5}{8}$ in. (17.8 × 11.7 cm.)
Gary Crawford

19 *Akbar Offering Timur's Crown to Shah Jahan*
Mogul, c. 1650–1700
Ink on paper
8⅜ × 6⅛ in. (21.3 × 15.6 cm.)
The Art Institute of Chicago, Gift of Mrs. Joseph L. Valentine
(1945.311)

orders of Shah Jahan, Asaf Khan executed Shahriyar, Dawar Bakhsh, and the three sons of Jahangir's brother Daniyal, thereby removing all other claimants to the throne except his own remaining brother, Parviz. Shah Jahan reached the outskirts of Agra on 28 January 1628, but decided to wait in a garden until the astrologers announced the auspicious hour. When the time came he made a triumphant entry into the capital riding his favorite elephant, Mubarak Manzil. It was a grand occasion, and as Asaf Khan had predicted, "The high and low of this ageless city of Agra did give him a reception the like of which had not been extended to any ruler before". A painting in Chicago from a *Padshah-nama* (see below, p. 93) vividly captures the mood of such an occasion [Fig. 12].[10] That he felt he was the

rightful heir to the throne as Akbar's favorite grandson is clear from a royal portrait, of which several versions exist, where he is seen receiving the crown directly from Akbar rather than his father [Fig. 19]. The painting after which the drawing was made is the frontispiece for the well-known Minto Album in the Chester Beatty Library, Dublin.[11] It is unlikely that this was a mere conceit: his early experience with his grandfather must have convinced him of the justice of his claim, even though the path to the throne would prove to be awash with royal blood. These struggles were only a preview of the even more tragic drama he would experience thirty years later in a yet bloodier fight among his sons for his own throne. That throne, however, would be the famous Peacock Throne, rather than the one he ascended on a chilly February day in 1628 in Agra.

Although his reign was not as long as his grandfather's or his son Aurangzeb's, Shah Jahan did rule for three decades and lived on for another eight years after his dethronement, dying in 1666. The first eighteen months augured well and Shah Jahan enjoyed a peaceful stretch in Agra. By the end of 1629, however, the troublesome Deccani rulers once again required his military attention and the court moved down to Burhanpur [Fig. 13]. Today Burhanpur is an unprepossessing town. In Shah Jahan's youth, however, when it was the launching pad for the Deccani campaign of the Moguls, it was both prosperous and pleasant. Once again he took his family with him, including his favorite Mumtaz Mahal. Babur had strongly advised against taking women on military campaigns, a suggestion that Akbar had followed but his successors did not. Although during his father's reign Shah Jahan had spent many a year at Burhanpur with Mumtaz, this was their first visit to the town after he became emperor. This time tragedy lay in store for them both, for it was here, while giving birth to their fourteenth child in nineteen years of married life, that Mumtaz died, on 7 June 1631.

Mumtaz's death was a devastating blow to the emperor. In the words of the *Shahjahan-nama* (The History of Shah Jahan) of Inayat Khan,

On the 17th Zil-kadah, the unfortunate demise of Nawab Mehad Ulia [which is how Mumtaz was addressed], which took place shortly after her confinement, made the whole world a house of mourning. His Majesty immediately put on white garments, and all the illustrious princes, nobles, and

"mansabdors," as well as the officers and servants of the palace, dressed themselves in deep mourning. . . . The whole week after this distressing occurrence, His Majesty from excess of grief did not appear in public, nor transacted any affairs of state. On Thursday, the ninth day after the event, he visited the tomb of that pilgrim to the realm of eternity and gladdened her spirit with the opening chapter of the Kuran. He also made the rule, as long as he remained in Burhanpore, always to visit the shrine of that recipient of God's mercies, every Friday evening, and refrained, after this calamity, from the practice of listening to music and singing, and wearing fine linen. From constant weeping, he was forced to use spectacles, and his august beard and mustachios which had only a few white hairs in them before, became from intense sorrow, in a few days, more than one third white.[12]

He remained in mourning for two years, and led almost an ascetic existence, wearing simple clothing, rejecting the rich food and music that he loved so much, and abandoning all forms of ostentation. However, he did recover and continued with his imperial duties, although the Taj must have taken up much of his time. Increasingly thereafter architecture rather than state-craft became his principal preoccupation, even though this is not apparent from his official biographies.

Politically he seems to have thrown the lessons he learnt from his grandfather to the winds. It was natural for him to turn to the Koran and seek solace in religion. He seems to have come under the influence of the orthodox Muslim hierarchy at court, and early in 1632 he ordered the destruction of all recently built Hindu temples throughout the empire. At about the same time he also launched a full-scale assault on the Portuguese at Hugli in Bengal. Shah Jahan had always been less tolerant than either his grandfather or father of the Europeans in India, and while a governor had refused to grant permission to the English to build fortifications at Surat in Gujarat. The establishment at Hugli, in particular, had earned his ire for several reasons: against all orders the Portuguese had fortified their settlement, consistently refused to accept other imperial orders, worked hand-in-glove with the rulers of Arakan in Burma against Mogul interests, and, imprudently, neither supported Shah Jahan when he rebelled against his father nor congratulated him on his accession. The straw that broke the camel's back was the abduction of a couple of women who were close to Mumtaz Mahal. It is not difficult to see that the intensity of the emperor's

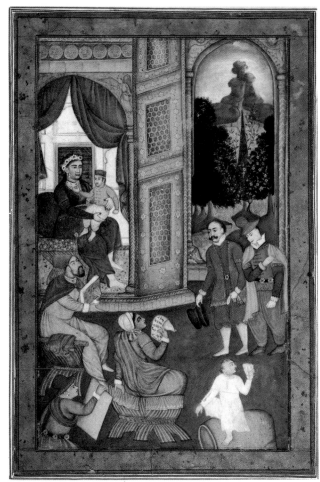

20 *Armenian Family Gathering*
Mogul, c. 1650
Opaque watercolor on paper
$8 \times 5\frac{3}{8}$ in. (20.3 × 13.7 cm.)
Navin Kumar, New York

grief could easily have added fuel to the fire, and he released some of his pent-up emotions by attacking the infidel Hindus and Christians. Both acts would earn him immediate credit with the orthodox elements of his court and make his future passage to paradise smoother. After the sack of Hugli some four thousand prisoners, not all Portuguese but mostly Christians, were brought to Agra in great misery, severely maltreated, and forcibly circumcised and converted to the Muslim faith.

The intensity of Shah Jahan's dislike of the Christians from Bengal is clear from the treatment of Mirza Zulqarnain (1592–1656). Mirza Zulqarnain was an Armenian Christian. His father, Sikander, was a merchant from Aleppo who, like many other Armenians, had settled in India [Fig. 20]. Sikander acquired

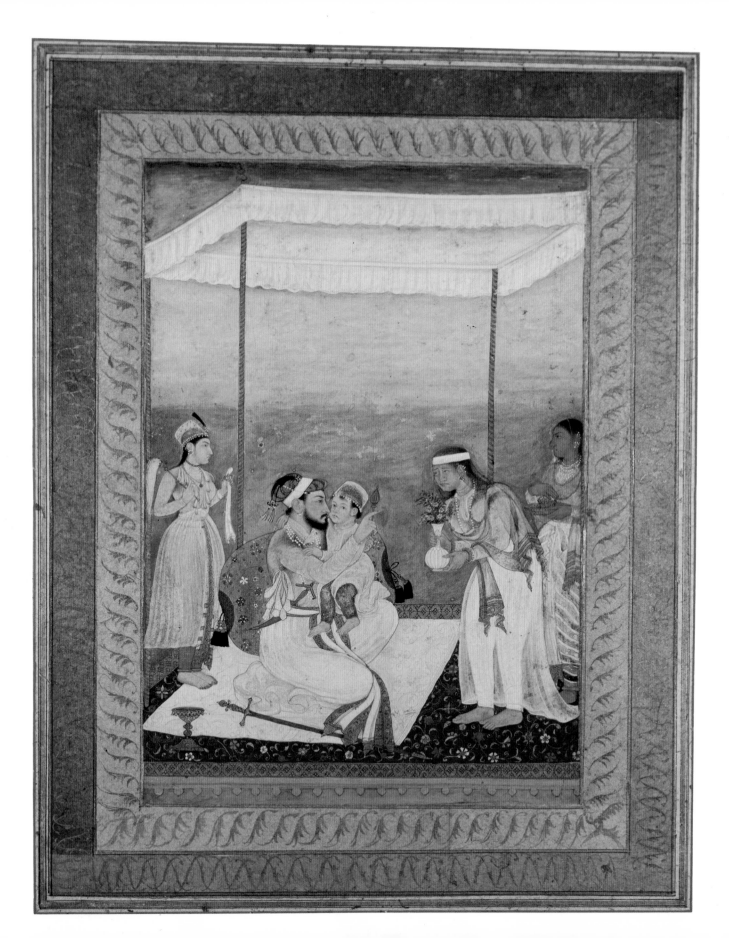

21 *The Emperor Shah Jahan Holding a Child*
Mogul, c. 1621
Opaque watercolor on paper
$7\frac{1}{2} \times 5\frac{3}{8}$ in. (19 × 13.6 cm.)
Trustees of the Victoria and Albert Museum,
London (IS 90–1965)

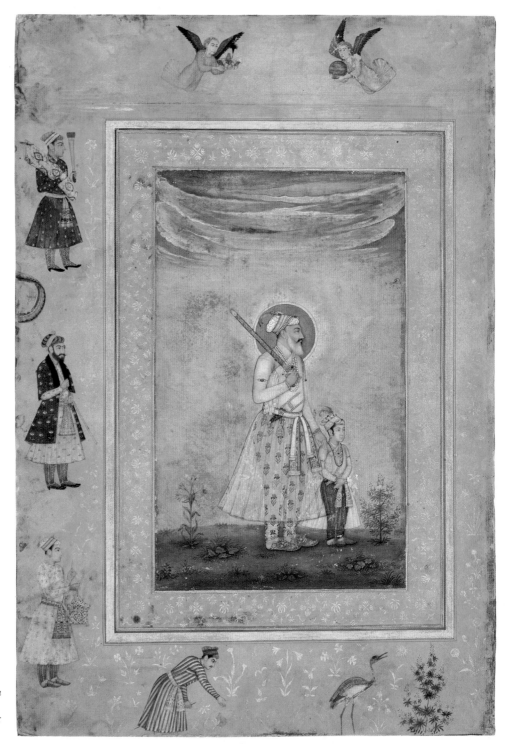

22 *Shah Jahan and Grandson*
Mogul, c. 1650
Opaque watercolor on paper
Robert Hatfield Ellsworth

great favor at Akbar's court: not only did Akbar support his request to the Pope for a dispensation to marry his sister-in-law after his wife's death, but the emperor also adopted his two sons. Mirza Zulqarnain was therefore brought up at court, and as he was born in the same year as Shah Jahan and both were favorites of Akbar, they may well have been playmates. And yet when Mirza Zulqarnain, who by this time was an important official of Shah Jahan's court, extended a helping hand to the Christian prisoners at Agra, the emperor had him thrown into prison and his wealth confiscated. His misfortunes did not last long, however, and by 1640 he had regained the imperial favor. Several Mogul pictures, such as the one reproduced here, have been identified as showing Europeans when in fact they represent Armenian households of the period.

Like his father, Shah Jahan also sent his sons to fight his battles or to govern his empire, except for the eldest, Dara Shikoh (1615–59), who was his favorite. His other sons were Shah Shuja (1616–c. 1661), Aurangzeb (1618–1707), and Murad Bakhsh (1624–61), all of whom were the children of Mumtaz [Fig. 17]. The most competent and astute among them, though the least liked by the emperor, was Aurangzeb, who accompanied his father to the Deccan when he was only sixteen years old and was left in charge there [Fig. 18]. Dara was sent occasionally on military expeditions but generally remained close to the emperor. It was Aurangzeb who fought most of his father's wars, which must have given him an unusual control over the imperial army. As it turned out, when the aging emperor became severely ill in 1657 Aurangzeb, who was in command of the Deccan campaign, had almost the entire Mogul army and its outstanding general Khan-i-Jahan at his command. Shah Shuja was then governor of Bihar and Bengal, while Murad was governor of Gujarat in the west.

As soon as they heard of their father's illness Shuja and Murad each proclaimed himself emperor and marched towards the capital. The astute Aurangzeb did nothing of the sort: feigning total lack of interest in the throne, he persuaded Murad to join with him in preventing Dara from gaining the crown. Thus began a fratricidal struggle that lasted for almost two years.

In February 1658 Shah Shuja was defeated near Varanasi by a force sent from Agra. Another army, led by Jaswant Singh of Marwar, had less luck against Aurangzeb, who continued to march north rapidly and faced Dara's army near the capital. No match for Aurangzeb's superior generalship, Dara fled, and a triumphant Aurangzeb entered Agra as his father had done three decades before. He did not occupy the fort, however, but confined his father there in the beautiful marble pavilions that had been built by the emperor himself.

Aurangzeb then turned toward Delhi and met Murad at Mathura. The unsuspecting Murad was invited to his tent, plied with liquor, and arrested. Aurangzeb proclaimed himself emperor in Delhi on 21 July 1658. Before the end of the following year, Shah Shuja disappeared in the jungles of Arakan, Murad's murder was arranged, Dara Shikoh was brought to Agra and beheaded, and Dara's son Suleiman Shikoh was slowly poisoned in the Gwalior fort. Thus ended the reign of the "Ruler of the World."

Because of his posturing and obsession with his "imperial" image, as evident in his portraits, scholars have often characterized Shah Jahan as a cold and calculating man. He may have been calculating but he certainly was not cold. Although he was partial to Dara Shikoh, he was fond of all his sons, and several paintings show him with his own children as well as his grandsons. Two such paintings are included here. In a charming picture in the Victoria and Albert Museum [Fig. 21] we see a young Shah Jahan fondling one of his sons. This display of affection could hardly be expected from a cold man. In another work [Fig. 22], a much older Shah Jahan is portrayed with one of his grandsons. The painting is formal, but the subtle placement of the emperor's left hand on his grandson's shoulder speaks volumes for his grandfatherly concern and affection.

Scholars should be careful of interpreting formal Mogul portraits too literally. Just as the humanity of the emperor is played down in the official biographies, so imperial portraits were not meant to depict their subjects' emotions and human foibles. Indeed, the Jahangir of his memoirs is quite a different character from the hero of the *Jahangir-nama*. It was Jahangir who began the practice of glorifying the imperial image, and Shah Jahan merely added icing on the cake. For instance, in a pair of matching portraits of the father and son that were once part of an imperial album [Figs. 23, 24], one can hardly differentiate between the two personalities. They are equally stiff, formal, and imperious, even though Jahangir receives a courtier and Shah Jahan his favorite son, Dara Shikoh. In another official

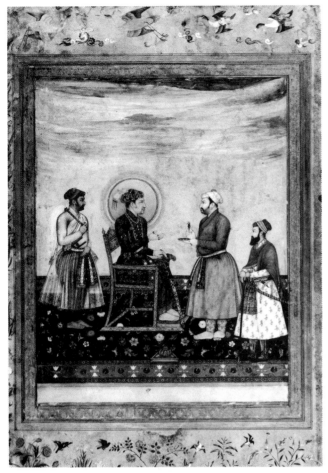

23 *Jahangir with Courtiers*
Page from the Late Shah Jahan Album
Mogul, c. 1650
Opaque watercolor and gold on paper
$17\frac{3}{4} \times 13$ in. (44.9 × 33 cm.)
Arthur M. Sackler Gallery, Smithsonian Institution, Washington,
D.C., Purchase made possible by Smithsonian Unrestricted
Funds, the Regents' Acquisition Fund, and Arthur M. Sackler
(s86.0407)

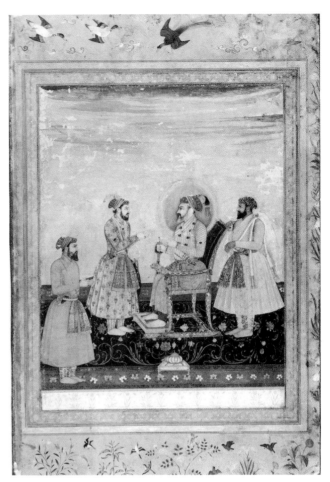

24 *Shah Jahan Receiving Dara Shikoh and an Attendant*
Page from the Late Jahan Album
Mogul, c. 1650
Opaque watercolor on paper
$14\frac{5}{8} \times 10$ in. (37.2 × 25.4 cm.)
Los Angeles County Museum of Art, From the Nasli and Alice
Heeramaneck Collection, Museum Associates Purchase
(M.83.105.21)

picture, perhaps one of the finest portraits of the period, we see Shah Shuja seated in conversation with the Rajput ruler Gaj Singh of Marwar [Fig. 26]. Even though it is a friendly occasion and the Mogul prince is offering a *pan* (betel leaf) to his guest, their faces betray no emotions. This is generally true of most Mogul portraits, notwithstanding the naturalistic delineation of the facial features. Hence it would be a mistake to conclude from such flattering, formal representations that in life the sitters were less humane. Even though his sons did rebel against him, all historical evidence indicates that Shah Jahan was a warmhearted man who loved his children as most fathers do.

Despite its unhappy end, Shah Jahan's long reign has generally been characterized by historians as the most prosperous in Mogul India. Unlike his father, who lost part of the empire, depleted the treasury with his extravagance, and rarely fought his own wars, Shah Jahan was an active and conscientious ruler. Although he too sent his sons off to govern the realm, he took more interest in his own wars and, while he was unsuccessful in Central Asia and Afghanistan, he made

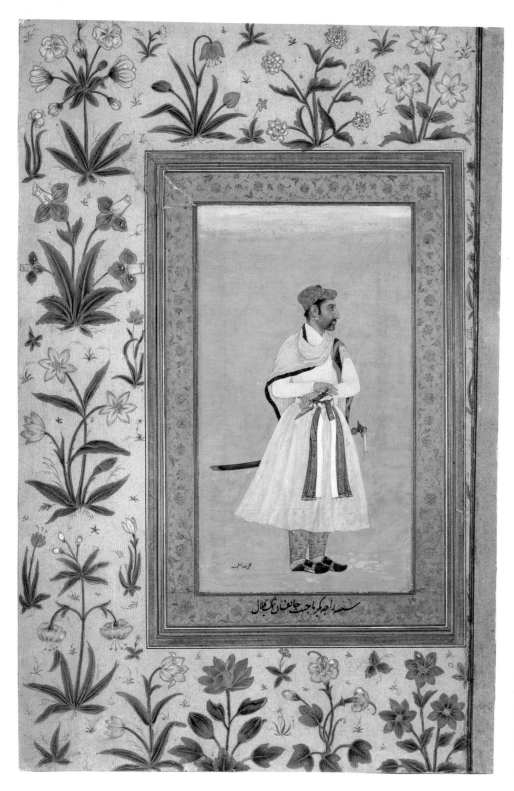

25 Lal Chand (inscr.), *Portrait of Raja Bikramajit*
Mogul, c. 1620–30
Opaque watercolor on paper
$13\frac{1}{8} \times 8\frac{3}{4}$ in. (33.3 × 22.2 cm.)
The Cleveland Museum of Art, Purchase from the J. H. Wade Fund (45.170)

26 Bichitr (attr.), *Shah Shuja and Gaj Singh of Marwar*
Mogul, c. 1638
Opaque watercolor on paper
$9\frac{7}{8} \times 6\frac{7}{8}$ in. (25.2 × 17.5 cm.)
Los Angeles County Museum of Art, From the Nasli and Alice Heeramaneck Collection, Museum Associates Purchase (M.80.6.6)

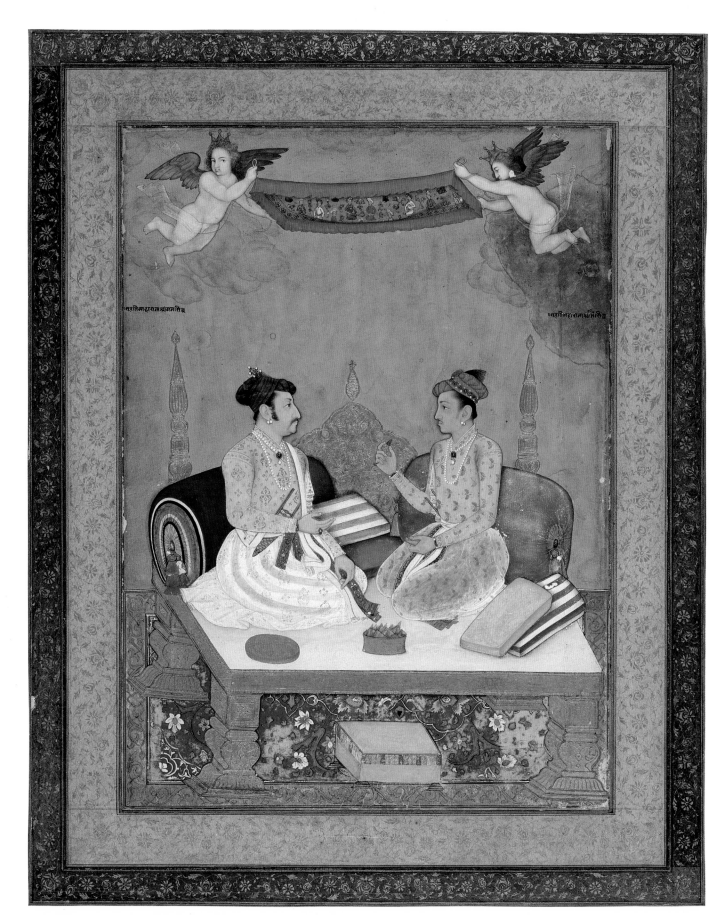

some conquests in the south and east. Certainly the imperial treasury was once again replenished, and despite Shah Jahan's lavish building activity his son Aurangzeb inherited a much more prosperous empire than he himself had acquired from Jahangir. The very fact that Shah Jahan could expend fortunes in pursuing his interest in architecture without exhausting the treasury indicates that his fiscal policy was more successful than that of his father. He expended less money in lavish presents to his nobles; more significantly, increased trade, both internal and external, was instrumental in generating larger revenues. Aurangzeb's successes in the Deccan and better control over the rich province of Bengal also helped to swell the treasury.

Shah Jahan's court was less dominated by the faction from Iran than that of his father but no less luxurious. Until his death in 1641, Asaf Khan proved to be an efficient prime minister. His successors Fazil Khan and Saadulla Khan, Muslims of Indian origins, were equally efficient. Other native Muslims, as well as the Hindu nobility who had been pushed into the background during Jahangir's reign, were once more encouraged to serve the state, as had been the case during the time of Akbar. In religious matters Shah Jahan appears to have been ambivalent. By birth he was only a quarter of Muslim descent, but significantly, unlike Jahangir and Akbar, he did not marry Hindu women, and while he was not a bigot, he was certainly a more orthodox Muslim than either of them. Although he did destroy some Hindu temples early in his reign and persecuted the Christians after his beloved wife's death, in general he was more supportive of the Hindus, with whom he mixed socially. Many of his generals and high officials, such as Raja Bikramajit of Bandhu [Fig. 25] and Jaswant Singh of Marwar, were his trusted friends. He did not condone Akbar's excesses and innovations in religious matters, but neither did he display the zeal and severe orthodoxy of his son Aurangzeb.

After his wife's death Shah Jahan was increasingly influenced by his daughter Jahanara and his eldest son Dara Shikoh, both of whom were intellectually liberal and religiously tolerant. Dara had inherited Akbar's free spirit and intellectual curiosity [Fig. 27]. He was unquestionably Shah Jahan's favorite son, and had he been less philosophically inclined and more practical, he might have awakened fewer anxieties and received greater support from the generals and the Muslim hierarchy than he did. It was his openly unorthodox

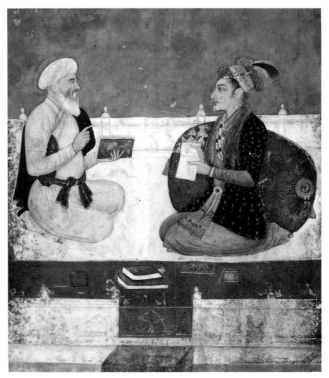

27 *Dara Shikoh and Mulla Shah*
Mogul, c. 1640–60
Opaque watercolor on paper
$5\frac{1}{4} \times 4\frac{5}{8}$ in. (13.3 × 11.7 cm.)
Bibliothèque Nationale, Paris (Ms. Or. Persan 98, fol. 355)

behavior that provided Aurangzeb with the ammunition he required to prevent Dara's succession to the Mogul throne.

Although his life ended tragically, and although he was overshadowed by Jahangir, Shah Jahan, and Aurangzeb, who dominate Indian history for the entire seventeenth century, Dara Shikoh made significant contributions to the intellectual history of India. As the historian S. M. Ikram has observed,

In *Majma-ul-Bahrain* (The Mingling of Two Oceans), which was completed in 1655, Dara Shukoh tried to trace parallels between Islamic Sufism and Hindu Vedantism. In the introduction he says that after a deep and prolonged study of Islamic Sufism and Hindu Vedantism he had come to the conclusion that "there were not many differences, except verbal, in the ways in which Hindu monotheists and Muslim

Sufis sought and comprehended truth." Here he sounded a note that was to become the hallmark of many Hindu [as well as Western] thinkers in the nineteenth and twentieth centuries.[13]

It was Dara Shikoh, a Muslim prince, who was responsible for introducing the Upanishads, the major repositories of Hindu philosophy, to the West. With the help of Sanskrit scholars he had completed a Persian translation of the Upanishads a year before his death in 1658. This was the version that was translated into Latin by Anquetil Duferron, a French traveler, and published in two volumes in 1801 and 1802. That Latin translation in turn fell into the hands of the German philosopher Arthur Schopenhauer. Schopenhauer's enthusiasm for this new world of thought profoundly influenced several thinkers including Ralph Waldo Emerson and other Transcendentalists in the United States.

Apart from his interests in philosophy and religion, Dara Shikoh was an accomplished poet, and no less a patron of the arts than his illustrious forebears. He attracted many distinguished poets, musicians, artists, and architects. His love for pictures and calligraphy [see Fig. 119], an essential attribute of a Mogul prince, may best be gleaned from the celebrated album prepared by him and now in the India Office Library in London. Several pictures from the album included in this book demonstrate his sensitive connoisseurship and his catholic taste [see Figs. 29, 98, 101, 107]. It is no wonder that of all the sons of Shah Jahan it was this hapless misfit who became a romantic and legendary figure in the minds of Hindus and Muslims alike. He may have lost the crown as well as his head to his younger brother, but the lasting influence of his charismatic personality and intellectual prowess almost proves the adage that the pen is mightier than the sword.

THE IMPERIAL LADIES

One of the least explored but most fascinating aspects of Shah Jahan's life and personality is his relationships with women. After all, it was his love for a woman that led to the creation of the Taj Mahal.

As has already been stated, the first woman in his life was Ruqayyah Sultan Begum, one of his grandfather's childless wives. Though born to a Hindu mother, he was removed from her at the moment of his birth and brought up by this devoutly Muslim lady. That may partially account for the fact that his upbringing was more orthodox than that of his father. It may also explain why later in life he did not take a Hindu woman as a wife, nor was he ever associated with one by gossipmongers. (However, his harem probably did include Hindu and Christian women, particularly some of the captured Portuguese women.) Although we know very little about his relationship with his foster-mother, one can imagine how well-loved and pampered he must have been by this childless lady. By all accounts he was a very attractive boy with a cheerful and outgoing personality, and she was a mature but gentle woman with a bosom full of unspent maternal love. And as Jahangir noted, "She loved him a thousand times more than if he had been her own."[14]

The second woman who played an important role in Shah Jahan's life was Nur Jahan [Figs. 8, 16, 30, 240]. Her given name was Mehr-un-nisa, and at the age of seventeen she was married to Ali Quli, a Persian adventurer who was given the title of Sher Afghan by Jahangir and sent to Bengal. In 1607 he was killed in a skirmish with imperial emissaries; some sources have claimed that Jahangir was responsible. She was brought back to Agra, where she became a lady-in-waiting to Salima Begum, one of Akbar's widows. She was by then thirty-seven and the mother of a teenage girl, but age had augmented rather than diminished her attractiveness. For three years she resisted his advances, but finally she gave in and the wedding took place in 1611. From then until Jahangir's death in 1627 she was the undisputed mistress of both the emperor's heart and his throne. What is surprising is that Jahangir himself has very little to say about the intensity of their feelings. Although no monument commemorates their relationship, their love for one another was no less profound and passionate than that of his son and her niece. It is interesting that Jahangir and Nur Jahan had no children of their own. She was forty when they were married, and the fact that she had only one daughter by her first husband despite two decades of conjugal life may indicate that she was incapable of having any more children after that first childbirth.

While very little information is available about her niece, there is abundant material about Nur Jahan. Not only do we have numerous contemporary accounts of this remarkable woman's life and character, but even more than Mumtaz Mahal her image continued to linger in the Indian memory. For instance, there are far

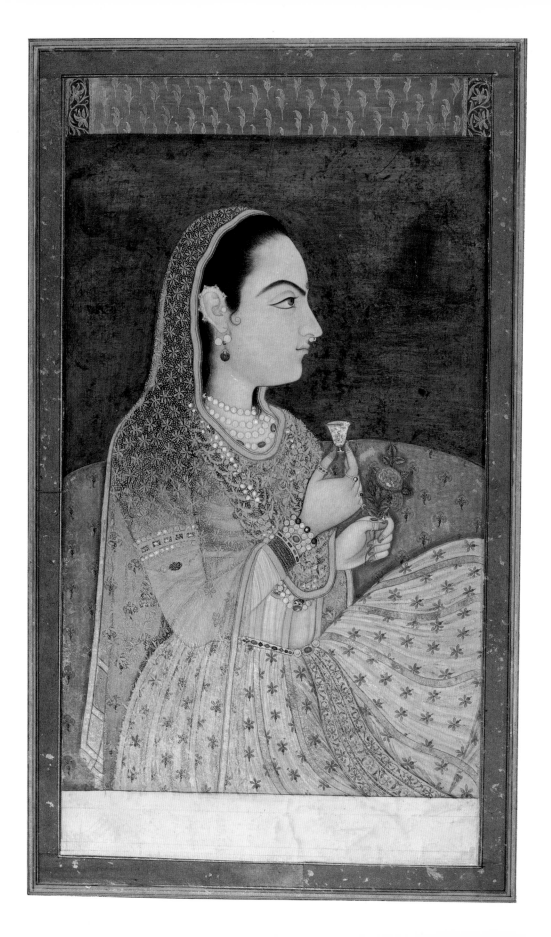

28 *Portrait of Mumtaz Mahal* (?)
Mogul, 17th C.
Opaque watercolor on paper
18$\frac{1}{8}$ × 12$\frac{5}{8}$ in. (46 × 32 cm.)
Mehdi Mahboubian

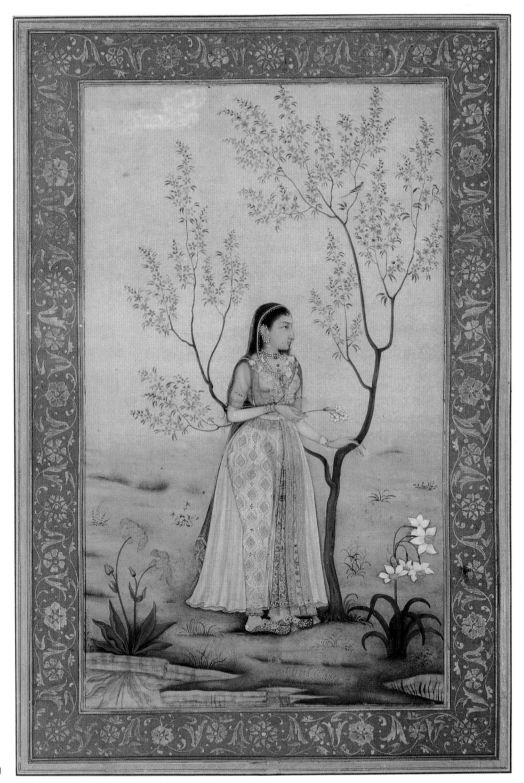

29 *A Young Lady Beneath a Tree* (*Jahanara*?)
Page from the Dara Shikoh Album
Mogul, c. 1635; attributed to Artist C
Opaque watercolor on paper
6$\frac{9}{16}$ × 3$\frac{15}{16}$ in. (16.6 × 9.9 cm.)—actual size
The British Library (India Office Library and
Records), London (Ms. Add. Or. 3129, fol. 34)

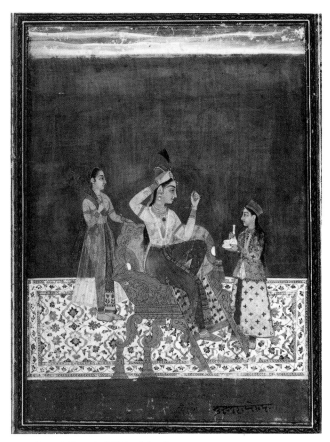

30 *Portrait Inscribed "Nur Jahan"*
From an 18th-C. album
Deccan or Mogul, late 17th C.
Opaque watercolor on paper
$8\frac{1}{2} \times 6\frac{1}{4}$ in. (21.6 × 15.9 cm.)
Kapoor Galleries Inc.

Nur Jahan, who virtually ran the empire for the greater part of her husband's reign and who frequently appeared in court and went out hunting, would have been too strict in such matters. There are one or two contemporary paintings, such as one of those illustrated here [Fig. 16], which may have been drawn from life. She appears there without much regal ceremony or affectation, but later generations would paint a more idealized portrait as befitting an empress with absolute power [Fig. 8].

Mumtaz Mahal is better known because of her association with the Taj, but Nur Jahan is unquestionably the greatest woman to have appeared on the Mogul stage. Even though she opposed Shah Jahan, one court historian, Inayat Khan, had no hesitation in writing the following eulogy upon her death:

On the 29th of the above-named month [Shawwal] in 1055 A.H., the Queen Dowager Nurjahan Begum, whom it is needless to praise, as she has already reached the pinnacle of fame, departed to paradise in the 72nd year of her age. She was buried in the mausoleum which she had erected during her lifetime. . . . In the sixth year of Jahangir's reign, when she was united in the bonds of matrimony to that emperor, she acquired such unbounded influence over His Majesty's mind that she seized the reins of government, and assuming to herself the supreme civil and financial administration of the realm, ruled with absolute authority till the conclusion of his reign.[16]

As has already been noted, after her marriage to Jahangir for over a decade she was extremely fond of Shah Jahan, who must have felt quite secure about the future even though the various campaigns for his father kept him away from the court a great deal. We will never know exactly how the relationship soured. It may have been because of Shah Jahan's rebellion against her husband or because, having enjoyed absolute power for more than a dozen years, Nur Jahan was unable to accept the young prince's ambition, which was a threat to her own position. What is interesting is that in the struggle for the throne her brother sided with his son-in-law rather than his sister. Nevertheless, once Shah Jahan was victorious Nur Jahan prudently accepted her situation and retired gracefully to Lahore, where she spent her remaining years without interfering in the new emperor's affairs. Perhaps because of their long-standing relationship, or perhaps because of her personality, Shah Jahan too proved not to be vindictive.

more numerous and varied pictures allegedly of Nur Jahan than of Mumtaz Mahal. While there is only one standard type of representation of Mumtaz [Fig. 14], perhaps invented in the nineteenth century because of the increasing fascination with the Taj, there are numerous portraits of Nur Jahan both in Mogul and Rajput styles, some going back to the seventeenth century [Figs. 8, 16, 30]. Although these surviving examples reveal a wide variety of impressions of her physiognomy, it is not improbable that originally her portrait was taken from life. It is generally believed that Mogul princesses and women of the harem were not seen in public without a veil, and therefore they did not sit for portraits either. However, while they may not have sat for male artists, they would readily have done so for female painters, for which there is some evidence.[15] Moreover, it is very difficult to believe that

Although less ambitious, her niece Mumtaz Mahal was equally accomplished and gifted. Certainly in Shah Jahan's eyes she must have been the most beautiful woman he had ever known. No less graceful and charming than her aunt, she was probably more amiable and affable. Physically she must have been strong, for she bore fourteen children. We know remarkably little, however, about the woman whose death inspired a bereaved emperor to erect the most celebrated memorial to love. Unlike Nur Jahan or her own daughter Jahanara, who was the fourth important woman in Shah Jahan's life, Mumtaz remains a mysterious, shadowy figure.

We do know that like other ladies of the period she was well educated. From the time of their marriage in 1612 until her death in 1631 Mumtaz was a constant companion of her husband both in peace and in war. Throughout their marriage she was certainly Shah Jahan's principal confidant and adviser. This is not surprising, since in political matters and statecraft she had excellent mentors in her father, grandfather, and aunt. Although she has been blamed, without sound evidence, for the treatment of the Portuguese at Hugli, she was by and large a pious and compassionate woman. Most writers have noted her gentle and generous nature, her willingness to intercede with her husband on behalf of humble petitioners, and her eagerness to help widows, orphans, and the indigent in general.

These are virtually the only reliable facts that we know about the woman who was the inspiration behind the Taj. It is remarkable how little contemporary observers say about her compared with her aunt or her daughters. Probably she did not have as strong a personality as the others and she may have been rather reticent about pushing herself into the limelight. One wishes one was better informed about her relations with her children, and whether she would have had any influence over her sons and thereby altered the course of history had she been allowed a normal span of life. In that case, however, she might have remained just another empress rather than the famous figure that she has become.

There are two legends about Mumtaz and Shah Jahan which may be briefly mentioned. Even if neither is based on fact, they have contributed to enhancing the romance of the Taj Mahal. One concerns their first meeting, and the other records her last wish as she lay dying in the palace at Burhanpur.

The romantic story about their first encounter is not recorded in any contemporary source and is palpably a later fabrication. It is best savored in the words of an early twentieth-century maharani, and is a good illustration of how living myths continue to be embroidered:

It was Naorati or New Year's night, and the Imperial Gardens at Agra were brilliant with lights and music. Every stall glittered with diamonds, rubies and other precious gems for the emperor Jahangir had expressed a wish that at this Nauroz Mela [New Year Fair] the ladies should sell precious stones and that the nobles and gallants of the court should buy them at whatever prices the fair vendors chose to ask. In an empty stall stood Arjemand Banu, the daughter of Asaf Jah, the Grand Vizier. When Shah Jahan came to the fair, he was charmed to see her wonderful beauty, and had a talk with her. He was so much infatuated with love that when the fair was over he sought the Emperor and the Grand Vizier.[17]

In point of fact, the marriage was arranged by Jahangir as a diplomatic match. It is not improbable, however, that they did meet after their engagement at a Meena Bazaar as the legend says, and gradually fell in love.

The second legend, concerning Mumtaz's death, sounds more plausible, although again no contemporary account mentions it. Apparently just before she was to give birth to her last child Mumtaz heard the infant cry in her womb, which was a bad omen. Realizing her end was near, she sent for Shah Jahan. When the emperor arrived she told him of her premonition, begged his forgiveness for any offense she might have given, and extracted two promises from him. One was that he would not beget children on any other wife after her death, and the other was that he should build the world's most beautiful mausoleum over her grave. Whether or not the story is true, Shah Jahan certainly had no other children, and he did begin the mausoleum almost immediately after her death.

While one does not wish to dismantle such legends and doubt the intensity of their love for one another, one cannot help but wonder about the true nature of their relationship. For most of their married life she was pregnant, a condition that in Indian society would have prevented any sexual encounter between husband and wife for prolonged stretches. Shah Jahan has been accused of being a philanderer, particularly by contemporary European visitors. And yet all his children were by Mumtaz. Was she possessive and influential enough

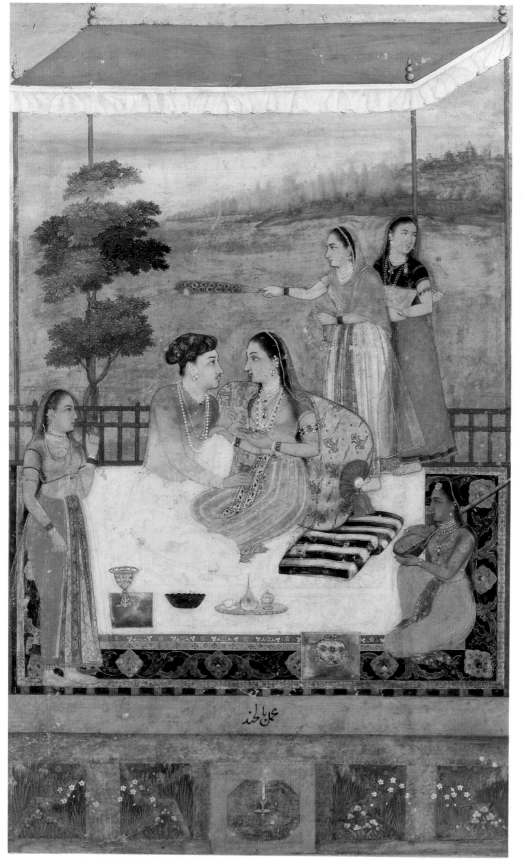

عمل بالچند

31 Balchand (inscr.), *Royal Lovers on a Terrace*
Mogul, c. 1633
Opaque watercolor on paper
$8\frac{7}{8} \times 5\frac{3}{16}$ in. (22.5 × 13.1 cm.)—actual size
Arthur M. Sackler Museum, Harvard
University, Cambridge, Mass., Anonymous
Loan

32 *Harem Night-Bathing Scene*
Mogul, c. 1650
Opaque watercolor on paper
$14\frac{7}{8} \times 10\frac{3}{4}$ in. (37.8 × 27.3 cm.)
The Cleveland Museum of Art, Gift of
Mr. and Mrs. Alton W.
Whitehouse (87.153)

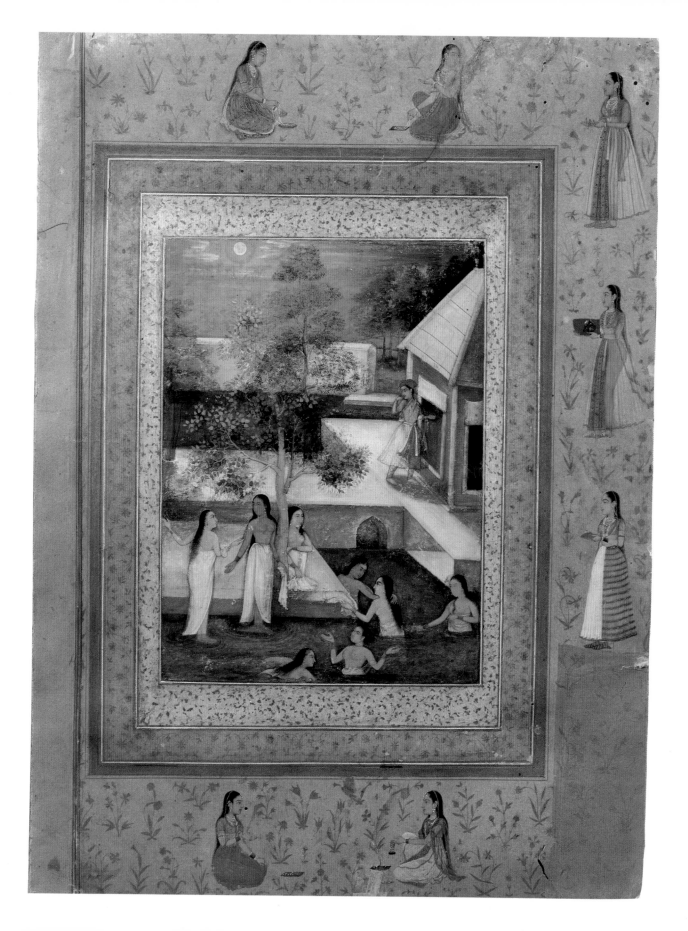

to prevent him from performing his conjugal duties with his other wives and concubines? In that case he must have been an unusually steadfast husband for his position and time. In the absence of contemporary evidence, however, such questions must remain unanswered, thereby leaving the flame of their passion glowing forever.

As has already been remarked, there are no contemporary portraits of this beautiful empress. We will therefore never know whether the nineteenth-century representation reproduced here [Fig. 14] was based on lost portraits taken from life or is a figment of an enterprising artist's imagination created to satisfy the demands of European tourists. While it is true that Mogul women rarely revealed themselves in public, it is difficult to believe that Shah Jahan, who was not a bigoted Muslim and who loved his wife very much, would not have had a portrait done for personal use. After all, as has already been said, it could have been painted by a woman artist. In any event, while innumerable Mogul as well as Rajput pictures of Nur Jahan are known, only two or three seventeenth-century portraits of Mogul ladies, one of which is included here [Fig. 28], have been identified as representing Mumtaz. Although we have no way of determining whether this is an authentic portrait of Mumtaz, she could have been as beautiful as this. Moreover, it is unquestionably one of the finest seventeenth-century portraits of a Mogul princess and was very likely drawn from life by a master artist: such sensitive delineation could hardly have been achieved without the painter being familiar with his or her sitter.

Like most Indian rulers of the period Shah Jahan had a large harem that included several wives and countless concubines. Whether he was any more licentious than the others depends on whether one can accept the accounts of contemporary European observers without a generous amount of salt. The Italian Niccolao Manucci (in India from 1656 to 1717), who was much more objective about Shah Jahan than his contemporary, the French physician François Bernier, does discuss at length Shah Jahan's love for the fairer sex. Some of his anecdotes such as the following are amusing whether they are true or not.

The intimacy of Shah Jahan with the wives of Ja'far Khan and Khalilullah Khan was so notorious that when they went to court the mendicants called out in loud voices to Ja'far Khan's wife, "O Breakfast of Shahjahan! remember us!" And when the wife of Khalilullah Khan went by they shouted "O Luncheon of Shahjahan! succour us!" The women heard, and without taking it as an insult, ordered alms to be given.[18]

The most scurrilous bazaar gossip recorded by Bernier would have us believe that after Mumtaz's death Shah Jahan had an incestuous relationship with his older daughter Jahanara. Other contemporary sources such as Manucci denounced Bernier's claim, while modern historians have cogently disproved the allegation. Moreover, although Jahanara openly espoused Dara Shikoh's cause against Aurangzeb, after his victory and until her death Aurangzeb treated her with the utmost respect. Had she been guilty of such a crime, she could scarcely have escaped the orthodox Aurangzeb's wrath. However, in a post-Freudian world one cannot deny the probability of some sort of Oedipal complex in their relationship. What can be said however with certainty is that Jahanara was Shah Jahan's "dutiful daughter . . . the one who found her destiny in safeguarding the shrine of his achievement."[19]

Jahanara, who was only seventeen when her mother died, immediately had to take care of a disconsolate father as well as her younger siblings. It was almost inevitable that she would become the first lady of the realm, but her role was far from ceremonial. Of all Shah Jahan's relationships with women, his close association with his daughter was the longest, lasting from 1632 until his death in 1666. She sacrificed her own life to look after her father, kept the empire moving, and was the glue that held the family together. Although less well known than her great-aunt Nur Jahan or her mother, she was no less gifted and certainly had a much larger and more difficult role to play, as a helpmate and nurse to her father, a surrogate mother to six very different youngsters, and the first lady of the empire.

To her contemporaries Jahanara was known as the Begum Saheba. She is supposed to have been as beautiful as her mother and possibly there was a strong resemblance between the two, which may have been one reason why she became so close to her father during their bereavement. It may also have led to a sexually ambivalent attitude toward her on his part. Like her mother and great-aunt she was highly educated, generous, and concerned about women and the indigent, yet strong and astute in state affairs. She seems to

have been less self-effacing than her mother and not as ambitious or ruthless as Nur Jahan.

Once again there is no inscribed portrait of Jahanara. There are, however, two small pictures of women in the Barberini Album in the Vatican Library, one of which may be a likeness of Jahanara.[20] It is clear from the context that they are Mogul princesses, and since the male portraits represent Shah Jahan's sons, the two females may depict Jahanara and her sister Raushanara. Similarly, a beautiful painting in the Dara Shikoh Album may well be a portrait of Jahanara, considering how close they were [Fig. 29]. Other similar pictures of a forlorn lady standing beside a tree have been identified as Jahanara.

Unlike the others, Jahanara lived in her own palace outside the fort at Agra. We do not know how she lived, but we can form some idea of the life in a Mogul *zenana* from contemporary paintings. Two of the paintings included here depict love scenes, a genre that became especially popular during Shah Jahan's reign. In one of these the prince may well be Shah Shuja [Fig. 31; cf. Fig. 26]. Surrounded by maids, one of whom plays a musical instrument, the prince and his lady stare intently into each other's eyes as they drink. The second is a more risqué picture, where all decorum is thrown to the winds and the lovers abandon themselves to the tyranny of passion [Fig. 127]. The prince may be Murad Bakhsh, another brother of Jahanara. More intimate glimpses of the *zenana* can be gleaned from a somewhat damaged but rare picture in Boston [Fig. 33]. Here the drinking party is only for females, and there are distinct suggestions of lesbian activity that must have prevailed in harems where the women were so secluded and deprived of male company. In a fourth picture a group of women is bathing in a pool on a full moon night [Fig. 32]. The moon is not their only witness, for on the terrace a princely Peeping Tom expresses his delighted surprise. As usual with Shah Jahan's pictures, the border is decorated with figures—here charming representations of women with various offerings. Thus, one can see them, sitting or standing as they would in the Meena Bazaar, eagerly awaiting royal customers. In any event, we can well imagine Jahanara or her friends enjoying such a dip on a warm summer night in Agra.

Because she lived independently, there was much speculation about her love life. Like other Mogul princesses Jahanara was not permitted to marry, a cruel injunction introduced by Akbar in order to prevent

33 *Ladies in Zenana*
Mogul, c. 1650
Opaque watercolor on paper
$9\frac{1}{4} \times 6\frac{5}{16}$ in. (23.5 × 16 cm.)
Courtesy, Museum of Fine Arts, Boston, Gift of John Goelet
(66.149)

additional claimants to the throne. Like Nur Jahan, Jahanara was also a wealthy lady who had her own sources of income and commercial enterprises. The revenues of the port of Surat were transferred from Nur Jahan to her. Apparently her father bestowed this income on his beloved daughter for her expenditures on *pan*. Surat was at the time the principal port where the British and other Europeans transacted much of their commercial activity. Jahanara was also interested in music, architecture, literature, and religion, and held her own court or salon, which was the meeting place for many distinguished luminaries of the period.

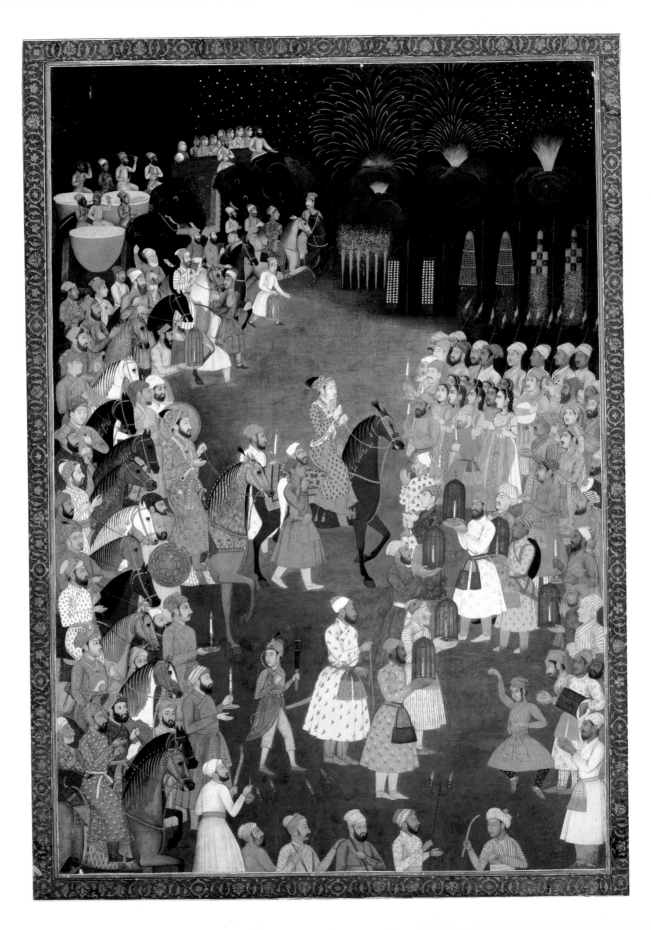

34 *Celebrations at the Wedding of Prince Dara Shikoh*
Mogul (Oudh), c. 1700
Opaque watercolor on paper
$15\frac{3}{4} \times 11\frac{1}{16}$ in. (40 × 28 cm.)
Hashem Khosrovani Collection

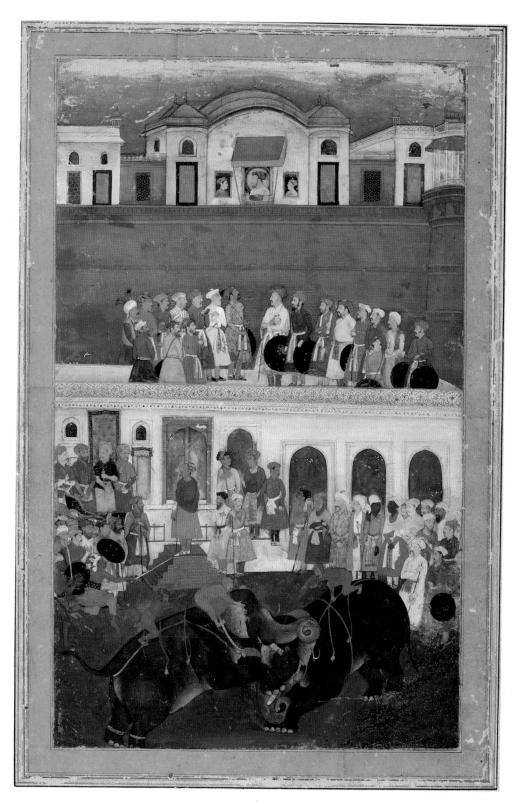

35 *Shah Jahan at the* Jharoka *Window in the Red Fort*
Mogul, c. 1650
Opaque watercolor on paper
13 × 8 in. (33 × 20.3 cm.)
D. A. J. Latchford, Bangkok

Her favorite brother was Dara Shikoh, with whom she shared a special affinity because of their love for Sufism. In 1640 both joined the Qaderia sect and became devotees of Mulla Shah [see Fig. 27]. As Jahanara herself wrote,

Of all the descendants of Timur, only we two, brother and sister, were fortunate enough to attain this felicity. None of our forefathers ever trod the path in quest of God and in search of the truth. My happiness knows no bounds, my veneration for Mulla Shah increased and I made him my guide and my spiritual preceptor in this world as well as the hereafter.[21]

A writer and a poet, she wrote a book about her own preceptor and another on the lives of the great Sufi saint Muin-ud-din Chishti and his successors [see Fig. 97]. It was Jahanara who made all the arrangements for Dara Shikoh's wedding and spent sixteen lakhs (1,600,000 rupees) of her own money. It was a lavish wedding, as may be gleaned from a painting [Fig. 34] and from an eyewitness account by the English traveler Peter Mundy. Describing the spectacular fireworks display on the occasion, Mundy writes of "great elephants whose bellies were full of squibbs, crackers, etc.; giants with wheels in their hands, then a rank of monsters, then of turrets, then of artificial trees [and other] inventions, all full of rockets, etc. as was the rail round them."[22] The veiled Dara Shikoh is the focus of the picture and precedes the haloed emperor. Although a later copy of a representation of the scene in the Windsor *Padshah-nama* (see below, p. 93), it is of excellent quality and demonstrates the continued interest in Shah Jahan's reign in eighteenth-century India.

That Jahanara should espouse Dara Shikoh's cause during the war of succession is hardly surprising. Apart from their intellectual and spiritual compatibility, she strongly believed in his right to rule. Nevertheless, she was fond of all her brothers and sisters. In 1644 she even interceded with her father on behalf of Aurangzeb, and she was responsible for extracting from her dying father a pardon for him. Such was the latter's respect for his elder sister that after their father's death Jahanara was allowed to return to her own palace (she had voluntarily spent eight years as Shah Jahan's nurse and companion at the fort). Until her own death in 1681 she was one of the very few persons around Aurangzeb not afraid to speak frankly.

Jahanara's importance in her father's life and his intense love for her are nowhere more explicit than in the account given in his official biography of an accident that she suffered. Much more space is devoted to that event and her recovery than to the death of Mumtaz or the building of the mausoleum. On the night of 6 April 1644, when she was returning to her apartments from the presence of the emperor, the skirts of her dress brushed against a candle and caught fire. The four maidservants in attendance tried to extinguish the fire but Jahanara was severely burned. The distraught emperor did not attend court the next day, and ordered that prayers be said in the mosques, prisoners be released, and alms be given to the poor to ensure her recovery. For three days thereafter a vast amount of money was given to the poor. Dozens of physicians, both native and foreign, were summoned to the palace.

When ultimately the princess recovered, after nine months, her grateful father held a feast that lasted for a week. She was weighed against gold, which was then distributed among the poor. She was given an extraordinary amount of gems and jewelry, and it was on this occasion that the port of Surat was bestowed upon her. The successful physicians were also weighed against gold and silver which was theirs to keep, and they were handsomely rewarded with other gifts. A slave named Arif who had provided the healing ointment was weighed against gold as well and was given a robe of honor, a horse, an elephant, and a great deal of cash. While the accident proved to be a blessing in disguise for a large number of people, the most far-reaching effect was on the growth of British commerce and power in India.

Apparently one of the European doctors attending the princess was the British physician Gabriel Boughton, who had been sent from Surat. Boughton appears to have been the only doctor who did not accept personal remuneration: instead, he secured for his countrymen trade concessions in the empire. Certainly his presence at this crucial time must have helped the British cause with Jahanara, who was much more liberal towards the Europeans than her father had been. Moreover, it may have paved the way for Shah Shuja, governor of Bengal, to make advantageous trade concessions in the most lucrative province of the empire.

Upon Jahanara's death the following eulogy was penned by none other than the Emperor Aurangzeb's court historian:

On the 7th of Raadzan, it was reported (to His Majesty) from the capital, that the queen of angelic virtues, the soul of charity and benevolence, Jahanara Bano Begum, had concealed her face behind the veil of nonexistence and found rest in the seraglio of eternity on the third of the month . . . on hearing the sad news of the demise of his elder sister, who had been so kind and loving, the heart of His Majesty was filled with gloom. For three days the customary music sounded at the watches was forbidden. Orders showing proper respect to the departed were issued, and it was decreed that "Queen of the Age" be the name by which her sainted memory was to be preserved for posterity.[23]

She was buried in a simple grave with a small bed of grass above it on the cenotaph in the shrine-complex of the Sufi saint Nizam-ud-din Auliya, in Delhi. Her epitaph, engraved on a slab above her head, reads: "Let nothing cover my grave but green grass, for the verdant turf is sufficient covering for the humble stranger."

AN AESTHETE FOR ALL SEASONS

While it seems evident that Shah Jahan thoroughly enjoyed feminine company—his food was generally served by females and he was often entertained by female musicians and dancers—the comments made by Europeans as to his sexual appetite were probably exaggerated. A fairly detailed account of his normal day is provided by contemporary historians, who do not endorse such a view. He rose before dawn, and usually was in position to perform the *jharoka-darsan* ceremony, when he communicated directly with his subjects from the rear window of the palace, by 7:30 a.m. [see Figs. 35, 145]. By then he had said his morning prayers, made himself ready, and had his breakfast. As he was a very fastidious man one imagines that he gave a good deal of attention to his cosmetics and dress. (One must remember that unlike his father or grandfather, and in keeping with Muslim practice, Shah Jahan wore a beard, which must have needed daily grooming.) After the ceremony he moved to the Hall of Public Audience (Diwan-i-am) and thereafter to the Hall of Private Audience (Diwan-i-khas). Several paintings show the emperor on various state occasions or *darbars* [see, for example, Fig. 130]. One of the most elaborate of these *darbar* paintings [Fig. 36], done around 1700, is set in a tent, not in a palace. The young emperor is seen accepting or offering to an older courtier a set of pearls

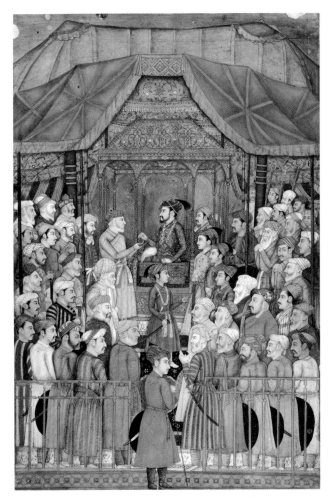

36 *Shah Jahan in Audience*
Mogul, c. 1700
Opaque watercolor on paper
12 × 8 in. (30.5 × 20.3 cm.)
Private Collection

while princes of the realm and other courtiers stand with mute, expressionless faces. The youngest prince is precociously out of line as he stands before the throne. Thoughtfully most of the figures are identified by Arabic inscriptions on their shoulders. The painting shows how the Moguls traveled in style, for wherever they went all the imperial trappings, including the enormous throne on which Shah Jahan sits, had to follow. Thank heaven for elephants!

By noon the emperor was in the more private chambers known as the Shah Burj, where only the intimate and highest officials were invited. He then retired to the harem for a meal, his favorite dish being *khichri*, a concoction of rice and pulses, a plebeian rather

than a princely dish. After a brief siesta, by 3 p.m. he completed an audience with the ladies of the harem, taking care of their needs and petitions. Thereafter he returned to the public hall to say his afternoon prayers. The late afternoon was spent in the private apartments, usually watching dancers or animal sports, and if necessary another council was held at the Shah Burj. A spectacular imperial picture shows Shah Jahan at the window while two elephants duel on the ground below [Fig. 35]. Elephant fights were a favorite sport of all Moguls. What is curious about this picture is that while the combating animals are realistically rendered, the audience on all three levels seems peculiarly uninterested. Notwithstanding their skill in painting realistic portraits, Mogul artists were strangely averse to *en face* representations, which is why no one seems to be actually watching the elephants.

By 8 p.m. Shah Jahan retired to the harem for supper and relaxation, with music provided by female musicians. He retired to bed at about 10 p.m., and loved to fall asleep while listening to stories being read aloud. His favorite book was Babur's memoirs. As he hardly ever drank, not even to escape from the tragedies of his life, he never sank into a stupor as his father often did. It should also be noted that for long spells in his life he abstained from all forms of entertainment, as for instance after his wife's death, when Dara Shikoh was seriously ill, and again when Jahanara had her accident.

Most writers who have related the history of the Moguls have especially emphasized Shah Jahan's obsession with gemstones and with architecture. We are reminded that he would ignore even a bevy of beautiful dancing girls if presented with an exciting new bauble; and the Taj Mahal alone would suffice to confirm the brilliance of his patronage of architecture. His other aesthetic interests have been overlooked, particularly his passion for music and his continued interest in painting, which is discussed in Chapter Three. Jahangir was not particularly devoted to music, and Shah Jahan may have learned to appreciate it early in life during his association with his grandfather, whose court was graced by the famous Tansen, often regarded as the greatest exponent of North Indian classical music. Shah Jahan patronized the maestro's disciple and son-in-law Lal Khan Gun Samudra, who specialized in the form of music known as *dhrupad*. Another master vocalist at his court was Jagannath, whose compositions were much appreciated by the emperor. Among the principal instrumentalists were Sukh Sen, who played a stringed instrument known as the *rabab*, and Sur Sen, the great *vina* player.

Shah Jahan's obsession with gems, which will be considered in greater detail in Chapter Four, may well have been inherited from his father. Jahangir's aesthetic passion is supposed to have been painting, but his memoirs mention his acquisitions of gems and his delight in them (including their weight and financial value) more often than paintings. Reading through the *Tuzuk-i-Jahangiri*, one is left to wonder who was more avaricious for precious stones, the son or the father. It was Jahangir's reputation as a collector of gems that reached the bazaars and markets of West Asia and Europe in the early part of the seventeenth century and brought Armenian and European merchants and jewelers to India in search of fortune. His memoirs make it clear that his scouts scoured the Indian ports, and Shah Jahan himself picked up unusual specimens for his father.

The son, however, surpassed his father not only in his expertise in precious stones but also in his ability to realize their artistic potential. A perceptive passage in Jahangir's memoirs about his son's expertise seems to have been generally overlooked. Recording the gifts he had received from Shah Jahan, after noting the weight, price and quality of a number of rubies and pearls and a diamond, the emperor writes:

Also a jewelled *parda* (sash), a sword hilt made in his own goldsmith's shop; most of the jewels he had himself set and cut. He had brought great dexterity to bear on the design. Its value was fixed at Rs. 50,000. The designs were his own; no one else had up to this day thought of them. Undoubtedly it was a fine piece of workmanship.[24]

Thus, not only was Shah Jahan an outstanding gemologist, but he was also a designer of jewelry whose workmanship was admired by no less a connoisseur than Jahangir. No wonder that in his portraits he is frequently shown holding a jewel of some kind. In a beautiful painting in Los Angeles [Figs. 37, 144] the handsome young emperor admires a turban ornament that must have been particularly attractive. Along the bottom border we see two craftsmen with jeweled offerings which may well have been made in his workshop—for even as a prince Shah Jahan owned his own goldsmith's shop, just as his father when a prince had had his own atelier of painters. Jahangir was also

37 *Portrait of Shah Jahan*
Page from the Late Shah Jahan Album
Mogul, c. 1635
Opaque watercolor on paper
14 × 9⅜ in. (36.7 × 23.8 cm.)
Los Angeles County Museum of Art, From the Nasli and Alice
Heeramaneck Collection, Museum Associates Purchase
(M.78.9.15)

appreciative of his son's inventiveness in the design of the dagger hilt, which was inlaid with gemstones. One may well conclude from Jahangir's eloquent testimonial that Shah Jahan later played a large role in designing the buildings that have made him famous. The use of rich inlay of *pietra dura* work in the Taj and other edifices must reflect his own personal taste, if not his own design.

It is for his architectural achievements that Shah Jahan is best known. He is often considered the greatest builder among the Moguls, and certainly his additions and alterations to the Agra Fort and the construction of the Jami Masjid and Red Fort at Delhi, and of course the Taj Mahal, have won him a place in history as one of the greatest builders of all time (see Chapter Two).

Here again one cannot ignore his grandfather's influence during his early years. Although much is made of Shahjahanabad, the new city he created at Delhi, one should not forget that his grandfather's fort in Agra and Fatehpur Sikri, the abandoned capital near Agra, are no less spectacular architecturally. And those are some of the buildings where Shah Jahan "remained in attendance" on Akbar "day and night." As a child he must also have visited his great-grandfather Humayun's tomb at Delhi [see Fig. 64], which was then the most impressive Mogul mausoleum in the realm. Thus, the seeds of his architectural ambition were very probably sown in his young and impressionable mind.

By the time he was in his teens he owned several houses and displayed his architectural skills by making significant and felicitous improvements. Jahangir noted his son's interest in architecture on several occasions. Once when they were in Fatehpur Sikri, the father and son went on a tour of inspection of the palace complex. Jahangir's account further demonstrates how the legends about the fabulous wealth of the Moguls had begun:

On this day, going over in detail the buildings of the palace of the late King (Akbar), I showed them to my son, Shah Jahan. Inside of them, a large and very clear reservoir of cut stone has been constructed, and is called the *kapurtalao* (camphor tank). It is a square of 36 yards by 36, with a depth of 4½ yards. By the order of that revered one, the officials of the public treasury had filled it with *fulus* (copper coins) and rupees. It came to 34 krors [1 kror = 10 million], and 48 lakhs [1 lakh = 100,000] and 46,000 dams (a denomination), and 1,679,400 rupees . . . for a long time the thirsty-lipped ones of the desert of desire were satisfied from that fountain of benignity.[25]

On another occasion the emperor records that while the royal party halted on the bank of the river Beas in Panjab on the way to Kashmir, Shah Jahan "took ten days leave, and hastened to Lahore in order to see the palace buildings recently erected."[26]

Thus, even if the son did eclipse the father as a patron of architecture, it is clear that Jahangir encouraged his interest. Apart from his father and grandfather, Shah Jahan must have been inspired by his father-in-law Asaf Khan and his stepmother Nur Jahan. Both were avidly

interested in buildings and also in gardens, which were much admired by Jahangir and Shah Jahan. Jahangir has glowingly described the beauty of Asaf Khan's mansions and gardens, none of which exists today. Of Nur Jahan's buildings, however, the most celebrated is the tomb of her father Itimad-ud-daula in Agra [see Fig. 59]. Although less well known than the Taj, it is considered by many to be finer. Certainly the nineteenth-century architectural historian James Fergusson did, when he wrote, "there is no other building like it in the entire range of Mughal architecture, the delicacy of treatment and the chaste quality of its decoration placing it in a class by itself."

In the exclusive use of white marble, the mausoleum of Itimad-ud-daula antedates the Taj. Another earlier structure made of white marble embellished with exquisitely carved marble screens is the shrine of Shaikh Salim Chishti in Fatehpur Sikri. The tradition of building in marble was familiar in India long before the seventeenth century when these Mogul edifices were raised. Shah Jahan must have known of the beautifully designed Jain marble temples in Mount Abu and elsewhere in Rajasthan and Gujarat. Among earlier Muslim monuments he had certainly seen the fifteenth-

century marble mausoleum of Hushang Shah at Mandu in Central India.

Thus, Shah Jahan's selection of white marble with which to commemorate his beloved wife was by no means an innovation. His genius rather is expressed in the overall concept and design of the mausoleum. Both formally and symbolically he introduced fascinating new ideas that created one of the most admired and certainly the most romantic building in the world. Justifying Shah Jahan's alterations in the Agra Fort, Abdul Hamid Lahori, one court historian, writes:

By the command of His Majesty (Akbar) were built in that heaven like fort lofty buildings of red sandstone for royal residence. As in this everlasting reign (Shah Jahan's) the demand for arts has a different market and the Divine care has adopted a new method of embellishing the world, at the place of the old have been built sky-touching mansions of marble.[27]

In his grandfather Shah Jahan had a difficult ideal to follow, which may explain his multifaceted interest in all the arts and his need to be innovative. Each in his own way, Akbar and Shah Jahan could well be characterized as aesthetes for all seasons.

Mausoleum for an Empress

Janice Leoshko

Six months after the melancholy event of the death of the Empress Mumtaz Mahal (which took place on 17 Zul Qadah 1040 A.H. (17th June 1631 A.D.) the Prince Shah Shuja was entrusted with the bringing of the corpse of the deceased to the capital, Akbarabad [Agra], on Friday the 17th Jumada I, 1041 A.H. (12th December 1631 A.D.). Nawab Wazir Khan, the most trustworthy old royal physician and Siti Khanam, who was the head stewardess of the royal household, accompanied the corpse. Throughout the whole journey from Burhanpur to Akbarabad, the last resting place of the deceased, food and money were distributed among the poor and the needy. Immediately on the arrival of the corpse at Akbarabad, it was interred on the 16th Jumada II 1041 A.H. (9th January 1632 A.D.), in the paradise-like tract of land, situated south of the city facing the Jamna river, which was the property of Raja Man Singh. In exchange for this piece of land the Emperor Shah Jahan gave a lofty edifice to him. On this spot a temporary grave with a dome was constructed in haste, so that the corpse of the chaste lady might remain concealed from the public eye. Then on this blessed spot the foundation of the sky-like lofty mausoleum was laid, which later on was built wholly of white marble with an adjoining garden.[1]

Kanbo

By 1800 the lofty mausoleum known as the Taj Mahal [Fig. 39] had already achieved some fame in the Western world. Early travelers' reports and pictures had secured its reputation as a glorious building. But it was not until the British established a permanent presence in the area that this empress's mausoleum, which also housed the body of her husband, Shah Jahan, was subjected to the close scrutiny of a large number of Western admirers. Soon after the military victory in 1803 that gave the British control of Agra, a careful survey of all the buildings surrounding the tomb was conducted. The report submitted by Lieut.-Col. Kyd dated 8 November 1808 detailed their condition. Noting only surface damage, the engineer enthused:

this splendid monument, which for magnificence and taste and costliness of materials far exceeds anything of the same kind that is probably in the universe, the repairing and keeping in order of which will reflect such credit on the British Government through every part of Indoostan.[2]

Repeated repairs and surveys were subsequently undertaken, and throughout the nineteenth century the interest in the mausoleum continued to grow ever greater. Among the depictions by Indian artists of various Mogul monuments at Agra and Delhi, painted largely for foreign patrons, the Taj Mahal appears most often. It even inspired individual studies of its details which were occasionally drawn to scale. Complete models were also made, sometimes of rather large dimensions, to serve as souvenirs or appear in exhibits outside of India. (For the "afterlife" of the Taj, see Chapter Six.)

Surprisingly, the origin of the name "Taj Mahal" is not clear. Court histories from Shah Jahan's reign only call it the *rauza* (tomb) of Mumtaz Mahal. It is generally believed that "Taj Mahal" (usually translated as either "Crown Palace" or "Crown of the Palace") is an abbreviated version of her name, Mumtaz Mahal (Exalted One of the Palace). As Peter Mundy and other early travelers refer to the empress in their accounts as "Taje Mahal," the mausoleum may have also acquired the name in the seventeenth century.

Agra was the Mogul capital, and surviving descriptions by Europeans who visited it indicate that this impressive city enjoyed a large degree of prosperity and development throughout the seventeenth century. One English visitor even considered it to be greater than London.[3] A merchant named Francis Pelsaert, who was in Agra just before Shah Jahan began to rule, relates:

the breadth of the city is by no means as great as the length, because everyone has tried to be close to the river bank, and consequently the water-front is occupied by the costly palaces of all the famous lords, which make it appear very gay and magnificent.[4]

38 Samuel Bourne, *View of the Taj Mahal from the Agra Fort*
England, c. 1865
Albumen print
$9\frac{3}{8} \times 11\frac{1}{2}$ in. (23.8 × 29.2 cm.)
Los Angeles County Museum of Art, Gift of Mr. and Mrs.
Phillip Feldman (M.83.302.26)

The arcaded building is the Diwan-i-am, or Hall of Private
Audience. Beyond it on the river front, just visible through its
arches, is the Muthamman Burj, the Octagonal or Jasmine
Tower.

40 *Schematic Plan of the Grounds of the Taj Mahal*
Agra, c. 1805 (2 watermarks: 1799, 1800)
Opaque watercolor on paper
$27\frac{5}{8} \times 16\frac{1}{8}$ in. (68.9 × 41 cm.)
Paul F. Walter

See the note on Fig. 41.

39 John Murray (?), *Panoramic View of the Taj Mahal*
England, c. 1860
Albumen print
$12 \times 49\frac{5}{8}$ in. (30.5 × 126 cm.)
Paul F. Walter

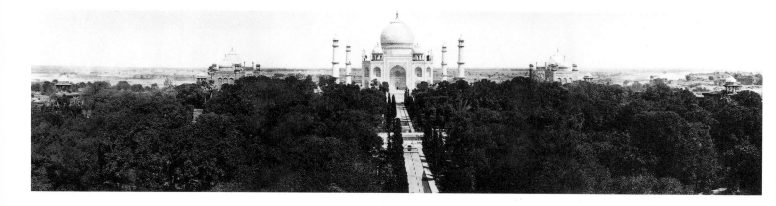

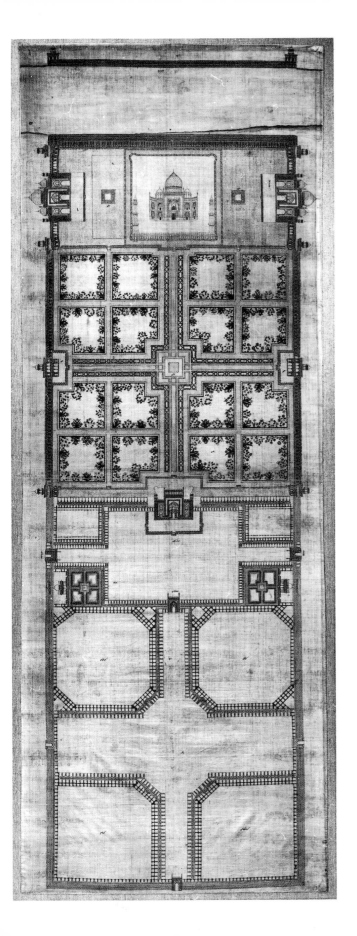

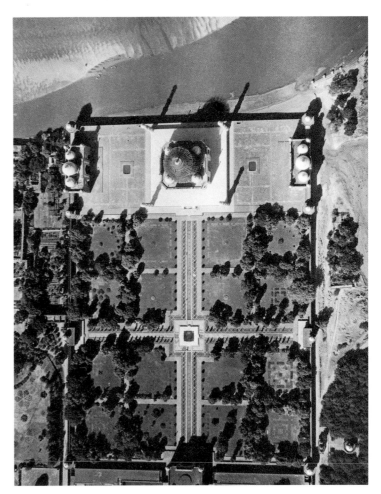

42 Aerial photograph of the Taj Mahal c. 1943†
Collection of Roy C. Craven, Jr.

41 *Schematic Plan of the Grounds of the Taj Mahal*
Agra, c. 1800
Opaque watercolor on cloth
110¼ × 33⁷⁄₁₆ in. (280 × 85 cm.)
Museum für Indische Kunst, Staatliche Museen Preussischer
Kulturbesitz, Berlin (West) (MIK. I. 10060)

At the top is the mausoleum, flanked by the mosque (left) and
the rest-house; in the center is the *jilokhana*, with the great
gateway. The entire grounds are shown, and the buildings are
depicted in elevation. Note the planting of the garden.

The Taj Mahal is on the bank of the Yamuna river downstream from the fort at a point to the east where the river makes a sharp turn [Fig. 38]. In addition to the court history written by Abdul Rahman Lahori, *firmans* (imperial decrees) document that the Hindu noble who had owned this tract of land was compensated when it was chosen to be the place for Mumtaz's tomb.[5] Some writers from the nineteenth and twentieth centuries have suggested the choice resulted from the desire to have a peaceful site separated from the bustle of the thriving city. But as the land adjacent to the river was obviously well populated, the location actually meant that the magnificent mausoleum which Shah Jahan planned to erect would remain very much a part of the community. Another important factor must have been the marvelous view of this particular site from the palace quarters.

Virtually every aspect of the Taj Mahal seems to have enjoyed the same careful consideration given to the selection of its location. The astounding appearance of this mausoleum is largely a result of such meticulous planning—in addition, of course, to the extraordinary resources which Shah Jahan was willing to expend. Lahori records that five million rupees were spent on building alone, not including the cost of materials, which must have been very high considering the vast quantities of marble and gemstones used. The court histories also state that the complex construction of the foundations and base was completed within three years of Mumtaz Mahal's death. That the mausoleum was largely finished within twelve years is revealed by descriptions of the death anniversary ceremony of 1643. This ceremony occurred every year to allow the living to gather together and honor the deceased with prayers and benedictions. The descriptions of Lahori and Muhammad Salih Kanbo, who also wrote a history of Shah Jahan's reign, note that the ceremony of 1643 included the emperor among the distinguished participants and took place in the recently completed mausoleum.[6]

THE FUNERARY COMPLEX

As Kanbo and Lahori indicate in their lengthy accounts, for a true appreciation the Taj Mahal must be considered with its surrounding structures, for the well-known marble mausoleum is but one part of a large funerary complex [Figs. 40–42]. Although the central building has justly received the greatest attention through the centuries, numerous visitors have understood the importance of the total complex. Col. J. A. Hodgson, then Surveyor-General of India, warned against oversimplification when he wrote in 1847:

Many descriptions of the mausoleum itself have indeed been attempted, but they relate only to that perfect structure which contains the remains of the emperor Shah Jahan and his consort; the subordinate parts are in their degree worthy of it; the great gateway of the garden alone is a noble structure, and the mosque and its counterpart, the *mihman-khana* [rest-house], as well as the six octagonal pavilions of four stories high, and other buildings, and the various platforms, the reservoirs for water, the fountains, and canals of the garden bounded by lofty trees, compose a most harmonious whole.[7]

Indeed, as grand in scale as the marble tomb is its garden which encompasses more than forty-two acres. Today this vast setting unfortunately retains only a general impression of its former elegance: long gone are the plantings of Shah Jahan's time. The grounds are enclosed by a large red sandstone wall which contains galleries, pavilions, and multi-storied towers. Shah Jahan seems to have traveled from the fort to the tomb by boat [Fig. 45]; court histories describe his arrival on the river side of the monument and his ascent to its terrace by way of the embankment. This approach, however, was reserved for the emperor and members of his party. Others passed through a large courtyard, a *jilokhana*, to enter the main gateway on the south [Figs. 40, 44]. Members of the court could gather in the *jilokhana* before the ceremonies associated with the death anniversary. Texts describe it as a courtyard of great dimensions with 128 rooms for servants' quarters in its cloisters. Bordering it are bazaars and other courtyards, and further away there are additional tombs and residences of court nobles. Some of these remain standing, but many have disappeared, and the *jilokhana* is partly ruined. The suburbs surrounding the complex seem to have been encouraged to develop, and upon completion of the tomb the revenue from thirty villages in the vicinity was designated for its maintenance.[8] Part of this region came to be known as Mumtazabad or Taj Ganj, reflecting the name of its local star attraction.

Amid these marketplaces and courtyards, the gateway to the funerary compound proves a fitting herald to the grandeur contained within [Figs. 43, 44].

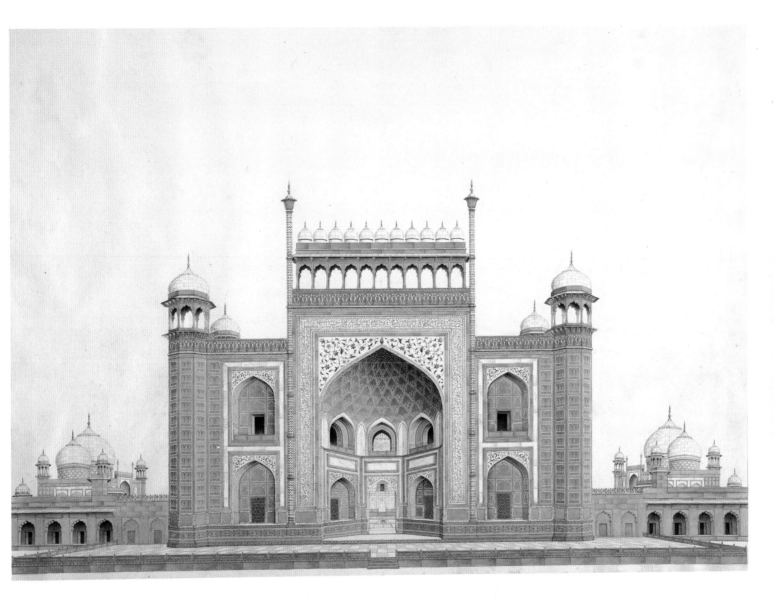

43　*The Gateway of the Taj Mahal*
India, c. 1820
Opaque watercolor on paper
21½ × 27 in. (54.6 × 68.6 cm.)
Paul F. Walter

The mosque rises in the distance on the left, and
the rest-house on the right. The central tank and
part of the white marble mausoleum can be
glimpsed through the central arch.

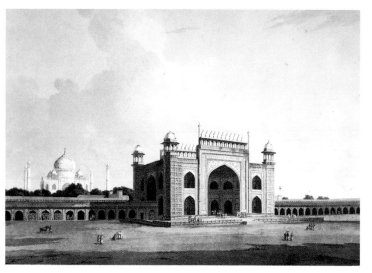

44 Thomas and William Daniell, *The Taje Mahel, at Agra*
England, 1796
Aquatint with hand coloring, from *Oriental Scenery*
$16\frac{5}{8} \times 23\frac{3}{4}$ in. (42.2 × 60.3 cm.)
Max and Peter Allen

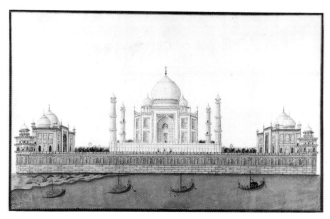

45 *The Taj Mahal from the River*
India, c. 1818
Opaque watercolor on paper
$11\frac{3}{4} \times 18\frac{15}{16}$ in. (29.8 × 48 cm.)
Yale Center for British Art, New Haven, Paul Mellon
Collection (B1977.14.22433)

Made of red sandstone and more than 100 feet (30 meters) high, it is richly embellished. Of particular note are the floral arabesques fashioned from gemstones and inlaid in white marble which decorate the spandrels of the arches. Also impressive are the inlaid black marble inscriptions that frame the central vaulted portal or *iwan*. Both in form and in content these panels are commanding: the beautifully designed passages are excerpts from the Koran, which is considered by Muslims to be the word of God as revealed by Muhammad. They are probably by the same artist whose name, Amanat Khan, is included in the inlaid texts on the marble mausoleum [Fig. 48]—an indication of his great status, for few calligraphers signed such projects.[9] (Amanat Khan had begun his career in India at Akbar's tomb: see below, p. 74.) Since in the Muslim world calligraphy is considered the highest level of artistic expression, it is often a significant element in the ornamentation of buildings.[10] At the Taj Mahal more inscriptions appear than are found on any other Mogul tomb, and it is also notable that almost all the passages are Koranic verses.[11] There are none of the flowery eulogies that often occur on such monuments. The sacred nature of the words, enhanced by their exquisite form and large size, emphatically proclaims the lofty purpose of the complex. A particularly impressive passage is the one to be read last before entering the garden. It states:

> O thou soul at peace,
> Return thou unto thy Lord, well-pleased
> and well-pleasing unto Him!
> Enter thou among My servants—
> And enter thou My Paradise![12]

The passage is one key to comprehending the magnificence of the Taj Mahal as a vast symbolic image of the Islamic concept of paradise.

Passing through this impressive portal one enters the landscaped grounds [Fig. 47]. The view of the Taj that is presented at this vantage point to the modern visitor is different from what it would have been when the monument was created. In the seventeenth century, instead of lawns the garden was densely planted with beds of flowers and trees of different varieties, and must have had a greater sense of intimacy as well as greater color [compare Figs. 40 and 42]. The lawns were installed only in the late nineteenth century during the restoration undertaken by Lord Curzon. Although much overgrown, the garden as it appears in views made before that restoration probably more closely approximates to the original ambience [see Figs. 39, 210, 217, 218, 234, 254].

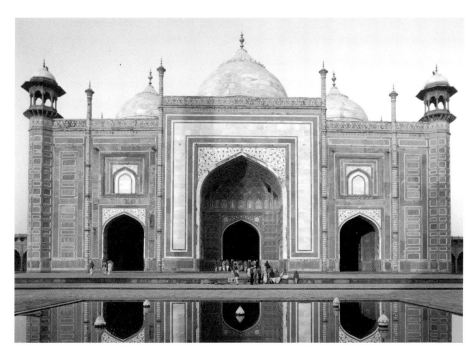

46 The mosque next to the Taj Mahal†
(Photo by Robert Holmes)

The Taj Mahal is situated more than 900 feet (275 meters) away from the entrance at the opposite end of the garden. Towering almost 250 feet (76 meters) in height, the tomb stands on its own marble plinth, which rests on a red sandstone platform that serves to level the land as it slopes to the river. This platform is shared with two flanking red sandstone buildings. The west structure is a mosque [Fig. 46], and the east one a rest-house. Although used for different purposes, they are virtually identical in form, and thus a symmetrical harmony with the marble mausoleum is achieved. Linked to these pleasing buildings by the shared plinth, the tomb, however, by virtue of its material and greater height, remains quite separate and literally above all other elements. In fact, seen from the entrance gateway, the Taj seems almost to be floating above the grounds.

The plan of the grounds [Figs. 40–42] differs from that found in earlier Mogul funerary garden complexes where the tomb was situated in the center of the enclosure [see Fig. 58]. However, like those earlier compounds the garden of the Taj follows the model of the Persian *chahar bagh* (four-part garden), which is quartered by two intersecting water channels. At the Taj Mahal, each of these quadrants is further sectioned into four units. The divided garden is meant to symbolize the grounds of paradise, and the water channels,

the rivers.[13] This effect is heightened here because the channels are wider than at other Mogul tombs [Figs. 58, 64, 65], evoking a greater sense of actual rivers.

The water for the garden is collected from the river by an elaborate system of buckets and storage tanks in an area west of the funerary compound. It is brought into the grounds through an ingenious system of underground pipes and then fed into the channels by a series of fountains running the length of the major north-south channel. The only fountains in the complex, these underscore the direct alignment between the gateway and the mausoleum. Only a raised tank located at the crossing of the main east-west channel interrupts this line.

THE FORM OF THE TAJ MAHAL

The domed mausoleum can seem deceptively simple since on first sight its white marble form appears to be a matchless example of purity and simplicity. But as one moves closer, the Taj Mahal's elaborate design reveals itself. While individual elements such as the refined inlays and myriad surface details are testimony to the fine quality of this monument, it is the superb manner in which all the elements are harmonized that most clearly reveals the great complexity of its creation. Another

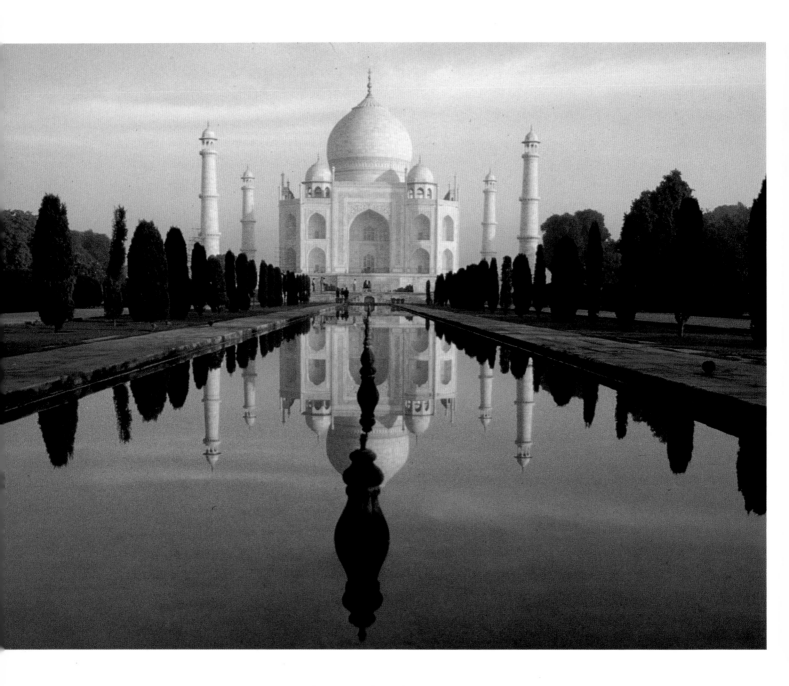

47 The Taj Mahal seen from the
garden†
(Photo by Robert Holmes)

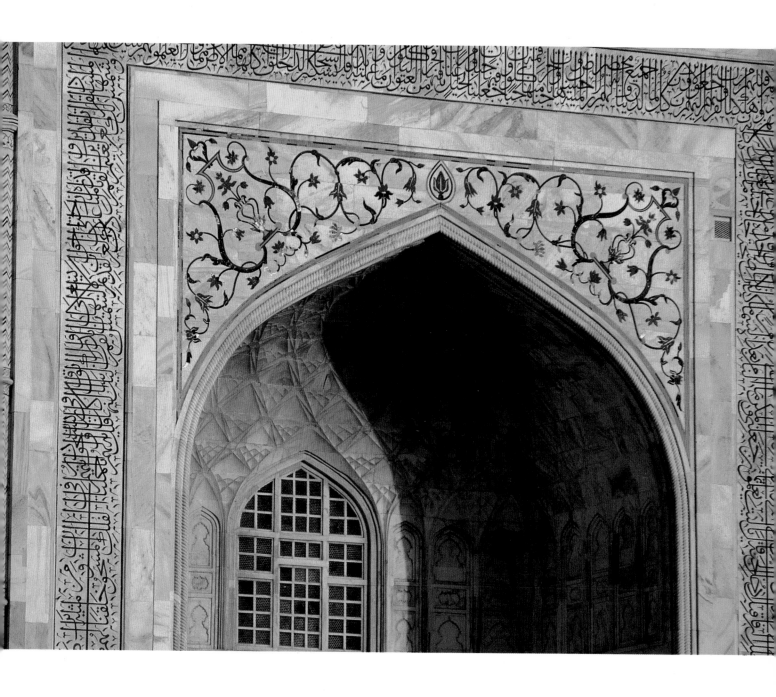

48 Detail of one of the faces of the Taj Mahal†
(Photo by Robert Holmes)

49 The dome of the Taj Mahal†
(Photo by Sunil Janah)

50 Detail of the sculpted flowers
and *pietra dura* inlay on the
exterior dado of the Taj Mahal†
(Photo by Robert Holmes)

51 Close view of the Taj Mahal†
(Photo by Robert Holmes)

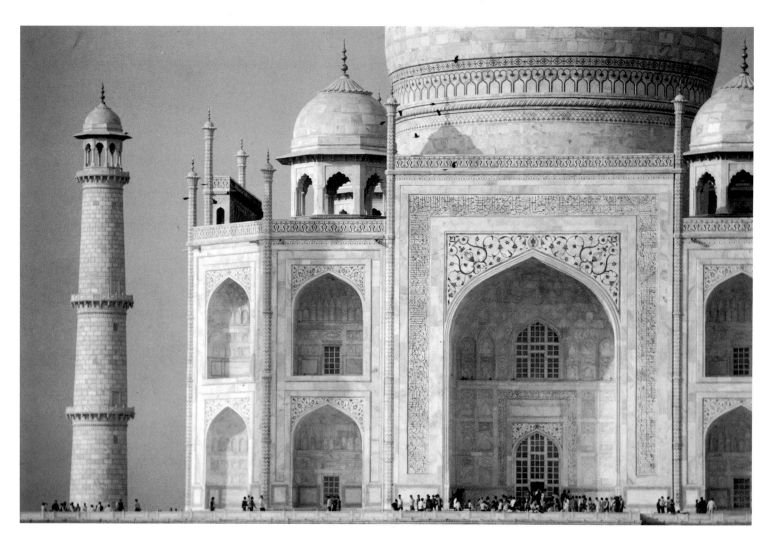

component that one is never quite prepared for is its great size [Fig. 51]. Many descriptions seem to have been specifically inspired by the astonishing experience of seeing such apparent perfection on such a grand scale. Hodgson attempted to convey this feeling:

It is known that it is entirely cased with white marble, within and without, and that it is highly ornamented with inlaid work throughout. From the descriptions which have been given of its high finish, from the temptation, for want of other means of similitude, to liken it to a fairy fabric built of pearl or of moonlight, and from its having been not ineptly said that it should be kept under a glass case, those who intend to visit the Taj are apt to form an idea, that though beautiful it is small; but the contrary is the truth; it is of considerable dimensions and altitude. . . . It is, I suppose, one of the most perfect and beautiful buildings in the world.[14]

The marble mausoleum is square in plan with chamfered corners [Figs. 40, 42]. Vast *iwans* framed by bands of calligraphy mark the centers of the four sides [Figs. 48, 51], and the doorways inside these *iwans* are also adorned with calligraphy. The huge dome emphasizes the monumentality of the structure as its pear-shaped form sits on a tall drum [Fig. 49]. The height from the base of the drum to the top of the finial is almost 145 feet (some 44 meters). Four small kiosks clustered around the dome lessen the severity of the vertical emphasis. Opposite the chamfered sides of the tomb, four tall minarets rise up from the corners of the white marble plinth. Kanbo characterized these minarets as analogous to "an accepted prayer ascending to heaven from a pious heart or in eminence and glory to a fortunate man in ascendance."[15] They elegantly accent the central structure, framing the space like the mounting of a jewel.

The exterior of the Taj Mahal is a seemingly perfect balance of ornamented and unadorned surfaces. Intricate floral and geometric inlays, profuse surface detailing by reliefs, and the exquisitely rendered calligraphic panels are all indicative of the great attention lavished on the building. The techniques of this decoration and the motifs used are characteristic not only of Shah Jahan's architectural projects but also of the other arts that flourished during his reign. Although geometric patterns appear, such as the chevrons that decorate numerous pilasters or the ripple pattern inlaid in the terrace floor, floral designs are the dominant decorative motifs. As on the monumental gateway, inlays of floral arabesques embellish the spandrels of the arches, while elegant floral sprays sculptured in high relief appear on the dado of the exterior walls [Figs. 48, 50].

Flowers had long been important in Islamic cultures, where they were generally seen as symbols of the divine realm. For instance, in Persian poetry flowers are often described as springing from the waters of paradise.[16] But the Moguls had maintained a special interest in flowers and gardens since the days of Babur, the founder of the dynasty, who was an avid garden-builder. Shah Jahan's father, Jahangir, had been quite fascinated with nature, and his passion for flowers is well documented by his memoirs. Shah Jahan seems to have shared this interest. One of his first architectural projects was the development of the much-loved Mogul gardens of Kashmir, and most of his buildings make great use of forms derived from plants.[17] This was a result of the intention to transform the palace buildings into garden pavilions in order to create for the emperor not just a general garden setting but a paradisiacal environment on earth as clearly described by Kanbo: "every house is so pleasing to the mind and agreeable to the heart that it looks like the garden of Rizwan (the gardener of paradise) and seems to be one of the apartments of heaven."[18]

Jahangir seems to have been the catalyst in the introduction of naturalistic plants into Mogul paintings, which were inspired by engravings in European herbal books that had been brought into India by foreign visitors.[19] But it was in the time of Shah Jahan that Indian artists refined such depictions, transforming them into a hallmark of the Mogul decorative style [Figs. 98, 100]. The Taj Mahal reveals that the importance of floral motifs in an architectural context was established early in the emperor's reign.

As already mentioned, the floral decoration of the Taj Mahal consists of intricate inlays and relief carvings; floral motifs also appear as incised painted decoration on the mosque and rest-house. The superb quality of the sculpted flowers can be attributed to the ancient tradition of stone carving in India. These reliefs, however, are also indebted to European sources for their more naturalistic forms. Unfortunately, the influences that developed the exquisite inlay or *pietra dura* decorations are less easily identified. The use of the technique in India has been a matter of great controversy for years. Some have claimed it was derived from Florentine traditions, others that it developed

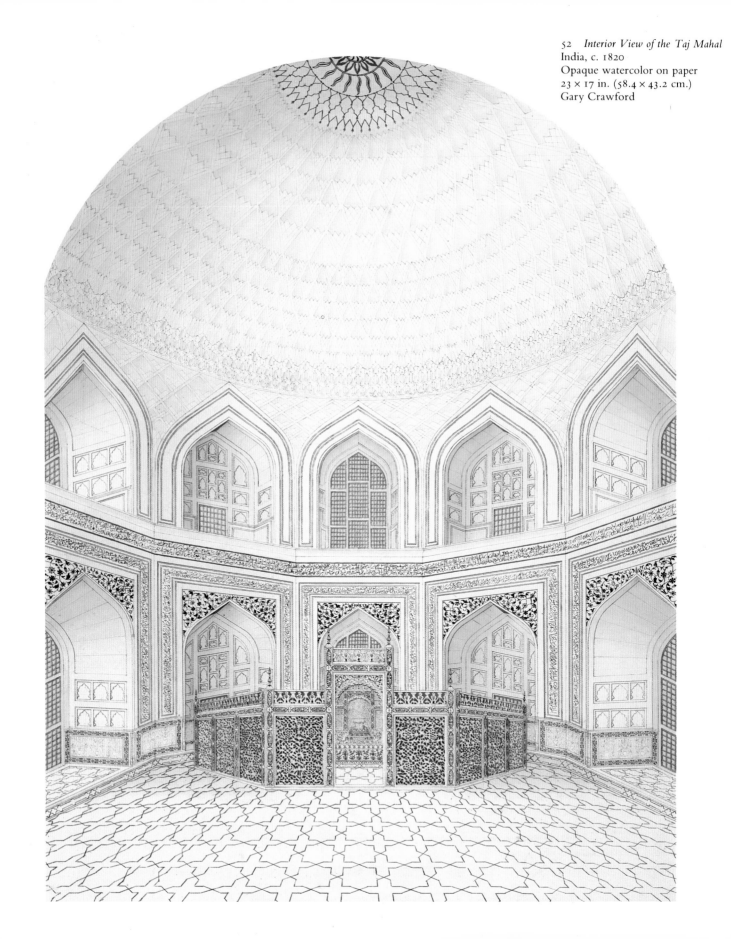

52 *Interior View of the Taj Mahal*
India, c. 1820
Opaque watercolor on paper
23 × 17 in. (58.4 × 43.2 cm.)
Gary Crawford

53 Shaikh Latif, *Three Panels from the Cenotaph Screen in the Taj Mahal*
From an album prepared for Robert Home
Agra, c. 1820
Opaque watercolor on paper
c. 14⅛ × 5¼ in. (35.9 × 13 cm.) each
Lois A. Ehrenfeld

54 Shaikh Latif, *Flower from the Cenotaph Screen* [to scale with Fig. 53]
Detail of page from an album prepared for Robert Home
Agra, c. 1820
Opaque watercolor on paper
14⅝ × 25⅞ in. (37.1 × 65.7 cm.) (overall)
The Ehrenfeld Collection

55 BELOW Shaikh Latif, *Panel with Sculpted Flowers from the Interior Dado of the Taj Mahal*
From an album prepared for Robert Home
Agra, c. 1820
Opaque watercolor on paper
10¾ × 22½ in. (27.3 × 57.2 cm.)
Gloria Katz and Willard Huyck

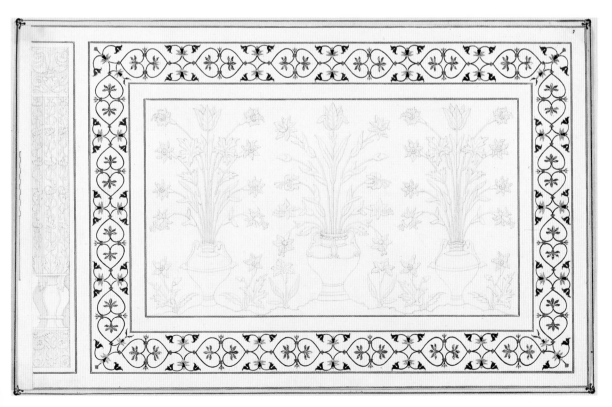

Shaikh Latif's drawings were illustrated by Fanny Parks in her book, *Wanderings of a Pilgrim in Search of the Picturesque* (1850). She noted that in addition to his excellent draftsmanship he was also an architect and could do inlay work in the style of the Taj Mahal. The drawings included here were executed for the English artist Robert Home, who was a court artist at Oudh from 1814 to 1827. (See also Fig. 74.)

56 Architectural fragment
Mogul, c. 1630
Marble with inlay
10¾ × 8½ in. (27.3 × 21.6 cm.)
Courtesy, Museum of Fine Arts, Boston, Given by Alfred
Greenough, 1908 (Apparatus)

important means of decoration [Figs. 56, 133]—perhaps the ideal one to be employed at the court of an emperor who would appreciate both the high level of skill entailed by the process and the jewel-like qualities realized in its finest products.

Yet another testament of the exquisite sensibility present in the design of the Taj Mahal is that the profuse ornamentation of its surfaces does not detract from or compete with the innate richness of the white marble. Instead, decorative details enhance the gleaming material which changes with the play of light throughout the day and night. Even the very prominent calligraphic panels of black marble with their strong linearity help to highlight the sensuous quality of the white marble.

While the building is in many ways like no other, the spatial organization of the interior is similar to that of earlier tombs, using a form known as the "eight paradises" or *hasht behisht*, in which eight chambers surround a central, larger one, producing a nine-part plan [Fig. 40]. This form originated in Timurid buildings in Iran and Central Asia, and its use at the Taj Mahal was certainly intended both to continue the paradisiacal symbolism and to underscore the dynastic relationship of the Moguls with Timur, their famous ancestor.[22] Shah Jahan was especially obsessed with his heritage, as revealed by his commission of a number of ancestral portraits.

The Taj Mahal is entered through the large portal on its south side. Inside, two stories of eight rooms surround a central chamber [Fig. 57]. In this nine-part plan, the visitor can circumambulate through the subsidiary rooms on each floor since they are interconnected. The central chamber is octagonal [Fig. 52]. On the lower level, its eight sides are outlined with bands of inlaid calligraphy—again passages from the Koran—and meticulously sculpted flowers framed by borders of delicate inlay appear on the dado [Fig. 55]. These flowers emerge from vases, whereas most of those on the exterior walls of the mausoleum, the mosque, the gateway, and elsewhere take the form of a single plant emerging from a small mound [Fig. 50]. Flowers, especially those in vases, along with wine and fruit, are well-known Islamic symbols of the bounty promised to the faithful in paradise. Flowers in vases are found as painted decoration in the interior of other tombs such as that of Itimad-ud-daula, and they appear in the painted decoration of some rooms of Shah Jahan's palace in the Agra Fort, but they are not as common as the motif of

independently in India. Recently, it has been cogently argued that the technique was indeed Italian in origin, but that it was modified by Indian traditions of craftsmanship.[20] The argument hinges on the recognition of the difference between two related types of inlay. Although conventional stone inlay had been known in India for a long time, the practice of *pietra dura*, which involves inlaying stones of extreme hardness, has in every instance of its development been traced back to an Italian source, and it is quite likely that European craftsmen taught it to the Mogul artists. Both normal stone inlay and hardstone inlay are found in the tomb of Itimad-ud-daula and his wife at Agra, built between 1622 and 1628 [Fig. 59].[21] But it was in the earliest projects of Shah Jahan's reign that the *pietra dura* work was fully perfected and then adopted as an

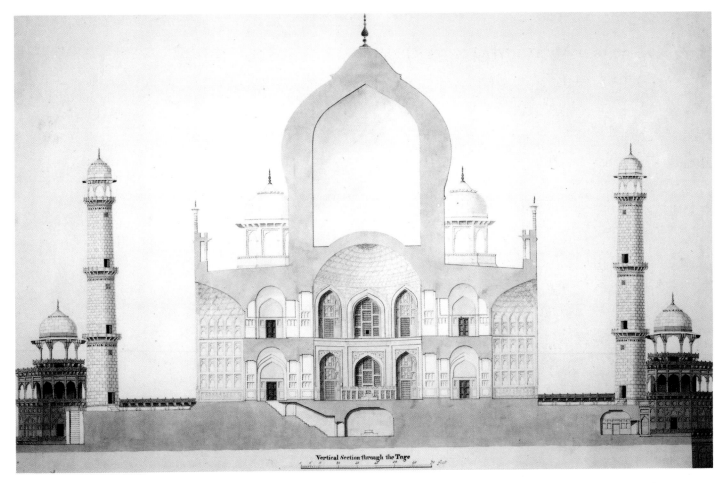

Vertical Section through the Tage

57 *Vertical Section through the Tage*
India, c. 1820
Opaque watercolor on paper
22¼ × 31 in. (56.5 × 79 cm.)
Trustees of the Victoria and Albert Museum, London
(IM 179–1920)

This is part of a group of drawings made by a Delhi or Agra
artist for Col. Powell Phipps, who was Superintendent of Public
Buildings in India from 1816 to 1822.

the single plant in the architecture of this emperor [Fig.
70]. Moreover, the reliefs inside the Taj Mahal are
unusual, as the vases are placed on small mounds. This
distinctive treatment may have been due to a desire to
define its inner rooms in a special way.

In the subsidiary chambers on both levels, delicately
carved screens, now fitted with panes of milky glass,
emit diffused light, subtly altering the atmosphere of
the interior. The tall dome (which is actually much
lower than the exterior one) fades in the subdued light.
Although the architectural vocabulary is not the same,

the effect of these forms recalls the great Gothic
cathedrals of the West where tall, vast spaces and
controlled light were used as symbols of the divine
realm. In the Taj Mahal, the filtered light imparts a
mysterious, ethereal quality to the interior and, as it
changes throughout the day, it becomes almost a
palpable entity, a symbol of the divine presence which
could never be figured.

In the center of the main chamber stands an octagonal
screen of marble more than six feet (some two meters)
in height [Fig. 52]. When the tomb was being
constructed a gold screen was placed around the
cenotaph of Mumtaz. The court histories record that
Shah Jahan ordered this be replaced,[23] apparently
deeming its opulence inappropriate and worrying that
it would invite vandals. It had cost 600,000 rupees,
whereas the marble screen, which took ten years to
complete and was installed in 1643, cost only 50,000.
That, however, did not deter vandals.

Inside the screen, two cenotaphs stand above the
remains of Mumtaz Mahal and Shah Jahan, who upon

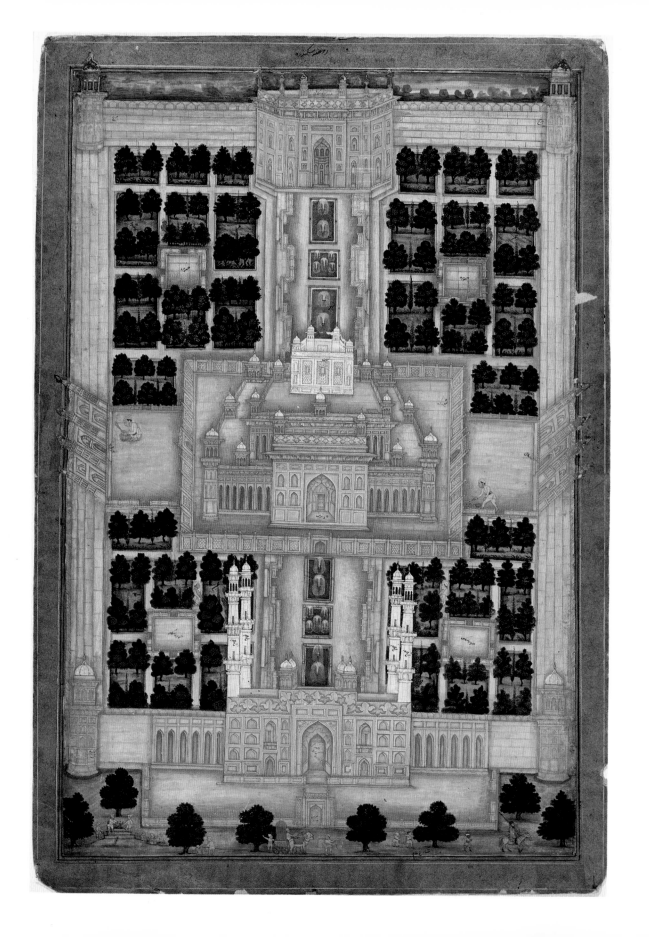

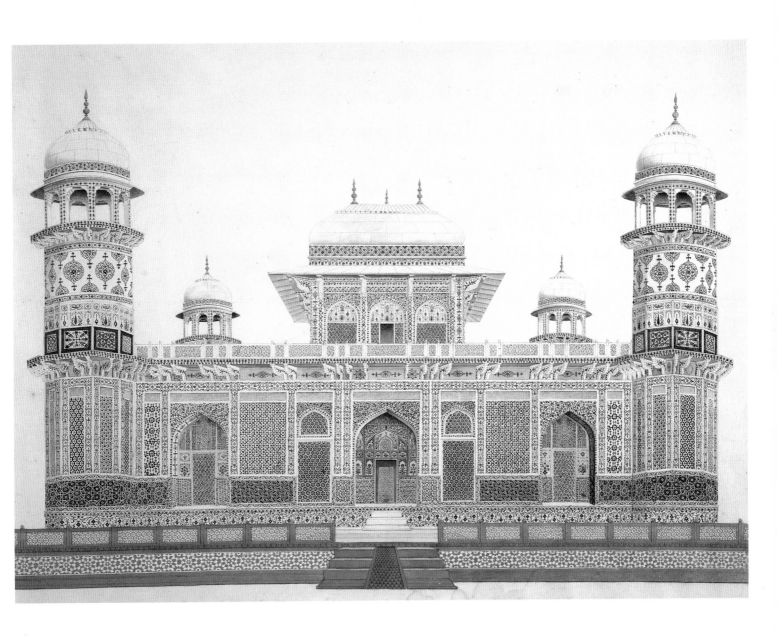

58 *Akbar's Tomb at Sikandra*
Jaipur or Agra, c. 1760–1800
Opaque watercolor on paper
21 7/16 × 14 15/16 in. (54.5 × 37.9 cm.)
Arthur M. Sackler Museum, Harvard
University, Cambridge, Mass., Anonymous
Loan

This view contrasts with those more generally
made for foreign patrons by lacking any feeling
of accurate perspective.

59 *Itimad-ud-daula's Tomb, Agra*
India, c. 1820
Opaque watercolor on paper
21 1/2 × 27 in. (54.6 × 68.6 cm.)
Paul F. Walter

his death in 1666 was buried beside his long-dead wife in the crypt below. As is customary in Islamic practice, they are oriented longitudinally north to south. Her cenotaph is in the center, while the emperor's is to her right on the west side of the enclosure. This asymmetrical placement has been used as evidence that Shah Jahan did not intend to be buried in this mausoleum, but a similar configuration was used in the tomb of Nur Jahan's parents, which was planned for both Itimad-ud-daula and his wife.[24] Nonetheless the presence of Shah Jahan's cenotaph can seem an afterthought, interfering with the symmetry within the encircling screen. The bodies of Mumtaz Mahal and Shah Jahan lie in the crypt under cenotaphs similar to those in the central chamber [see Fig. 57]. Bernier noted that this room was opened once a year, and although no Christians were allowed to enter, he had heard that the interior was magnificent. The Frenchman Jean-Baptiste Tavernier, who claimed to have witnessed the commencement and completion of the construction of the Taj Mahal, noted that both in the crypt and on the main floor "from time to time occasionally they change the carpet, the chandeliers and other ornaments of that kind."[25] Such descriptions, which also mention the continual presence of mullas praying, remind us that despite the good condition of the building, our experience of the Taj Mahal today is far from complete.

The quality of the inlay work on both sets of cenotaphs and the screen [Figs. 53, 54] surpasses all other decoration of the Taj. Although obviously made much later, the designs on Shah Jahan's cenotaphs are quite similar to those on Mumtaz Mahal's except that the calligraphy on hers includes verses from the Koran [Figs. 60, 61]. The exceptional quality inspired the artists of the nineteenth century who made numerous copies of these details. The floral sprays and flaming halo that decorate the top of Shah Jahan's cenotaph were especially popular [Figs. 62, 132; and see Fig. 256 for an overall view]. The extraordinary character of this inlay work was stressed in the contemporary histories: "compared with the extreme beauty of the entire display, the masterpieces of Arzhang [from ancient Iran] and the picture galleries of China and Europe are like pictures on water, shapeless and unreal."[26]

Although these histories by Lahori and Kanbo praise the building profusely, they do not identify the architect responsible. Only the two officials who supervised its construction are named: Makramat Khan and Mir Abdul Karim. The list of possible designers has become quite long over the years. Father Sebastien Manrique, who visited Agra in 1641, claimed that the Taj Mahal was designed by Geronimo Veroneo, an Italian jeweler.[27] None of the other travelers' accounts from the seventeenth century, however, supports this contention or mentions any architect's name. In the nineteenth century, a number of Persian histories of the Taj Mahal, which seem to have been created largely to satisfy the British quest for more facts, listed "Ustad Isa" as the architect. His name, however, does not appear in any earlier records. In his popular memoirs first published in 1844, Sir William Sleeman (better known for crushing the sect of assassins known as the Thugs) attributes the building to a French goldsmith named Austin de Bordeaux.[28] Other contenders helped to keep the controversy fueled into the early decades of the twentieth century.[29] Not surprisingly, the possibility that this wondrous monument was really the design of a European has proved especially popular in the travel accounts of Western visitors.

The first real evidence of the architect's identity emerged in the 1930s when a seventeenth-century manuscript called the *Diwan-i-Muhandis* was found to mention the Taj Mahal. This manuscript contains a collection of poems written by Lutf Allah, including several verses in which he describes his father, Ustad Ahmad from Lahore, as the architect of the Taj Mahal and the Red Fort at Delhi.[30] Lutf Allah notes that these achievements "represent only one aspect of his many-sided genius and constitute a single pearl out of his mine of pearls."[31] He also states that Shah Jahan conferred upon his father the title "Nadir al-Asr" (the Wonder of the Age); unfortunately the court histories do not corroborate this claim. Kanbo and Lahori do, however, record that Ustad Ahmad was one of the architects of the Red Fort in Shah Jahan's new imperial city at Delhi known as Shahjahanabad. Further evidence has been found of other large projects undertaken by Ustad Ahmad, strengthening the plausibility of his son's claim. Manuscripts by his other sons reveal additional information about this illustrious family, which enjoyed the patronage of the ill-fated Prince Dara Shikoh.[32] This relationship placed the family in a precarious situation when Aurangzeb seized the throne and had Dara Shikoh killed, but apparently they were reinstated at the court. In fact, another son, named Ata Allah, who had probably collaborated with his father

60 *End View of Mumtaz Mahal's Cenotaph*
Agra, c. 1820
Opaque watercolor on paper
$35\frac{1}{2} \times 33$ in. (90.2 × 83.8 cm.)
Terence McInerney, New York

This was among a number of watercolors formerly in the collection of Brig. Sir Gregor Macgregor, Bart. Some were signed on the back by J. G. Hoare, which may mean that they were acquired by the engineer and mapmaker James Hoare, who is known to have reached Agra in 1795.

61 *Detail of the Top of Mumtaz Mahal's Cenotaph*
Agra, c. 1820
Opaque watercolor on paper
$15\frac{1}{2} \times 18$ in. (39.4 × 45.7 cm.)
Honolulu Academy of Arts, Gift of John Gregg Allerton, 1951
(13,054)

62 *Detail of the Top of Shah Jahan's Cenotaph*
Agra, c. 1820
Opaque watercolor on paper
$15\frac{1}{2} \times 22\frac{7}{8}$ in. (39.4 × 58.1 cm.)
Honolulu Academy of Arts, Gift of John Gregg Allerton, 1951
(13,055)

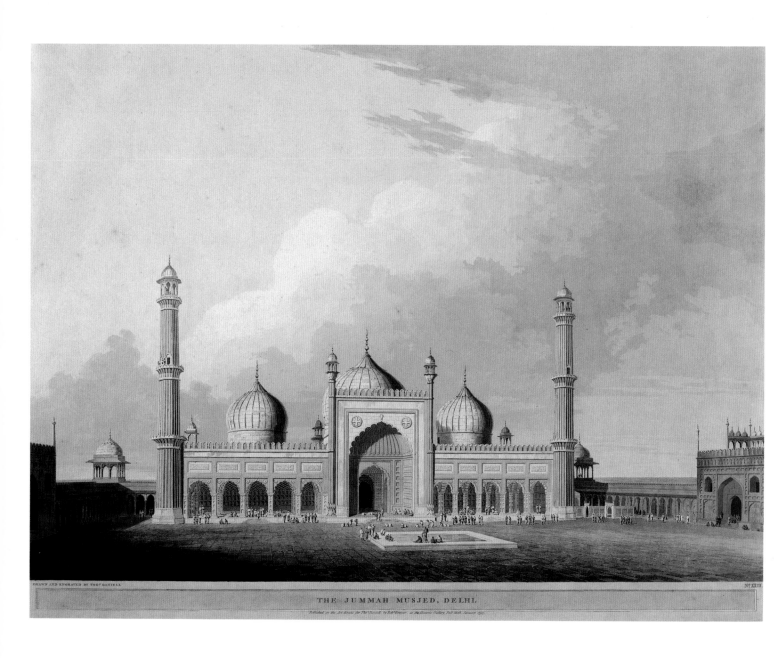

THE JUMMAH MUSJED, DELHI.

63 Thomas and William Daniell, *The Jummah Musjed, Delhi*
England, 1797
Aquatint with hand coloring, from *Oriental Scenery*
17 × 23⅝ in. (43.2 × 60 cm.)
Paul F. Walter

on previous projects, was the architect of the tomb of Aurangzeb's wife at Aurangabad, modeled on the Taj Mahal [see Fig. 75].

Ustad Ahmad may well be the architect of the Taj Mahal, despite the court histories' silence about this point. But why would they mention Ahmad's name in relation to the Red Fort and not note that he was also the architect of the Taj Mahal? Or why would they mention the names of the supervisors of construction rather than of the architect? Perhaps the grand scope of the project meant that no one person was in sole control. Unfortunately, we have no details about the design process other than some fabrications related in the spurious nineteenth-century manuscripts.[33] Lahori, however, did record the active role that Shah Jahan generally held in the erection of his buildings, noting that most were initially conceived by him and that he made "appropriate alterations to whatever the skillful architects designed after many thoughts and he asked many competent questions."[34] Thus, it may not be surprising that the court histories fail to credit a specific individual in this instance. In any event, simply having the name of an architect would not settle questions concerning the meaning and development of the Taj Mahal's form within the context of Mogul architecture. Some of these issues are better addressed by examining the earlier Mogul tombs, as the Taj Mahal is, in part, the culmination of a brilliant tradition of funerary architecture. Moreover, consideration of its precedents also helps to define further the unique nature of the Taj Mahal, which specifically reflects the refined sensibility of its imperial patron, Shah Jahan.

THE MOGUL TOMB TRADITION

From their Timurid heritage and personal experiences Babur, the founder of the Mogul dynasty, and Humayun, his son, established the foundations for the general character of Mogul architecture. The course that it followed was especially determined by the exile from India of Humayun when he took refuge at the court of the shah of Iran. On his return he brought artists and architects and, importantly, the memory of lavish architectural traditions. While little evidence of the actual buildings and gardens that Babur and Humayun erected survives, some traces and literary descriptions amply testify to the importance of non-Indian traditions for their architectural projects. We do

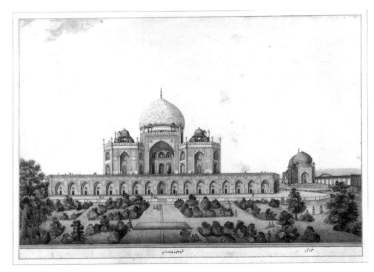

64 *Humayun's Tomb, Delhi*
India, c. 1820
Opaque watercolor on paper
21 × 28 in. (52.5 × 73.7 cm.)
The British Library (India Office Library and Records), London
(Ms. Add. Or. 1809)

know that due to Babur's love of nature, he established various gardens in his new empire. He recorded in his memoirs: "Then in that charmless and disorderly Hindustan, plots of garden were laid out with order and symmetry, with suitable borders and parterres in every corner and in every border roses and narcissus in perfect arrangement."[35] Humayun seems also to have had an interest in lavish settings. One description of a water-palace created by him is particularly fascinating: it consisted of four barges which supported a two-storied structure, forming a *hasht behisht*, the nine-part pavilion that symbolized paradise.[36] To complete the setting, Humayun supposedly had several other barges planted with fruit trees and flowering plants that could then accompany his water-palace down the river.

The impact of Humayun's experience in Iran and the importance of specifically Timurid architecture is best demonstrated by his tomb [Fig. 64], raised near the city he had founded in Delhi called Din-pannah. It was not erected by him, however; the patron was said to be his wife, who journeyed with him into exile, but a recent argument credits its creation to Akbar, Humayun's son and successor.[37] This first imperial Mogul mausoleum was built between 1562 and 1571, and the architect was Mirak Mir Ghiyas, who had worked previously in Herat and Bukhara. Like the Taj Mahal, Humayun's mausoleum is situated in a vast formal garden which is entered

on the south and divided by water channels into quarters, each of which is divided into smaller units. Unlike the Taj, however, which towers above and at the end of its garden, the tomb building is in the center of the grounds, where the two main waterways intersect.

The tomb of Humayun is a synthesis of different traditions. Lisa Golombek has established that the monumentality and rationality of plan as well as some specific architectural features are Timurid characteristics found in such tombs as the Gur-i-Amir, where Timur himself is buried.[38] Timurid tombs, however, seem to have been situated in large enclosures informally planted, not in formal gardens. That idea was derived from the spacious royal gardens which encircled the major cities of Timur's empire: here formal landscapes with running courses of water, pavilions, and gateways combined the Islamic concept of paradise as a garden with the ancient Persian idea of the royal garden. Some of the pavilions they contained are described as "*hasht behisht*," the plan which is also found in many surviving Timurid mausoleums. (The combination of a Timurid funerary building form with a palace garden setting, seemingly inaugurated by the Moguls, was eventually exported back into Iran. In the seventeenth century one finds it used not only in the Taj Mahal but in later buildings of the Safavids.[39]) While the plan, size, and setting of Humayun's tomb can be traced to Timurid precedents, the use of red sandstone and white marble as building materials seems to be a conscious revival of previous Islamic building practices in India.[40]

The magnificent mausoleums of the Moguls, initiated by Humayun's tomb, proclaimed through their size and elaboration the might of the new dynasty. In a general way the imperial tomb could be viewed as a potent symbol that defined the exalted status of the emperor, concretely demonstrating the vast resources at his command; and, by its particular form and layout, the dynasty's links with glorious past traditions of rulership were also clearly articulated.

The active role that the Mogul rulers took in the creation of architecture is fully demonstrated during the reign of Akbar, who constructed the Agra Fort and Fatehpur Sikri. His tomb at Sikandra, a short distance from Agra, was unfinished at the time of his death in 1605, and was completed by his son Jahangir [Fig. 58]. European visitors found it the most notable building in the region until the erection of the Taj Mahal. The construction of this grand edifice in the first decade of the seventeenth century is likely to have had a great effect on the young Prince Khurram who later became the Emperor Shah Jahan.

As is true of other aspects of Akbar's reign, the design of his tomb is an amalgamation of various influences. Much less Timurid than Humayun's tomb, its unusual form consists of five stages arranged as a stepped pyramid: the first four levels are made of red sandstone, and the top is white marble, culminating in an open terrace upon which stands the marble cenotaph. On the other hand, there are certain correspondences between Akbar's tomb complex and both Humayun's tomb and the Taj Mahal. The mausoleum is situated in a large divided garden which is entered through a monumental gateway. The gateway is more than 137 feet (some 42 meters) high. The four minarets that crown its corners are used here for the first time in a sepulchral monument. They would remain an important feature of subsequent tombs including the Taj Mahal. The gateway is elaborately decorated with inlays of various colored stones and broad bands of sculpted calligraphy. The calligraphic panels provide important evidence for the meaning of these mausoleums. The verses meant to be read last before one passes through the entrance proclaim that inside is the garden of Eden, clearly establishing the paradisiacal nature of the complex. These inscriptions were likely composed by the calligrapher himself, Abdul Haqq, who was later given the title "Amanat Khan" (Trustworthy Noble) and put in charge of the inscriptional program of the Taj Mahal.[41] He came from Shiraz in Iran in about 1608, the year in which Jahangir was first able to visit Akbar's tomb after the death of his father. Noting that the architects had deviated from the plans, Jahangir ordered some changes and parts to be rebuilt, and it is likely that at the same time he commissioned Abdul Haqq to design the calligraphy for the gateway.

The verses clearly indicate that the vast funerary garden was a symbolic replica of the heavenly paradise, a message similar to that of the passages from the Koran inscribed more than twenty years later on the gateway of the Taj Mahal.[42] As Shah Jahan was particularly fond of his grandfather and surely impressed with the work on his tomb, it is easy to understand Amanat Khan's appointment to design the calligraphy for the Taj Mahal.

Two other tombs reflect developments that were to be further refined in the creation of Shah Jahan's tomb

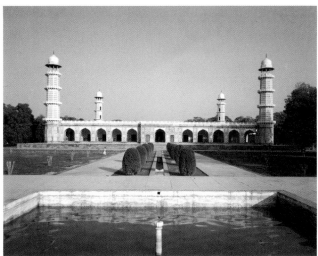

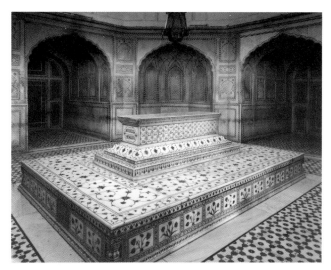

65 Jahangir's tomb, Lahore†
(Photo by Wim Swaan)

66 Interior of Jahangir's tomb, Lahore†
(Photo by Wim Swaan)

for Mumtaz Mahal. One of these, located at Agra on the east bank of the Yamuna river, had just been completed in 1628 when Shah Jahan assumed the throne. This is the tomb of Nur Jahan's father, Itimad-ud-daula, and her mother [Fig. 59]. Although small, it is lavish, reflecting the immense resources that she had at her disposal. It is located in the center of a traditional garden complex: in fact, the site was chosen because the garden had been established by her parents. The tomb stands on a low red sandstone plinth, and its noteworthy features include the white marble used for the walls and the abundant inlay of colored stones embellishing them. Whereas in earlier tombs red sandstone had been inlaid with white marble and other colored stones, here the white marble was lavishly encrusted with various stones so that the exterior surface seems a mosaic. Although Jahangir had constructed some of his buildings of white marble, this tomb built by Nur Jahan relates more closely to those that Shah Jahan would erect, with its lavish use of both the simpler stone inlay and *pietra dura*. These techniques are used to create designs which are a mix of geometric motifs, flowers, vases, and cypress trees, more closely related to Persian motifs than is usual in Mogul monuments.[43]

The two-storied tomb is square in plan with four towers rising from the corners of its plinth. Its general form echoes a pavilion in a palace; inside, the first floor

is divided into nine rooms, conforming to the *hasht behisht* plan. Instead of a dome, a curvilinear roof in what is known as a *bangla* form—popular also in Shah Jahan-period palaces—crowns the small second-story pavilion. The walls of this upper room are almost entirely composed of large pierced stone screens known as *jalis* which emit dazzling yet diffused light [see Fig. 236]. As in the Taj Mahal, controlled light and the costly inlay and stucco decoration echo the theme of the glorious appearance of paradise. The cenotaphs of Nur Jahan's parents are placed side by side, with her mother's located in the center and her father's off to the right. This is, as was mentioned earlier, the same configuration found later at the Taj Mahal. While those cenotaphs were obviously installed at different times, these are seemingly contemporary. However, Itimad-ud-daula's wife had died several months before her husband, just as Mumtaz had predeceased Shah Jahan. Perhaps the arrangement of the cenotaphs was meant to reflect this fact.

A final imperial tomb begun before the Taj Mahal is the mausoleum of Shah Jahan's father, Jahangir, who died in 1627 [Fig. 65]. It was constructed in one of his favorite gardens in Lahore, far away from Agra.[44] Its size befits an emperor, yet it is today sadly incomplete: it was originally similar to Itimad-ud-daula's tomb, but the top pavilion was torn down in the eighteenth

century. The combination of the very large platform with corner towers prefigures the layout of the Taj Mahal; and while a higher proportion of the more economical red sandstone was used in the building as a whole, the cenotaph of Jahangir [Fig. 66] is as richly embellished with delicate *pietra dura* as those in the Taj Mahal. Although Shah Jahan erected this mausoleum, the details might have actually been supervised by Jahangir's widow, Nur Jahan.

The Taj Mahal thus stands in the tradition of these earlier imperial Mogul tombs, conceived as conscious attempts to define the emperors' exalted status. This tradition was brilliantly developed under the patronage of Shah Jahan as the ultimate expression of imperial rule. In its actual form the Taj Mahal represents a break with its immediate predecessors. Instead of following palace models like the tombs of Akbar and Jahangir, it is closer to the older Timurid-inspired type exemplified by Humayun's tomb [Fig. 64]. This choice seems to reflect Shah Jahan's conscious concern to emphasize the Mogul dynasty's connections to the great ruler Timur. Although it was one of Shah Jahan's first major projects after he had become emperor, the Taj Mahal—a perfectly evolved embodiment of the Islamic concept of paradise—established the parameters for the architectural concerns of his reign.

THE MEANING OF THE TAJ MAHAL

Wayne Begley has recently argued that the Taj Mahal is not just a general image of paradise but a very precise visual representation of the Throne of God on the Day of Judgment.[45] While many points support his interpretation, perhaps the most significant one is the unusual placement of the tomb building, which unlike previous Mogul tombs is not in the center of its garden. Noting that the Throne is supposed to be placed above the garden of paradise, not in it, Begley has amassed considerable textual and visual information to suggest that by siting the marble mausoleum at the end of and above the garden a deliberate allusion was intended. It has already been said that there are more inscriptions than usual on the tomb and its gateway and that they are mostly passages from the Koran, the Word of God. Their content emphasizes the vision of the Day of Judgment, which is when God appears, seated on the Throne.

The passages decorating the four massive *iwans* come from the "Ya Sin Sura" of the Koran. Known as the

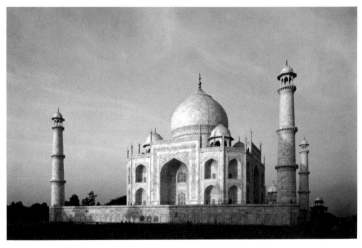

67 The Taj Mahal†
(Photo by Robert Holmes)

heart of this holy text, it affirms the vision to be offered as the final reward of the just, and was thus commonly recited at funerals. But the passages around the exterior doorways focus on the apocalyptic vision of the Day of Judgment, which is, as Begley has pointed out, not exactly the imagery one expects for the tomb of a beloved wife. He has noted, however, that according to a text popular in Mogul India these are the words to be recited by anyone who would like to see the Day of Resurrection as though it were before their very eyes:[46] they might indeed then have a special meaning for the tomb. The Koranic verses inscribed on the top of Mumtaz Mahal's cenotaph have also been used by Begley as evidence for his allegorical interpretation of the monument's meaning. They are a prayer that is uttered by the angels who support the Throne of God:

O Lord! Thy reach is over all things, in Mercy and Knowledge. Forgive, then, those who turn in repentance, and follow Thy Path; and preserve them from the penalty of the Blazing Fire!
And allow them, O Lord! to enter the Gardens of Eden which Thou has promised unto them, and unto the righteous among their fathers, their wives, and their posterity—for Thou art surely the All-mighty, and the All-wise![47]

Considering Shah Jahan's great obsession with thrones and other symbols of imperial power meant to underscore his semi-divine status, Begley's interpretation of the Taj Mahal as a symbol of the Divine Throne certainly seems plausible. The question arises, however, as to whether or not Shah Jahan planned to be

buried here. There is no evidence that he intended it when the monument was created, but there is also no indication that he had ever made plans for a separate mausoleum for himself. The traditional story still told by guides on the spot, that Shah Jahan had planned to build a replica of the Taj Mahal but in black marble across the river, has no factual basis. Although Tavernier claims that a second mausoleum was begun, no other early sources mention it nor have any traces of such foundations been found among the ruins on the other side of the Yamuna.[48] As Tavernier was writing after the emperor's death, it is possible that he was simply repeating a fanciful tale. Whatever the degree of specificity in the meaning of the Taj Mahal as a symbol of paradise, its peerless quality was clearly meant to reflect the exalted status of its patron. And such concerns can be seen in other architectural projects undertaken in Shah Jahan's reign, such as the construction of an entirely new capital city in Delhi called Shahjahanabad, and the enormous Jami Masjid built within that city.

THE REIGN OF MARBLE

The profusion of white marble buildings raised during the period of Shah Jahan led one scholar to characterize it as the reign of marble. Red sandstone and brick remained major building materials, but the use of marble is expressive of the very high standards of elegance and luxury that governed all aspects of an architectural project throughout Shah Jahan's reign. Whatever the materials, style and excellence were given priority. Shah Jahan had many earlier structures in the Agra Fort dismantled in order to make room for his own marble pavilions; and since some of the earlier ones were made of white marble, what he objected to must have been their appearance as a whole.

The amazing achievements in the Mogul architectural tradition owe much to the great talent of Indian artisans and the wealth of material found in India, including the abundance of stone. But the innovations seen in the buildings created during Shah Jahan's reign are striking demonstrations of the effect of particular aesthetic and political concerns. In addition to a greater use of marble, which has a textural quality quite distinct from the red sandstone favored by his predecessors, there was a greater refinement of the architectural vocabulary. Among specific changes were the intro-

68 Pavilions by the side of Ana Sagar, Ajmer†
(Photo by Wim Swaan)

duction of cusped arches and of pillars with tapering shafts and baluster detailing [Fig. 71]. Many developments can be directly related to a desire to articulate more forcefully paradisiacal and imperial themes, drawing on sources that included European motifs.[49] Palace buildings especially incorporated a great amount of ornament based on plants that helped to transform them into stone replicas of garden settings [Fig. 70]. While ultimately not different in meaning from Timurid buildings, Shah Jahan's palaces, due to their insistent perfection of form and materials, more emphatically present themselves as earthly visions of paradise created by a mighty imperial patron.

Buildings of many different types were constructed during the reign of Shah Jahan. In addition to palaces, tombs, and mosques, he commissioned gardens such as the Shalimar gardens at Lahore, pleasure pavilions such as those at Ajmer [Fig. 68], and hunting lodges such as the large red sandstone complex at Bari. Indeed, one modern historian has observed:

Every place which Shah Jahan visited during his reign bears a monument of his insatiable architectural interest. It is impossible to give even a list of all such buildings, not to speak of a detailed description of them. At Ajmer the mosque in the mausoleum of Shaykh Mu'inuddin Chishti and the Barah Dari on the Anna Sagar bear eloquent testimony to his taste. Kashmir, Lahore, Ambala, Bari, Faizabad, Gwalior, Kabul and many other cities are mentioned by contemporary chroniclers as towns where Shah Jahan erected buildings. But the most representative and the best preserved are those at Agra and Delhi.[50]

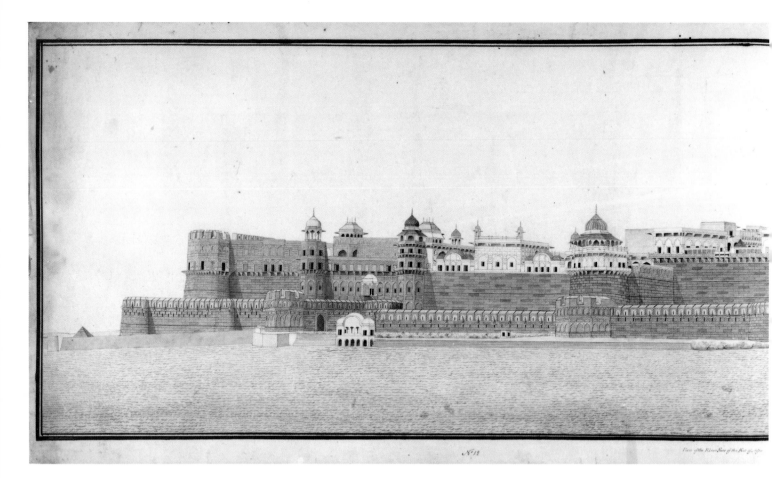

It seems that immediately upon his accession in 1628 Shah Jahan ordered palace additions to the existing forts at Agra and Lahore. Although the Agra Fort was constructed by Akbar, many of the remaining buildings, most of which are marble, date from the reign of Shah Jahan. Those finished before 1640 show particularly strong similarities to the Taj Mahal, which was being built simultaneously nearby. The most notable complex of white marble palace structures is situated on the eastern edge of the fortified walls built by Akbar bordering the Yamuna river [Fig. 69]. Among these is the Muthamman Burj (Octagonal Tower, also called the Jasmine Tower), built at a point where the main north-south wall of the fort takes a turn towards the east [see Fig. 38]. Lahori states that the site first held a small marble house erected by Akbar that was then demolished by Jahangir to make way for another marble building which Shah Jahan did not like and so removed in its turn.[51] The octagonal room, which offers an exceptional view of the Taj Mahal, is supposedly the place where Shah Jahan died in 1666 [see Fig. 247]. In front (or to the west) is another elaborately decorated room with a carved tank [Fig. 70]. In addition to profuse inlay, sculpted flowers appear on the dado, while the upper region of the walls contains small niches known as chinikhanas [cf. Fig. 16]. Although the rooms display the same high quality in the execution of their ornamentation as is found in the Taj Mahal, the latter's is more restrained and thus, to some, more effective. In the palace, under such decoration, marble with its own inherent sumptuousness can seem somewhat overwhelmed.

The Muthamman Burj is connected with a series of other marble pavilions forming the east side of a large courtyard that once contained a garden, the Anguri Bagh. Only the structure and not the flora survives today. Absent also for the modern visitor is the water that once animated and cooled this setting. Water was not only an integral element for the Mogul gardens and tomb complexes such as the Taj Mahal, but often figured prominently in many of Shah Jahan's palaces. Travelers' accounts record their impressive appearance, with water running through channels inside and outside the rooms, and flowers always in bloom.

69 *View of the River Face of the Fort of Agra*
Agra, c. 1808 (1803 watermark)
Opaque watercolor on paper
15 × 51¼ in. (38 × 131.5 cm.)
The British Library (India Office Library and
Records), London (Ms. Add. Or. 929)

The first riverside tower left of center is the
Muthamman Burj, the Octagonal or Jasmine
Tower. To the left of it is the white,
symmetrical Khas Mahal. At a distance to the
right are the three domes of the Pearl Mosque.
This is among fifteen drawings in the India
Office collection which seem to have belonged
to George Steell, who served in the Bengal
Engineers and was posted at Agra from 1807 to
1813.

70 Samuel Bourne, *Agra Fort*
England, c. 1865
Albumen print
9⅜ × 11½ in. (23.8 × 29.2 cm.)
Los Angeles County Museum of Art, Gift of
Mr. and Mrs. Phillip Feldman (M.83.302.25)

This shows the landward side of the
Muthamman Burj, with its marble fountain (cf.
Fig. 225).

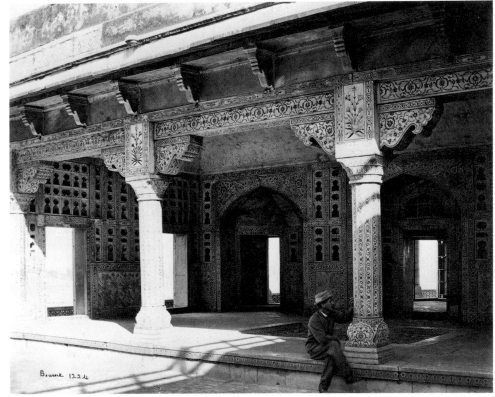

To the north of the palace quarters bordering the Anguri Bagh are additional rooms, including the Diwan-i-khas, the Hall of Private Audience, which is a marble pillared hall decorated with profuse inlay [Fig. 38]. A Persian inscription by Shah Jahan's court poet Mirza Talib Kalim, inlaid in black marble and including the date 1046 (A.D. 1636–37), praises not only the building but the emperor and the righteous nature of his reign. One particularly telling section states:

When his palace decorated the world, the head of the earth on account of it touched the heavens.
The Emperor of the World, Shah Jahan, (is the monarch) of whom the soul of *Sahib Qiran* is proud.[52]

The inscription is clear evidence of the paradisiacal imagery inherent in these palace buildings as well as their role as suitable reflections of the might of Shah Jahan. The mention of "Sahib Qiran," literally "Lord of the Auspicious Conjunction," is a reference to Timur: it is interesting in that it shows the importance to Shah Jahan of his illustrious ancestor, and his wish to be found worthy of him. The impressive nature of both the residential and official buildings of the Agra Fort demonstrates that he intended the architectural setting for all aspects of his life to reflect properly his imperial character.

THE RED FORT AT SHAHJAHANABAD

The various architectural projects undertaken at the same time as the Taj Mahal included construction at Shahjahanabad. The foundations of the new fortified palace at a site north of the citadel of Humayun at Delhi were laid in 1639, and it was finished in 1648 [Figs. 72, 252]. Bernier attributed its construction in part to the excessive summer heat of Agra, and the crowded conditions of the town and fort at Agra have also been cited as reasons for Shah Jahan's decision. Equally compelling, however, might have been his desire to construct a completely new city according to his own design and bearing his name. An inherent feature of monumental architecture is its expression of vast power, as the financial means and authority to build great structures are direct reflections of the might of the patron. The creation of a new city was an established means for the expression of absolute power throughout many parts of the world. But certainly Shah Jahan must have been specifically inspired by his much beloved

grandfather, Akbar, who built the fort at Agra as well as the town of Fatehpur Sikri. In his turn, Akbar was in a sense continuing a tradition of extensive building activity launched by Timur. Shah Jahan's interest in undertaking similarly grand projects was almost certainly a conscious reflection of his desire to emphasize his connections to both these ancestors.

The Red Fort included many of the same features found in the buildings that Shah Jahan erected at the Agra Fort. The forms have been further refined, and since the Red Fort was a new structure its plan could be more symmetrical. Indeed, Bernier saw the plan of Delhi as a major feature distinguishing it from Agra.[53] As at Agra, the east wall of the fort borders the Yamuna; and it is again here that the principal palace buildings are located.

Inside the western or Lahore gate, which was the royal entrance from the city, is a vaulted arcade where traders and merchants plied their wares—as they do still today. Next is the Naubatkhana (watch house) where the royal band played. Although they do not seem to record accurate details of the actual buildings, contemporary miniature paintings depict such parts of the fort [see, for example, Figs. 12, 35]. In line with the gate to the east is the Diwan-i-am, the Hall of Public Audience, which is similar in plan to the one at the Agra Fort. At the back (on the east side) of this pillared hall is a lavishly decorated marble alcove where the emperor sat [Fig. 71]. This alcove, known as a *jharoka*, continues in function the earlier Mogul practice as the place where the emperor made his most official appearance within the palace; but its form and decoration at Delhi represent a break with earlier styles. Elements that were used separately in the Agra Fort have been fused together to create a new vocabulary of imperial ornamentation.[54] The most extraordinary feature of this decoration is the presence of *pietra dura* plaques of undoubted Florentine origin mixed with Mogul *pietra dura* designs.[55] This remarkable assemblage epitomizes the complex definition of Mogul rule that Shah Jahan sought to present in his architecture, which was a synthesis of many traditions: Indian, Timurid, and European.

Other structures in the Red Fort such as the baths (*hammams*) and the Diwan-i-khas, the Hall of Private Audience [Fig. 73], are equally imperial. The effect of the latter's lavish decoration, which includes *pietra dura* designs, has been called one of exuberant grace. On the

71 The emperor's seat in the Diwan-i-am, Red Fort, Delhi†
(Photo by Robert Holmes)

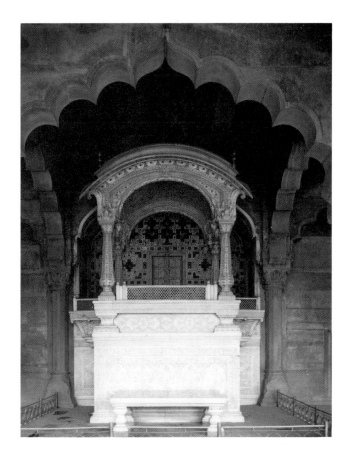

72 *The Red Fort at Delhi*
India, c. 1860
10$\frac{3}{16}$ × 16$\frac{13}{16}$ in. (25.8 × 42.8 cm.)
On loan from the Royal Ontario Museum, Toronto, Canada

Several versions are known of this schematic composition showing the palace structures along the east wall bordering the river. The Lahore Gate stands in the center of the far side. Moving forward, on axis, you pass a square tank, then the Naubatkhana pavilion, before reaching the Diwan-i-am (Hall of Public Audience). In the foreground is the octagonal Muthamman Burj; to the left are the *zenana* or harem quarters; and to the right is the Diwan-i-khas (Hall of Private Audience), with the little Pearl Mosque behind it. (For a view of the Fort from the opposite direction, see Fig. 252.)

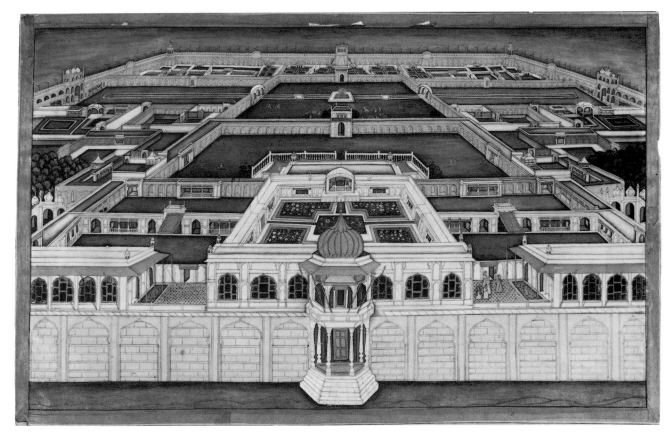

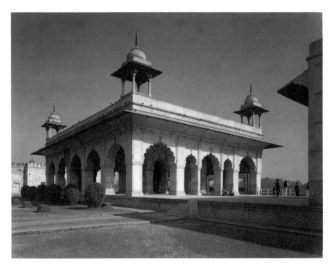

73 Diwan-i-khas, Red Fort, Delhi†
(Photo by Wim Swaan)

north and south sides the most famous inscription on all Shah Jahan's buildings is repeated: "If there be a paradise on earth, it is here, it is here, it is here." This quote from the renowned poet Amir Khusrau makes the intention of such structures very clear. The famous Peacock Throne stood in this building until it was carried off in 1739 by Nadir Shah to Iran (see below, p. 134 and Fig. 130).

As at Agra, gardens and water courses both indoors and out were important components of the imperial architectural complex at Delhi. Unfortunately, little remains to convey the original effect of the water running through such architectural features. Bernier, however, has left a report of their appearance:

Nearly every chamber has its reservoir of running water at the door; on every side are gardens, delightful alleys, shady retreats, streams, fountains, grottoes, deep excavations that afford shelter from the sun by day, lofty divans and terraces, on which to sleep coolly at night. Within the walls of this enchanting place, in fine, no oppressive or inconvenient heat is felt.[56]

MOSQUES

In addition to his civic and residential projects, Shah Jahan also supported religious architecture, most notably in the form of the mosque. Prayer is one of the foundations in Islam for the faithful to demonstrate their allegiance to God. Five times a day, each individual must pray, turned toward the city of Mecca (which in India means facing the west or northwest). The mosque, as a center of prayer, is thus a focus of public displays of faith, and endowing mosques is an act of great piety.

Of the three largest mosques connected with Shah Jahan, two were erected at Agra. The earlier mosque at Agra was the Jami Masjid, the Friday or Congregational Mosque, which was apparently conceived as early as 1637 but was finished only in 1648, immediately prior to the completion of the Red Fort at Delhi. Although it was initiated by Shah Jahan, he was apparently persuaded by his daughter Jahanara to allow her to endow the red sandstone mosque.[57] The other is the Moti Masjid or Pearl Mosque inside the Agra Fort, finished in 1653 [Figs. 74, 228]. It is recorded that Shah Jahan made a special trip down the river from Delhi to see the new structure complete.[58] It is entirely made of white marble and built on high ground so its three gleaming domes are visible above the fort's walls [see Fig. 67]. The exterior is rather plain, not preparing the visitor for the sumptuous vision inside of a large courtyard paved in white marble and enclosed by marble cloisters on three sides with a deeper prayer hall also made of marble on the fourth, western side. The name "Pearl Mosque" is given to two other palace-mosques, one in Lahore and one in Delhi [Fig. 223], but those are quite small: only the one in Agra was meant for a congregation. The inscription inlaid with black marble across its facade proclaims:

Verily it is a palatial building of Paradise made of an invaluable pearl, for since the beginning of this inhabited world a parallel of this mosque built entirely of marble has never been produced, and since the creation of the world no place of worship, like it, resplendent and brilliant from top to bottom, has ever appeared.[59]

The building has been much admired. Sleeman, for example, noted:

There is no mosaic upon any of the pillars or panels of this mosque; but the design and execution of the flowers in the bas-reliefs are exceedingly beautiful . . . and [it] is by some people admired even more than the Taj, because they have heard less of it; and their pleasure is heightened by surprise.[60]

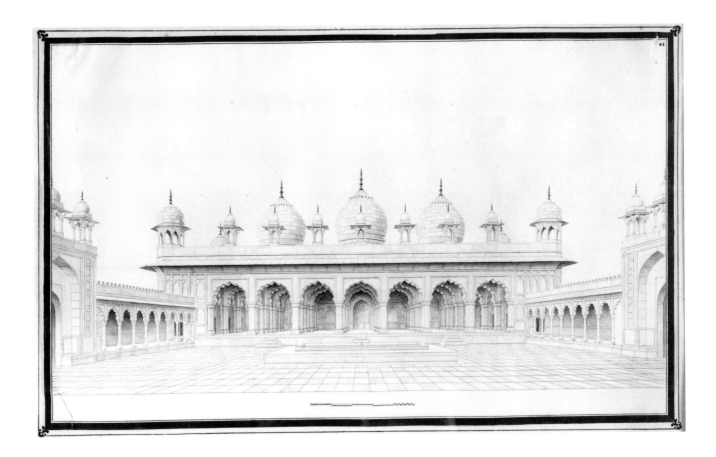

74 Shaikh Latif, *Moti Masjid, Agra Fort*
From an album prepared for Robert Home (see Figs. 53-55)
Agra, c. 1820
Opaque watercolor on paper
11 × 18 in. (27.9 × 45.7 cm.)
Gary Crawford

The Moti Masjid can, in fact, be appreciated as a further development in the exploitation of the intrinsic decorative qualities of the stone itself, as the absence of profuse inlays allows the marble building to seem truly a transcendent work. The purity of the forms, the elegant proportions of the cusped arches, and the harmonious arrangement of the domes create an environment decidedly heavenly, showing that lessons had indeed been well learned from the successful completion of the Taj Mahal. It is a significant achievement that this large and substantial structure could so successfully evoke visions of heaven for visitors, a fitting reflection of its function as a house of prayer. The Moti Masjid's one inscription, positioned unobtrusively on the facade, not only records that it took seven years to complete and cost three hundred thousand rupees, but also mentions the great piety of its patron. Although in general mosques from the period of Shah Jahan use fewer Koranic passages, their complete absence here is quite unusual.[61] This perhaps resulted from a personal decision on the emperor's part to let the building's appearance create the realm of God.

Producing a rather different effect is the Jami Masjid, built to enhance Shah Jahan's new city at Delhi, which stands near the Red Fort [Fig. 63; see also Figs. 218, 222]. This red sandstone building embellished with much white marble is impressive, both for its size and for its form. Called in its lengthy inscriptions the "Masjid-i-Jahannuma" (World-Displaying Mosque), in all ways it was meant to establish the might of its earthly ruler as a reflection of the power of the divine.[62] It was the last great building project of Shah Jahan's reign, completed in 1656—less than two years before he lost his throne. Inscriptions, which record that the mosque took six years to build and cost one million rupees, detail its grandeur and proclaim that even those who have traveled throughout the world have never seen and could never imagine a greater building; both the emperor and the land that he ruled are incomparable. Like other imperial

buildings, the mosques were intended to impress not only the subjects of the emperor but the whole world.[63]

The Jami Masjid at Delhi, like the Agra Moti Masjid, contains numerous references in its Persian inscriptions to paradise, making it clear that it was conceived as a symbolic replica of a divine realm. Paradise imagery is thus an integral part of most of Shah Jahan's buildings, indicative of their patron's interest in articulating his reign as a heavenly regime, a paradise on earth, in what has been aptly called a mixture of vanity and mysticism.

THE LEGACY OF SHAH JAHAN'S ARCHITECTURE

While the Taj Mahal in particular has inspired many copies in India and elsewhere in the world, the architectural style created during Shah Jahan's reign also in a general way exerted great influence on later Mogul art and on the architecture developed in the Rajput kingdoms of Northern India, many of which had close ties with the Mogul court.

Although patronage declined after the reign of Shah Jahan, elaborate architectural projects were undertaken for later Mogul rulers. The Badshahi Mosque in Lahore and the Pearl Mosque in the Delhi Fort are but two examples built for Aurangzeb, Shah Jahan's son and self-appointed successor. Although small, the Pearl Mosque in particular [Fig. 223] represents a continuation not only of the architectural vocabulary established during the reign of Shah Jahan but also of the use of expensive building materials such as white marble, though the elongated shape of the domes and arches signals a change in taste. A few grand tombs were also made for the Mogul nobility. Aurangzeb chose to be buried in a simple open-air grave, but the tomb of his wife at Aurangabad, completed in 1660–61, is quite elaborate. The monument, known as the Bibi-ka-maqbara [Fig. 75], has been dismissed as a poor imitation of the Taj Mahal, as it is similar in form but smaller and built of less expensive materials; and it is true that although the architect, Ata Allah, was the son of Ustad Ahmad, the presumed architect of the Taj Mahal, the building does not have the same harmonious proportions or lavish detail. The last grand Mogul tomb to be built has also been unfavorably compared to the Taj: this is the tomb of Safdarjang, a nephew of a later Mogul king [Fig. 76], erected in Delhi during the middle of the eighteenth century, of red sandstone embellished with white marble.

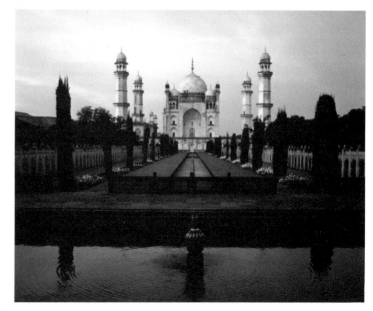

75 Bibi-ka-maqbara, Aurangabad†
(Photo by Tom Hammond)

Perhaps the most surprising tomb inspired by the Taj Mahal was built not for a Muslim but for a Dutchman, Col. John William Hessing [Fig. 77]. Hessing ended his long stay in India as commander of the Agra Fort and its Maratha garrison. He died a few months before the British took the fort in 1803, and his monument—which has rightly been called the most magnificent European tomb in Agra—was erected in the Roman Catholic cemetery by his sons and daughters.[64] Much the smallest of the Taj's progeny in this line, it is 34 feet (some 10 meters) high. It is made of red sandstone and ornamented by freely adapted versions of Mogul decorative designs.

Mogul forms freely adapted also characterize the magnificent palaces built by the Hindu Rajputs at places like Deeg or Jaipur, which include buildings that in varying degrees adopted the architectural style first developed by Shah Jahan.[65] Various aspects of life at the courts of the Hindu maharajas were in fact inspired by Mogul practice. Many specific motifs were retained, such as cusped arches and baluster columns; marble or stucco painted to look like marble was also preferred. Rajput gardens followed models such as the Anguri Bagh at Agra. Actual fragments of buildings were even carried off to Rajput territories after the decline of Mogul power. And although the technique of *pietra dura* was seldom used, such forms continued to inspire the Rajput styles. New motifs were often mixed with

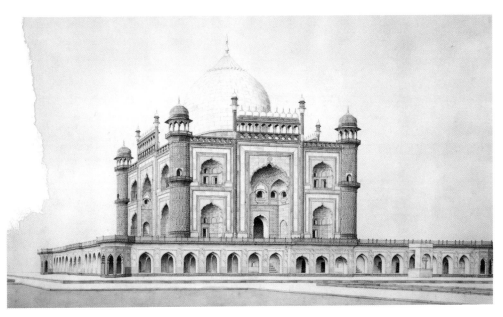

76 *Safdarjang's Tomb, Delhi*
India, c. 1850
Opaque watercolor on paper
20¼ × 28¹⁵⁄₁₆ in. (51.5 × 73.5 cm.)
Trustees of the Victoria and Albert Museum,
London (IM 2427)

77 Hessing's tomb, Agra†
(Photo by Robert Holmes)

78 Lunette
India, late 17th C.
White marble
39 × 184 in. (99.1 × 467.4 cm.)
Peter Marks

79 Architectural slab showing a banana plant
Rajasthan, Amber, late 17th C.
Marble
25¼ × 19¹⁵⁄₁₆ in. (64 × 50.6 cm.)
Virginia Museum of Fine Arts, Richmond,
Museum Purchase, The Arthur and Margaret
Glasgow Fund (86.123)

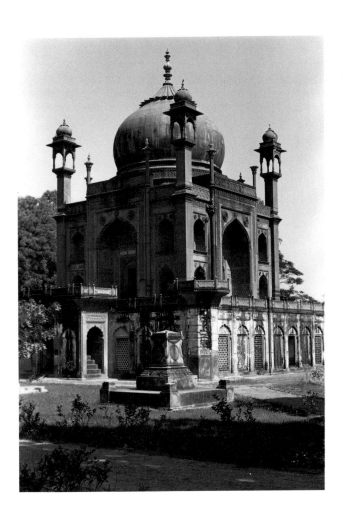

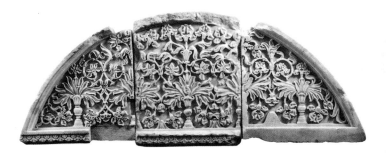

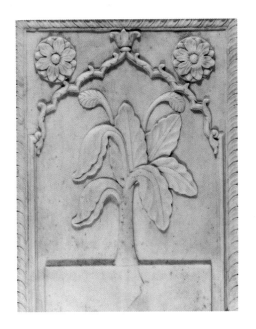

borrowed ones, so that it can be quite difficult to determine if a particular element was originally Rajput or Mogul since the two traditions were already influencing each other in the late seventeenth century [Figs. 78, 79]. The Rajput palaces developed to their fullest glory in the eighteenth century as the power of the Rajputs' Mogul overlords weakened.

In the nineteenth century both Mogul and Rajput patronage declined as the British gained greater power on the Indian subcontinent; but the Mogul monuments of Delhi and Agra—the Taj Mahal in particular—began to command greater attention from these foreigners. Restoration work on the Taj began as early as 1810 and continued intermittently throughout the century. The damage that the British detected in their initial survey was not serious, and it appears that the building had endured fairly well through one hundred and fifty years. Some problems had developed as early as 1652, when Aurangzeb in a letter to his father reported defects in the dome and vaults which had allowed leaks during the rainy season.[66] But he noted that repairs had been made; and these must have been sufficient, since no remedial work of that sort is listed among the early undertakings of the British.

The obsession with the Taj Mahal in large part helped to develop the British interest in preserving other monuments which were now under their control. Lord Hastings in 1815 and then Lord Curzon at the end of the century both referred specifically to the Taj Mahal in their statements about the need for British authorities to have enlightened policies toward the remains of India's heritage.[67] Lord Curzon, who as Viceroy was especially instrumental in conserving buildings throughout India, was personally most interested in Mogul monuments, and he took particular pride in describing the recent efforts to upgrade the site of the Taj in a speech in 1904 to the Legislative Council in Calcutta presenting his bill to provide for the Preservation of Ancient Monuments.[68]

Curzon spoke rather strongly about the neglect these monuments had suffered throughout the previous century. That was less true of the Taj, although some visitors did behave badly, carousing and picking out the inlaid gemstones. The notorious story about the desire of Lord Bentinck to tear it down and sell its marble seems to have been fabricated by Bentinck's enemies in India when he had to enforce unfavorable financial policies ordered by the authorities back in England.[69] It

80 Charles Mason Remey, *Design for Baha'i Temple*†
United States, c. 1920
From Remey, *A Nonagonal Temple in the Indian Style of Architecture* (privately printed, 1927)

appears to have been based on a decision in 1831, during Bentinck's time in Agra, to sell off the remains of a marble bath, of which a large part had already been shipped to Calcutta sixteen years earlier under Lord Hastings when it was deemed irreparable.[70]

In the early part of this century the Archaeological Survey of India continued repairs to the Taj Mahal, and a special committee was formed in 1942 to provide recommendations for future work.[71] It found that while much minor repair work was needed—most wartime visitors to the Taj Mahal found the dome obscured by scaffolding [see Fig. 42]—the building

seemed to be in no worse structural condition than when Aurangzeb made his report more than two centuries earlier. Since the independence of India, the complex has been mostly viewed by the nation as an important national treasure. Unfortunately a group of Hindu fundamentalists which seeks to deny any positive role of Muslims in India disputes the claim that it was built by Shah Jahan. Instead, as outlined in the book *Taj Mahal Was a Rajput Palace*, fourth-century Hindu rulers are given credit for its erection.[72] The claim is without serious merit, but it has acquired something of a following in India, an ironic reflection of the continued importance of this imperial mausoleum.

Of even more recent date another controversy has also developed concerning the Taj Mahal—the effects of modern pollution on its marble surface. This concern first emerged when a refinery was planned for a nearby area.[73] During a study of the situation, the pollution level in Agra was found to be already excessively high. Although plans for the refinery proceeded, certain measures were taken to improve conditions in this important area, in order to prevent damage to its monuments.

In many ways the Taj Mahal clearly remains a building of significance for the modern world. Indeed, in varying degrees, it still influences architecture. While nineteenth-century English designs inspired by it may be better known (see below, p. 203), twentieth-century examples also exist. The American architect Charles Mason Remey made a number of designs modeled on the Taj Mahal in the early part of this century;[74] the closest was his choice for a temple for the Baha'i faith that was intended to be built in Palestine [Fig. 80].

Despite ongoing concern for its safety and debates about its meaning, the majority of those who visit the monument simply continue to derive immense pleasure from it. Indeed, many of the ever-growing number of visitors to this empress's mausoleum would likely agree that Shah Jahan had accomplished what John Ruskin meant when he wrote in the nineteenth century, "There are but two conquerors of the forgetfulness of men, Poetry and Architecture."

Artists for the Emperor

Joseph M. Dye, III

Better remembered today for his architectural achievements, Shah Jahan has generally been overlooked as a connoisseur and patron of painting; yet, like his father, Jahangir, and his grandfather Akbar before him, he too was keenly interested in calligraphy and painting. At least one superb assemblage of sketches and portraits—the "Sultan Khurram Album" (c. 1611)—is known to have been prepared for him when he was about fourteen. Later in his life, Shah Jahan not only continued to support the imperial workshops inherited from Jahangir, but he also meticulously labeled paintings in his own hand with the names of the artists who created them; sometimes he even recorded his personal reactions to portraits of himself.[1]

Shah Jahan's interests in calligraphy and painting were no doubt kindled during his youth when, as Prince Khurram, he must have watched his father and grandfather admire the many books, albums, and paintings produced by artists of the imperial Mogul atelier. In the days before printing and photography, these treasured volumes of history, religious learning, and poetry were laboriously copied by hand in beautiful calligraphy by master scribes. Many were illustrated by skilled painters in opaque watercolor on smoothly burnished paper made from cloth, rag, grass, or rice straw. The artists also produced independent pictures depicting a wide range of themes.

It is not unlikely that the impressionable young prince occasionally visited the imperial studios where painters and calligraphers drawn from various parts of the vast Mogul empire worked with masters who supervised and trained them. There, the future emperor may well have spent time observing the painters as they labored for hours to produce the jewel-like pictures so beloved by his father and grandfather. The techniques that they employed were very demanding. Once the subject of a painting was determined (most probably by the emperor or the studio master), its composition was sketched on a sheet of paper in black or ochre and then covered with a thin priming layer of white paint.

Different colored pigments prepared from mineral and vegetable sources were then laid down, one at a time, with animal hair brushes. After each layer of paint was applied, the back of the paper was rubbed with a polished stone to smooth the pigments and impart an attractive sheen to the surface. This burnishing was followed by further refinements: outlines were carefully reinforced; subtle details were added; pictorial elements were lightly modeled to give them a sense of volume; and gold and silver were added in appropriate areas.

Upon completion, the painting was presented to the ruler-patron for his approval. Since the emperor supported artists financially and could also reward them with gifts and prestigious positions, his personality and tastes ultimately shaped the general aesthetic vision that guided the imperial studio. It is, of course, unlikely that the ruler actually supervised the day-to-day operations of his atelier, but in the final analysis, the painters worked and competed to please him. Shah Jahan, who probably heard, and, perhaps, even participated in Akbar's and Jahangir's aesthetic evaluations, must have been keenly aware of the crucial role that they played in the artistic process.

When he ascended the throne in 1628, Shah Jahan inherited not only a great empire but also an atelier of painters who had labored for many years to satisfy Jahangir's passion for the humanistic and "objective." Addicted to drugs and wine, Jahangir disliked governmental responsibility; but he was a man of great visual sensitivity, who was deeply devoted to his painters. Under his direction, the energetic Mogul style developed under Akbar was refined to produce pictures of penetrating psychological insight, convincing naturalism, and remarkable technical virtuosity. Jahangir, who viewed the world as a place to be objectively explored and recorded, preferred paintings which, in a very personal way, penetrated deep into the nature and individuality of the subject depicted. Rendered with exceptional naturalism, spatial depth, accurately

observed visual detail, and technical control, these pictures dealt with a wide variety of standard Mogul themes: the pleasures and pastimes of court life; incidents from historical and poetic texts; portraits; bird, animal, and flower studies; scenes derived from European pictorial sources; and studies of holy men. They were often mounted in sumptuous albums or *muraqqas* that also contained Deccani, Persian, and Turkish miniatures and examples of calligraphy, as well as European prints and Mogul copies of them.

Inscribed paintings and other evidence indicate that Shah Jahan retained many of his father's finest painters when he assumed control of the empire.[2] The presence of these brilliant artists (Bichitr, Balchand, Govardhan, Payag, and others) guaranteed the continuity of earlier Mogul taste and aesthetics. The polished refinement and technical virtuosity of the Jahangiri style were readily accepted by the new emperor, as were many of the conventional subject-matter categories. Like Jahangir, Shah Jahan preferred individual paintings rendered by a single artist to illustrated manuscripts executed by a host of collaborators. These individual works, surrounded by elaborate borders, were bound into lavish albums with exquisitely painted frontispieces such as the superb *shamsa* ("little sun") pages [Figs. 81, 128].[3]

Shah Jahan and his artists, however, did more than simply continue, elaborate, and refine the themes and techniques of Akbari and Jahangiri painting. They also forged a new and highly interesting reinterpretation of the Mogul style which, though rooted in past achievements, differed radically from them. Jahangiri artists accepted the physical reality of the universe as they perceived it and attempted to record its unique inner character and outward appearance; Shah Jahani painters present, instead, an idealized or perfected image of the world. Their ultimate purpose, it seems, was to show the universe not as it is, but rather as it should be—i.e., a harmoniously ordered, sublimely beautiful paradise, a realm of radiant purity, which, like the Taj Mahal, seems to lie somewhere between heaven and earth.

It is not surprising, therefore, that in Shah Jahani paintings a simple ascetic's hut becomes a picturesque, rustic cottage; sumptuous imperial palaces are elevated into celestial mansions; and a grove of shady trees is transformed into a luxuriant growth of extraordinary beauty. The men and women who inhabit these painted paradises, even if portrait likenesses, are perfected images of real people and, in many cases, simply ideal

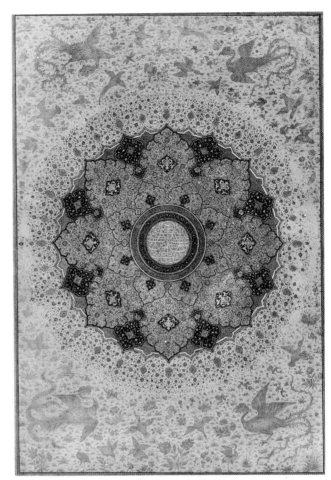

81 *Shamsa Inscribed with the Titles of Shah Jahan*
Page from the Kevorkian Album
Mogul, c. 1640–45
Opaque watercolor on paper
15⅜ × 10½ in. (39.1 × 26.7 cm.)
The Metropolitan Museum of Art, New York, Purchase, Rogers Fund and The Kevorkian Foundation Gift, 1955 (55.121.10.39)

figural types [Fig. 82]. Psychological depth and human individuality are on the whole neither deeply explored nor lovingly emphasized. Instead, people are largely defined in terms of externals—clothing, jewelry, and so forth. Moreover, to invest these idealized figural types with a pseudo-reality, the accurate techniques of Jahangiri naturalism are used and, indeed, significantly heightened, to create superbly detailed, highly decorative surface descriptions of the clothes that they wear, the objects that they possess or the places in which they dwell. Shah Jahani painting is full of richly woven textiles, marble, and glimmering jewels, all rendered with an unearthly and, at times, almost eerie perfection.

82 *Portrait of a Young Prince*
Page from an artist's sketchbook
Mogul, c. 1640–50
Opaque watercolor and gold on paper
6¾ × 6 1/16 in. (16.2 × 15.3 cm.)
Cincinnati Art Museum, Gift of John J. Emery (1950.292)

obsessed, with the substance and external expression of imperial power. He wished to present himself not as a vulnerable human being, but as the perfect ruler of a mighty empire which, under his wise and just rule, and with the benediction of God, had entered into a golden age of peace and prosperity. For such a man, painting formed part of the trappings of Mogul kingship and, therefore, had its place in the overall scheme of things. Like vast public monuments such as the Taj Mahal, pictures could be used to project the emperor's imperial image to himself, to his contemporaries, and to posterity. The visual splendor, spotless technique, idealized reality, and utopian vision of paintings rendered in this new interpretation of the Mogul style perfectly suited the needs of Shah Jahan: they flattered him; they reminded all those who saw them that their emperor was, indeed, the ruler of a mighty empire; and they ensured that he would be remembered as such forever. He must have played a major role in their creation.

PORTRAITS OF SHAH JAHAN AND HIS IMPERIAL ANCESTORS

Nowhere are the new aesthetic values of Shah Jahani painting more obvious than in the numerous official portraits of the emperor painted between 1628 and 1658. Jahangir ordered more likenesses of himself than Akbar, but Shah Jahan carried this preference to the extreme. Indeed, so many portraits of him have survived that they must have been produced almost continuously. One such likeness, a portrait painted by Abul Hasan in the first year of Shah Jahan's reign [Fig. 129], already reveals much about the new visual attitudes that were to dominate his imperial painting studio. The sharply outlined head and torso of the thirty-six-year-old emperor are shown against the same light green background used in Akbari and Jahangiri portraits. His pink *jama* (long coat), seen in three-quarter view, is almost completely free of folds and serves as a plane upon which minutely rendered jewelry is ostentatiously displayed. The bejeweled fingers of the emperor's right hand touch the hilt of a sword, an emblem of imperial power, while those of his left hold a flower-like accession seal marking the first year of his new reign. Polished, hard, and finely rendered, this chilly painting depicts Shah Jahan almost as a deity, bearing symbols of imperial power and legitimacy that recall, in spirit, the prescribed attributes of Hindu gods.

Although occasionally lacking the warmth and spontaneity of earlier Mogul works, Shah Jahani paintings can be visually spectacular. The technique with which they are rendered is so impeccable that, as Milo Beach has noted, the purely formal qualities of painting assume an expressive weight of their own.[4] Released from the earlier Jahangiri goal of defining the individuality and inner character of a subject, technique is now made to serve a cold passion for the ideal. Its consummate perfection contributes to the feeling of calculation that lies just beneath the appealing surfaces of most Shah Jahani pictures.

Such heavenly paintings, such visions of paradise, must have pleased the emperor for whom they were made. A rather formal and intelligent man, Shah Jahan was, like his beloved grandfather Akbar, an organized and practical administrator. He presided over a glittering, highly ritualized court and was himself somewhat of a dandy as well as a great admirer of sparkling gems and sumptuous objects. More than any other Mogul monarch, Shah Jahan was concerned, perhaps even

How very different is the smaller portrait of Jahangir mounted on the same album page [Fig. 129]! Subtly painted by Balchand toward the end of the sovereign's reign, it depicts him with telling insight and sensitivity. Balchand, accepting the emperor for what he actually is, attempts to define the unique essence and physical appearance of the man at the very moment when the picture was painted. Although nimbed and bejeweled, Jahangir's face is naturalistically modeled and each fold in his *jama* is lovingly noted. The old ruler appears not as a god but as a man disturbed by the anguishing events that troubled his later years.

The frigid formality and aloofness of Abul Hasan's likeness can be found in many other state portraits of Shah Jahan. Whether standing in a field, seated on a richly caparisoned horse [Fig. 13], or occupying a throne [Fig. 130], the emperor is usually shown as a slightly stiff, remote figure: his strong head is haloed; his eyes stare into the distance and the future; his hands bear fixed attributes that proclaim superior wisdom, taste, and power (sword, dagger, fly-whisk, flower, health-giving amulets [Fig. 84], jewels, archer's ring, spear, turban ornament [Figs. 37, 144], and so forth). Depictions of Shah Jahan in his later years [Fig. 22], though they may record his whitened beard, frequently depict him with a smooth face and a barely altered physique; even time, it would seem, does not affect his eternal visage. Transitory feelings and vulnerable emotions are almost never revealed in his face.

Much the same message, though more frankly stated, is conveyed in portraits of Shah Jahan that contain allegorical or symbolic references. Similar likenesses made for Jahangir revealed his hopes and sometimes his insecurities; they often referred symbolically to specific historical events. In *Jahangir Embracing Shah Abbas* [Fig. 83], for example, the emperor is shown as a powerful monarch standing on a globe and affectionately embracing a rather submissive Shah Abbas of Iran; both men are united in an immense halo composed of the sun and the moon. The subject of this painting, as several scholars have noted, is pure wish-fulfillment, and has nothing to do with historical fact: in reality, the two men were intense military rivals and Shah Abbas was by no means meek.[5] The painting, despite its grandiose symbols, actually records Jahangir's personal insecurity with the military rivalry and his hopes for attaining peace so that the predatory lion would lie with the gentle lamb.

83 Abul Hasan, *Jahangir Embracing Shah Abbas*†
Mogul, c. 1618
Opaque watercolor on paper
9⅜ × 6¹⁄₁₆ in. (23.8 × 15.4 cm.)
Courtesy of the Freer Gallery of Art, Smithsonian Institution, Washington, D.C.

Although based upon such Jahangiri models, the allegorical portraits produced for Shah Jahan do not usually refer to specific historical events nor do they convey the emperor's personal vulnerabilities. Instead, these rather superficial icons are simply meant to impress us with the power, glory, and eternity of his imperial rule. In *Shah Jahan, Master of the Globe* [Fig. 84], for example, the haloed emperor is shown holding a sword and a carnelian amulet, and standing on a globe, its surface covered with a panegyric to the emperor and several oft-repeated allegorical figures: the scales, symbolizing justice; the lion lying with the lamb, representing the peace of the emperor's righteous rule;

84 Mir Hashim, *Shah Jahan, Master of the Globe*†
Page from the Kevorkian Album
Mogul, dated 1629
Opaque watercolor on paper
9⅞ × 6¼ in. (25.7 × 15.8 cm.)
Courtesy of the Freer Gallery of Art, Smithsonian Institution,
Washington, D.C.

the Moguls' descent from the Timurids, thus affirming the dynasty's position as a great Muslim house and his own status as its legitimate head. Painted family trees were, therefore, produced to connect pictorially the Moguls with the Timurids [Fig. 5]. In addition, imaginary family portraits, grouping several generations of the Timurid house (including the Moguls) together in one picture, were also commissioned; they frequently feature the transfer of a symbol of imperial authority—such as a turban ornament or jewel—from Amir Timur to one of his royal descendants.[7]

Even posthumous likenesses of Akbar and Jahangir were transformed into iconic propaganda that glorified the Mogul past, and, by extension, proclaimed Shah Jahan's proud lineage and legitimate authority. Such portraits of Akbar, for example, often show him not as a dynamic leader, but as the haloed patriarch of a venerable dynasty standing beneath a dramatically lit sky or surrounded by a border filled with putti bearing symbols of imperial authority; in at least one of these pictures the lion and the calf, a variant of the lion and the lamb so frequently seen in Shah Jahani paintings, appear in the foreground.

Some Shah Jahani portraits of Akbar with Jahangir stretch reality to the limits of plausibility. One depicts the old emperor, whose posthumous title was "The One Nesting in the Divine Throne" (*Arsh-Ashiyani*), sitting peacefully with Jahangir in heaven [Fig. 212], and yet another shows him quietly standing with his adoring son in a field. Considering the severe rift between Akbar and Jahangir, caused by the latter's armed rebellion, it is remarkable that the two men are shown in serene communion only a few decades later. Such pictures, which possibly represent Shah Jahan's own wish-fulfillment, must have seemed quite extraordinary to the artists who painted them, many of whom had actually worked for Akbar and Jahangir and must have known the real situation; but if Shah Jahan's artists were willing to deify the living emperor visually, they could also reinterpret the past. Mogul rulers had always been concerned with their imperial image and ancestry, but none of them had carried these interests to such remarkable extremes.

DEPICTIONS OF SHAH JAHAN'S LIFE AND COURT

Given the exaggeration and grandiosity of these imperial portraits, it is hardly surprising that depictions

and the lightly drawn holy men who attest to his "humility" and wisdom. Three European-inspired putti, descending from the heavens, bear an imperial sword and crown as well as a royal parasol inscribed with Shah Jahan's genealogy. The meaning of this portrait is quite clear: power, authority, and legitimacy, conveyed to the perfect emperor from the heavens above, result below in the golden age of his just kingdom, a place where the lion can lie with the lamb.[6]

Shah Jahan's passion for grandiose imperial imagery was by no means confined to portraits of himself: it also extended to depictions of his imperial ancestors. Like Akbar, the "Ruler of the World" wished to emphasize

85 *The Meeting of Shah Abbas and Khan Alam*
Mogul, c. 1650
Opaque watercolor on paper
9$\frac{15}{16}$ × 6$\frac{11}{16}$ in. (25.2 × 16.8 cm.)
Courtesy, Boston Museum of Fine Arts, Boston, Francis Bartlett
Donation of 1912 and Special Contributions (14.665)

This scene was copied from an original by Bishndas and depicts
Shah Abbas of Iran meeting with a Mogul ambassador.

various public and private collections, may have been
intended for further, now missing volumes of Lahori's
text or for another illustrated history.

Most of the *Padshah-nama* illustrations depict the
principal activities of Shah Jahan's public life: military
campaigns; formal audiences of the emperor with his
subjects; imperial hunts and visits to Muslim shrines;
and royal celebrations such as weddings or the annual
weighing of the emperor on his two birthdays (accord-
ing to the solar and lunar calendars). Abid's painting of
Shah Jahan [Fig. 130], completed on 19 December 1639,
is a fine example of these technically flawless works.
The remote, haloed emperor is shown seated on a
magnificent jeweled throne flanked by three princes
(Dara Shikoh, Shah Shuja, and Murad Bakhsh) and a
host of courtiers; below them, other notables and
female musicians stand in rapt adoration. From the
lowest to the highest, all the figures keep their eyes fixed
on the emperor, the center of their universe.

Although Abid no doubt presents a factually accurate
visual record of this ceremonial event, his picture has
the perfection of a fantasy. It is created by manipulating
composition, space, figural groups, and visual details to
heighten the scene's formality and splendour, its drama
of domination and surrender. The emperor, seated on
high, is placed not to the left or right but directly on the
painting's central vertical axis. His exalted position is
augmented by the roughly symmetrical arrangement
of the courtiers standing beside and below him; it is
further reinforced by a series of diagonal movements
(rows of courtiers near the emperor, throne canopy,
floor of the pillared pavilion in the background, etc.)
which, rising up and back through the composition,
culminate in the central vertical axis.

The immaculately rendered figures in Abid's picture
(some of whom can be identified) as well as those in
other *Padshah-nama* paintings such as the attendants in
the left half of a double-page composition [Fig. 12][9]
have varied faces and clothing; but the nearly identical
size, weight, and appearance of their bodies, as well as
the dense crowding, transform them into groups of
interchangeable human "things." Their role in these
pictures is to act as a tightly contained chorus of
supplicating "types" shown in ever-swelling numbers
rather than as assemblies of distinct individuals. The
unnatural, suffocating density of the crowds in both
paintings is heightened by large, relatively empty spaces
near them.

of Shah Jahan's life and court were also elevated by
imperial artists into visions of almost cosmic splendor.
Most of the historical pictures that survive, with a few
exceptions such as *The Meeting of Shah Abbas and Khan
Alam* [Fig. 85], illustrate mid-seventeenth-century
imperial copies of the *Padshah-nama*, one of the court
histories of Shah Jahan written by Abdul Hamid
Lahori. Whereas Jahangir himself wrote a very personal
account of his reign, Shah Jahan hired others to glorify
him.[8] Of the *Padshah-nama* illustrations that survive,
forty-four, covering the first ten years of Shah Jahan's
reign, are preserved at Windsor Castle and relate most
closely to Lahori's text. Several paintings, dispersed in

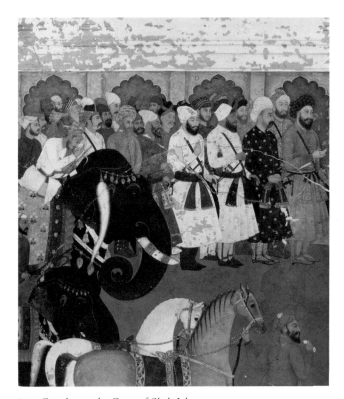

86 *Grandees at the Court of Shah Jahan*
From a manuscript of the *Padshah-nama*
Mogul, c. 1640
Opaque watercolor on paper
9 11/16 × 6 7/8 in. (24.7 × 17.5 cm.)
Museum Rietberg, Zurich, Acquisition Funded by the Volkart
Foundation, Winterthur

One is struck by the stunning sumptuousness of Abid's picture, a quality that it shares with other *Padshah-nama* paintings such as *Grandees at the Court of Shah Jahan* [Fig. 86], the left half of a double-page illustration. Rich coloring, variously patterned fabrics, and the liberal use of gold are combined in both pictures to create an atmosphere of radiant, heavenly splendour. Of great delight to the painters is copious decorative detail—the flowers in a sash, the arabesques and pearls on a canopy, the glowing jewels of rings and bracelets. Here, the heightened visual precision already used by Jahangiri artists to describe the physical world has been exaggerated even more to create a sense of unearthly reality: were one actually to attend the events represented in these paintings, such details would not be clearly visible from the distant vantage point taken by the artists.

The various means by which Abid idealizes his subject are also employed in many other *Padshah-nama*

paintings. Most of these works are, no doubt, historically accurate, but they are "adjusted" in so many small ways (figural groupings, composition, and so forth) that even the most intense, violent scenes assume an air of staged formality. In Balchand's *Prince Khurram Attacking a Lion that Had Thrown Down Anup Singh*, the radiantly haloed emperor-to-be lifts his sword with stately dignity to kill the beast that had been attacking one of Jahangir's officers.[10] Two other companions also participate in the attack: one bends over to tap the lion's head ever so politely with an elegant stick; the other slices the animal's rear haunches with his sword, an act that he performs with all the conviction of someone carving a Christmas goose. A nimbed Jahangir and an attendant, their weapons lowered, quietly stand a few feet away from the scene, apparently unmoved: their rather unnatural calm, one that almost suggests ineffectuality, serves to heighten and glorify Khurram's heroic deed.

PORTRAITS OF THE ROYAL PRINCES AND DEPICTIONS OF THEIR LIVES

Compared to depictions of Shah Jahan and his predecessors, extant paintings with the royal princes—Dara Shikoh, Shah Shuja, Aurangzeb, and Murad Bakhsh—as their subjects tend to be somewhat less bombastic, though by no means candid. Most surviving portraits, whether full-length, half-length, or cameo, do, of course, show them in an accurate but rather idealized manner: they are dressed in sumptuous clothes with eyes staring straight ahead and little revealed about their personality. Their heads, however, are not nimbed and, on the whole, they seem less "glorified" than their father. The only notable exceptions to this general rule are some portraits of Dara Shikoh, which, accepting his proclaimed position as Shah Jahan's heir apparent, depict him with a halo around his head.[11] One of these works, a grand epiphany by Chitarman now in the Pierpont Morgan Library in New York, shows the nimbed crown prince elevated beyond time and space by a radiant aureole that encircles his body.

Like the portraits, many of the paintings depicting moments in the lives of Shah Jahan's sons are rather reserved and artificial. Although a few atypical works, such as the *Battle of Samugarh* [Fig. 87], which records Dara Shikoh's defeat in the war of succession (1658), possess an air of compelling immediacy, almost all the

87 *The Battle of Samugarh*
Mogul, c. 1658
Black line with ink, and opaque watercolor
on paper
$8\frac{15}{16} \times 12\frac{7}{8}$ in. (22.6 × 32.7 cm.) (sight)
Arthur M. Sackler Museum, Harvard
University, Cambridge, Mass., Anonymous
Loan

88 *A Reclining Prince*
Mogul, c. 1635
Opaque watercolor and gold on paper
$7\frac{3}{4} \times 9\frac{3}{4}$ in. (19.7 × 24.8 cm.)
The Nelson-Atkins Museum of Art, Kansas City, Mo., Nelson
Fund (NAMA 31–131/6)

89 Payag (attr.), *Shah Shuja Hunting*
Mogul, c. 1650
Opaque watercolor on paper
$6\frac{5}{8} \times 10\frac{1}{4}$ in. (16.8 × 26 cm.)
Museum of Art, Rhode Island School of
Design, Museum Works of Art Fund (58.068)

pictures that document the public careers of the princes, especially those in the *Padshah-nama*, are flattering, formal, and somewhat idealized.

Equally opaque are paintings that depict the private lives of the princes: they reveal very little that is truly personal. Following age-old conventions for representing Muslim rulers, the sons of Shah Jahan are most often shown as princely "types" engaged in clear-cut but generalized royal activities such as hunting, riding horses and elephants, entertaining beautiful women, or visiting holy men and teachers for advice and education, rather than as real people participating in specific historical situations. These pseudo-biographical paintings differ little in thematic range and content from earlier Mogul pictures representing the private activities of Jahangir's sons or from Jahangiri and Shah Jahani depictions of moments in the lives of idealized (or, at least, unidentified) princes. Payag's *Shah Shuja Hunting* [Fig. 89], for example, is a conventional princely image set in a verdant jungle paradise shimmering with gilded light. Balchand's painting of the same prince with his wife [Fig. 31] is essentially a restrained version of another standard theme, that of romance on the terrace, seen in earlier Mogul and Shah Jahani pictures of ideal or unidentified royal lovers. Likewise, the paintings of Dara Shikoh sitting with holy men [Fig. 93] are very similar in theme to many showing the encounters of sages or teachers and princes, both known and idealized, painted by Shah Jahani artists and their predecessors.

To be sure, some of these "intimate" scenes may seem generalized today because, without inscriptions or an accompanying historical text, the figures in them, other than the princes, cannot always be identified. Still, their impersonality, lack of visual specificity, adherence to rigidly established representational categories, and resemblance to depictions of other Mogul royalty suggest that these works were primarily painted not to depict specific historical events, but rather to establish the facts that like all good princes, the sons of Shah Jahan were potent lovers, humble seekers of truth, and so on. The only themes used in Mogul depictions of princes that were not widely employed to represent the personal lives of the emperor's actual male progeny are those that suggest effete indolence or extreme inebriation: paintings of the royal princes ripe with the self-indulgent languor of *A Reclining Prince* [Fig. 88], or the frank intoxication of *Prince and Courtiers at Camp* [Fig. 94][12]—both imaginary scenes—are not common.

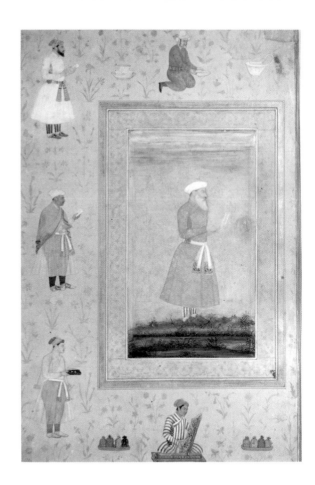

PORTRAITS OF COURTIERS, WOMEN, AND EXOTICS

The desire to present people as perfected types, often defined in terms of their status or rank, not only affected depictions of the members of the imperial house but also extended to Shah Jahani portraits of courtiers, women, and various individuals that the Moguls found amusing, unusual, or exotic. This preference is apparent, for example, in the many likenesses of nobles and retainers that fill Shah Jahan's splendid *muraqqas*. Some of these works, which show effete noblemen reading or gazing into the distance, are simply portraits of ideal courtiers; others, however, are perfected likenesses of known individuals. Mir Hashim's portrait of Khwajah Abul Hasan, an important Mogul official, is typical of the latter [Fig. 91]. This painting follows conventions established during the Akbar period, in that it shows the subject full-length with his body in three-quarter view and his head and feet in profile, standing against a flat background. Earlier Mogul portraits, however, presented an unvarnished description of the subject's physical characteristics. In this Shah Jahani likeness and

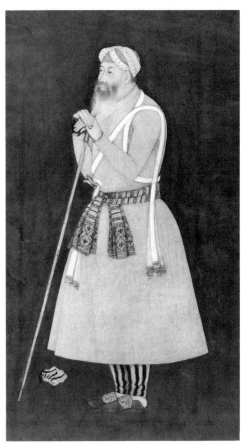

90 *Portrait of the Lord Steward Ala al-Mulk Tuni*
Page from the Late Shah Jahan Album
Mogul, c. 1650
Opaque watercolor and gold on paper
$15\frac{1}{4} \times 10\frac{1}{2}$ in. (38.8 × 26.7 cm.)
The Ehrenfeld Collection

91 Mir Hashim, *Portrait of Khwajah Abul Hasan*
Mogul, c. 1625–30
Opaque watercolor on paper
$13\frac{1}{8} \times 8\frac{3}{4}$ in. (33.2 × 22.3 cm.)
Musée National des Arts Asiatiques—Guimet,
Paris (MA 7163)

92 Mir Hashim (attr.), *Mirza Rustam*
Mogul, c. 1635
Opaque watercolor on paper
$6\frac{9}{16} \times 3\frac{3}{4}$ in. (16.7 × 9.6 cm.)
Los Angeles County Museum of Art, From the
Nasli and Alice Heeramaneck Collection,
Museum Associates Purchase (M.78.9.14)

in many others, the primary aim is to suggest that the subject is a person of sufficient wealth and importance to be included in the court and album of the "Ruler of the World." Thus, while Khwajah Abul Hasan's face is probably recorded with some fidelity, it is the contour of his robe, the intricate designs on his costly sash, and his boldly striped pants that really fascinate the artist and capture our attention. Much the same may be said about a portrait of Mirza Rustam [Fig. 92], probably also painted by Hashim, in which precisely rendered costume details and dramatic juxtapositions of color are equal to, if not more important than, character delineation.

The predilection for idealizing a subject rather than analyzing his inner nature is also evident in such portraits from the "Late Shah Jahan Album" as that of Ala al-Mulk Tuni, the Lord Steward in charge of the stores of the imperial house [Fig. 90]. Shown holding an inventory list, he stands on a beautiful sward beneath prettily streaked clouds at the center of the page. The surrounding borders, like others from the album, are filled with figures related to the main subject—in this

case, members of the steward's staff who count and record imperial jewels, porcelains, and fabrics. The presence of this busy clerical retinue tells us most emphatically that the steward is a proud, important, and responsible official. It is not so much his personality that is assessed in this album page: rather, he is portrayed and glorified in terms of status, rank, and social responsibility.

While Shah Jahani artists produced portraits of both imaginary and real courtiers, their likenesses of female subjects were almost totally confined to the pleasurable realm of fantasy. Women exercised considerable power in Shah Jahan's court, but did not hold official public positions: instead, female members of the royal family remained hidden away in their own quarters, like rare treasures meant only for their owner's eyes. These conditions, of course, encouraged ideal portraiture and, true to form, Shah Jahani artists produced such likenesses according to their own aesthetic norms. *Standing Female*, illustrated here, is typical of these works [Fig. 95]. Like all the women depicted in these arousing portraits, the subject is neither old nor

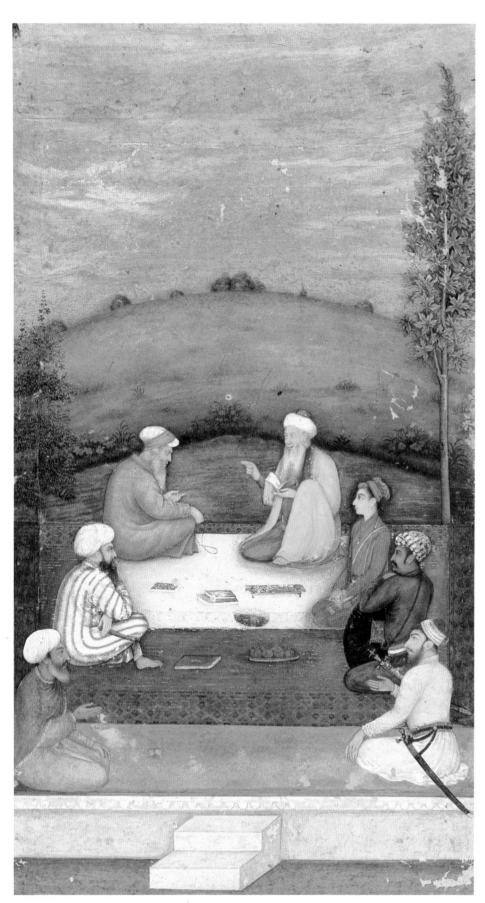

93　*Dara Shikoh with Sages*
Mogul, c. 1630
Opaque watercolor on paper
8 × 3⅞ in. (20.3 × 9.8 cm.)
Arthur M. Sackler Museum, Harvard
University, Cambridge, Mass., Gift of Mr. Eric
Schroeder, in honor of John Coolidge (1968.47)

94　*Prince and Courtiers at Camp*
Mogul, c. 1650
Opaque watercolor on paper
8 × 12 in. (20.3 × 30.5 cm.)
Terence McInerney, New York

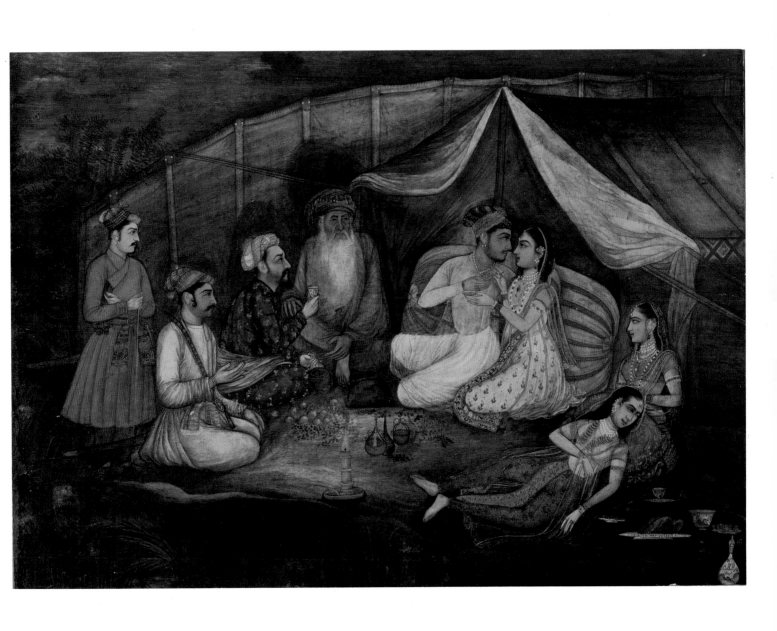

distinguished, but young, beautiful, and as fresh as a spring day. The painter dwells lovingly upon pretty details: sumptuous textiles, diaphanous robes, and delicate flowers, a universal symbol of feminine sensitivity. Not surprisingly, the woman's fragile face is almost identical to those of other images of women produced during the Shah Jahan period and later. One of these is said to depict Mumtaz Mahal [Fig. 28]. (On the depiction of women, see also pp. 40 and 226.)

Not all Shah Jahani portraits were as formal as those of courtiers or idealized women. Occasionally in the emperor's albums exotic or unusual individuals belonging to the lower social orders were represented with considerable liveliness, though not without a degree of exaggeration. One such depiction, a lightly colored drawing of a *Negro Musician* [Fig. 96], conveys the great charm that these pictures of exotic types can have. Playing a stringed instrument and dancing as he sings, this man no doubt amused the artist and the patron. Despite the foppish turban and slight feeling of caricature, the man's poignant face and eyes are rendered with sympathy.

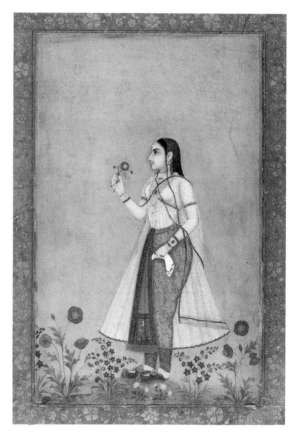

STUDIES OF HOLY MEN AND SAGES

Portraits and historical scenes, many of which featured the emperor and served his political needs, stand, of course, as some of the most interesting subjects painted during the Shah Jahan period. They were not, however, the only themes depicted by the royal atelier. Surviving works indicate that most Jahangiri non-official subjects, such as flora and fauna and religious figures, were also continued and reinterpreted by Shah Jahani artists. Amongst these established themes, one particularly fascinated the worldly Moguls—Indian holy men and their activities. Virtually every emperor, including Shah Jahan, visited with Muslim and, sometimes, Hindu divines on auspicious occasions (Fridays, lunar and solar birthdays, after hunts or illnesses, etc.) to honor them, to seek their advice or to make use of their supernatural powers. The exact nature and extent of Shah Jahan's involvement with these holy men are not known, but inscriptions on paintings describe him as a "friend of dervishes." Moreover, he permitted his favorite son, Dara Shikoh, and his beloved daughter, Jahanara, to study with Sufi divines and to pursue their interests in Islamic mysticism.

The attractions that mystics, dervishes, hermits, and other divines held for Shah Jahan's predecessors are reflected in many early Mogul paintings. These include portraits of holy men; scenes of them conversing or receiving princely visitors in a hermitage or walking in a landscape; and representations of rapturous Sufi dancing. In most Akbari and Jahangiri paintings, these odd, colorful creatures are shown in ways that emphasize their intense spirituality, and, oftentimes, their asceticism and poverty. In Shah Jahani pictures, on the other hand, something quite different and very predictable happens. Rather than focusing upon the bizarre physical characteristics or spiritual depths of these otherworldly men, Shah Jahani artists idealize them into charming, highly picturesque characters.[13] They are often shown as well-bred and prosperous gentlemen, who, dressed in flowing robes, discuss religious topics with stately dignity [Fig. 117]; at other times they are depicted as delightful fops, garbed in rakish attire, or as rather elegant, slightly amusing, fellows performing their ascetic exercises with the finesse of professional acrobats [Fig. 110]. Now tamed and often immaculately clean, these divines would be equally at home in a quaint hermitage or in one of the emperor's sumptuous

95　*Standing Female*
Mogul, c. 1640
Opaque watercolor on paper
$6\frac{9}{16} \times 4\frac{1}{8}$ in. (16.7 × 10.5 cm.)
Virginia Museum of Fine Arts, Richmond, The
Nasli and Alice Heeramaneck Collection, Gift of
Paul Mellon (68.8.126)

96　*A Negro Musician*
Mogul, c. 1650–75
Opaque watercolor on paper
$8 \times 4\frac{3}{4}$ in. (20.2 × 12 cm.)
National Gallery of Victoria, Melbourne,
Australia, Felton Bequest 1980

This painting reflects the international character
of Mogul India; Abyssinian slaves were common
in the seventeenth century.

97　*A Gathering of Mystics*
Mogul, c. 1650–55
Opaque watercolor on paper
$16\frac{1}{4} \times 11\frac{1}{8}$ in. (41.5 × 28.4 cm.)
Trustees of the Victoria and Albert Museum,
London (is 94–1965)

palaces. Indeed, they almost seem to be courtiers in religious fancy-dress.

Several exceptions to this general rule do, however, exist. The artist Govardhan's Shah Jahan-period studies of ascetics and holy men [Figs. 117, 118], which will be discussed later in this chapter, do, indeed, show idealized types, but they possess an intellectual depth that distinguishes them from more superficial contemporaneous depictions of the same subject. Occasionally, too, the content of an exceptional picture such as *A Gathering of Mystics* [Fig. 97], painted by an unknown artist, deviates from the norm. This fascinating work depicts Sufi saints and Mogul courtiers in the shrine of Muin-ud-din Chishti at Ajmer, viewing a *sama*—a ritual undertaken by dervishes who attempt to attain mystical states and achieve *wajid* (finding God) by ecstatic dancing, music, and chants. Amongst the onlookers are three Muslim saints—Qutb-ud-din Bakhtiyar Kaki (d. 1235), Muin-ud-din Chishti (d. 1235), and Mulla Shah Badakhshi (d. 1661)—whose presence at this imaginary assembly stresses the spiritual lineage linking the Sufis to Muhammad and thence to God. Outside the blind-arched enclosure wall at the bottom of the picture sits a remarkable group of twelve unorthodox Hindu divines, members of various eclectic groups that rejected the orthodox Brahmanical religion.

Taken as a whole, this painting, as has been demonstrated by Elinor Gadon,[14] depicts three levels of religious experience: the saints (heads of the Sufi orders) who symbolize the unbroken chain connecting one master to another back to Muhammad himself; the dervishes, who through their ecstatic dancing and chanting seek to find God; and the Hindu holy men who have, in their own individualistic ways, realized divine truth. The Hindu-Muslim synthesis implied here resembles the efforts of Crown Prince Dara Shikoh, who was deeply involved in Islamic mysticism (see above, pp. 36–37). This painting and some of Govardhan's works are so profound that they might have been commissioned by the sensitive and scholarly Dara Shikoh rather than the emperor (below, pp. 120–24).

STUDIES OF FLORA AND FAUNA

Idealized physical reality, rich color, and sumptuous decoration were used by Shah Jahani artists not only to reinterpret such unlikely non-official subjects as

98 *Exotic Flowers and Insects*
Page from the Dara Shikoh Album
Mogul, c. 1635; attributed to Artist A
Opaque watercolor on paper
6⅞ × 3⅞ in. (17.5 × 9.8 cm.)—actual size
The British Library (India Office Library
and Records), London (Ms. Add.
Or. 3129, fol. 49v)

99 *Tulips and an Iris*
Mogul, c. 1650; attributed to the Master
of the Borders
Opaque watercolor on paper
10⅜ × 6⅜ in. (26.4 × 16.1 cm.)
Collection Prince Sadruddin Aga Khan

dervishes and sages, but also to transform depictions of birds, animals, and especially flowers, the Moguls' favorite form of nature. Individual portrait-like studies of flowers were first painted for Jahangir, who relished the beauties of nature and admired European botanical etchings and engravings. Influenced by these Western prints and relying on his own acute powers of observation, Jahangir's artist, Mansur, produced brilliant studies of tulips, narcissus, and other blossoms isolated against a plain ground and, sometimes, accompanied by a butterfly or a dragonfly. These sensitive paintings recorded the outward appearance of each flower with scientific exactitude, and also captured the essence or animating life force that lay within it.

Like his father, Shah Jahan apparently loved flowers, for it was during his reign that they began to be widely used as the Mogul ornamental motif *par excellence* [Fig. 100] in textiles, architecture, and decorative arts. The most widely known flower studies of the Shah Jahan period are contained in a splendid *muraqqa* now in the India Office Library, London, known as the "Dara Shikoh Album"; they were probably painted by artists from the imperial studio. One of these works, *Exotic Flowers and Insects* of c. 1635 [Fig. 98], fully reveals the decorative transformation of the Mogul flower study during Shah Jahan's reign. The painting's general format is based upon Jahangir's flower pictures—a clump of flowers isolated on a plain ground—but everything else is much different. In place of the gently turning, delicately colored foliage and blossoms of Jahangiri flowers, we now see a highly stylized, brightly colored plant that is gripped by an exaggerated intensity. Its force rises up the stalks through the flattened, spiky foliage and out to the petals like the jet of a fountain. Bursting with energy, the leaves and blossoms are rendered in sharply contrasting hues that glow like the hardstone inlays of the Taj Mahal [Fig. 134]. Stylized clouds, ultimately of Chinese origin, push through the sky above; their focused aggressiveness is equaled by the dragonflies that attack the plant from all sides. In this picture, the keenly observed naturalism of Jahangiri painting has been swept aside by a decorative force so powerfully realized that the plant almost seems to reach beyond itself. Richly colored and highly patterned, these robust, flamboyant flowers are as suited to the tastes of Shah Jahan's time as the fresh, scientifically explored blossoms were to the preferences of Jahangir's age.

100 *Flower Studies*
Mogul, c. 1650
Ink on paper
$8\frac{1}{16} \times 11$ in. (20.5 × 27.9 cm.)
Howard Hodgkin, London

Not all Shah Jahani flower studies are as forceful as this, but most of them are rendered with a sense of decorative exaggeration. The flowers in *Tulips and an Iris* [Fig. 99] painted in the mid-seventeenth century by an anonymous artist known as the "Master of the Borders," for example, are so stylized that, as S. C. Welch and several other critics have noted, they seem to possess human characteristics—a regal tulip, demure iris, and a slightly embarrassed *tulipa montana*.[15] The rich colors of the blossoms, stalks, and foliage are more potent than they would be in real life; the deep modeling makes them jump off the page. Like *Exotic Flowers and Insects*, this highly poised painting is the work of an artist who is not satisfied with the physical reality of God's handiwork; rather, he seeks through carefully calculated exaggerations to transport the subject to a different realm. These unblemished, gem-colored flowers grow in paradise, not on earth.

Representations of animals and birds were similarly idealized by Shah Jahani painters, but usually in somewhat more subtle ways. *A Nilgai* [Fig. 102] painted about 1635–40, for example, differs markedly from a study of the same subject executed for Jahangir by the artist Mansur in about 1620. Standing against a sandy pink ground, Mansur's noble blue bull is caught unaware in a fleeting moment; its body is lovingly rendered. It has been suggested that the picture is a study of a particular animal because its left horn, unlike the

101　*A Night Heron*
Page from the Dara Shikoh Album
Mogul, c. 1635
Opaque watercolor on paper
6½ × 4 in. (16.5 × 10.2 cm.)
The British Library (India Office Library and Records), London
(Ms. Add. Or. 3129, fol. 9v)

one on the right, is broken off at the tip.[16] Although based upon such Jahangiri prototypes, the Shah Jahani nilgai is treated in both a more forceful and a more decorative manner: the markings on his legs and ears, which were so delicately shaded in Mansur's painting, have become boldly ornamental patches and stripes; the soft fur is now a patterned mass of compulsively detailed hairs; and the outline surrounding the body is thicker and more pronounced. Rather than sympathetically depicting an individual creature at a specific moment, the Shah Jahani picture presents a grand, somewhat self-conscious animal, standing frozen in time, that casts a knowing sidelong glance at the viewer. The same calculated formality is repeated in many other animal and bird studies of the period [Figs. 103, 104].

As one might expect, the intrusion of decorative values also affected the settings in which the birds and animals were placed. Most Jahangiri zoological studies included an indication of habitat that did not interfere with the impact of the picture's accurately observed main subject. In many Shah Jahani nature studies, however, these landscape and botanical elements, rendered with great decorative vigor, begin to assert themselves. In *A Night Heron* [Fig. 101], a striking painting from the Dara Shikoh Album, the long-legged bird stands in a stream near a pink lily. This typically Shah Jahani flower is so large, vibrantly colored, and perfectly symmetrical that it competes with the heron for our attention. In such paintings, one senses that the overall decorative effect of the work is as important as an accurate depiction of a bird or animal.

Stylized flora and fauna were also incorporated into rich decorative borders that framed the paintings and calligraphies of Shah Jahan's albums [e.g. Figs. 25, 26, 101, 105, 109]. Some of these borders contain gold-edged flowering plants formally arranged in rows and occasionally placed within trellis-like geometric shapes; others accommodate elaborately composed floral scrolls and abstract arabesques; and still others are filled with hybrid combinations of flowering plants, floral scrolls, and arabesques. Clouds, animals, birds, insects, and, later, human figures were frequently added. As refreshing as the gardens of paradise, these exquisite borders, with their fine gold lines, are so subtly executed that one must turn them in the light, as one would a jewel, to appreciate fully their shimmering effects. Their geometric and floral designs are also seen, in whole or in part, in Shah Jahani architectural ornament, decorative arts, and textiles, especially carpets.

PERSIAN SUBJECTS AND LITERATURE

Not all of the themes inherited from Jahangir were as enthusiastically received by Shah Jahan as those that have just been discussed. Subjects dealing with the past and present realities of India were retained and reinterpreted; but depictions of Persian and European subjects seem to have met a different fate. Although these two foreign cultures had made significant contributions to the sophisticated synthesis that was Mogul India, paintings representing their exotic tales and pictorial

102 *A Nilgai*
Mogul, c. 1635–40
Opaque watercolor on paper
$7\frac{7}{8} \times 10\frac{11}{16}$ in. (20 × 27.1 cm.)
Mr. and Mrs. John Gilmore Ford

103 *Pair of Wild Fowls*
Mogul, c. 1645
Opaque watercolor on paper
$7\frac{5}{16} \times 4\frac{13}{16}$ in. (18.6 × 12.3 cm.)
Navin Kumar, New York

104 *Black Buck*
Mogul, c. 1650
Opaque watercolor and gold on paper
$8 \times 5\frac{7}{8}$ in. (20.3 × 14.9 cm.)
Jane Greenough

105 Mir Ali, *Calligraphy* (two couplets from a poem)
Page from the Late Shah Jahan Album
Mogul, c. 1640–50
Opaque watercolor and gold on paper
$14\frac{1}{2}$ × 10 in. (37.1 × 25.3 cm.)
Arthur M. Sackler Gallery, Smithsonian Institution, Washington, D.C., Purchase made possible by Smithsonian Unrestricted Funds, the Regents' Acquisition Fund, and Arthur M. Sackler (s86.0091)

106 *A Rich Man Views the Corpse of His Enemy*
Page from a manuscript of the *Bustan*
Mogul, 1629–30
Opaque watercolor on paper
15 × $10\frac{1}{16}$ in. (38 × 25.5 cm.)
The British Library, London (Ms. Add. 27262, fol. 162v)

107 Muhammad Khan (inscr.), *A Prince in Persian Costume*
Page from the Dara Shikoh Album
Mogul, dated 1633/34
Opaque watercolor on paper
$6\frac{13}{16}$ × $4\frac{1}{16}$ in. (17.4 × 10.3 cm.)
The British Library (India Office Library and Records), London (Ms. Add. Or. 3129, fol. 21v)

themes declined in popularity during the reign of Shah Jahan for a variety of reasons.

Many Mogul images with Persian subjects were not independent pictures, but rather illustrations to poetic, historical, and philosophical Persian texts. These works were especially popular during the early decades· of Mogul rule when artists from Iran supervised the royal atelier. The demand for illuminated copies of Persian texts, however, began to diminish under Jahangir and Shah Jahan, both of whom preferred luxurious albums of independent paintings and calligraphies. Illustrated Persian classics, to be sure, were produced, but they were fewer in number and not always very successful. Two examples are provided by copies of the *Bustan* (The Flower Garden) and *Gulistan* (The Rose Garden), both famous collections of moral tales written by the Persian poet Muslih-ud-din Sadi (c. 1189–1291), which

were prepared for Shah Jahan in 1629–30, just after he ascended the throne. The volumes were produced in the same format and both contain large calligraphy as well as horizontal illustrations that run across the page, a convention found in a *Gulistan* painted for Jahangir of 1605–10 and in Persian manuscripts of the fourteenth and fifteenth centuries. Somewhat dwarfed by the text's size, the illustrations are rendered in the sumptuous, idealizing manner of the period [Fig. 106]; but, as Jeremiah Losty has noted, the rich pigments and rather static, formal style give the compositions a kind of unnatural stiffness.[17] Aside from these two works, few, if any, large, lavish manuscripts illustrating Persian subjects are known to have been produced by the imperial atelier. Standard Persian texts such as the *Shahnama* (The Book of Kings), the Persian epic poem on the ancient kings of Iran by Firdausi, were illustrated for

Mogul patrons other than the emperor [Fig. 113].

Persian themes, particularly those suited to the album format, were not altogether abandoned during Shah Jahan's reign. Some pictures of idealized youths in exotic garb, pouring wine, holding a cup, and so on, based ultimately upon Safavid prototypes, are included, for example, in the Dara Shikoh Album [Fig. 107]. Moreover, at least one literary subject, "Majnun in the Wilderness," an episode from the romance of Layla and Majnun, seems to have acquired a kind of independence from, or perhaps came to stand for, an entire story; as such, it was a suitable image for independent album paintings. Depictions of the emaciated hero in a barren landscape accompanied by animals who, forgetting their natural instincts, assemble to serve him may have been popular for reasons other than the poignancy of the subject: the image of a man attended by peaceable animals possibly suggested the tranquil rule of a just king, a theme close to Shah Jahan's heart.[18]

While the emperor's atelier seems to have produced few illuminated Persian texts, his artists occasionally re-explored Persian subjects when they retouched earlier manuscripts to "improve" the quality of illustrations or to restore them. A particularly beautiful example of the latter is a *Gulistan* from the imperial library that was originally copied in the city of Herat in Iran in 1468 and illuminated with Timurid paintings. Six of Shah Jahan's finest artists, Govardhan, Abid, Payag, Balchand, Lal Chand, and Murad, were commissioned to paint over the presumably damaged Timurid miniatures. Each master did one illustration and signed it [Figs. 114, 115].[19]

EUROPEAN SUBJECTS AND EUROPEAN INFLUENCE

Like Persian subjects, European themes [Fig. 108] also declined in favor during the reign of Shah Jahan, perhaps for different reasons. The sources of these Western subjects were etchings, engravings, and illustrated printed books from Germany, Flanders, Holland, France, and Italy as well as English miniatures and Continental paintings. Supplied by foreign envoys, Christian missionaries, and representatives of European trading colonies on India's coasts, these exotic works intrigued Akbar and Jahangir. Some Mogul artists made full copies of them; others extracted a single Western motif to incorporate into their Indian scenes. Occasionally, quotations from several different

108 *The Entombment of Christ*
Mogul, after 1610
Opaque watercolor on paper
$6\frac{9}{16} \times 3\frac{7}{8}$ in. (16.6 × 9.8 cm.)
Navin Kumar, New York

This picture closely resembles another depiction of the subject now in the collection of the Free Library, Philadelphia. (See Beach, 1978, p. 157, fig. 55.)

Western sources were combined in a partially Mogul composition to create pastiche paintings. These hybrid works, the Indian equivalent of Chinoiserie, artfully balanced the comfortably familiar with the exotically foreign. They were charming, but not so bizarre as to be threatening.[20]

That both copies and pastiche pictures fell out of favor during the late Jahangir and Shah Jahan periods can probably be attributed, at least in part, to a growing familiarity with European images, which continued to enter the Mogul empire in quantity, and were surely less strange and exciting by the mid-seventeenth

109 Mir Ali al-Sultani, *Calligraphy* (a poem
by Amir Shali)
Page from the Late Shah Jahan Album
Mogul, calligraphy c. 1500–1600, borders
c. 1640–50
Opaque watercolor and gold on paper
$18\frac{1}{2} \times 13\frac{3}{4}$ in. (47 × 35 cm.)
Arthur M. Sackler Gallery, Smithsonian
Institution, Washington, D.C., Purchase made
possible by Smithsonian Unrestricted Funds, the
Regents' Acquisition Fund, and Arthur M.
Sackler (s86.0090)

110 *Ascetics*
Mogul, c. 1645
Opaque watercolor on paper
$7 \times 4\frac{5}{8}$ in. (17.8 × 11.8 cm.)
Linden Museum, Stuttgart (SA37426L)

century. Mogul painters, already quite familiar with Western illusionism, did not need to copy whole prints in order to comprehend the foreign aesthetic principles upon which they were based; and increasingly cosmopolitan Mogul patrons no longer responded to the exotic titillation of the faddish pastiche picture.

As the need for slavish imitation and stylish recreations declined, a fuller and more assured assimilation of Western pictorial attitudes appeared. Visual quotations from European sources abound in Shah Jahani painting: the putti in *Shah Jahan, Master of the Globe* [Fig. 84], the muscular male figure in the left foreground of *The Astrologer* [Fig. 116], the architecture and bearded ecstatic lying on the ground in *A Gathering of Mystics* [Fig. 97], and the vistas filled with Netherlandish cottages in *Four Mullas* [Fig. 117] are but a few examples. Such European passages, of course, were common in earlier Mogul painting but now they are integrated into the framework of the court style with much greater ease and sophistication.

Shah Jahani artists also used Western techniques to enhance the impact of their work. Western *chiaroscuro* or representation in terms of light and shade, for example, was explored by such Shah Jahani artists as Payag. European *trompe l'oeil* effects, in which objects are shown with almost photographically realistic detail, were adopted by Bichitr and others to depict reflections on glass vessels and the glimmering highlights of jewels. The Western practice of placing a human figure, shown from the rear or three-quarter view, in the foreground to create a sense of space and to draw the viewer into the picture, was frequently employed by Govardhan [Fig. 116]. Although full linear perspective was not adopted, Shah Jahani painters used European-inspired panoramic views and low, sweeping vistas to garb their paradisiac visions with a smoother, more convincing sense of spatial recession.

THE ARTISTS OF SHAH JAHAN

By this point, the manner in which Shah Jahan and his artists transformed the aims, content, and flavor of Mogul painting should be quite clear. In their hands the established techniques of Jahangiri naturalism were elaborated into an instrument of heightened, rather mannered pseudo-realism and used to express a new paradisiacal creative vision. A passion for idealized reality and attractive surfaces, rendered with excessive,

almost fanatical precision, are common features of the period. Standardized themes that had been approached by Jahangiri artists from an intimate, humanistic point of view were reinterpreted in terms of an abstract, perfect ideal: the content and conventions of some subjects, such as the imperial portraits and court scenes, allowed almost every component of the grandiose Shah Jahani aesthetic to come into full play; other subjects, for example studies of flora and fauna, permitted the new idealism to express itself in terms of decorative stylization. Responding to the tastes of their patron, Shah Jahan's artists almost always created bold visual statements. Their paintings, like the theatrical court ceremonies of the emperor, are not so much private reveries as they are formal, staged public presentations.

Virtually all of Shah Jahan's painters worked within the general framework of this remarkable, new creative vision. Financial rewards and competition for approval doubtlessly solidified the hold of the emperor's artistic preferences over his atelier. At the same time, it must be remembered that these men possessed different abilities, interests, and backgrounds. Although they were sensitive to Shah Jahan's needs and worked within an increasingly rigid set of stylistic and thematic conventions, each one of them came to terms with his patron's artistic preferences in his own way.[21]

Few of Shah Jahan's painters, for example, fit in more comfortably with the atelier's new aesthetic than Bichitr. His earliest known works, painted during Jahangir's reign, are a series of portraits, the most famous being *Jahangir Preferring a Sufi Shaikh to Kings* now in the Freer Gallery of Art in Washington, D.C. Although full of youthful warmth and vitality, these paintings already reveal his later passion for decorative patterns and crisply rendered detail. Bichitr was still capable in the late 1620s of producing works such as *Dara Shikoh Riding an Albino Elephant* [Fig. 123] that combined meticulous surface decoration and soft color washes; but by the middle of Shah Jahan's reign (late 1630s) his style had hardened and was given over to sumptuousness, decorative pattern, and meticulous detail. In *Shah Shuja and Gaj Singh of Marwar* [Fig. 26], dating from c. 1638, the saturated colors of the textiles and shimmering gold of the relief-decorated throne are so compelling that they compete with the sharply edged, heavily modeled human figures. Perhaps more than any of his contemporaries, Bichitr was fascinated with the materiality and surface appearance of things.

111 Bichitr (attr.), *Episode in a Bazaar*
Mogul, c. 1650–60
Opaque watercolor on paper
$7\frac{5}{8} \times 5\frac{5}{16}$ in. (19.4 × 13.6 cm.)
Arthur M. Sackler Museum, Harvard University, Cambridge,
Mass., Anonymous Loan

112 Mir Hashim (inscr.), *An Abyssinian (Fath Khan?)*
Mogul, c. 1633
Opaque watercolor on paper
$5\frac{15}{16} \times 3\frac{3}{16}$ in. (15 × 8.1 cm.)
Arthur M. Sackler Museum, Harvard University, Cambridge,
Mass., Anonymous Loan

No doubt the *trompe l'oeil* effects for which he was so well known would have been completed in his meticulous, but unfinished *Episode in a Bazaar* [Fig. 111].

As concrete as Bichitr, but more austere, Mir Hashim, another painter who worked for both Jahangir and Shah Jahan, was originally from the Deccan. He is best known for his portraits, many of which brilliantly combine cool, sometimes forceful, characterizations with lucidly rendered decorative detail [see Figs. 84, 91, 92]. *An Abyssinian* [Fig. 112], painted in the early 1630s, is one of numerous pictures depicting Deccani themes

that Hashim painted for the Moguls. The subject, possibly Fath Khan, son of Ahmadnagar's great slave-general Malik Ambar, is delineated with stark objectivity. Each pattern in his sash and jewel in his girdle is exactly noted. Hard and sparkling, these elements are set against the man's subtly modeled, diaphanous robes and the sharply outlined, rounded contours of his body. While serving Shah Jahan and, later, Aurangzeb, Hashim further refined his style and sometimes painted double portraits as well as complex group compositions.

113 *Rustam Slays the White Dragon*
Page from a manuscript of the *Shah-nama*
Mogul, c. 1650
Opaque watercolor on paper
13$\frac{9}{16}$ × 10$\frac{7}{16}$ in. (34.5 × 26.5 cm.)
Museum Rietberg, Zurich

114 Balchand, *A Prince While Riding Comes
Upon a Man Resting Under a Tree*
Page from a manuscript of the *Gulistan*
Mogul, c. 1645 (painting)
Opaque watercolor, ink, and gold on paper
4$\frac{1}{8}$ × 2$\frac{3}{4}$ in. (10.5 × 6.7 cm.)
A. Soudavar Collection

115 Murad, *A Warrior Frightened by Tribesmen*
Page from a manuscript of the *Gulistan*
Mogul, c. 1645 (painting)
Opaque watercolor, ink, and gold on paper
3$\frac{3}{4}$ × 2$\frac{5}{8}$ in. (9.5 × 6.6 cm.)
A. Soudavar Collection

The work of another major Shah Jahani painter—Balchand—is as sweet and tender as Hashim's is firm and forceful. Balchand's earliest known paintings belong to the late Akbar period. As Milo Beach has noted, almost all of his works before the 1630s seem to be more like softly colored drawings than paintings.[22] *Royal Lovers on a Terrace* [Fig. 31], of c. 1633, which depicts Shah Shuja and his wife, is an excellent example of Balchand's later, more richly colored work. In this painting there is deep emotion and great dignity. The intimacy of the couple's relationship, focused in the steady gaze of their eyes and in the touch of his hand upon her leg, is restrained by the emotional detachment of the four attendant figures. This equilibrium is augmented by the painstakingly patterned textiles so beloved by Shah Jahani artists, and by the gentle washes of subdued colors that vaguely define the background.

In some ways like Balchand, but far more profound, Govardhan was perhaps Shah Jahan's greatest painter. Although quite capable of rendering imperial opulence, he also specialized in studies of Hindu and Muslim holy men, which usually seem to present much more than meets the eye. *Four Mullas* [Fig. 117], of c. 1630, like many of Govardhan's works is serene in mood and flawless in execution. Seated at some great distance from each other on a mat-covered platform, the four very self-contained men are wrapped in delicately modeled robes. As the bearded mulla on the upper right speaks or reads from a book, the others listen: the holy man on the lower right strokes his beard, rationally considering what he hears; the one on the lower left stares off into the distance as though transported by the words; and the one on the upper left holds a rosary as he peers out of the painting with an uneasy, slightly skeptical glance. These men are drawn together not by emotional interaction or by conversation but, rather, by their strongly differentiated responses to the bearded mulla's words: rational pondering, mystical transport, and uneasy, probably opinionated, skepticism. In this painting, Govardhan has taken a central theme, that of man's response to the word, and subdivided it into the various *types* of response, each one of which is represented by an individual figure. Ideas have, in effect, been given anthropomorphic form.

Many features of *Four Mullas* can also be seen in other paintings of holy men by Govardhan such as the Cleveland Museum's *Prince and Ascetics* [Fig. 118] and

116 Govardhan (attr.), *An Astrologer*
Mogul, c. 1635
Opaque watercolor on paper
$8\frac{1}{16} \times 5\frac{3}{4}$ in. (20.5 × 14.6 cm.)
Musée National des Arts Asiatiques—Guimet, Paris (MA2471)

the Musée Guimet's *An Astrologer* [Fig. 116], both done c. 1635. The idea analyzed in the Cleveland picture seems to be that of age and wisdom, represented by two figures: a gaunt ascetic on the left, whose body is filled with ecstasy and racked by years of rigorous physical discipline; and a mellow, wise old man on the right, who must have acquired knowledge by more moderate means. A visiting prince seeking their advice sits between them. His conventionalized youthful beauty emphasizes the timeworn, highly individualized appearance of the two ascetics whose seasoned experience is as deep and complex as the roots of the tree growing near them.

The unifying idea underlying the Guimet painting [Fig. 116] is unclear, but again we see four self-contained figures who do not overtly interact but respond in distinctly different ways to the contents of the moment that they share: an absorbed white-bearded astrologer, who sits holding a book; an assistant

intensely concentrated upon finding something in another volume; an ecstatic (or sleepy?) man apparently totally out of touch with what is being done; and a muscular, European-inspired figure whose attention, somewhat like the skeptical man in the *Four Mullas*, is diverted by something outside the picture.

Although Govardhan's style became harder and more fastidious under Shah Jahan, he retained his technical brilliance. The delicate definition of tactile surfaces and subtle use of thin washes in these works are extraordinary; one can almost feel the mat upon which the four mullas sit and the woven walls of the astrologer's picturesque hut. His idyllic, evocative backgrounds filled with feathery trees as well as clusters of European-inspired buildings and figural groups attest to Govardhan's thorough assimilation of Western sources. Flowers, plants, and foliage, rendered with rapturous delight, give a properly Shah Jahani decorative quality to these paintings, but they do not overwhelm their content.

Equally individualistic in his approach is Payag, whose earliest known work appears in minor Akbari manuscripts. By Shah Jahan's reign, he had developed two modes of painting: the first, used for state portraits and depictions of *darbars*, is appropriately glittering and formal; the second, and more personal, mode is deeply romantic and particularly concerned with atmospheric effects and the play of light and shade [see, e.g., Fig. 89]. He may well have been influenced by the strong *chiaroscuro* and high melodrama of European Baroque paintings and prints.

Payag's special artistic passions may be seen in a number of paintings, for example *Siege of a Fort*, of c. 1645 [Fig. 124]. The strong composition, tightly massed rows of almost interchangeable warriors, and minutely detailed landscape make this a superb battle scene, but it is the dramatic hellish mood, largely established by atmospheric effects, that ultimately carries the work. The billowing flames on the mountain top, curls of smoke wafting up from the bone-littered ground, and flickering passages of color all contribute to the painting's apocalyptic atmosphere.

One of Payag's favorite conventions—the illumination of a darkened scene with the radiant light of a single candle or an open campfire—is probably borrowed from European sources. This device is employed, for example, in a painting illustrating a story from the *Gulistan* of Sadi which tells of a *qazi* (judicial officer)

who, after spending a night with the beautiful son of a farrier (one who shoes horses), is surprised by his king [Fig. 122].[23] The *qazi's* room in the center of the painting is illuminated by a single candle placed under a cover. Its bright, truthful light reveals: the drunken old official with his youthful paramour; the informant who stands behind their bed; and the king, with his hand raised toward the morning sun. Outside, the ruler's waiting retinue melts into the velvety darkness. A servant sleeps in the safety of the shadows on the left. Although this painting depicts a story, its real subject is the effect of light as it plays on the carefully delineated surfaces so beloved by Shah Jahani painters.

While the works of the artists discussed so far are relatively abundant, paintings that can be firmly attributed to Abid, one of Shah Jahan's most interesting painters, are so few in number that little can be said about their maker's stylistic development. The son of Aqa Riza and the brother of Abul Hasan, two prominent Mogul painters, Abid must have produced earlier work, but the only pictures of his that survive date from the Shah Jahan period. Abid's painting of Shah Jahan enthroned [Fig. 130], discussed earlier in this chapter, reveals two important aspects of his style. The first is his obsession with accurate, meticulously detailed patterns. This painting, for example, is full of fabrics patterned with boldly packed stripes, dense frothy scrollwork, and minuscule flowers. The variety, differing visual weights, and minute execution of these patterns are extraordinary.

The second distinctive feature is Abid's ambiguous pictorial space. The spatial stage is tipped up so closely to the picture plane that any sense of spatial recession is virtually eliminated; indeed, the painting's structure recalls that of some indigenous Indian pictures in which the foreground, middle ground, and background are depicted as three flat, horizontal registers, piled one on top of the other. This unusually shallow stage is made even more peculiar by the presence of a pillared pavilion in the background. With its sharply diagonal sides, the structure is meant to recede far into the background; yet, because this background is essentially a flat, horizontal register rather than an illusionistically articulated deep space, it seems to hover in midair above the emperor's shoulders. Abid's decision not to depict the top of the pavilion's columns or its roof, which might have clarified the building's relationship to the rest of the painting, augments this deliberately planned

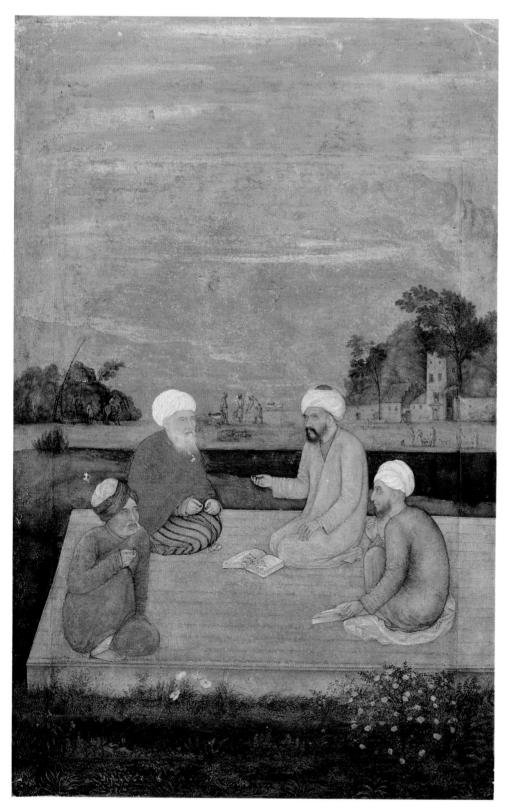

117 Govardhan (attr.), *Four Mullas*
Mogul, c. 1650
Opaque watercolor on paper
$8\frac{3}{16} \times 5\frac{3}{16}$ in. (20.6 × 13.3 cm.)—actual size
Los Angeles County Museum of Art, From the
Nasli and Alice Heeramaneck Collection,
Museum Associates Purchase (M.85.2.3.)

118 Govardhan (attr.), *Prince and Ascetics*
From the Late Shah Jahan Album
Mogul, c. 1635
Opaque watercolor, ink, and gold on paper
$8 \times 5\frac{5}{8}$ in. (20.3 × 14.3 cm.)—actual size
The Cleveland Museum of Art, Purchase from
the Andrew R. and Martha Holden Jennings
Fund (71.79)

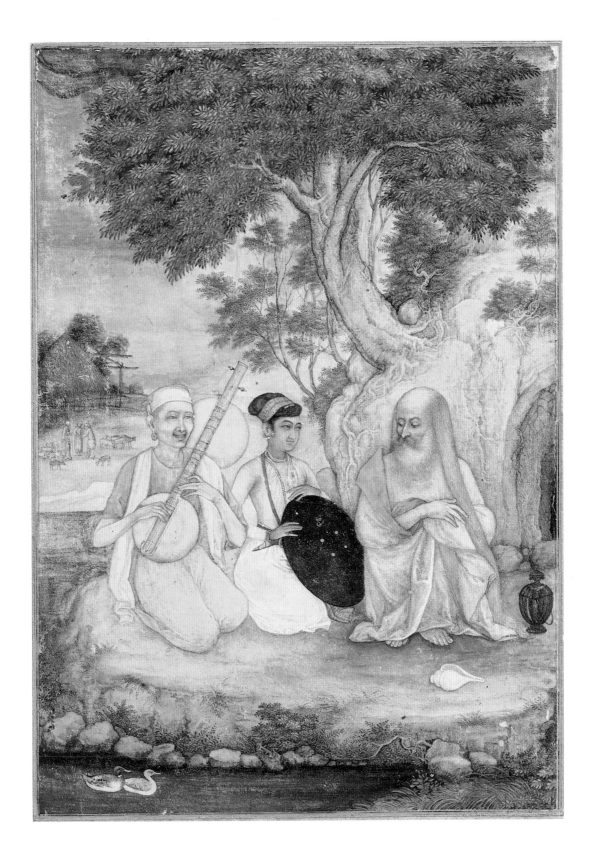

spatial ambiguity. Mannered almost to the point of eccentricity, Abid pushes the Shah Jahani creative vision into another and, perhaps, more native Indian dimension. One only has to compare his treatment of space with that of his contemporaries to realize his individuality.

MOGUL PATRONS OTHER THAN SHAH JAHAN

The pictures of Bichitr, Mir Hashim, Balchand, Govardhan, Payag, Abid, and other equally talented imperial artists were ordered by and intended for the emperor. These paintings, however, were not the only ones produced for Mogul patrons. During the reign of Shah Jahan, there were probably other nobles and courtiers who also commissioned pictures and illustrated manuscripts. Patrons of this sort are known from the very earliest years of Mogul painting. Some imperial princes, for example, maintained their own studios or had independent contacts with artists: Jahangir, when he was still a prince, kept a private atelier; Mirza Hindal, Humayun's brother, and Shah Jahan, while he was still Prince Khurram, had associations with artists.[24] Beyond the royal family, too, there were Mogul courtiers and notables who sponsored independent ateliers: Abdul Rahim Khan Khanan and Mirza Aziz Koka, for example, engaged calligraphers and artists during Akbar's reign.

The member of Shah Jahan's immediate family most frequently mentioned by scholars as a possible patron of painting is Crown Prince Dara Shikoh, the emperor's eldest son. Like his great-grandfather Akbar, the heir apparent was intensely interested in religious and philosophical matters and wished to synthesize Islam and Hinduism. Sensitive, scholarly, and a calligrapher in his own right [Fig. 119], Dara Shikoh is thought to have maintained his own atelier or, perhaps, to have occasionally engaged his father's painters. Pictures of mystics, sages, and ascetics, particularly those that include the image of the crown prince [e.g. Fig. 93], are often said to be works made under his patronage.

Unfortunately, the concrete evidence linking Dara Shikoh to painting is somewhat ambiguous. A label on one miniature in the Bibliothèque Nationale in Paris suggests an association between the prince and the artist Manohar.[25] Another inscription, connecting him to the painter Anup Chattar, is written on a rather idealized

119 *Calligraphy by Dara Shikoh*
Mogul, c. 1634
Opaque watercolor on paper
$6\frac{7}{8} \times 4\frac{3}{8}$ in. (17.5 × 11.1 cm.)
Arthur M. Sackler Museum, Harvard University, Cambridge, Mass., Anonymous Loan

120, 121 Bishndas (attr.), *Zafar Khan in Kashmir with Poets and Scholars*
Double-page from the manuscript of the *Masnavi* of Zafar Khan
Mogul, paintings from late 1640s
Opaque watercolor on paper
Each page 10 × 6⅜ in. (25.5 × 16.2 cm.)
Royal Asiatic Society, London (Ms. Persian 310, fols. 19v and 20)

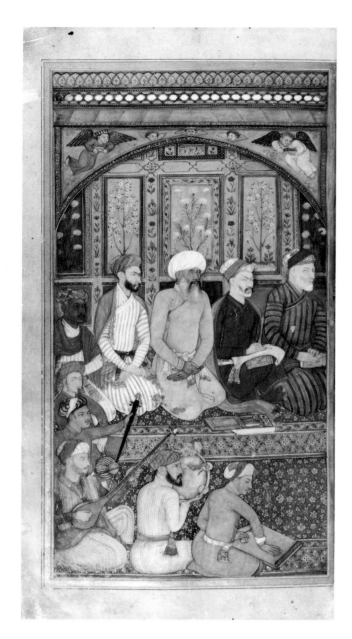

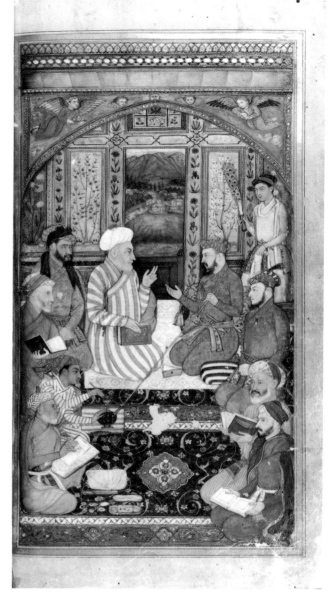

portrait now in the India Office Library, London, of a woman said to be Gul Safa, a sweetheart of the crown prince's. This inscription implies that Anup Chattar was in the service of Dara Shikoh, but it is written on the outer border of a backing paper which is later than the miniature and its borders.[26]

In addition to such tantalizing but inconclusive inscriptions there is yet one more piece of evidence that associates the crown prince with painting—the India Office Library's "Dara Shikoh Album." This volume contains an inscription in the crown prince's own hand which records the gift of the album to his wife and

cousin Nadira Banu Begum in 1641–42. It seems likely that the work was assembled for Dara Shikoh rather than for another patron: not only are the calligraphy and most of the paintings contemporary with the dates of the crown prince's life, but the contents of the album suggest that it was made for a woman, i.e., his wife.[27] They cover a full range of non-official themes: idealized portraits of young Indian princes and princesses [Fig. 29] and a few Persian courtiers [Fig. 107], studies of flora and fauna [Figs. 98, 101], and depictions of ascetics and dervishes, all dating to the Shah Jahan period; a picture of a European gentleman and lady from the Jahangir

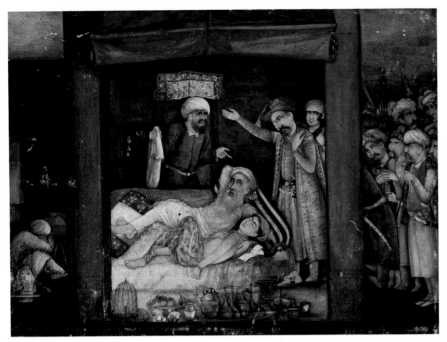

122 Payag (attr.), *An Honorable Qazi Caught by Surprise with a Young Man*
Page from a manuscript of the *Gulistan*
Mogul, c. 1640
Opaque watercolor on paper
$3\frac{5}{8} \times 4\frac{7}{8}$ in. (9.2 × 12.5 cm.)
Hashem Khosrovani Collection

123 Bichitr (attr.), *Dara Shikoh Riding an Albino Elephant*
Mogul, c. 1628–30
Opaque watercolor on paper
$9\frac{11}{16} \times 13\frac{7}{16}$ in. (24.6 × 34.5 cm.)
Arthur M. Sackler Museum, Harvard University, Cambridge, Mass., Anonymous Loan

124 Payag (attr.), *Siege of a Fort*
Page from a manuscript of the *Padshah-nama*
Mogul, c. 1645
Opaque watercolor on paper
$13 \times 9\frac{7}{16}$ in. (34.3 × 23.9 cm.)
Arthur M. Sackler Museum, Harvard University, Cambridge, Mass., Anonymous Loan

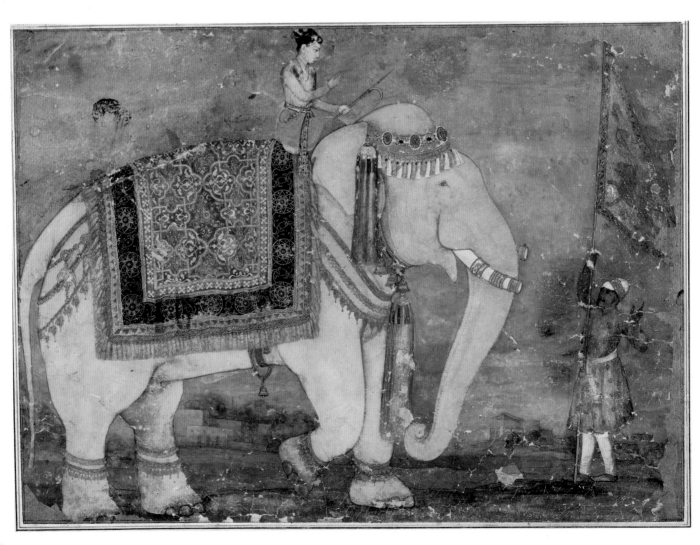

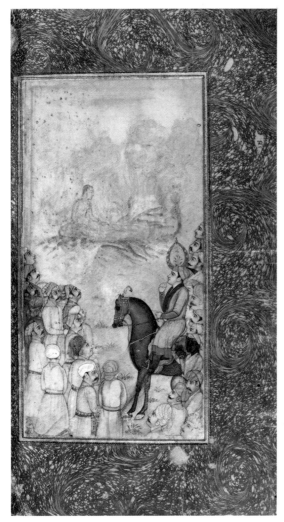

125 *Prince Daniyal Watches as Flames Consume the Sati and Her Dead Lover*
Page from a manuscript of *Suz u Gudaz*
Mogul, c. 1630
Opaque watercolor on paper
$8\frac{1}{4} \times 4\frac{3}{8}$ in. (21 × 11 cm.)
The British Library, London (Ms. Or. 2839, fol. 17v)

known as "Artist B," have recently been attributed by S. C. Welch to Chitarman, a member of Shah Jahan's royal studio.[29] Although the paintings in this album are of imperial quality, it is difficult to say whether they were done for Dara Shikoh by his own atelier, by artists who were temporarily borrowed from his father's studio, or both.

Much more conclusive evidence exists for the patronage of another man, Zafar Khan, who was at various times the Mogul governor of Kabul, Kashmir, and Sind. Like Abdul Rahim Khan Khanan and Mirza Aziz Koka of Akbar's day, he valued painters, calligraphers, and poets and supported their work. His beautiful *Masnavi* copied in Lahore in 1663 and containing six double-page illustrations as well as marginal illuminations survives. The paintings were done in the late 1640s to commemorate Zafar Khan's service in Kashmir and were added later to the 1663 text.[30] They show scenes from his life, some of which include the presence of Shah Jahan, who visited him in Kashmir in 1644. One of the most charming depicts Zafar Khan and his brother conversing with poets and scholars in a sumptuous Kashmiri pavilion [Figs. 120, 121]. An artist sits working on a portrait in the lower left corner of the right page: he may be Bishndas, to whom the paintings in this *Masnavi* have been attributed.[31]

There were, no doubt, other Mogul patrons of painting and calligraphy during Shah Jahan's reign. In some cases we have works inscribed with the name of a patron, about whom we know nothing; in others, we have manuscripts and miniatures that might have been done outside the royal atelier, but no record of their patronage. An example of the latter is the delightful little copy of *Suz u Gudaz* (Burning and Melting) pictured here [Fig. 125. The text was originally composed in Persian by Muhammad Riza Naui, who worked for Abdul Rahim Khan Khanan during Akbar's reign. It relates the story of a Hindu princess who, unpersuaded by Akbar's pleas, burnt herself on her husband's funeral pyre, as Prince Daniyal, the emperor's younger son, watched.[32]

THE INFLUENCE AND AFTERLIFE OF SHAH JAHANI PAINTING

Because the Shah Jahani style was associated with the empire's paramount political power, its influence

period; two Persian paintings in the Bukhara style of c. 1560–70; and mounted late sixteenth- and seventeenth-century European engravings. Entirely absent from this assemblage of the pretty and exotic are historical paintings and portraits of the emperor.

With the exception of a picture signed by Muhammad Khan, none of the Dara Shikoh Album's paintings is inscribed with the name of an artist. It would seem that several painters, possibly four or more, worked along with Muhammad Khan on the *muraqqa*.[28] Some of the paintings by one of these men, traditionally

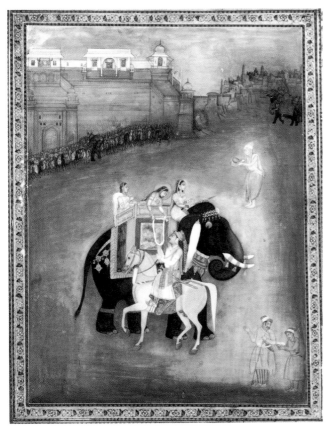

126 *Princess Presenting a Garland to a Prince*
Mogul, c. 1675
Opaque watercolor on paper
12 × 9$\frac{1}{16}$ in. (30.5 × 23 cm.)
Navin Kumar, New York

127 *Lovers Embracing*
Mogul, c. 1675
Opaque watercolor on paper
6$\frac{3}{4}$ × 4$\frac{5}{8}$ in. (17 × 11.7 cm.)
Mehdi Mahboubian

extended far beyond the relatively small circle of Mogul nobles and officials who surrounded the emperor. Pictures produced in the seventeenth century by the ateliers of some of the Deccani sultans and the Hindu kings of Rajasthan and the Panjab Hills, though often far removed in style and content from Shah Jahani painting, were, nonetheless, touched by its technical refinements and pictorial conventions. The means by which such influences were transmitted are not specifically known. The ruler-patrons of these kingdoms perhaps saw or were given Shah Jahani paintings while visiting the emperor's court or when serving with his imperial forces; it is also possible that they hired artists who had previously worked in the royal atelier or who knew the Mogul style or some sub-imperial variant.

The appeal of Shah Jahani painting was also felt long after the death of the "Ruler of the World." Its conventions (particularly those connected with portraiture) were adopted with some modifications by his successor, Aurangzeb, who initially patronized painters, but later ceased to do so for religious reasons. Some subjects, however, such as love themes, first fully developed during Shah Jahan's reign, continued to inspire artists in the late seventeenth and eighteenth centuries [Figs. 126, 127]. More importantly, the style and themes of Shah Jahani painting, somewhat transformed and often mixed with elements from other traditions (Indian and European), were continued in several eighteenth- and nineteenth-century North Indian centers [Figs. 8, 237–240]. During these rather sad years of Mogul decline, Shah Jahan's reign was nostalgically viewed as a golden moment when the empire was at its peak of wealth, splendor, and influence. Painters employed in Delhi and Lucknow, as though trying to regain paradise, copied or adapted Shah Jahani works. Albums and manuscripts dating from the reign of the "Ruler of the World" and still in the imperial libraries were remounted in sumptuous borders; others were removed and replaced with copies. Paintings on ivory and lavishly illustrated histories of Shah Jahan's reign, often intended for Europeans fascinated with the Taj Mahal and other imperial monuments, were also produced (see Chapter Six). No one, it seems, could ever quite forget the wealth, beauty, and sublime perfection of Shah Jahan's India.

128 *Shamsa*
Mogul, c. 1650
Opaque watercolor on paper
H: $15\frac{1}{2}$ in. (39.4 cm.)
Anonymous

129 Abul Hasan (inscr.), *Shah Jahan
Examining the Royal Seal*
Mogul, c. 1628
Opaque watercolor on paper
$21\frac{3}{4} \times 13\frac{9}{16}$ in. (55.2 × 34.5 cm.)
Collection Prince Sadruddin Aga Khan

Mounted above is a portrait of Jahangir
inscribed "Balchand."

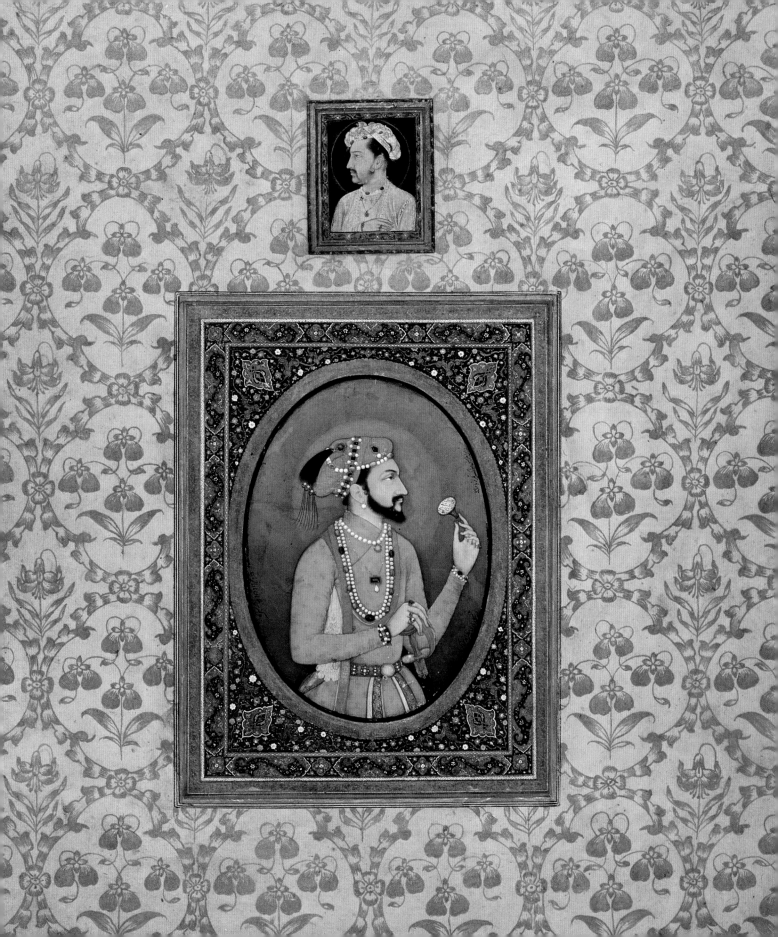

Jades, Jewels, and Objets d'Art

Stephen Markel

Everywhere are seen the jasper, and *jachen*, or jade, as well as other stones similar to those that enrich the walls of the *Grand Duke's* chapel at *Florence*, and several more of great value and rarity, set in an endless variety of modes, mixed and enchased in the slabs of marble which face the body of the wall. Even the squares of white and black marble which compose the pavement are inlaid with these precious stones in the most beautiful and delicate manner imaginable.[1]

François Bernier

As the French physician Bernier described in his letter from Delhi in 1663, the Taj Mahal is profusely adorned with the finest gemstones. Indeed an often repeated nineteenth-century characterization of the monument is that it was "built by Titans, finished by jewelers." It is these qualities of extravagant ornamentation and lustrous finish of the minutest details that enable the Taj Mahal to be defined as the largest and most spectacular decorative art object in the world.

No expense was spared to make the mausoleum the grandest "jewel box" ever fashioned by the hand of man. Although the popular nineteenth-century notion that the most accomplished architects and artists from around the world were called upon to work on the monument is largely fictitious, the breathtaking gemstones used to decorate the tomb of the "Exalted One of the Palace" were indeed scoured from the far reaches of the empire and beyond. The white marble came from the Makrana mines, slightly southwest of Jaipur in Rajasthan. Nephrite jade was imported from Kashgar and Khotan in Chinese Turkestan in Central Asia, and lapis lazuli from Badakhshan in the high mountains of northeastern Afghanistan. Yellow amber came from upper Burma. Carnelian, jasper, amethyst, agate, heliotrope, and green beryl were mined in various regions of India. The cumulative effect of the inclusion of such an abundance of costly stones was the creation of an unparalleled edifice as rich and ornate as the finest jewelry and rightly ranked among the wonders of the world.

The decorative features of the Taj Mahal reflect and epitomize the refined aesthetic sensibilities of its imperial patron Shah Jahan. Similar design characteristics are also exhibited in the contemporary decorative arts. There are two separate yet related modes of ornamentation found on the monument: hardstone carving and *pietra dura* inlay. Both forms of embellishment are crucial to an understanding of the nature and development of the decorative arts associated with the emperor.

A long tradition of hardstone carving existed in India and the Islamic courts of Iran and Central Asia. The Moguls incorporated this art form into their architectural programmes and corpus of decorative objects in the early seventeenth century. Although the technique of carving white marble as a building material was first utilized during the reign of Jahangir and jade luxury items were fashioned even earlier, it was not until the reign of Shah Jahan that hardstone carving achieved its full artistic expression: the Taj Mahal and other monuments commissioned by the emperor display exquisitely modeled floral sprays sculpted in shallow relief in the white marble [Figs. 50, 55, 70]. Besides its architectural role, hardstone carving was also used to create decorative objects and vessels, with the most accomplished articulation of the art form indisputably being the famous white jade wine cup dated 1657 now in the Victoria and Albert Museum, London [Fig. 131].

The technique known as *pietra dura*, whereby thin sections of precisely carved hard and semi-hard gemstones are inlaid into the surface of marble, is another mode of ornamentation prominently featured on the Taj Mahal [Figs. 48, 134]. The *pietra dura* inlay is wrought into the form of arabesque floral tendrils which meander over the surface of the white marble in a lyrical and graceful pattern that transcends its inherently restrictive symmetry. Perhaps the most enthusiastic description of the fantastic *pietra dura* flora found on the Taj Mahal is that of Helena Blavatsky (1831–91),

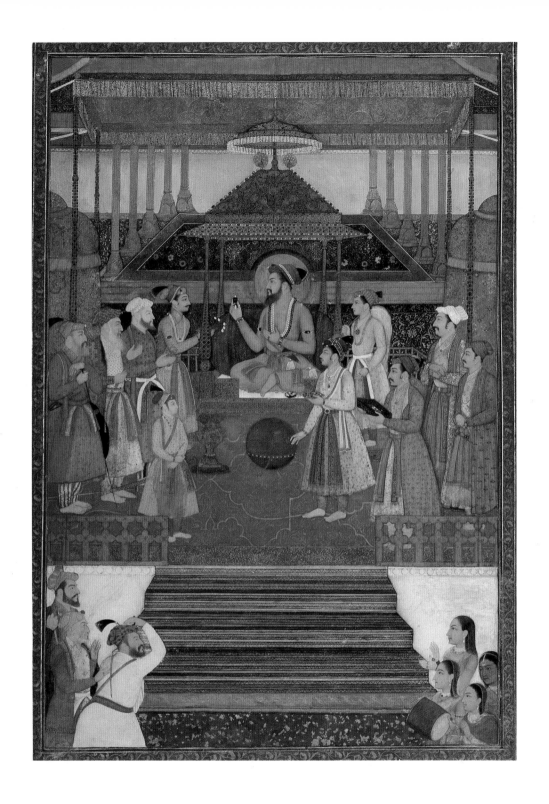

130 Abid, *Shah Jahan on the Peacock Throne*
Page from a manuscript of the *Padshah-nama*
Mogul, dated 1639
Opaque watercolor and gold on paper
14½ × 9¹¹⁄₁₆ in. (36.9 × 24.6 cm.)
San Diego Museum of Art, Edwin Binney, 3rd,
Collection

131 Wine cup of Shah Jahan†
Mogul; inscribed with the title of Shah Jahan and the date 1657
Nephrite jade
2½ × 7⅜ in. (6.4 × 18.7 cm.)
Trustees of the Victoria and Albert Museum, London
(IS 12–1962)

the Russian founder of the Theosophical Movement, who visited India in 1879:

Some of them look so perfectly natural, the artist has copied nature so marvelously well, that your hand involuntarily reaches to assure yourself they are not actually real. Branches of white jasmine made of mother-of-pearl are winding around a red pomegranate flower of carnelian, or the delicate tendrils of vines and honeysuckle, while some delicate oleanders peep out from under the rich green foliage. . . . Every leaf, every petal, is a separate emerald, amethyst, pearl or topaz; at times you can count as many as a hundred of them for one single bunch of flowers, and there are hundreds of such bunches all over the panels and perforated marble screens.[2]

The hardstone carving and *pietra dura* inlay of the Taj Mahal appear in the floral arrangements and geometric patterns that became the decorative trademarks of Mogul art from the early seventeenth century onward. Both types of design were used extensively in the architecture, painting, textiles, and decorative arts commissioned by all of the succeeding Mogul rulers. Floral motifs inlaid in white marble were so closely identified with the dynasty that even modern objects made in this fashion are designated by the term "Mogul style."

Floral imagery was frequently used in earlier Islamic art and was often shown in the art of Akbar's reign, for example in the exuberant landscapes sculpted on the panels inside the so-called House of the Turkish Sultana at Fatehpur Sikri. It was during the reign of Jahangir, however, that the motif of naturalistic flowers formally arranged against a plain background first appeared in textiles and painting. The general inspiration is believed to have come from the flowered borders of Persian manuscripts and the floral decoration of Timurid architecture. The specific stylistic stimuli for Jahangir's flowers, however, were the detailed illustrations in engraved European herbal books. Several botanical studies which were published in the late sixteenth and early seventeenth centuries are known to have been in the possession of a number of the early Western visitors. The pages of some contemporary Northern European manuscripts, which consist of an inset miniature surrounded by flowering plants, also show a remarkable compositional similarity to their counterparts in Mogul albums, though no such texts are known to have entered India by the early seventeenth century.

Mogul floral representations were also inspired by Jahangir's desire to portray the beautiful wild flowers of Kashmir by which he was awed during his first springtime visit to the lush valleys in March of 1620.[3] In commissioning the paintings he was extending a tradition originated by the founder of the Mogul dynasty, Babur, who gave precise descriptions in his memoirs of the flora and fauna he encountered in his travels. Jahangir, who was also an ardent naturalist, described in his memoirs the "sweet-scented flowers" of India and stated that he preferred them over all the other blossoms in the entire world.[4] Later in the same text, he states that he initiated the practice of depicting the wonders of nature: "Although King Babar has described in his Memoirs the appearance and shapes of several animals, he had never ordered the painters to make pictures of them. . . . I both described them and ordered that painters draw them."[5] Jahangir's belief that he was the first Mogul emperor to commission animal studies is apparently inaccurate, however, as it is mentioned in the memoirs of the court servant Jauhar that Humayun ordered a portrait of a captured bird to be painted in 1543.[6]

Inlaid geometric patterns were also used to enrich the marble surface of the Taj Mahal. Derived from the long heritage of Islamic design, they provided a dynamic

quality of movement to the facade. The abstract geometric patterning common to Islamic architecture, painting, and decorative arts perhaps had its motivation in the well-known religious injunction against the representation of the human figure and other living creatures, but the frequent depictions of rulers, members of court, and selected individuals belie any imperial adherence to the proscription.

The style of decoration found on the exterior of the Taj Mahal was also used to ornament the perforated screen and the four cenotaphs inside the mausoleum. *Pietra dura* inlay covers the marble surface in the form of graceful flowers, delicate arabesques, and superb calligraphy [Figs. 52–55, 60–62, 132]. The ornamentation on the screen and cenotaphs not only replicates that used on the outside of the monument, but even surpasses it. As a foremost architectural historian of India, Percy Brown, has stated, "So sensitive and yet so firm is the drawing that it resembles the spirited sweep of a brush rather than the slow laborious cutting of a chisel."[7]

SHAH JAHAN AS A CONNOISSEUR OF GEMS

The exquisite inlaid stones and jewel-like decorative qualities of the Taj Mahal were a reflection of Shah Jahan's passion for fine gems. From an early age he was also an astute connoisseur of their distinctive quality and characteristics. In 1614, when he was twenty-two and still Prince Khurram, his father Jahangir desired a pearl of a certain size, shape, and quality to match one he had recently acquired. Khurram recalled seeing an appropriate one in an old turban ornament that had belonged to his grandfather Akbar; the pearl was retrieved from the royal treasury and found to be an exact mate, "not differing in weight even by a trifle," and as if it had been "shed from the same mould."[8] Besides the literary evidence, there is pictorial proof of Shah Jahan's early interest in precious jewels. While still crown prince, at the age of twenty-five, he is shown admiring a spectacular jeweled turban ornament in a painting by Abul Hasan, which dates from c. 1616/17.[9] A painting executed some twenty years later demonstrates that Shah Jahan maintained his interest [Fig. 144]; while in a yet later picture, painted near the time of his deposition, he is portrayed examining several gems handed to him by a man who presumably is an officer of his jewel treasury.[10]

Shah Jahan inherited his passion from his father, Jahangir, who had previously been described by a contemporary English visitor, the Rev. Edward Terry, as the "greatest and richest master of precious stones that inhabits the whole earth."[11] Shah Jahan acquired even more than his father, and eventually became known as the greatest gem expert of the age. Jean-Baptiste Tavernier, a traveling French jewel merchant who visited India several times between 1640 and 1667, recounts an incident when the imprisoned Shah Jahan was asked by his son Aurangzeb to verify the disputed authenticity of a balas ruby (red spinel)—a stone favored by the Moguls—that was valued at 95,000 rupees.

As in the whole Empire of the Great Mogul there was no one more proficient in the knowledge of stones than Shahjahan, . . . [Aurangzeb] sent the stone to the Emperor, his father, asking for his opinion. After full consideration he confirmed the verdict of the old jeweller, and said that it was not a balass ruby, and that its value did not exceed 500 rupees.[12]

Shah Jahan valued beautiful gems perhaps more than life itself. At times his love turned to obsession, as when Aurangzeb asked to borrow some of his father's jewels in order to appear in sufficient imperial glory upon his accession to the throne. As Tavernier relates,

Shahjahan became so enraged at this demand of Aurangzeb, which he regarded as an insult levelled at him in his prison by his son, that for some days he was like a madman, and he even nearly died. In the excess of his passion he frequently called for a pestle and mortar, saying that he would pound up all his precious stones and pearls, so that Aurangzeb might never possess them.[13]

In the light of Shah Jahan's infatuation with gems and considering the sheer opulence of the Taj Mahal with all its costly inlay, the monument can be seen as his most precious jewel, a large-scale version of the choicest imperial baubles.

MOGUL DECORATIVE ARTS

The aesthetic vision so clearly expressed in the ornamentation of the Taj Mahal is also revealed in the decorative arts produced under Shah Jahan's patronage. Countless luxury items were made of precious materials, often inlaid with gems. There was an allied expression in the technique, media, and design motifs used to embellish the royal accouterments. The variety

132 Detail of design on the top of Shah Jahan's cenotaph
Agra, c. 1820
Opaque watercolor on paper
$29\frac{3}{4} \times 21\frac{1}{4}$ in. (75.6 × 54 cm.)
Terence McInerney, New York

134 Detail of the *pietra dura* inlay on the exterior of the Taj Mahal†
(Photo by Stephen Markel)

133 Frieze
Mogul, c. 1640
Marble with gemstone inlay
$9\frac{11}{16} \times 32\frac{1}{2}$ in. (24.5 × 82.6 cm.)
Trustees of the Victoria and Albert Museum, London (IS 54–1855)

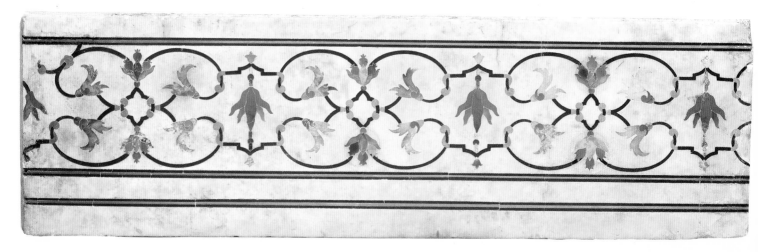

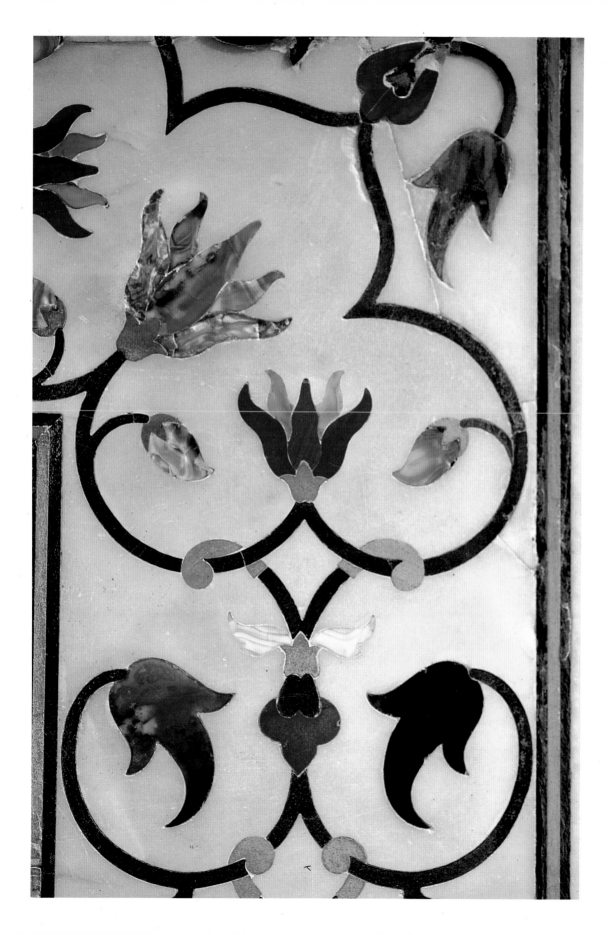

of articles needed to serve and grace the imperial lifestyle enabled the emperor's ateliers to produce objects which were not only useful but which were also artistic masterpieces that transcended their mere functional rationale.

Certainly the most famous of all of Shah Jahan's works of decorative art was the Peacock Throne, which was seized in 1739 by Nadir Shah, the king of Iran, when he sacked Delhi, and subsequently melted down after its precious gems had been removed. Although accounts of its shape and ornamentation differ, all agree on the thousands of stones and the great amount of gold that went into its construction. The Peacock Throne was depicted in a number of contemporary paintings, one of the finest of which shows Shah Jahan examining jewels presented to him by his son Dara Shikoh [Fig. 130]. It continued to be a favorite subject in Mogul art, and its fame endured to the extent that several inferior versions of it were constructed later in India and other countries.

The materials used to produce decorative arts in the imperial ateliers during the reign of Shah Jahan include radiant gems, jades and other hardstones, and precious metals. Although they were incorporated in the Taj Mahal purely for their intrinsic splendor, various gemstones and minerals were traditionally associated with beneficial or malefic effects which were perhaps taken into account in the commissioning and designing of jewelry, vessels, and weapons. The overriding concern of the artists and the emperor, however, was always that the objects display the regal grandeur commensurate with one of the wealthiest empires the world had ever known.

Spectacular jewels fully embodied the opulent spirit of the age of Shah Jahan. Beautiful gems were the most ostentatious form of personal adornment, and were used abundantly to enrich the surface of objects made of gold, silver, or hardstones. Thousands of precious stones were acquired by the Mogul rulers and nobles in the sixteenth, seventeenth, and eighteenth centuries. Great quantities of gems in the imperial treasury are mentioned as far back as the reign of Babur, when he appropriated the wealth of the previous North Indian dynasties after his decisive victory at Panipat in the Panjab in 1526.[14] Seventy years later the official court chronicler of Akbar, Abul Fazl, stated, "If I were to speak about the quantity and quality of the stones it would take me an age."[15]

During the reigns of Jahangir and Shah Jahan, the amount of gems that entered the treasury was enormous, as even a casual perusal of the historical sources indicates. Besides presents given to the emperors, a major source was the Mogul decree whereby all the jewels and riches of any nobleman who died were immediately appropriated for the imperial treasury. The gems continued to accumulate until Nadir Shah's raid in 1739. According to a history of his reign, Nadir Shah plundered the imperial coffers of jewels valued at over three hundred million rupees, which is today worth more than three hundred million dollars![16]

The quantity of stones acquired by the Moguls was matched by their superb quality. Nothing but the best was purchased by the emperor. The jewel merchants of the day knew this and tailored their business to suit the imperial demand. A letter dated 4 January 1628 to the home office of the East India Company from the President and Council of the English Factory in the great emporium city of Surat comments on "All jewells being declined from their wonted estimacion, except extraordinary rich orient round pearles, paragon rubies, and beautiful great ballasts; but of ordinary sorts be pleased to send no more."[17]

Jade was the Moguls' favorite hardstone for decorative objects. It was carved and fashioned into vessels for food and drink, fittings for weapons, and an assortment of personal and domestic artefacts. The Islamic tradition of jade carving apparently began under Timur, the renowned Central Asian ancestor of Shah Jahan, whose dynastic descendants developed an artistic vision that was adopted by the Moguls in order to recall their Timurid heritage and publicize their own dynastic aspirations. In a military context, jade was also valued because of its reputation among Muslim soldiers for bringing about victory on the field of valor.[18] Moreover, by virtue of its supposed efficaciousness in counteracting poison, it was deemed to be a powerful safeguard in the deadly world of Mogul court machinations.

Gold and silver not only served as the currency of the Moguls, but were cast and chased into vessels, ornaments, and weapons. The food servers and wine containers were particularly sumptuous and were sometimes inlaid with over a thousand gems. The finest surviving examples of such ornate vessels are those which were looted from Delhi and presented by Nadir

Shah's embassy to Catherine the Great of Russia in 1741, and are now in the State Hermitage Museum in Leningrad. Gold and silver vessels of the Mogul period are exceedingly rare today because most were melted down for their cash value. Vessels of precious materials are often shown in contemporary paintings and are described in the journals and letters of seventeenth-century European travelers. Sir Thomas Roe, the English ambassador to Jahangir's court, tells of being presented by the emperor in 1616 with a jeweled gold cup.

The cupp was of gould, sett all over with small turkyes [turquoise] and rubies, the cover of the same sett with great turquises, rubyes and emralds in woorks, and a dish suteable to sett the cupp upon. The valew I know not, because the stones are many of them small, and the greater, which are also many, are not all cleane, but they are in number about 2,000 and in gould about 20 oz.[19]

Tavernier relates that while he was staying in Ahmed-abad at the end of 1652 he daily received from Shah Jahan's brother-in-law, Shaista Khan, "four silver dishes from his table containing pulao [special rice] and choice meats."[20]

The Mogul fondness for food and wine vessels made of precious metals is in direct contravention of the Islamic prohibition against eating or drinking out of gold or silver vessels.[21] As was the case regarding representations of living creatures in art, however, these most potent of rulers must have considered themselves excused from the injunctions of Islamic law. In this the Moguls followed the example of earlier Muslim dynasties who had also ignored the dining regulation.

PRECIOUS GEMS AND JEWELRY

The most spectacular class of object made by the imperial decorative artists was the opulent jewelry used to complement the luxurious existence of the Mogul emperors. Gems were set into ornate mounts of gold and silver or strung into necklaces. Shah Jahan and his father are particularly noted for having worn lavish quantities of precious gems, as can be seen in their official portraits [e.g. Figs. 83, 144]. William Hawkins, a Turkish-speaking English merchant who was befriended by Jahangir during his stay in Agra from 1609 to 1611, described the emperor's jewelry:

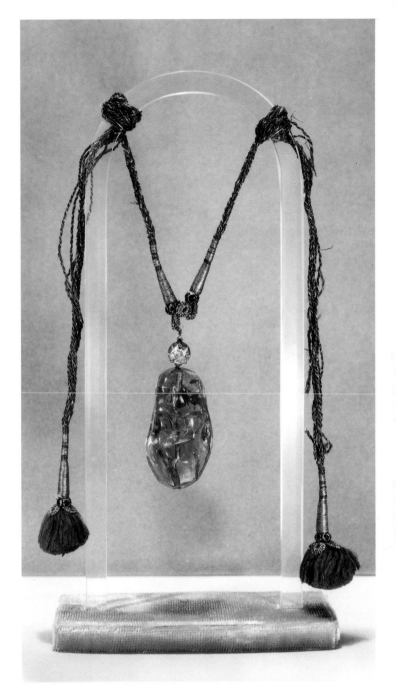

135 The Carew Spinel
Mogul; inscribed with the titles of Jahangir, Shah Jahan, and Aurangzeb and the dates 1612/13, 1629/30, and 1660 or 1666
Balas ruby (red spinel), diamonds; silk, silver, and gold tie
$1\frac{9}{16} \times \frac{15}{16}$ in. (4 × 2.3 cm.)
Weight: 133.5 carats
Trustees of the Victoria and Albert Museum, London,
Bequeathed by the Rt. Hon. Julia Mary, Lady Carew
(IM 243–1922)

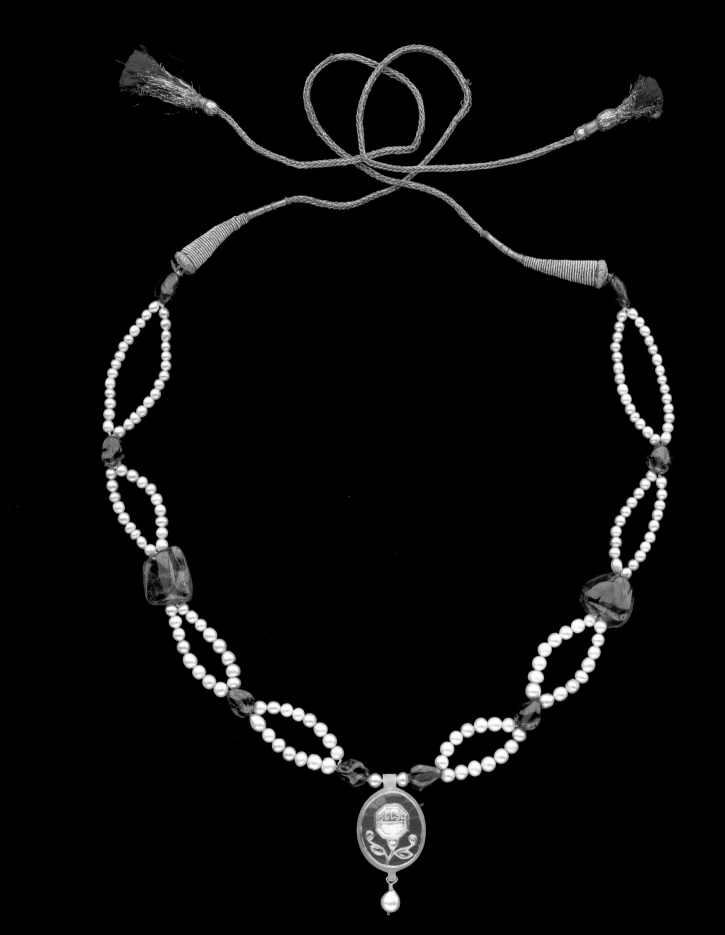

136 Necklace with inscribed pendant
Mogul, c. 1630–50; inscribed with the name and
title of Shah Jahan
Pearls, red spinels, rubies, nephrite jade, and a
diamond; gold, silver, and silk tie
L: 18½ in. (47 cm.)
Private Collection, Switzerland

137 Cameo portrait of Shah Jahan
Mogul or Deccan, c. 1660 (cameo); Golconda or
Hyderabad, c. 1700 (mount)
Sardonyx, foiled rubies, and silver mount
D: 1¼ in. (3.2 cm.)—twice actual size
Dar al-Athar al-Islamiya, Kuwait National
Museum (LNS 43 J)

138 Centerpiece of an armlet
Mogul, c. 1650–1700, with later European
additions
Gold inlaid with rubies, emeralds, and colorless
sapphires (additions of diamonds in silver or
platinum mounts, pearls and black beads)
2 × 3¾ in. (5 × 9.5 cm.)—actual size
The Metropolitan Museum of Art, New York,
Gift of George Blumenthal, 1941 (1941.100.118)

He is exceeding rich in diamants and all other precious stones, and usually weareth every day a faire diamant of great price; and that which he weareth this day, till his time be come about to weare it againe he weareth not the same; that is to say, all his faire jewels are divided into a certaine quantitie or proportion to weare every day. He also weareth a chaine of pearle, very faire and great, and another chaine of emeralds and ballace rubies. He hath another jewell that commeth round about his turbant, full of faire diamants and rubies.[22]

The raid of Nadir Shah and the high intrinsic value of the Mogul gems caused many of them to be remounted in later times. There are thus relatively few examples of jewelry that can with certainty be associated with Shah Jahan or any of the other Mogul emperors. The majority of those that can be so attributed are in the collection of the crown jewels of Iran. One striking example outside of that magnificent assemblage is the famed "Carew Spinel" [Fig. 135]. This large red spinel or balas ruby weighs 133.5 carats, and is engraved with the titles of three Mogul emperors and the dates of the stone's engraving: Jahangir, 1612/13; Shah Jahan, 1629/30; and Aurangzeb, 1660 or 1666 (?).[23] Undoubtedly part of Nadir Shah's plunder, it was purchased in Tehran by the former British Ambassador to Iran, Charles Alison, some time before 1870 and given to the Victoria and Albert Museum in London by his grand-niece Lady Carew in 1922. The polished spinel is shaped like a pear and drilled longitudinally to accommodate a diamond-tipped pin, to which are attached two ties of silk, silver, and gold thread. The practice of engraving imperial titles upon gems of rare beauty or noteworthy size was a Timurid tradition and is frequently mentioned in imperial Mogul memoirs and European historical accounts.

Although most inscribed Mogul gems are red spinels like the Carew stone, at least one engraved diamond from the period survives. It is the centerpiece of a jade and ruby pendant on a spectacular pearl necklace [Fig. 136]. The royal epithet on the gem reads, "Shah Jahan, the Emperor, the Religious Warrior." The necklace consists of twin strands of pearls joined at intervals by ten red spinels, one of which is inscribed with the title of Jahangir and the date 1609. The engraved diamond functions visually as the head of a flower atop a stem of gold wire and leaves made of smaller diamonds. A background of rubies surrounds the flower and a single pearl dangles below. The back of the pendant is carved

139 Turban ornament
Mogul, c. 1750–1800
Gold, enamel, rubies, and colorless sapphires
Mr. and Mrs. James W. Alsdorf, Chicago

with an open flower bordered by curved petals. Although few strands of pearls from the Mogul period survive intact, numerous painted depictions of such necklaces and several literary references attest to their popularity. Tavernier devotes two chapters to pearls in the accounts of his travels and states that they were the most desired jewels in India.[24]

In addition to necklaces, turban ornaments were a favorite form of adornment for Muslim rulers. Traditionally consisting of jewels and feathered plumes, they changed dramatically in design during the second half of Jahangir's reign with the introduction and adaptation of the European aigrette [Fig. 144].[25] The standard shape consists of a jeweled stem of precious metal or carved hardstone curved in imitation of a flexed plume, with a large gem serving as a pendant finial. Surviving seventeenth-century examples are extremely rare, but the basic form remained fairly constant, and indeed became so stereotyped in the eighteenth and nineteenth centuries that it is often only the presence and type of enamel work that enables the date of the object to be determined (see below, p. 151). A fine example, probably of late eighteenth-century date, is made of gold backed by enamel and enriched with rubies and colorless sapphires [Fig. 139].

A popular form of personal decoration in the Mogul period was the jeweled armlet. Numerous paintings show the emperors wearing around their upper arms

tripartite pieces of jewelry set with large gems. While most surviving armlets are from the eighteenth and nineteenth centuries, a particularly striking one may be attributed to the seventeenth century [Fig. 138]. Its golden surface is encrusted with fine gems, including rubies, emeralds, and colorless sapphires. The original Mogul armlet was modified in the late 1920s or 1930s by Cartier's of Paris when diamond insets, rows of pearls, and two black beads were added to the piece and it was converted to a brooch.

Perhaps the most spectacular examples of Mogul jewelry are those works created from carved Colombian emeralds. Although India was erroneously considered for centuries to be the place of origin of emeralds, major finds of the gorgeous gem were not known there until the early 1940s when prospectors searching for mica discovered green crystals at Kaliguman near Udaipur in Rajasthan.[26] Emeralds had, however, been plentiful in India since the late sixteenth century when they were first imported into the country by Spanish traders, probably through Bengal, after a long ocean voyage from the New World via Manila in the Philippines.[27] In 1537 the Spanish Conquistadors discovered the old Incan emerald mine of Chivor near Boyaca in the mountains of central Colombia; in 1567 they located the mines of Muzo and Coscuez, and by the end of the century they were steadily exporting jewels to Europe and India.[28] The astonishing quantity of emeralds shipped to India and acquired by the Mogul emperors can be judged by the thousands that have survived from the war booty of Nadir Shah as part of the crown jewels of Iran.

Upon their arrival in India, the emeralds were sent to Jaipur where they were fashioned into jewelry and, more significantly, often carved with elegant floral motifs to please the tastes of the Mogul emperors and nobles. One of the finest surviving examples of this work is an oval stone, superbly sculpted with a blossoming flower whose crisp leaves surround and echo its swelling volumes [Fig. 142]. The cool, sublime beauty of this fine gem aptly conveys why emeralds were once poetically called "tears of the moon."[29] It may even be the very stone that Jahangir described in awe as being "of such a beautiful colour and delicacy as I have never before seen."[30]

Perhaps the most extraordinary emerald to have survived from the Mogul period is known, appropriately enough, as the "Taj Mahal Emerald" [Fig. 143].

140 Hexagonal emerald
Mogul, c. 1700–1750
Colombian emerald
$\frac{25}{32}$ × 1$\frac{1}{16}$ in. (2 × 2.7 cm.)—actual size
Weight: 52.5 carats
Lewis Collection, Chicago

The spectacular green stone, which weighs 141.13 carats, is carved with what appear to be stylized chrysanthemums, lilies, poppies, and irregular lobed leaves, all arranged in an organic, asymmetrical pattern on the front of the gem. The superb quality of the carving suggests that the emerald was sculpted during the reign of Shah Jahan, probably between 1630 and 1650. It may have been worn as a necklace ornament and was probably mounted in gold or jade, as the reverse is unadorned.

A fashionable way of wearing emeralds in the Mogul period was as a necklace pendant. One fine carved hexagonal stone has a small channel drilled in the top which was used to fasten it, probably to a chain of pearls [Fig. 140]; it is decorated with a flowering plant on one side and an open bud on the other, and marching chevrons around the edges. Emeralds were often set into mounts of precious metal or jade, but the fact that this stone was carved on both sides and along the edges indicates that it was meant to be suspended from a necklace. Although the gem was probably carved in the early eighteenth century, it continues a style of personal decoration begun under Jahangir and Shah Jahan.

Emeralds were often shaped into spheres and strung together into dazzling necklaces. Raja Bikramajit of Bandhu, a high-ranking Mogul officer serving the young Shah Jahan [see Fig. 25], presented Jahangir with a strand of emeralds valued at 10,000 rupees when he

141 Necklace
Mogul, c. 1600–1650
Colombian emeralds with gold clasp
L: 26 in. (66 cm.)
Weight: 530 carats
Dar al-Athar al-Islamiya, Kuwait National Museum (LNS 30 HS)

142 Emerald with design of a flower
Mogul, c. 1625–50
Colombian emerald
$1\frac{3}{8} \times 1\frac{1}{4}$ in. (3.6 × 3.2 cm.)—actual size
Weight: 109.7 carats
Dar al-Athar al-Islamiya, Kuwait National Museum (LNS 35 HS)

143 The "Taj Mahal Emerald"
Mogul, c. 1630–50
Colombian emerald
$1\frac{9}{16} \times 2$ in. (4 × 5.1 cm.)—actual size
Weight: 141.13 carats
M. I. Harman, Martin I. Harman, Inc., Benjamin Zucker
(Precious Stones Company), and J. & S. S. De Young, Inc.

144 *Shah Jahan Holding a Turban Ornament*
Detail of page from the Late Shah Jahan Album (see Fig. 37)
Los Angeles County Museum of Art, From the Nasli and Alice
Heeramaneck Collection, Museum Associates Purchase
(M.78.9.15)

The emperor is holding an aigrette and wearing a plumed
ornament and pearls in his turban. Around his neck are ropes of
pearls, emeralds, and spinels. He has a jeweled armlet, bracelet
and rings, and a push dagger (cf. Fig. 179) is tucked into his
jeweled belt. His rich sword hangs from a brocaded sword belt
(cf. Fig. 176).

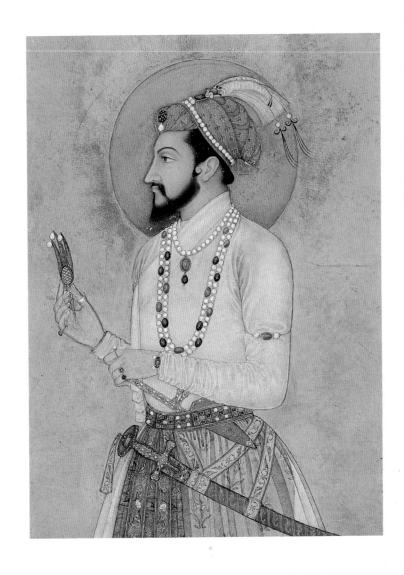

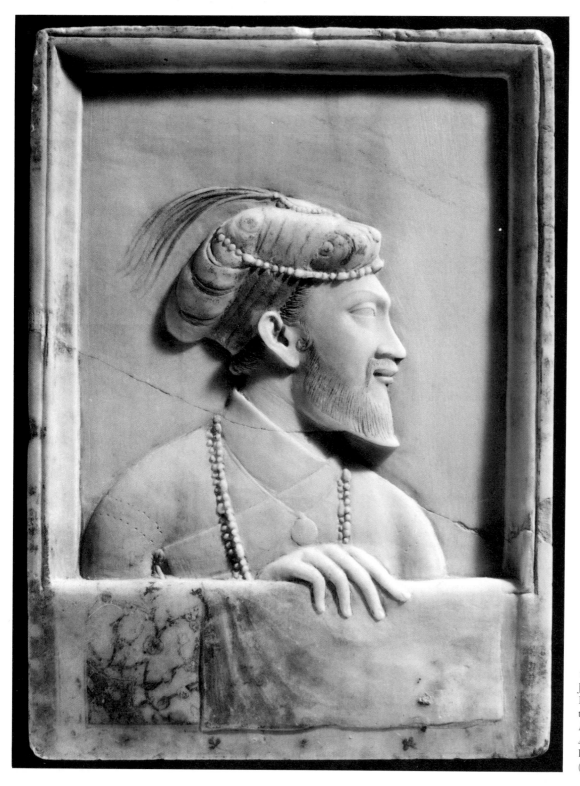

145 Relief portrait bust of Shah Jahan
By a Northern European artist at the Mogul court, c. 1630–40
Alabaster with polychromy
$4\frac{1}{2} \times 3\frac{1}{4}$ in. (11.5 × 8.4 cm.)
Rijksmuseum, Amsterdam (12249)

146 Archer's thumb ring
Mogul, c. 1650
Nephrite jade with gold, rubies, and emeralds
$1\frac{11}{16} \times 1\frac{1}{4}$ in. (3.7 × 2.8 cm.)
The Brooklyn Museum, New York, Anonymous loan (L77.33.3)

147 Archer's thumb ring of Shah Jahan
Mogul, Delhi or Agra; inscribed with the title of Shah Jahan and the date 1632
Nephrite jade with gold inlay
$1\frac{5}{8} \times 1\frac{1}{4}$ in. (4.1 × 3.2 cm.)
Trustees of the Victoria and Albert Museum, London, From the Waterton Collection (1023–1871)

was honored with the privilege of attacking the fort of Kangra in the Panjab Hills.[31] On his sixteenth birthday, Prince Khurram was given by his father an emerald necklace, which can be seen among the many splendid gifts depicted in a painting of the celebrated event.[32] Similar to it is an impressive graduated string of seventy-eight carved emerald beads, which is fastened by a golden globe pierced with a delicate filigree of abstract floral motifs [Fig. 141].

Archers' thumb rings were originally designed for military use, but those of the Mogul period were often decorative and ceremonial rather than functional. They were normally made of jade and often lavishly inlaid with gems set in fine gold wire. One particularly beautiful example has a carved ruby in the center with flanking ruby and emerald flowers and leaves [Fig. 146]. A historically important thumb ring demonstrates a totally different decorative style [Fig. 147]. Fashioned out of pure white jade, it is unadorned except for an elegantly engraved inscription inlaid in gold inside a curvilinear cartouche. The epigraph gives a date of 1632

and Shah Jahan's favorite royal epithet, "Second Lord of the Auspicious Conjunction," which referred to and emulated his illustrious ancestor Timur.

As we have seen, the formal qualities of Mogul decorative arts were partially inspired by works of art imported from Europe. In addition to those works, European artists influenced artistic production through their employment in the imperial ateliers. Niccolao Manucci, a Venetian artillery expert and self-professed physician who was in India from 1656 to 1717, reported that as far back as the reign of Akbar there were many Europeans working for the Moguls as "lapidaries, enamellers, goldsmiths, surgeons, and gunners."[33] The Jesuit missionary Father Francisco d'Azevedo wrote in 1632 that there were some four hundred Christians attending his church in Agra;[34] and while some of his congregation were certainly Armenians and Indian converts, there must have been a significant number of Europeans.

The art form most directly attributable to European craftsmen working at the Mogul court is the portrait

148　Wine cup in the shape of a gourd
Mogul, c. 1625–50
Nephrite jade
2⅞ × 8 in. (7.4 × 20.3 cm.)
Asian Art Museum of San Francisco, The Avery
Brundage Collection (B60J485)

149　Wine cup in the form of a poppy
Mogul, c. 1650–75
Nephrite jade with gold, rubies, and emeralds
H: ¾ in. (1.8 cm.); D: 2½ in. (6.4 cm.)
Private Collection

cameo. These minutely carved representations were cut from layered pieces of sardonyx so that solid, raised images were left revealed against the generally darker background. Perhaps inspired by a miniature painting of King James I of England (r. 1603–25) that may have been worn by Sir Thomas Roe, engraved and painted portraits of the Mogul emperors and nobility were the rage at court from 1615 to 1628. Orthodox Muslims frowned upon such images because of the religious prohibition against portraiture, and the formal wearing of such likenesses by imperial courtiers as a turban ornament, known as a *shast*, was accordingly banned by Shah Jahan in one of his first imperial proclamations.[35] The tradition was continued informally in the medium of cameo, however, as at least two portrait cameos of Shah Jahan have survived. The earliest dates from around 1630–40 and was apparently made by a European master engraver.[36] The second was probably carved around 1660 by an Indian artist trained in the European technique, as the eye is rendered in a style similar to that found in contemporary Indian painting [Fig. 137]. In the late seventeenth or early eighteenth century it was set in a silver mount, possibly in Golconda or Hyderabad in the Deccan.[37] The cameo realistically portrays the emperor in old age. His jeweled ornaments and luminous halo aptly convey the wealth and absolute authority enjoyed by the Mogul rulers. In addition to portraits, there are also cameos from Shah Jahan's reign with narrative scenes and animals. Perhaps the best known of the former depicts Prince Khurram attacking with a sword a lion, which was mauling an army officer, who was in turn defending Jahangir—a subject of which a painting also exists (see above, p. 94).[38]

A European craftsman must have been responsible for a unique portrait of Shah Jahan, made of alabaster with traces of polychromy [Fig. 145], which depicts the emperor at the palace window where he made his public appearance or *jharoka-darsan* (see above, p. 49 and Fig. 35). The image has an apparent informality to it, with the emperor looking to his left and his right hand resting on the window-sill, as if he were gazing at someone out of sight. The effect is like that of a snapshot, capturing a moment in the life of the monarch. It is also a glimpse of royalty such as might have been seen by a foreign artist perhaps not fortunate enough to have been granted imperial intimacy.

JADE AND HARDSTONE VESSELS

A broad range of luxury goods was provided for the Mogul rulers' daily necessities. The frequent feasts demanded suitably imperial vessels. Wine cups, food bowls, and serving platters survive in far greater numbers than any other vessels designed for court use. They are often crafted of nephrite jade, which in addition to its symbolic connotations possesses sensuous tactile qualities that must have greatly appealed to the acute aesthetic sensibilities of Shah Jahan and his fellow emperors. Although trading in jade from Central Asia is mentioned in imperial histories as early as the reign of Akbar, only one inscribed object from the period is known to have survived.[39] Mogul jades made in the reign of Jahangir were dependent upon Timurid prototypes, of which many examples were collected by the emperor.[40] It took the creative genius and enlightened patronage of Shah Jahan for the production of works of jade in a uniquely Mogul style to begin in earnest.

Early Mogul jade wine cups are often inscribed with passages from Persian poetry praising the glories of wine, and sometimes also with the emperor's name and the date of execution. The imperial inscriptions indicate the high esteem in which they were held, as well as their considerable rarity: inscriptions are not normally found later, when jade objects had become much more common.

A translucent, mottled green jade wine cup from the Shah Jahan period, fashioned in the shape of a halved turban gourd [Fig. 148], is inscribed with the command to "Drink at the order of Allah." There are two other such cups of the same form which are also engraved: one bears a couplet identifying the owner as Shah Jahan and the date 1647/48, while the other has an inscription stating that it is a Turkish copy of a Mogul vessel.[41] On the basis of the one date, all three are usually ascribed to the middle of the seventeenth century; but the use of dark green rather than white jade and the archaistic stout form suggest an earlier date, perhaps closer to the late 1620s. The peculiar gourd shape may ultimately be derived from vessels made during the Ming dynasty of China (1368–1644).

Perhaps developing out of the gourd shape, but showing a greater sophistication of form, is a white jade wine cup [Fig. 150]. The vessel is of the same basic design as the famous 1657 Shah Jahan cup [see Fig. 131],

150 Wine cup
Mogul, c. 1625–30
Nephrite jade
$1\frac{7}{8} \times 8$ in. (4.8 × 20.3 cm.)
Los Angeles County Museum of Art, From the Nasli and Alice
Heeramaneck Collection, Museum Associates Purchase (M.76.2.1)

151 Bowl
Mogul, c. 1650
Nephrite jade
H: $2\frac{1}{4}$ in. (5.7 cm.) D: $6\frac{1}{4}$ in. (15.9 cm.)
Los Angeles County Museum of Art, From the Nasli and Alice
Heeramaneck Collection, Museum Associates Purchase (M.76.2.2)

152 Jug
Mogul, c. 1650–1700
Nephrite jade
H: $3\frac{1}{4}$ in. (8.3 cm.) D: $2\frac{1}{8}$ in. (5.4 cm.)
The Brooklyn Museum, New York, Gift of the Guennol
Collection (78.7)

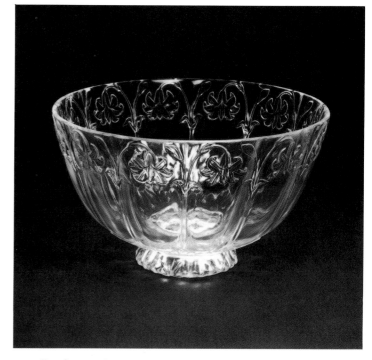

153 Bowl
Mogul, c. 1650
Rock crystal
H: $3\frac{1}{4}$ in. (8.3 cm.) D: $5\frac{7}{8}$ in. (14.9 cm.)
Trustees of the Victoria and Albert Museum, London
(IS 986–1875)

but the stiffer rhythms, bolder forms, and greater thickness of its walls suggest a somewhat earlier date of around 1625–30. This type of vessel adorned with a scrolling finial probably shows the influence of European (Florentine or South German) hardstone carving.

A direct borrowing by the eclectic Mogul artists from the European repertoire of decorative imagery is evident on a bowl made of mottled, spinach green jade [Fig. 151]. The vessel is fashioned with two handles formed from foliate scrolls of acanthus leaves, which were depicted in Western art as far back as the seventh century B.C. when they were used on Corinthian capitals. Floral forms in Mogul decorative arts often had a double function, serving as ornament and, at the same time, as handles or to define the shape of an object.

Another jade vessel popular in the Mogul period was a type of small jug or pot [Fig. 152], carved in a shape possibly derived from fifteenth-century Timurid covered metal tankards with a bulbous body and a vertical neck. Several Mogul examples survive, and at least one from Turkey. They are all decorated with two borders of acanthus leaves that encircle the shoulder and base. The handles are again formed from acanthus leaves; here, however, they terminate in pendant buds rather than curling back on themselves. Jugs of this particular shape continued to be made into the eighteenth century, with the chief stylistic differences being the degree of crispness in the outline and ribbing of the acanthus leaves and the addition of inlaid ornamentation.

A more sumptuous style of decoration for jade vessels began to be fashionable after the middle of the seventeenth century, as exemplified by a bejeweled wine cup [Fig. 149]. Carved to resemble a poppy flower, it is inlaid with rubies and emeralds set in gold and was presumably used to drink spiced wine laced with opium. Imperial memoirs and historical accounts are replete with references to the consumption of this concoction. It was extremely debilitating and probably shortened the lives of Jahangir and many other addicted members of the nobility.

Besides jade, several other hardstones were frequently fashioned into vessels and luxury items by the Mogul artists. Rock crystal was a favorite medium for carving in India for well over a thousand years before the reign of Shah Jahan. It was used in ancient times by the Buddhists to make amulets, reliquaries, and votive objects. In the Mogul period, crystal vessels were highly valued as presents to be given to the emperors in the hope of being granted a boon or trading concessions.[42] Tavernier records seeing Aurangzeb drink from a "large cup of rock-crystal, all round and smooth, the cover of which was of gold."[43] Though incredibly fragile, a number of such cups and bowls have survived. One of the largest and perhaps the most enticing is delicately carved with attenuated lily stems and dangling blossoms that ring the upper rim of the bowl [Fig. 153].

Another favorite hardstone used in the Mogul period was agate. Decorative objects carved from the variegated mineral were made in the coastal city of Cambay in Gujarat in Western India as early as the time of the Romans.[44] Such work continued to be produced, and over fifteen hundred years later Tavernier recorded of Cambay: "Here those beautiful agates which come from India are cut into cups, handles of knives, beads, and other objects of workmanship."[45] Agate was mined in the Deccan plateau of South-Central India and shipped to Cambay where it was heated to produce different hues and then carved into the desired shapes. Among the loveliest of such works from the Shah Jahan period is an extraordinary six-lobed bowl elegantly fashioned from pale rose-colored agate [Fig. 162], which rests on a plain circular foot and is unadorned except for a gilt copper rim. The subtle color and faceted surface invite its being caressed and savored.

OTHER LUXURY ITEMS

In addition to cups and bowls of jade and other hardstones, luxury goods made for the Mogul emperors and members of the nobility included highly decorated *huqqa* or water-pipe bases and mouthpieces, elaborate cosmetic containers, silvered glass or crystal mirrors with carved and inlaid jade frames, and even finely wrought fly-whisks and jeweled backscratchers. Rosewater sprinklers became particularly important because of their ceremonial function. They were initially used at the Mogul court to celebrate the festival of Ab Pashan, introduced from Iran, which commemorated a historical rainfall that ended a drought and famine,[46] and gradually they served on a broad range of auspicious occasions to welcome arriving guests. They continue to be used at traditional Indian weddings even today.

Although numerous later examples survive, seventeenth-century rosewater sprinklers—and silver objects

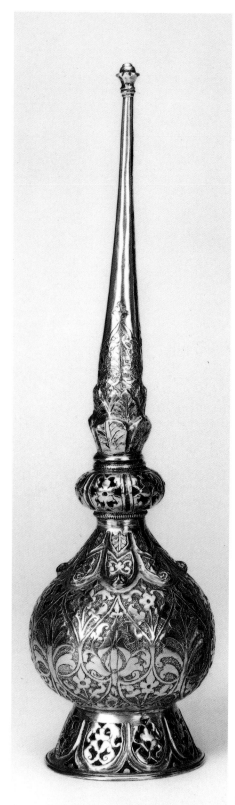

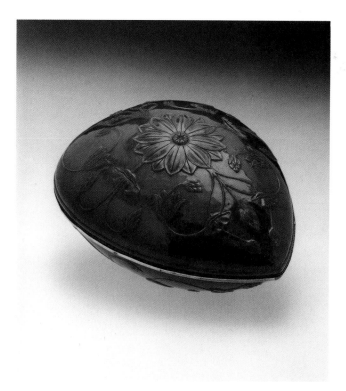

155 Teardrop-shaped box
Mogul, c. 1650
Nephrite jade with band of copper, gold, and silver alloy
$2\frac{7}{8} \times 5\frac{1}{2}$ in. (7.3 × 13.9 cm.)
Los Angeles County Museum of Art, From the Nasli and Alice
Heeramaneck Collection, Museum Associates Purchase
(M.76.2.3.a,b)

in general—are extremely rare. Among the finest is one of silver gilt with a long tapering neck and a globular body surmounting an openwork splayed footring [Fig. 154]. It is decorated in repoussé (formed in relief by being hammered from the underside) with ovate leaf-shaped panels alternately containing stylized plants and palmettes, with additional floral motifs in the spaces between the panels. The early seventeenth-century date is confirmed by its close similarity to two vessels from the same family collection that bear on their base the engraved coat of arms of William, 2nd Earl of Desmond and 3rd Earl of Denbigh. The 1st Earl of Denbigh went to India in 1631 and must have brought the three vessels back with him.[47]

Large numbers of gold and silver vessels are recorded as having graced the quarters of the harem.[48] Many no

154 Rosewater sprinkler
Mogul, c. 1600–1630
Silver gilt
H: $11\frac{1}{2}$ in. (29.5 cm.)
Paul F. Walter

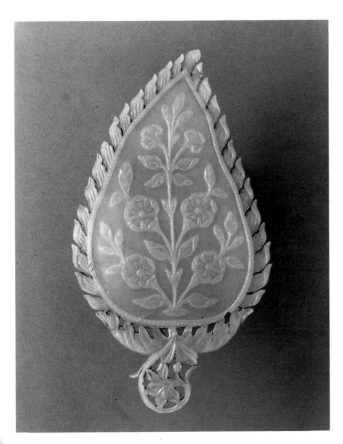

156 Leaf-shaped mirror
Mogul, c. 1675–1700
Nephrite jade and rock crystal
6½ × 3⅝ in. (16.5 × 9.2 cm.)
Los Angeles County Museum of Art, From the Nasli and Alice
Heeramaneck Collection, Museum Associates Purchase
(M.84.32.2)

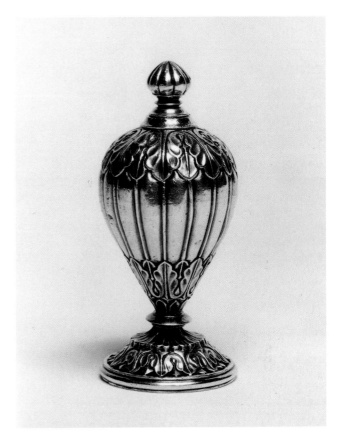

157 Flask for kohl (antimony)
Mogul, Agra or Delhi, c. 1650–1700
Silver
H: 3½ in. (8.9 cm.)
Arthur M. Sackler Museum, Harvard University, Cambridge,
Mass., Anonymous loan

doubt were used to store women's cosmetics, and that may have been the role of an especially extravagant cylindrical gold box with a domed lid, heavily adorned with rubies and emeralds set against a background of metal foil [Fig. 166]. Despite its small size, it is one of the finest examples of Mogul gold to survive from the early seventeenth century. It epitomizes the florid objects described by Bernier as "rare pieces of goldsmith's work, set with precious stones of great value."[49]

A delicate two-sided jade box has a surface enriched with stylized lotus plants whose graceful tendrils and tender buds accentuate its teardrop-shaped contours [Fig. 155]. It may have originally contained women's cosmetic powder; alternately, since its shape is similar to that of boxes used in later times to hold the popular delicacy betel nut, that may have been its function.

First imported in the early sixteenth century, silvered mirrors were in great demand at the Mogul court, where they not only aided the application of cosmetics but were regarded as exotic curiosities. They were fronted with rock crystal or glass panels, and backed with carved and inlaid jade frames. A particularly exuberant example is fashioned in the shape of a leaf with a handle formed by a flower encircled by its stem [Fig. 156]. The back is decorated with a blossoming plant set into a flat central plane. The dynamic asymmetry of the leaf shape results in a much livelier expressiveness than is shown by other known Mogul mirrors, which are normally more regular in form.

A common cosmetic still in use in India today as eye makeup is kohl, a preparation of black powdered antimony sulfide. Seventeenth-century vessels used to

hold the substance are extremely rare. One that has survived is made of cast silver [Fig. 157]. The tiny bottle's overall design appears to be derived from the baluster column that suddenly appeared in Mogul architecture during the early reign of Shah Jahan as a result of European influence [see Fig. 71].[50] The acanthus leaves embellishing its surface were borrowed from the arts of the West.

Another common type of vessel in the Mogul period was the *huqqa* or water-pipe. It was used to cool tobacco smoke by drawing it from a hot bowl in which it was burned through cold water in a vase; the smoker then inhaled it through a long, usually porous tube fitted with a mouthpiece [see Figs. 111, 121]. The practice of smoking tobacco was introduced into India in the late sixteenth century by the Portuguese traders in the Deccan, and reached the Mogul court in 1604 through its importation by one of Akbar's officers, Asad Beg. Members of the Mogul and Rajput nobility took great delight in smoking their pipes at leisure, often with companions in the evening on a cool terrace. The presence of a water-pipe in an intimate palace scene was a stock motif of painters to signify royal ease and luxury. Although representations of water-pipes first appear around 1620 or 1630 in paintings depicting mystics and ascetics, the Mogul emperors themselves apparently refrained from their use until the early eighteenth century.[51]

A major center for the production of water-pipe bases and other fixtures was the town of Bidar in present-day northern Karnataka in the Deccan. Beginning in the early seventeenth century, water-pipes and other types of vessels were produced here in a technique unique to India. Known as *bidri* ware (from Bidar), the objects were made of an alloy composed of zinc with smaller amounts of lead, tin, or copper. After casting, the surface of the vessel was chemically treated to blacken it. Patterns were engraved and inlaid with silver and/or brass, and the surface was burnished and again treated to darken the ground.

The earliest designs on such vessels were abstract floral arabesques derived from the long heritage of Islamic art. After the adoption of the naturalistic flower by the Moguls, and especially during the later part of Shah Jahan's reign, *bidri* ware water-pipes were enlivened with floral forms and exported to the Mogul court. One of the finest of these is spherically shaped and decorated with a cuspate trellis pattern separated by

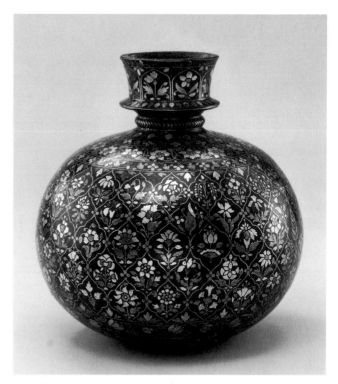

158 *Huqqa* base
Deccan, Bidar, c. 1650–1700
Alloy of lead, tin and zinc with silver and brass inlay
H: 8 in. (20.3 cm.)
Anonymous

quatrefoils [Fig. 158]. The interior of the lattice work is filled with representations of flowering plants, each one amazingly different from the others.

Another spherical water-pipe base is made of blown glass and adorned with wheel-cut blossoming plants in scalloped ogival cartouches [Fig. 160]. It is probably somewhat later than the Shah Jahan period, but its floral decoration represents the continuation of the decorative motifs featured on the Taj Mahal. Most so-called "Mogul" glass was made in England or on the European continent, and then decorated in India. A large number of glass vessels are depicted in contemporary paintings [see Fig. 122], but few survive.

Until the invention of flat-bottomed water-pipes in the third and fourth decades of the eighteenth century, support rings were needed to prevent the spherical vessels from toppling over onto their side. The most stunningly ornamented example is an enameled ring

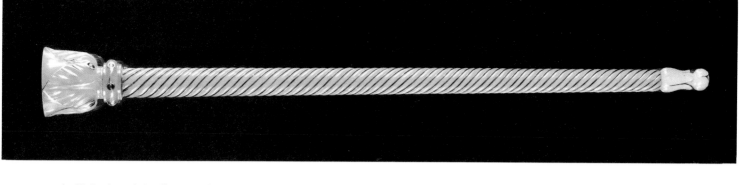

embellished with brilliant red poppies and green leaves set against a white background [Fig. 167]. Mogul enamel work is traditionally said to have begun in 1560 with the arrival of five enamelers from Lahore in the Panjab at Amber (old Jaipur) in Rajasthan.[52] It is more likely, however, that the technique was imported from Europe. Almost all the Mogul objects were created using the technique of inlaying known as "champlevé." In early examples the enamel is opaque, while in later works from the end of Shah Jahan's reign and afterwards it is translucent. As this ring shows both types of enamel (the white is opaque, the red and green translucent), it is a transitional piece and may therefore be dated to around 1635.

The method of smoking from water-pipes also involved the use of a mouthpiece, of which large numbers were made, as Mogul nobles tended to prefer to have their own. Mouthpieces were usually carved of jade and ornately decorated with floral motifs made of inlaid gems set in gold wire. Many are curved to facilitate their use. One of the finest, although slightly later than the Shah Jahan period, is made of white jade inlaid with diamonds, rubies, and emeralds in the form of blossoming flowers with prominent stamens fashioned out of gold and emeralds [Fig. 165]. Chinese-style clouds made of rubies float around the flowers.

Another of the numerous practical and emblematic articles that were produced for court use was the fly-whisk, which had been prominent in Indian culture for over fifteen hundred years. Symbolic of divine and worldly sovereignty, it was adopted by the Moguls as part of their own regal image. The handles and whisks were made in a wide variety of materials, with whisks made of the tail of the Tibetan yak preferred for imperial usage. A fine fly-whisk handle carved of jade and ornamented with jewels and precious metals has both ends terminating in floral motifs [Fig. 159]. The spiraled middle section is probably a later Turkish replacement.

159 Fly-whisk handle
Mogul, c. 1650, with later Turkish additions
Nephrite jade with gold, silver, and rubies
L: 12¾ in. (31.4 cm.)
The Metropolitan Museum of Art, New York, Anonymous Gift, 1971 (1971.262)

160 *Huqqa* base
Mogul, Agra, c. 1700
Glass with wheel-cut decoration
H: 6¾ in. (17.2 cm.)
Museum für Indische Kunst, Staatliche Museen Preussischer Kulturbesitz, Berlin (West) (I 331)

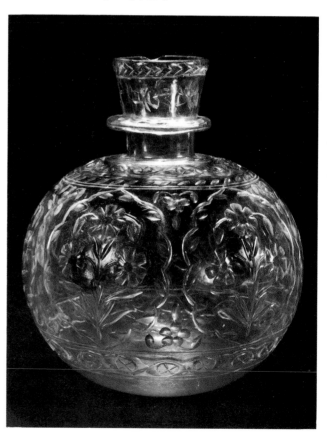

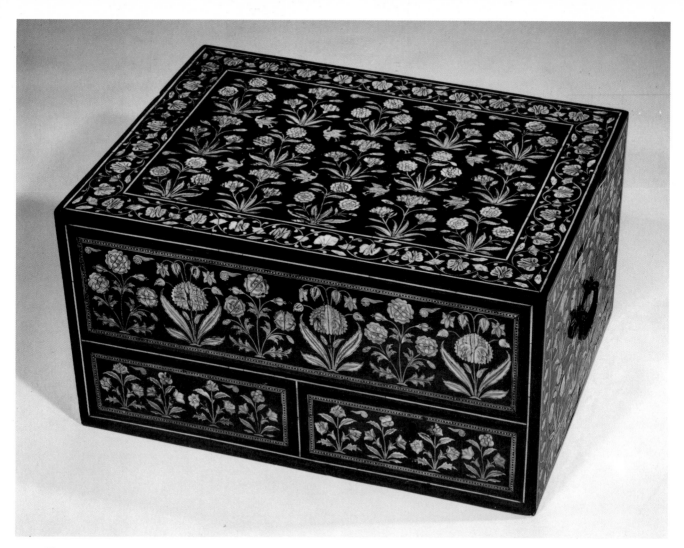

161 Chest
Western India or Deccan, c. 1650–1700
Wood with ivory inlay and iron fittings
11 × 21⅝ × 16¼ in. (28 × 54.9 × 41.3 cm.)
The Metropolitan Museum of Art, New York, Fletcher Fund,
1976 (1976.176.1)

162 Bowl
Mogul, c. 1625–50
Agate with gilt copper rim
H: 2¼ in. (5.7 cm.) D: 4¾ in. (12.1 cm.)
Los Angeles County Museum of Art, From the
Nasli and Alice Heeramaneck Collection,
Museum Associates Purchase (M.76.2.6)

Fine, often gossamer-like bed and floor coverings adorned the Mogul palaces [see Fig. 188], and were frequently held in place by weights called "carpet slaves." The shape of these weights relates to elements found in contemporary architecture, as do their design motifs. Several decorated with *pietra dura* inlay are known, including one in alabaster emblazoned with Mogul floral motifs made of fine gemstones [Fig. 168]. The slight stiffness of the flowers suggests a date somewhat later than the reign of Shah Jahan.

Wooden chests and writing cabinets, often inlaid or faced with ivory, survive in larger numbers than any other item of palace furniture from the age of Shah Jahan. The chests were made in Western India and the Deccan during the seventeenth century. Usually exported to foreign markets, they were designed with the prospective buyer's aesthetic preferences in mind: although the place of manufacture for many of these chests is disputed, scholars agree that their conception was influenced by the demands of Portuguese traders.

163 Seal of Shah Jahan
Mogul; inscribed with the name and title of Shah Jahan
and the date 1651
Brass with modern ebony handle
D: 1¾ in. (4.4 cm.)
P. McMahon Collection, Dublin, Ireland

164 Muhammad ibn Qaim Muhammad, Astrolabe
Mogul, Lahore, dated 1657/58
Brass
D: 6¾ in. (17.1 cm.)
Galerie J. Soustiel, Paris

The example illustrated here, inlaid in ivory with alternating species of flowering plants, was probably intended for the Mogul court [Fig. 161].

Numerous objects for palace use were made of brass, which is a medium that is not commonly associated with the Mogul rulers because of their fondness for more expensive materials. Elegant works of art could be made from the metal, however, as it was eminently suitable for calligraphic engraving and for chased patterns. Among the finest created during the reign of Shah Jahan is a seal dated 1651 and inscribed with the name of Shah Jahan and one of his imperial sobriquets, "Victorious Monarch" [Fig. 163]. The seal, which would have been used to authenticate royal documents, is similar to a silver example held by Shah Jahan in a painting by Abul Hasan [see Fig. 129].

Another exquisite brass object from the Shah Jahan period is an astrolabe, used to determine the altitude of various heavenly bodies and for other astronomical calculations [Fig. 164]. There is a long history of the production and use of astrolabes in the Islamic world, reflecting the importance accorded to astrological calculations by the Muslim rulers and populace. This especially beautiful example, ornamented with an elegant interlacement of floral motifs, was made in 1657/58 in Lahore by Muhammad ibn Qaim Muhammad, who was a member of a family that had constructed such instruments under imperial Mogul patronage for over a century.

WEAPONS

The refined sense of aesthetics exhibited in Mogul decorative arts was also displayed in the weaponry created for the emperors and the imperial army. Mogul daggers and swords were embellished with jeweled hilts

made of precious materials [see Fig. 144] and their blades were crafted of the finest damascene steel (layers of metal forged together and etched to enhance the watered pattern). Shields and other military trappings were equally ornate and made in a variety of materials. Although primarily ceremonial, these richly ornamented weapons could be deadly functional when the need arose. They were often given to officers who had been successful in leading the many military campaigns undertaken to capture new territory for the empire. The wearing at court of such ornate daggers and swords signified royal favor, and they formed a prominent feature of the apparel of the nobility. That unique or extremely fine daggers were greatly prized by the emperors can be deduced from the fact that they are among the most frequently mentioned presentation objects in the imperial Mogul memoirs.

The hilts of Mogul daggers and knives are masterpieces of hardstone carving. They are frequently fashioned in the shape of an animal's head: horses, lions, and rams are the most commonly portrayed, but there are also antelopes, wild goats, camels, and falcons. At least one knife with a human head is known. Mogul daggers may also be decorated entirely with floral forms. Starting some time in the early reign of Aurangzeb, the surface of the jade handles began to be inlaid with gemstones set in gold wire and arranged into floral motifs.

One of the most delicately carved of all Mogul dagger hilts is one made of white jade [Fig. 169], adorned with acanthus leaves on the upper edge of the pommel and a row of floral sprays along the sides. The curved pistol-grip form was probably derived from gun butts shaped like parrot heads that were popular in the southern Deccan, and seems to have been adopted by Aurangzeb during his years of service in that region. The style of carving is very close to that of the 1657 Shah Jahan wine cup [Fig. 131], which suggests a similar date of execution.[53]

The paucity of Mogul decorative art objects that are inscribed with a date has long presented difficulties in the attempts of scholars to determine a chronological framework with definite stylistic indicators and guidelines. The importance, therefore, of the few dated works of art cannot be overestimated. One that has heretofore been relatively unknown is a weapon with an inscription on the blade which states that it was the personal dagger of the Emperor Alamgir (Aurangzeb)

and furnishes the date 1660/61 [Fig. 173]. A gold parasol, the symbol of imperial ownership, is inlaid into the damascened blade near the inscription.

Hilts and blades were often sold separately in order to create a custom dagger. This is proven by a painting from around 1680 in which hilts without blades attached are shown displayed for sale.[54] Yet the fact that the gold decoration on the blade of the Aurangzeb dagger perfectly fills the space under the quillon or butt of the hilt, which is atypically curved as if perhaps to accommodate the adornment, suggests that the handle is original.

The Aurangzeb dagger is as beautiful as it is significant. Its hilt is superbly sculpted out of aqua-green jade in the shape of a horse's head. The burnt-orange skin of the jade, which is normally removed in Mogul work, has been left in certain areas to give a rich color. Where it adjoins the blade, the hilt is adorned with acanthus leaves and curled tulips. Stylized acanthus leaves cast in the steel on both faces of the blade echo the floral motifs found on the handle. The quality of the carving on the hilt is consistent with its attribution to the imperial ateliers, where the inscription indicates that the blade was manufactured. Fashioned in the second year of Aurangzeb's reign, the dagger must have been made by master artists who had previously worked under Shah Jahan. It is perhaps the earliest extant example of the survival of Shah Jahan's aesthetic ideals.

Besides warfare and ceremonial displays, weapons were also needed for hunting, a popular pastime which provided entertainment for the court and proved the bravery and prowess of the emperor and nobles. Among the most sought-after prey was the nilgai, the slate-blue wild buck antelope of India [see Fig. 102]. Numerous paintings depict the hunt of the creature [see Fig. 89]. A favorite tamed antelope, although of a related species and not a true nilgai, was so admired by Jahangir that he ordered a monument erected to it after its death.[55] Perhaps as testimony to the imperial fascination with the animal, one of the finest surviving Mogul dagger hilts is carved in the shape of a nilgai [Fig. 174], in a dark grey-blue jade of especially appropriate color. The antelope's delicate ears are perked up in attention. Its neck is gently rippled to assist in grasping the handle. Floral motifs and acanthus leaves complete the decoration at the base of the hilt.

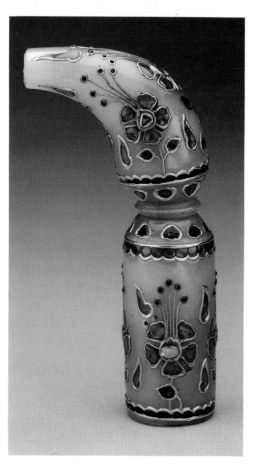

165 *Huqqa* mouthpiece
Mogul, c. 1675–1700
Nephrite jade with diamonds, rubies, and
emeralds set in gold
H: 3⅞ in. (9.9 cm.) D: ⅝ in. (1.6 cm.)—actual size
Los Angeles County Museum of Art, From the
Nasli and Alice Heeramaneck Collection,
Museum Associates Purchase (M.76.2.10)

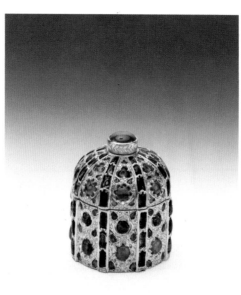

166 Cylindrical box with cover
Mogul, c. 1625
Gold inlaid with rubies and emeralds
H: 1¼ in. (3.3 cm.)—actual size
Anonymous

168 OPPOSITE Weight for floor covering
Mogul, c. 1700
Alabaster with gemstone inlay
3¾ × 3⅜ in. (9.5 × 8.5 cm.)
Virginia Museum of Fine Arts, Richmond,
The Nasli and Alice Heeramaneck Collection,
Gift of Paul Mellon (68.8.141)

167 Ring for a *huqqa* base
Mogul, c. 1635
Gold and enamel
H: 1⅛ in. (3 cm.) D: 5¾ in. (14.5 cm.)—actual size
Dar al-Athar al-Islamiya, Kuwait National
Museum (LNS 2 J)

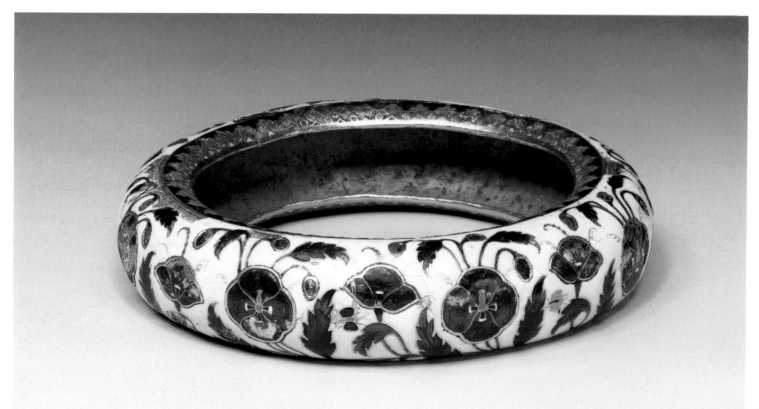

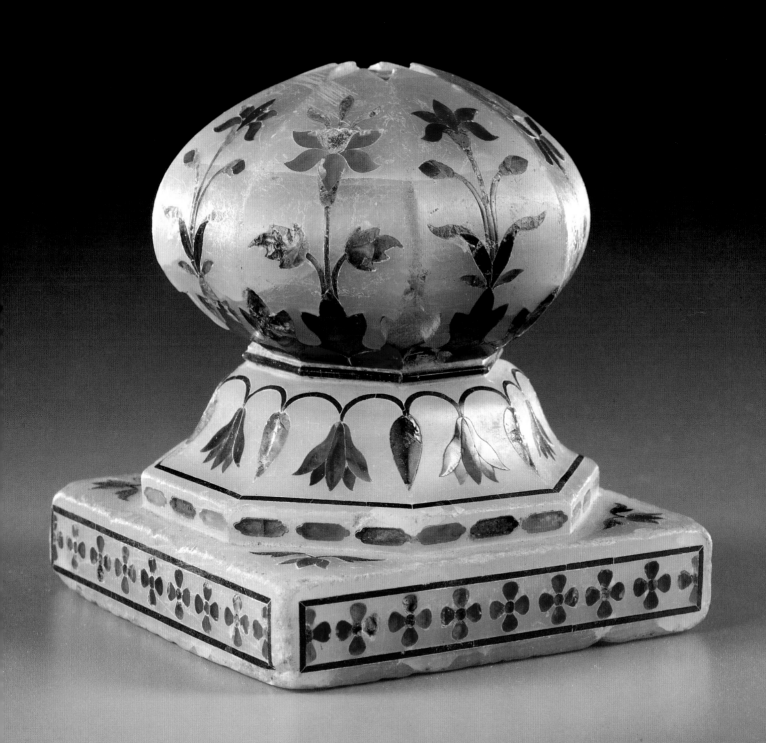

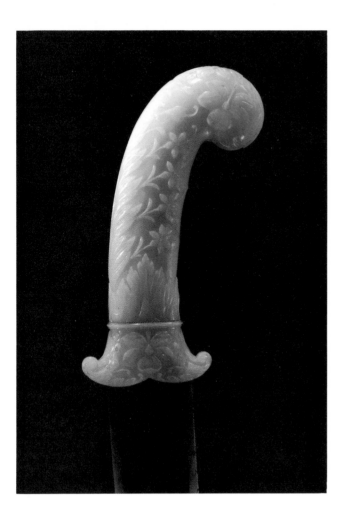

169　Dagger
Mogul, c. 1660
Nephrite jade hilt, steel blade
L (overall): 14⅜ in. (36.5 cm.)
The Metropolitan Museum of Art, New York, Purchase,
Mr. and Mrs. Nathaniel Spear, Jr., Gift, 1982 (1982.321)

170　Dagger hilt with ram's head
Mogul, c. 1650–1700
Nephrite jade
L: 4³⁄₁₆ in. (10.7 cm.)
Los Angeles County Museum of Art, From the Nasli and Alice
Heeramaneck Collection, Museum Associates Purchase
(M.76.2.12)

171　Knife with wild goat's head hilt
Mogul, c. 1700
Ivory hilt, steel blade inlaid with gold
L (overall): 7½ in. (19.1 cm.)
Mrs. J. LeRoy Davidson Collection, Los Angeles

172　Push dagger and sheath
Mogul, c. 1650–1700
Gold hilt inlaid with diamonds, rubies, and emeralds, steel blade
inlaid with gold, wooden sheath covered with red and green
velvet and gemstones
L: 14¹⁄₁₆ in. (35.7 cm.)
Dar al-Athar al-Islamiya, Kuwait National Museum (LNS 114 J)

Another dagger, with a horse's head hilt, is particularly instructive of how aesthetic preferences and decorative styles evolved at the Mogul courts [Fig. 175]. Probably carved late in the reign of Shah Jahan, the mottled grey-green jade hilt is fashioned into a spirited rendition of a neighing horse. At the base of the horse's neck, the quillon is decorated with blossoming flowers and acanthus leaves. The eyes and two triangular flowers on the handle, all made of rubies set in gold mounts, and a golden bridle inset with two rubies were added in the eighteenth or nineteenth century in order to conform to the more ornate mode of decoration favored by the later Mogul emperors. The dagger has a sheath which was probably fabricated at the same time.

The Mogul artists were keenly sensitive in their observation of nature and in their representations of various animals. One jade hilt precisely portrays a ram [Fig. 170; see also Fig. 18], which has curled horns, pendant ears, and tightly compacted swirls of hair, and a long muzzle with an open mouth showing its tongue and teeth. In contrast, a wild goat depicted on an exquisitely carved ivory hilt of a small knife, perhaps used to cut fruit by a lady of the court, is distinguished by its upstanding ears, its goatee, and its shorter, more angular snout [Fig. 171].

The type of personal weapon most commonly portrayed in Mogul and Rajput paintings is the push dagger [see, e.g., Figs. 112 and 144]. This deadly stabbing instrument is unique to India, and was quickly added to the Moguls' arsenal after its lethal effectiveness in the hands of Hindu warriors was pointedly and intimately realized. It consists of a sturdy steel blade

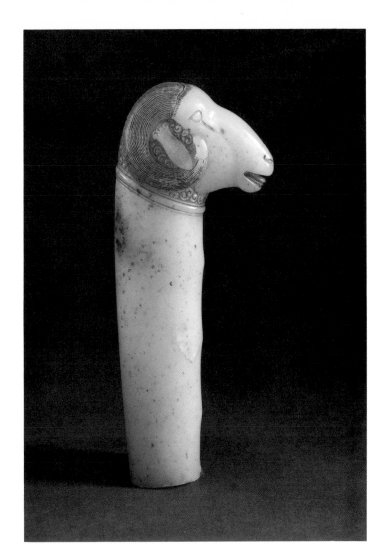
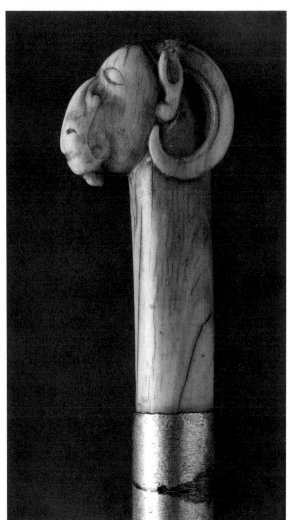
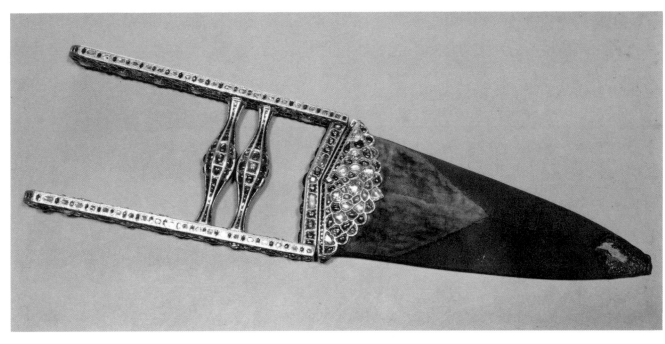

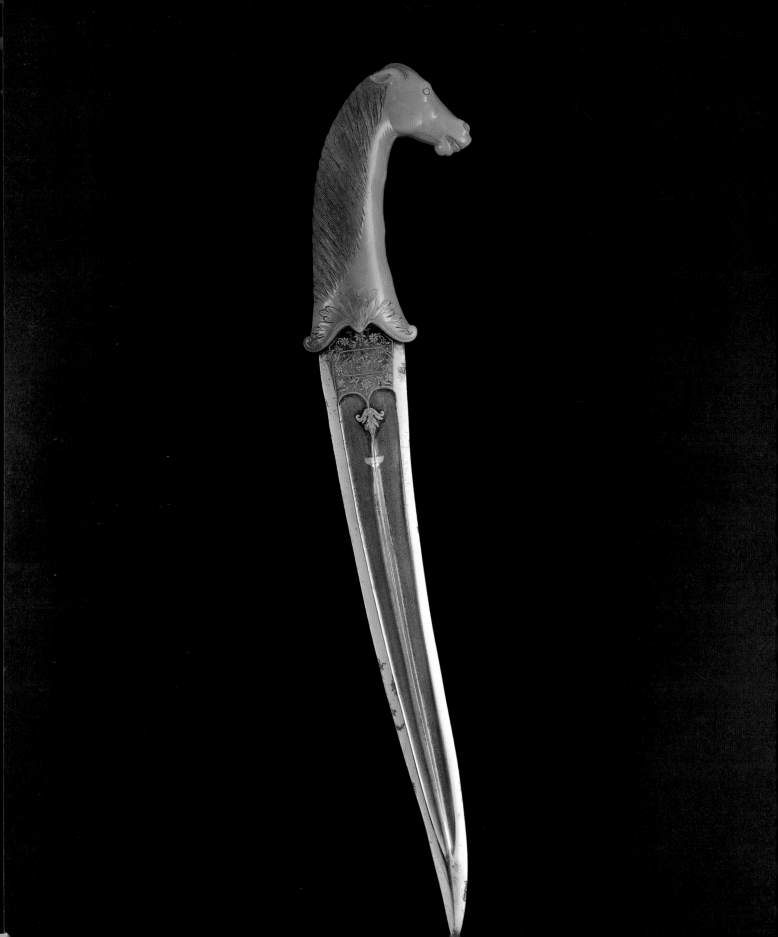

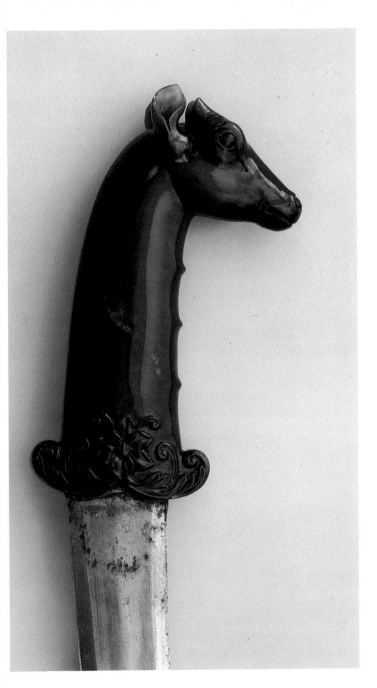

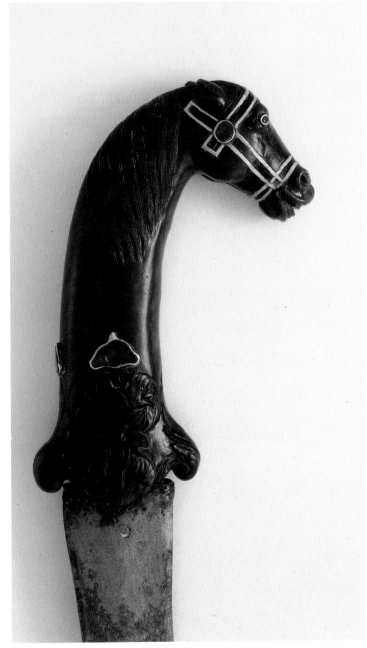

173 Dagger with horse's head hilt
Mogul; inscribed with the name of Alamgir
(Aurangzeb) and the date 1660/61
Nephrite jade hilt, steel blade inlaid with gold
L (overall): 13¾ in. (34.9 cm.)
Los Angeles County Museum of Art, From the
Nasli and Alice Heeramaneck Collection,
Museum Associates Purchase (M.76.2.7a,b)

174 Dagger with nilgai's head hilt
Mogul, c. 1650
Nephrite jade hilt, steel blade
L (overall): 15 in. (38.1 cm.)
The Metropolitan Museum of Art, New York,
The Alice and Nasli Heeramaneck Collection,
Gift of Alice Heeramaneck, 1985 (1985.58a)

175 Dagger with horse's head hilt
Mogul, c. 1650 with later additions
Nephrite jade hilt inlaid with gold and rubies,
steel blade
L (overall): 15 in. (38.1 cm.)
Lewis Collection, Chicago

with parallel iron handles and either one or two crossbars. More elaborate and later variations include double or scissoring blades, smaller blades hidden inside the larger blade, and even gun barrels extending from the handles. The push dagger is traditionally called a *katar*, although another term, *jamadhar* or "tooth of death," has recently been proposed.[56] During the reign of Shah Jahan, the term *phulkatar* was often used.[57] It means "flower-dagger" and probably designated a type that was decorated with floral motifs, as a number of such weapons have survived.

One of the most sumptuously ornamented push daggers known is encrusted with diamonds, rubies, and emeralds set in gold [Fig. 172; cp. Fig. 144]. A matching locket graces the mouth of the bicolored velvet sheath, which is missing its chape or tip. The blade is made of fine steel with an exuberant floral motif inlaid in gold. Another superb push dagger is particularly rare in having white enamel work on the handles, and has a design of rubies set in floral motifs punctuated by diamonds and emeralds [Fig. 179].

Swords were also fashioned into masterpieces of decorative craftsmanship during the Mogul period. The hilts ornately inlaid with gold and gemstones were usually made of iron rather than jade for greater strength. Like daggers, they were presented to high-ranking officers as a reward for meritorious service or bravery. Especially fine examples were also preferred gifts for inducing imperial favor. The most prized swords belonging to the Mogul emperors were honored with exalted epithets, such as "Infidel Slayer" or "Army Vanquisher."[58]

The personal swords of the Mogul emperors [see Figs. 18, 144], members of the imperial family, and the nobility were often inscribed with the owner's name, the date of manufacturing, and poetic or adulatory verses. Among the finest to survive has a stamped inscription giving the name of Shah Jahan's son Dara Shikoh and the date 1640/41 [Fig. 176]. On the back of the blade there is also an inscription inlaid in gold which states:

> This sword of the Prince called Dara Shikoh
> Takes care of a thousand enemies at one go.[59]

The weapon is composed of a blade of damascened steel made in Iran and a Mogul hilt of iron decorated with an overlaid gold design of flowering plants. A large tassel graces the pommel of the hilt, which is fashioned in a shape invented by Shah Jahan through his modification of an earlier style of handle common in Delhi.[60] The wooden scabbard is covered in green velvet, with a locket and chape made of gold and green enamel decorated with grape vines. The set is completed by a rarely surviving belt made of gold and silver brocade fastened with a buckle; the buckle and belt mount are made in the same medium and design as the scabbard fittings.

Swords and daggers survive in considerable numbers, while shields seem to have suffered more through the ravages of time. Mogul shields were made in a wide variety of materials, including metal, rhinoceros or buffalo hide, tortoise shell, crocodile skin, wood, and bamboo. Although lightweight, they were designed to stop the thrust of a sword or the penetration of an arrow. Manucci records that some could even resist a musket ball, and that the finest imperial shields were given special descriptive titles similar to those conferred upon swords, such as "Sun of the World" or "Splendor of the World."[61]

Shields were often decorated with scenes of the hunt. Although probably dating from the early eighteenth century, one such shield is a fine example of Mogul metalwork [Fig. 177]. Around the rim is a narrative band of hunting scenes: an emperor or perhaps a royal prince is shown firing a matchlock at a pair of antelopes, while a trained cheetah captures another antelope; a wild boar is attacked by a man on horseback, and a lean hunting dog pins a hare to the ground. The center of the shield is decorated with a rotating spiral design and seven metal bosses used to fasten the handles and straps on the interior.

A weapon that was to have immense consequences in Mogul warfare was the matchlock, invented in Europe in the fifteenth century and shortly thereafter imported into India, probably via Iran. As Abul Fazl exclaimed in his account of the culture and customs of the early Moguls, the *Ain-i-Akbari*, "Guns are wonderful locks for protecting the august edifice of the state; and befitting keys for the doors of conquest."[62] The early firearms required powder horns to load them, and primer flasks to prime the flashpan and touchhole. A number of these containers survive, many of which are fashioned in the shape of an antelope and decorated with hunt scenes. Unlike most Mogul decorative art objects, powder primer flasks can be assigned a fairly accurate date through stylistic comparisons with

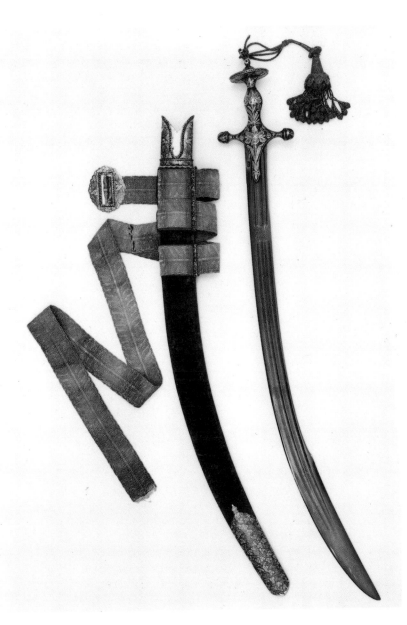

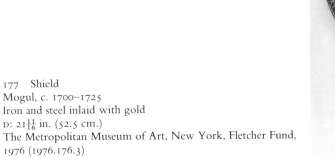

176 Sword of Dara Shikoh†
Mogul; inscribed with a poetic verse, the name of Dara Shikoh, and the date 1640/41
Iron hilt overlaid with gold, steel blade, wooden scabbard covered with green velvet, gold and green enamel scabbard fittings, gold and silver brocade sword belt
L: 33½ in. (85.1 cm.)
Trustees of the Victoria and Albert Museum, London, Given by Lord Kitchener (IS 214–1964)

177 Shield
Mogul, c. 1700–1725
Iron and steel inlaid with gold
D: 21¹¹⁄₁₆ in. (52.5 cm.)
The Metropolitan Museum of Art, New York, Fletcher Fund, 1976 (1976.176.3)

178 Powder primer flask
Mogul, c. 1650
Ivory with rubies and polychromy, steel spanner
L: 7¾ in. (19.6 cm.)
Virginia Museum of Fine Arts, Richmond,
The Nasli and Alice Heeramaneck
Collection, Gift of Paul Mellon
(68.8.142 a/b)

179 Push dagger
Mogul, c. 1650
Gold and enamel hilt inlaid with rubies,
emeralds, and diamonds, steel blade
L:15¾ in. (40 cm.)
Private Collection

examples documented as having been in European collections from the middle of the seventeenth century onwards.

Among the finest primer flasks is one [Fig. 178] that relates exceptionally well to an example known to have been in the collection of the Prince Elector Johann Georg II of Saxony at Dresden as early as 1658.[63] Both terminate in antelope heads at the mouth of the container and birds at the other end; both have a composite body designed with intermingling fowl and other animals; and in both, the central sections are enlivened with hunt scenes. Those on this flask depict a tiger capturing an antelope, while the Dresden flask has human hunters. The antelopes' eyes were made of rubies in both cases, though those in Dresden are now missing. Unlike the example in Europe, the flask illustrated here is adorned with several colored flowers that protrude from the surface.

SHAH JAHAN AS A COLLECTOR

Finally, it is important to mention a few objects that were not produced in Mogul India but were closely associated with Shah Jahan and demonstrate his eclectic taste as a connoisseur. Many types of foreign luxury items are known to have been collected by the emperors, but only a few Chinese porcelain dishes that survive with inscriptions can be proven to have been in the imperial treasuries. By acquiring such vessels, the Mogul emperors were following in the footsteps of previous Muslim rulers who had collected Chinese ceramics for centuries. A specific type of porcelain, blue-and-white ware, had been created in the early fourteenth century for exportation to the Islamic markets in the Middle East. It incorporated appropriate Islamic designs and used blue cobalt ore from Baluchistan in present-day Pakistan and Iran, which produced a pigment that became known in the West as "Muhammadan Blue."

The production of and international trade in blue-and-white porcelain was substantial. Extensive early collections survive in the Topkapi Saray Museum in Istanbul and the Ardebil Shrine Collection, now mainly housed in Tehran. Besides its visual splendor, the popularity of Chinese porcelain in the Islamic world can perhaps be attributed to a belief that it changed color when touched by poison.[64] Additional reasons may have been the religious ban on eating from vessels of precious metals, or its relative rarity and inexpensiveness compared to gold.

Numerous references to Chinese porcelain can be found in imperial Mogul memoirs and European accounts. In the *Babur-nama*, a "China cup" belonging to the emperor is reported as having been lost in a river in 1519.[65] The memoirs of Jahangir record several instances of porcelain being presented to the emperor.[66] Similar gifts are documented in the histories of Shah Jahan.[67] Sir Thomas Roe frequently mentions the high regard in which porcelain was held.[68] Bernier states that Aurangzeb's dinner table was set with porcelain.[69] William Hawkins narrates a sad tale of a servant in charge of an imperial porcelain dish which was broken when a camel fell. The unfortunate guardian was severely beaten and sent to prison. Reprieved and nurtured back to health by one of Jahangir's sons, the man was sent to China to procure another dish like the broken one. He was unable to do so after fourteen months of searching and was saved from the emperor's wrath only by the compassion of the Shah of Iran (Abbas I), who gave him a replacement after hearing of his plight.[70] Porcelain fragments have been found in the ruins of pre-Mogul and Mogul palaces,[71] and dozens of blue-and-white porcelain vessels are depicted in Mogul paintings [see, e.g., Fig. 94].[72] The most important evidence attesting the presence of the ware in India is the group of extant dishes variously inscribed with the dates when the vessels were acquired and the names of at least three of the Mogul emperors: Jahangir, Shah Jahan, and Aurangzeb.

Most of the dishes collected by the Moguls were large, deep serving plates with flat rims, a form created in response to the communal dining habits of the Muslim clientele.[73] An inscribed plain white fourteenth-century example of this type is engraved on the bottom with the name of Shah Jahan and also with its weight [Fig. 180].

To Western eyes, the most exotic porcelain vessel associated with Shah Jahan is another fourteenth-century dish [Fig. 183]. It is decorated in the center with cobalt blue underglaze in the design of a mythical deer-like creature (*qilin*) leaping through a riotous landscape of rocks and vegetation. The ornament in the curve, or cavetto, consists of lotus wreaths with botanically incorrect spiked leaves and tendrils. A diamond diaper motif forms the border. The underside of the dish is decorated with a band of flowers on an undulating vine.

180　Large dish
China, Yuan Dynasty, c. 1350–1400
Inscribed with the name of Shah Jahan
White porcelain
D: 17⅜ in. (44.1 cm.)
The Asia Society, New York, Mr. and
Mrs. John D. Rockefeller 3rd Collection
(1979.150) (Photo by Otto E. Nelson)

181　Large dish
China, Ming Dynasty, c. 1400–1425
Inscribed with the name of Shah Jahan
and the date 1643/44
White porcelain with cobalt blue
underglaze decoration
D: 17 1/16 in. (43.3 cm.)
Anonymous

182　Large dish
China, Ming Dynasty, c. 1400–1425
Inscribed with the name of Shah Jahan
and the date 1643/44
White porcelain with cobalt blue
underglaze decoration
D: 14¾ in. (37.5 cm.)
Asian Art Museum of San Francisco,
The Avery Brundage Collection (B65P6)

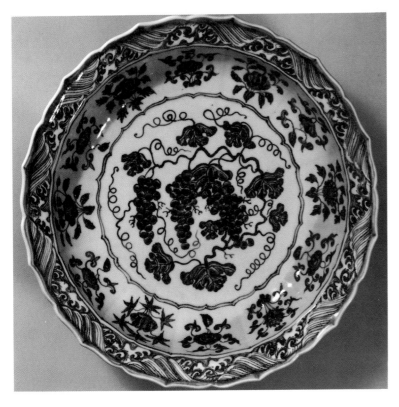

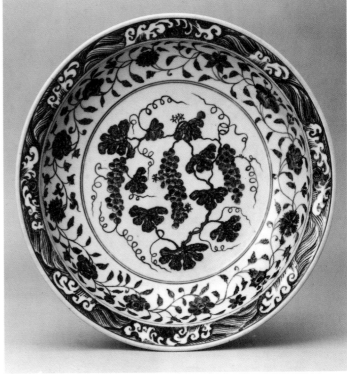

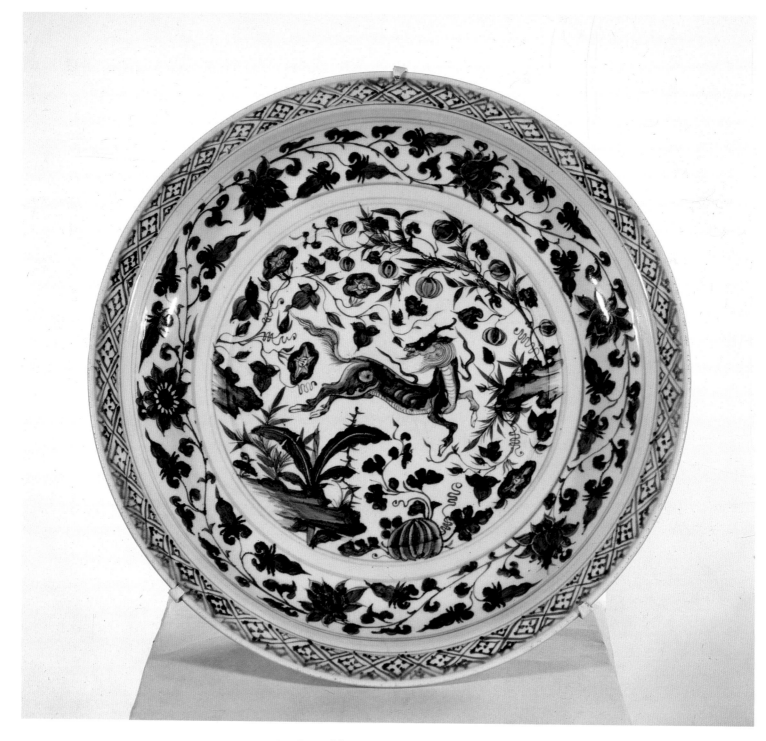

183 Large dish
China, Yuan Dynasty, c. 1350–1400
Inscribed with the name of Shah Jahan and the
date 1652/53
White porcelain with cobalt blue underglaze
decoration
D: 18⅜ in. (46.7 cm.)
The Asia Society, New York, Mr. and Mrs.
John D. Rockefeller 3rd Collection (1979.151)
(Photo by Otto E. Nelson)

Shah Jahan's name and the date 1652/53 are incised on the footring.

A popular decorative motif on blue-and-white porcelain ware in the early fifteenth century was the grape bunch. At least two dishes with this type of ornament associated with Shah Jahan are known. Both inscriptions give the emperor's name and the date 1643/44, suggesting that they belonged to a set which entered the imperial kitchens in that year. One of them is especially interesting because it also has an inscription stating that it had been a donation from Shah Abbas I of Iran, who gave over 1,100 porcelain vessels to his family's shrine at Ardebil in 1611 [Fig. 181]. In addition to the grapes in the center, the plate is adorned in the cavetto with various flowers, and a breaking wave motif decorates the rim. The underside is ornamented with twelve flowering plants. The second dish with a grape bunch in the center also has a breaking wave motif on the rim [Fig. 182], while a vine of morning glories and other blossoms runs around the cavetto. These tender flowers must have appealed greatly to Shah Jahan.

The surviving Chinese ceramic vessels inscribed with Shah Jahan's name are especially significant for the proof they offer that imported decorative art objects were present in the Mogul courts during the seventeenth century. Most other foreign luxury items have perished or been dispersed, such as the many Venetian glass wine decanters that are depicted in contemporary paintings [Fig. 122]. Historical accounts and imperial memoirs record the intense delight with which beautiful objects from abroad were received. In the eyes of the Mogul emperors, great works of art were independent of their geographic origin. The criterion of beauty was an inherent magnificence, born of the highest craftsmanship and defined by superb decoration.

CONCLUSION

The decorative arts associated with the reign of Shah Jahan reflect the same aesthetic concerns that were expressed in the ornamentation of the Taj Mahal. Floral motifs dominate and hardstone carving is the preferred medium. Opulence is paramount. The quality of craftsmanship is impeccable. Exquisite gems enrich an already lavish surface. Regardless of function, form, or material, sophisticated articulation and an inherent grace imbue this art with a sense of extraordinary perfection. As we shall see, these consummate features are also exhibited in the spectacular textiles created for the Mogul emperors.

Fabrics, Carpets, and Costumes

Joseph M. Dye, III

As with all the other arts, textiles had their place and uses within the glittering court of Shah Jahan. A dandy who relished perfumes, precious jewels, and sumptuous objects, the emperor may have been introduced as a youth to the beauties of carpets and fabrics by his grandfather Akbar, who deeply loved textiles and enjoyed designing innovative clothing. Literary evidence and miniature paintings of the period indicate that the palaces and buildings constructed by Shah Jahan after he ascended the throne in 1628 were, like those of his Mogul predecessors, luxuriously furnished with woven hangings, canopies, carpets, spreads, and cushions. Imperial standards, swords, and archery targets were covered with rich fabrics; members of the court wore splendid robes, sashes, turbans, and veils; and the royal elephants [Fig. 189] were dressed in elaborate fabric trappings. When the emperor and his entourage traveled, they often lived in magnificent cloth tents [see Fig. 36], some of which had an upper story. Even the royal horse stable, it is said, was fitted out with textiles: the floors had beautiful carpets laid down on them during the day; and each stable door was protected by a fly-screen made of bamboo "woven with twisted silk representing flowers."[1]

So important were lavish textiles to Shah Jahan and his court that they often figured in imperial ceremonies. Spectacular fabrics occasionally lined the roadway when an esteemed dignitary arrived in the Mogul capital. Rich carpets and hangings graced the emperor's palace on festivals such as the New Year. Rare weavings were also exchanged with foreign ambassadors and presented as gifts by members of the royal family to each other or to honored guests.[2] When a Mogul nobleman was elevated to a high office by the emperor, he was offered not only a sword appropriate to his new rank, but also a sumptuous costume, and, sometimes, suitably caparisoned elephants or horses or both. Silks were also used in imperial weighing ceremonies, when the weights of members of the royal family in various precious materials were distributed to holy men and the poor; they were exceeded in value only by gold and quicksilver.[3]

Textiles not only served utilitarian, decorative and ceremonial purposes, but they also helped to create an atmosphere of luxury and wealth appropriate to the "Ruler of the World's" imperial status. Paintings such as Abid's *Shah Jahan on the Peacock Throne*, completed in 1639 [Fig. 130], reveal the extraordinary opulence that textiles lent to court life.[4] Shown in the company of his richly garbed sons and courtiers, the emperor is completely surrounded by lavish weavings. His throne, crowned by a pearl-fringed parasol, is flanked by two beehive-shaped trellis tents made of metal-ground fabrics covered with floral arabesques. Carpets, one reddish-orange with a scroll-filled geometric design, and the other boldly patterned with multicolored stripes, grace the dais and steps; behind them stretch floral rugs. A rose canopy brocaded or embroidered with gold scrollwork and surrounded by pearl fringe is stretched on four jewel-encrusted gold poles above the throne.

The sensuous textures, rich patterns, and glowing colors of the fabrics and floor coverings depicted here magically transform the surroundings into a shimmering celestial world, a paradise on earth perfectly suited to the needs and interests of Shah Jahan. Like most monarchs, he viewed himself and wished others to see him as the mighty sovereign of a great and prosperous empire. Clothed in resplendent garments, surrounded by luxurious carpets, and sheltered by canopies dripping with pearls, he does, indeed, seem to be the "Ruler of the World" in this painting. Spectacular textiles, like such splendid monuments as the Taj Mahal, proclaimed the power, wealth, and glory of his rule.[5] They, too, were part of Shah Jahan's imperial stage.

THE SEVENTEENTH-CENTURY INDIAN TEXTILE INDUSTRY

Although exceptionally beautiful and quite important, very few Shah Jahani textiles like those depicted in

Abid's painting [Fig. 130] survive today; and fewer still can be dated with accuracy. Much that we know about the fabrics, carpets, and embroideries from Shah Jahan's reign is based upon information found in a wide variety of secondary sources: depictions and descriptions of textiles in Mogul miniatures and literary works; brief discussions of the weaving industry and trade in the writings of seventeenth-century Western travelers to India (Terry, Pelsaert, Mundy, Manrique, Tavernier, Bernier, Manucci, and others); and documents in the archives of various European national trading companies.[6]

The picture of the Indian textile industry that emerges from these varied bits of evidence is fascinating. In the mid-seventeenth century, it seems, the production of Indian fabrics, embroideries, and carpets was a highly organized and flourishing industry. Textiles of almost every conceivable type and quality were woven throughout the Mogul empire: some were fashionable works made in urban centers; others were folkish pieces produced in remote towns and villages; and still others were humble commercial goods intended for everyday use. Although many of these weavings were created strictly for the Indian market, others were specifically made for the Dutch, English, Portuguese, French, and Danish trading companies that conducted a thriving sea trade between India, the West, and other parts of Asia. Agents for these foreign companies often resided in important Indian entrepôts so that they could purchase or commission woven goods from the Hindu and Muslim brokers who supervised their manufacture. Universally admired for their low cost and high quality, these weavings were bartered by the trading companies for spices in the Malay Archipelago or sold to clients in the Middle East, Europe, Africa, and America.

Little is known about the lives, social position, and craft organization of the weavers and dyers who made these lovely textiles. Like other traditional occupations in India, their craft was, no doubt, hereditary. Many of these artisans probably lived near major textile market centers (Gujarat, Bengal, etc.), though some weavers from the Coromandel Coast resided in remote villages. Frequently too poor to buy their own materials, they had to depend upon the brokers for advances. Their work was often affected by factors lying beyond their control: famines; changes in political situations; extortion by local rulers, tax collectors, or brokers; and so

forth. On the whole, the lives of these craftsmen were not as beautiful as the exquisite fabrics and floor coverings that they wove.

IMPERIAL TEXTILE WORKSHOPS (KARKHANAS)

As the ruler of the great Mogul empire, Shah Jahan must have seen examples of many, if not all, of the major types of textiles produced in his realm. Since the emperor's needs were quite varied, he probably acquired woven goods from a number of different sources. Rare, highly prized foreign textiles, for example, were purchased from European traders in India or received as diplomatic gifts; other fabrics, especially utilitarian weaves, may have been ordered or commissioned from independent centers of manufacture. It seems quite likely, too, that Shah Jahan maintained imperial *karkhanas* or workshops to produce important textiles, particularly those made from costly materials. These ateliers must have been like the *karkhanas* of the Emperor Aurangzeb at Delhi as described in 1663 by François Bernier, the French physician who traveled in India:

Large halls are seen in many places [in the Red Fort] called *Karkanays* or workshops for the artisans. In one hall embroiderers are busily employed, superintended by a master. In another you see the goldsmiths; in a third, painters; in a fourth, varnishers in lacquer-work; in a fifth, joiners, turners, tailors, and shoemakers; in a sixth, manufacturers of silk, brocade, and those fine muslins of which are made turbans, girdles with golden flowers, and drawers, worn by females, so delicately fine as frequently to wear out in one night. This article of dress, which lasts only a few hours, may cost ten or twelve crowns, and even more, when beautifully embroidered with needlework.

The artisans repair every morning to the respective *Karkanays*, where they remain employed the whole day; and in the evening return to their homes. In this quiet and regular manner their time glides away; no one aspiring after any improvement in the condition of life wherein he happens to be born. The embroiderer brings up his son as an embroiderer, the son of a goldsmith becomes a goldsmith, and a physician of the city educates his son for a physician. No one marries but in his own trade or profession; and thus custom is observed almost as rigidly by Mohametans as by the Gentiles [i.e., Hindus], to whom it is expressly enjoined by their law.[7]

The precise location(s), organization, and output of Shah Jahan's royal ateliers, if they existed, are not known. Ahmedabad, Fatehpur Sikri, Agra, and Lahore, places where imperial textile workshops under the supervision of Persian masters had been founded by Akbar, probably continued to serve Shah Jahan; to these centers might be added others, such as Delhi. Quite possibly the members of these *karkhanas* worked first for the royal house, and then, in their spare time, for other patrons. It is difficult to say whether they monopolized the specific weavings that they produced.

SILK FABRICS

Amongst the many textiles available to Shah Jahan, the most dazzling were velvets, brocades, metal-ground cloths, and plain weaves made from silk or from silk mixed with other fibers, usually cotton. Since these fabrics were expensive, sumptuous, and frequently woven with designs used in other imperial arts of the period, it seems likely that many of them were made by royal workshops in some of India's traditional silk-producing centers—i.e., Ahmedabad, Surat, Benares, Agra, Kasimbazar, Malda, Sindh, and Delhi. According to Jean-Baptiste Tavernier, a French jewel merchant traveling in India between 1638 and 1668, the silk (mostly *Bombyx mori*)[8] used by seventeenth-century Indian weavers was largely imported in raw state from Kasimbazar and other areas of Bengal.[9] Bernier, confirming Tavernier's account, notes: "It is not possible to conceive the quantity [of silk] drawn every year from Bengale for the supply of the whole of the Mogul Empire, as far as Lahor [Lahore] and Cabul [Kabul], and generally of all those foreign nations to which the cotton cloths are sent."[10]

Most Shah Jahani silk fabrics were sumptuous and highly sophisticated works of art. Their colors ranged from simple natural hues to more intricately nuanced, exotic ones such as apricot, lilac, pistachio, pink, and ruby red. Metallic threads were frequently used to give the weaves additional glitter, gloss, and iridescence [Fig. 185]. Some of these fabrics were plain; others were elaborately patterned with floral scrolls, stripes, arabesques, and geometric designs similar in concept, though not necessarily in detail, to those from Jahangir's reign. By far the most popular designs, however, featured a relatively new motif—the flowering plant isolated or arranged in rows or other combinations

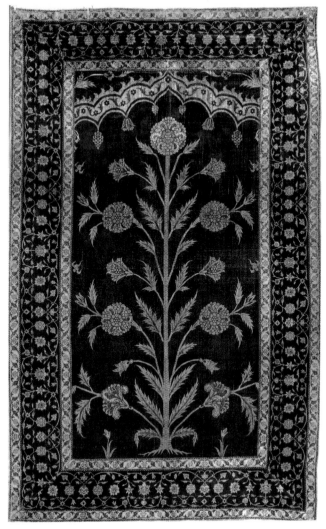

184 Hanging
Mogul, c. 1650–1700
Velvet
78 × 49 in. (198 × 124.5 cm.)
Los Angeles County Museum of Art, Gift of Anna Bing Arnold
(M.75.22)

185 Hanging or cover
Mogul, c. 1650
Velvet and metallic yarns
49 × 26½ in. (124.5 × 93 cm.)
Los Angeles County Museum of Art, From the Nasli and Alice Heeramaneck Collection, Gift of Joan Palevsky (M.73.5.703)

186 Fragment
Mogul, c. 1650
Velvet
32 × 28¾ in. (81.3 × 73 cm.)
Anonymous

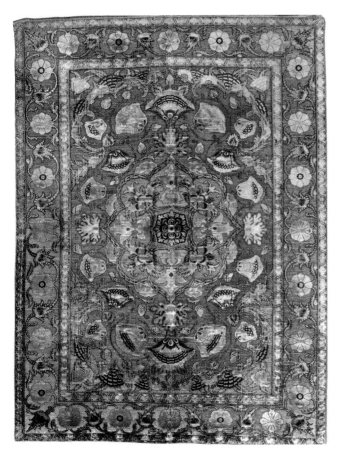

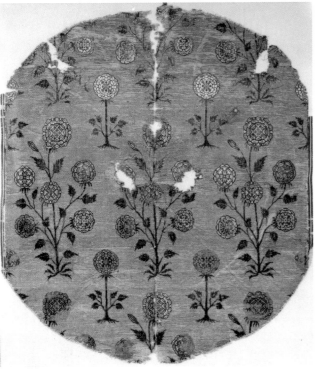

against a plain ground. Depicted exactly as it is in Shah Jahani painting, architectural sculpture, and decorative arts, the plant was shown both frontally and from the side, and in different stages of growth from bud to full bloom. Some of the flowers are stylized but identifiable (tulip, iris, narcissus, poppy, lily, etc.), while others are imaginary; none of them, however, is botanically correct in every single detail.

Of all the silk fabrics produced during Shah Jahan's reign, velvet, with its lustrous sheen and luxuriant pile, was certainly the most opulent. Although velvets sometimes have complex structures, they are basically woven according to a simple concept, i.e., the introduction of supplementary warp threads into the warp and weft of the textile's silk foundation weave. In the seventeenth century, velvets were used for a wide variety of purposes, especially to decorate the interiors of buildings. The handsome hanging illustrated here [Fig. 184], for example, was probably made to cover a wall or a doorway or an arch. It is dominated by a single flowering plant that stands alone beneath a foliated, cusped arch, save for two small flowers that flank it. This design—"the flowering plant in a niche"—is found on numerous Mogul textiles, decorative arts, and architectural monuments. The flowers of this hanging are more stylized than those appearing on Shah Jahani buildings, suggesting that the textile is of a slightly later date. It was probably made in Gujarat.

Velvets not only served as hangings and canopies, but were also used to cover cushions and bolsters. A fragment from one such furnishing fabric seen here [Fig. 186] is woven with a classic Shah Jahani pattern—alternating and staggered rows of single- and multiple-blossomed flowering plants resting on a gold field. In order to create this lively, continuous pattern—one that can be read in all directions (horizontally, vertically, and diagonally)—the weaver segregates these self-contained plants into alternating vertical rows (i.e., single blossom, multiple blossom, single blossom, and so on). The equidistant placement and repetition of the same plant motif in each vertical row establishes a linear movement that is supplemented by the rising undulations of the curving stems and blossoms. Equally powerful compositional rhythms are also created horizontally and diagonally by staggering the vertical rows: thus, moving diagonally, one encounters equidistant rows of single- and multiple-blossomed flowers alternating in regular succession; moving horizontally,

one finds equidistant and repeated sprays of the same flower.

The appeal of this sophisticated pattern is that, like the best Mogul design, it magically blends strength and delicacy, naturalism and abstraction: each floral spray is dainty and rather realistic, but presented with formal self-sufficiency; they are all, in turn, firmly locked into a structure of movement that enlivens rather than oppresses them. The textile's poised dignity is superbly augmented by a weaving technique frequently seen in Shah Jahani velvets: the flowers are woven in pile and the metallic thread background, which reflects shining light, is a flat void.

Velvets were also used in the large court tents of which the Moguls, descendants of Central Asian nomads, were so fond [Fig. 36]. When Shah Jahan's court hunted, campaigned, or traveled to distant parts of the empire, it was housed in an entire city of temporary enclosures and screens made from fabrics, all of which were duplicated so that they could be set up well in advance of the emperor's arrival. Enormous textile screens or *qanats* supported on poles sunk into the ground at regular intervals surrounded important areas in the camp. The main tents of the royal enclosures as well as the *qanats* were covered with decorated red cloth—the imperial color—and with fabrics such as chintz. The velvet tent hanging illustrated here [Fig. 193], which is painted with a gold flowering plant in a niche, gives a good idea of the spectacular appearance of such tentage, though it probably dates from the eighteenth century and may be made of fabrics imported from Europe.

Less sensual than velvet, but equally typical of luxurious Shah Jahani silks, are various gold- and silver-ground fabrics that were used for canopies, furnishing covers, garments, etc. These shimmering textiles woven with glistening metallic or metal-wrapped threads were usually patterned with flowering plants arranged in various combinations. The fragment illustrated here [Fig. 192], a typical example of its kind, is covered with rows of pale orange poppies arranged on a silver ground. This design, though not as complex as that of the velvet discussed above, is enlivened by reversing the poppies in alternating rows. The fragment's glazed appearance indicates that at some point it was calendered, a process which involves applying starch to the fabric and then passing it between two rollers infused with steam or dry heat.

Silks woven with metallic threads are said by Tavernier to have been produced in Western India,[11] especially at Ahmedabad, where imperial textile *karkhanas* were probably located. Unfortunately, Tavernier does not describe these fabrics, beyond suggesting that some of them were striped: it is, therefore, difficult to say whether the piece illustrated here [Fig. 192] was actually produced in Gujarat or somewhere else in India (Delhi or Varanasi?), or perhaps even in Iran. Surviving metallic-ground flowered silks exhibit several different weave structures, which suggest that they were made in various centers.[12] A number of Mogul paintings, do, however, document their widespread use in Shah Jahan's court.

Many seventeenth-century Indian silken fabrics were made not only of silk but also of silk combined with other fibers, usually cotton. One of the most famous of these mixed weaves—the "alacha"—was produced in the Cambay–Gujarat regions.[13] Besides simple stripes (blue and white; red and white), this silk-cotton textile was sometimes flowered or woven with gold and silver thread. Bernier refers to "alachas" as "silken stuffs striped, some with gold and some with silver, for vests and summer trousers."[14] Quite possibly, many of the striped materials seen in Shah Jahani paintings (particularly men's *pyjamas*) were "alachas." A similar striped cloth was woven in the Malda–Kasimbazar area of Bengal, but it contained more silk than the Cambay–Gujarat cloth.

COTTON FABRICS

Sumptuous, sophisticated, and costly, silks closely reflect the grandiose tastes of Shah Jahan; but we do know that other, somewhat less showy fabrics were also used by the emperor and his court. Foremost amongst them were cool, durable cottons which ranged in quality from superfine weaves to coarse sackcloth. Very fine muslins were particularly sought after [see Fig. 22]: lightweight garments made from them replaced heavier robes during the summer months; and somewhat more substantial grades, often brocaded or embroidered with silk and metallic threads, were used for sashes and turbans. A number of centers—including Burhanpur, Sironj, Dacca, Varanasi and Delhi—produced muslins in the seventeenth century. The sheer muslin of Sironj was described by Tavernier as being so fine that

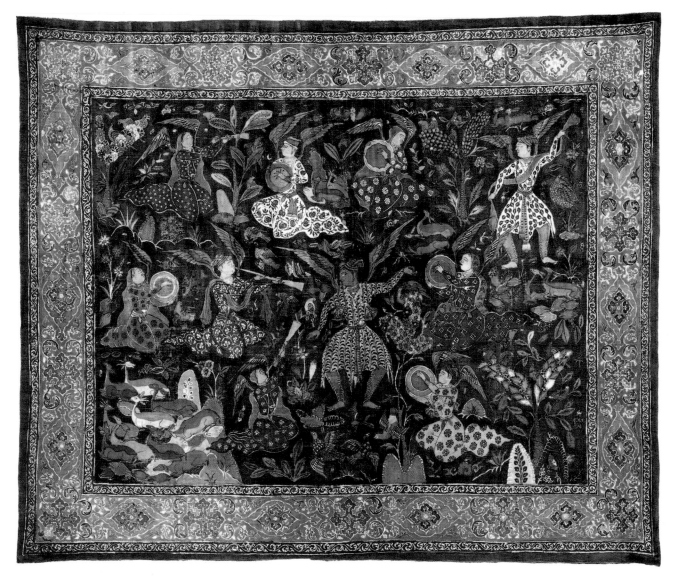

the merchants are not all allowed to export it, and the Governor sends all of it for the Great Mogul's seraglio and for the principal courtiers. This it is of which the sultanas and the wives of the great nobles make themselves shifts and garments for the hot weather, and the King and nobles enjoy seeing them wearing these fine shifts, and cause them to dance in them.[15]

Equally popular were painted or printed cottons known as chintzes [Fig. 187], which were also used by Shah Jahan and his court. Bernier mentions that imperial Mogul tent hangings were lined with hand-painted chintzes from Masulipatam in South India which were "figured expressly for that very purpose with flowers so natural and colors so vivid, that the tent

187 Rumal (cover for a ceremonial gift)
India, c. 1650
Cotton, stenciled, painted, and dyed
$26\frac{1}{2} \times 32\frac{15}{16}$ in. (67.3 × 82.3 cm.)
Courtesy, Museum of Fine Arts, Boston, Gift of John Goelet
(66.230)

seems to be encompassed with real parterres."[16] The most expensive chintzes were decorated with dye and mordant designs applied to the cloth freehand with a brush; less costly were those decorated with wood-block stamped and printed designs (sometimes painting and printing techniques were combined). Widely traded nationally and internationally, these colorful

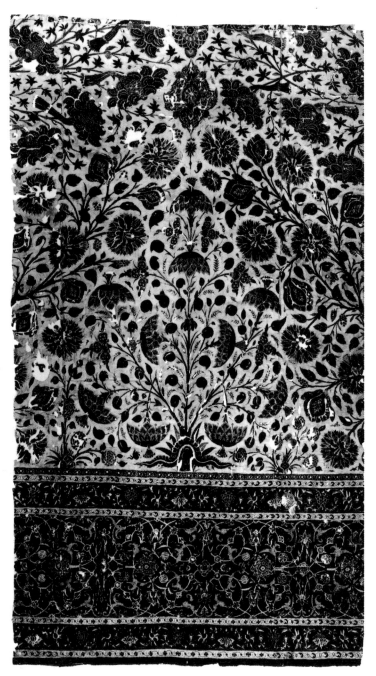

188 Fragment of summer carpet
Mogul, c. 1630–40
Cotton, painted and dyed
$109\frac{1}{2} \times 62\frac{1}{2}$ in. (278×159 cm.)
Cincinnati Art Museum, Gift of Professor Maan Z. Madina in
memory of his father Ali Agha Zilfo (1985.397)

textiles were made in West and Central India (Ahmeda-bad, Burhanpur, Multan, and Sironj); in South India, along the Coromandel Coast (Petapoli, Madras, etc., and inland); and in Northeast India, including Bengal, Orissa, and the Ganges Valley (Dacca, Patna, etc.). Some of these centers seem to have brushed or stamped their chintzes with stylized versions of Mogul motifs, while others used more regional design elements.

A fragment from a spectacular cotton floor spread, made in about 1630 and used in the summer when wool carpets were abandoned, is an example of the sort of imperial-quality painted chintz that Shah Jahan may have ordered or purchased [Fig. 188]. This piece, which bears two inventory dates (1645, 1652), resembles another summer carpet at the Cincinnati Art Museum that has been assigned tentatively to Burhanpur, the seat of Mogul administration of the Deccan and the headquarters of the army.[17] It is not certain whether royal workshops producing chintz existed; it is quite possible that agents of Shah Jahan simply acquired these painted and printed textiles by purchase or contract from different centers.

Besides chintzes and fine muslins, some of India's many types of ordinary cotton fabrics must also have been used by Shah Jahan's court for miscellaneous everyday purposes. Foremost amongst these were plain white cotton cloths produced in numerous centers throughout the subcontinent, among them "bafta," from Broach and Nosari in Gujarat; "semianoes," from Samana or Patiala; and "mercoolees," from Jaipur and Lucknow.[18] Unfigured cottons dyed blue, black, or red from Gujarat, Sanganer, Burhanpur, etc., as well as those woven in the loom with simple patterns, usually stripes or checks, were also produced.[19] These ordinary fabrics, made in all three of India's major textile-producing areas (Gujarat, the Coromandel Coast, and Bengal), were intended for domestic and foreign markets.[20]

WOOLEN FABRICS

Not as widely used in Mogul India as cool cottons, woolen textiles were woven during the seventeenth century in Agra, Patna, and Lahore as well as in various centers in Rajasthan and Himachal Pradesh. It was, however, in Kashmir that the finest woolen goods, especially the fabled Kashmir shawl, were produced. Known for its soft texture, lightness, and pleasing sheen, the shawl was a loose enveloping shoulder

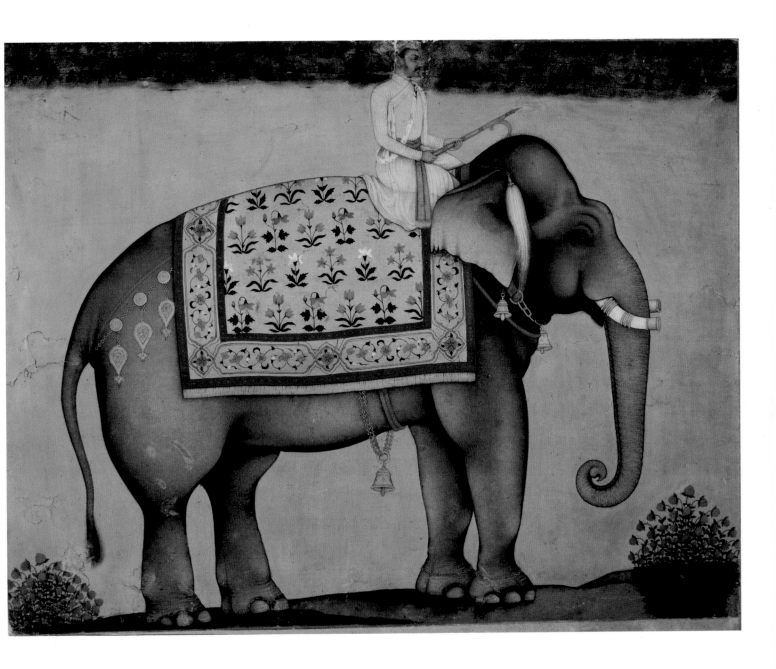

189　*Elephant with Flowered Textile*
Mogul, c. 1640
Opaque watercolor on paper
$12\frac{5}{8} \times 17\frac{3}{4}$ in. (32 × 45 cm.)
Howard Hodgkin, London

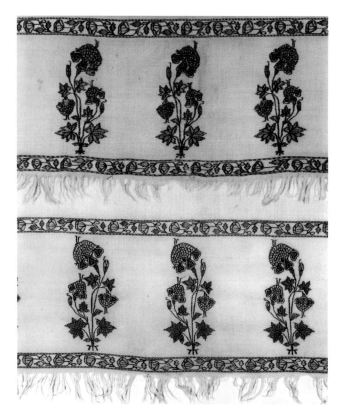

190 Detail of the borders of a shawl
Kashmir, c. 1700
Wool
82 × 50 in. (208.3 × 127 cm.) (overall)
Courtesy, Museum of Fine Arts, Boston, Anonymous gift, in name of Mrs. Arthur T. Cabot (45.540)

The upper one is turned to show the reverse side.

mantle traditionally woven from the fleece of a Central Asian mountain goat (*capra hircus*) according to the twill-tapestry technique.[21] It was deeply admired and avidly collected by Shah Jahan's grandfather Akbar, who introduced the dyeing of shawl wool, previously left in its natural state, and initiated new ways of wearing the garment. So valued were Kashmir shawls in the Mogul period that they were exported to other parts of the subcontinent, for example Gujarat and Agra,[22] as well as to distant lands.

Our knowledge of early Kashmiri shawls is incomplete, but we do know something about them from the writings of seventeenth-century European travelers in India. In 1630, the Augustinian Father Sebastien

Manrique describes the finest examples as having borders ornamented with fringes of gold, silver, and silk thread. "These choice cloths," he writes, "are of white color when they leave the loom, but are afterwards dyed in any hue desired and are ornamented with various colored flowers and other kinds of decoration, which make them very gay and showy."[23] A few decades later, Bernier describes Kashmir shawls as follows: "These shawls are about an ell and a half long, and an ell broad, ornamented at both ends with a sort of embroidery, made in the loom, a foot in width. The Mogols and Indians, women as well as men, wear them in winter round their heads, passing them over the left shoulder as a mantle."[24] The late seventeenth- or early eighteenth-century Kashmir shawl illustrated here [Fig. 190], with its plain field and decorated end-borders less than one foot in depth, generally conforms to Bernier's description. The end-borders are woven with an elegant row of repeated flowers, a classic Mogul design that may also be seen in a number of seventeenth- and eighteenth-century Mogul buildings, decorative arts, and textiles [Figs. 202, 204].

EMBROIDERIES

Many of the previously discussed fabrics, especially cottons and silks, were not only patterned in the loom but also richly embellished with colorful silk embroidery. The accounts of European travelers contain numerous references to embroideries rendered by independent professional ateliers (?) before, during, and after Shah Jahan's reign: muslins worked with colored or white silks, for example, were made in Dacca; and elegant turban cloths embroidered with metallic or colored silk threads were produced in Benares, Burhanpur, and Delhi. Manrique states that the Benares turbans were so beautifully embroidered, presumably with flowers, as to have "the appearance of a pleasant eternal springtime on brilliant fields."[25]

It is, indeed, quite possible that Shah Jahan supported embroidery *karkhanas*, like those maintained by his son Aurangzeb and described by Bernier in 1663 (see p. 171). The exact locations of these ateliers, if they existed, are not known; but at least one of them would almost certainly have been in Gujarat (especially Ahmedabad), a traditional center of embroidery in silver, gold, and colored threads.[26] A mid- to late seventeenth-century panel from a large screen or *qanat*

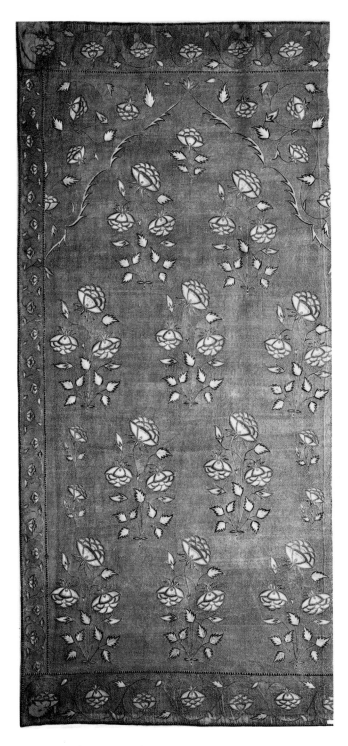

191 Part of a curtain or hanging
Mogul, c. 1650–75
Cotton, embroidered with silk and silver gilt yarns
71¾ × 33¼ in. (180.6 × 84.5 cm.)
Courtesy, Museum of Fine Arts, Boston, Gift of John Goelet
(66.861).

completely worked with colored silks and metallic threads is a fine example of the sort of embroidery that might have been done by Gujarati craftsmen for royal patrons [Fig. 191]. Its design is focused upon alternating rows of rose plants contained within a cusped arch of serrated leaves; sprays of roses and stems fill the spandrels. Three sides of the panel are decorated with an arabesque border of rose stems bearing flowers and buds. This piece is part of a set of *qanats* and a tent or tents previously in the royal collection of Amber/Jaipur in Rajasthan.

Given India's prominent role in the international textile trade, it is hardly surprising that seventeenth-century embroideries, especially those from Gujarat and Bengal, were also made for foreign markets. Gujarati export quilts and coverlets, first introduced to the West by the Portuguese, were embroidered on cotton or silk grounds with brightly colored silk threads.[27] Less colorful but equally interesting, Bengali export bedspreads, shawls, and hangings were densely embroidered in yellow silk with hunting and marine scenes as well as depictions of Old Testament, Graeco-Roman, and Hindu themes.[28] They were first traded by the Portuguese and, later, the English.

KNOTTED CARPETS

Fabrics and embroideries were, of course, not the only textiles produced for Shah Jahan's court. Available evidence (written accounts, miniature paintings, and extant examples) also indicates that luxurious knotted or pile carpets were also widely used: some were made for the floors of palaces, tents, tombs, and daises [Fig. 196]; others were woven to provide a suitable ground upon which the Muslim faithful could say Islam's obligatory five daily prayers. These rugs, like knotted carpets from other lands, consisted of a warp, weft, and a pile. They were produced by hand on a loom made from two horizontal beams of wood attached to upright side pieces. Once the design for a rug was determined, the weaver stretched cotton or silk warp threads from the top to the bottom of the loom; these threads were separated by a device known as the heddle into two alternating groups of openings or sheds for the weft threads. The weaver then tied or "knotted" a short length of dyed woolen yarn around each pair of warp threads. Since Indian rugs were woven with the Persian or Senna knot, one end of the yarn encircled one of the

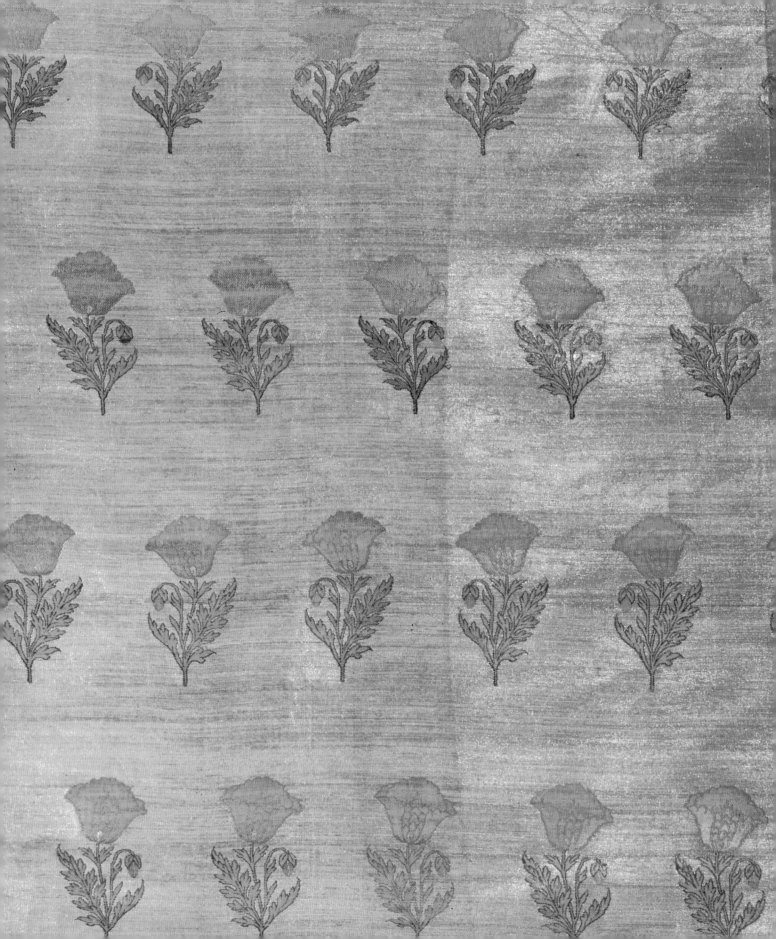

192 Detail of textile fragment
India or Iran, c. 1650
Silk and silver yarns
28 × 21 in. (71.1 × 53.3 cm.) (overall)—
detail actual size
Virginia Museum of Fine Arts, Richmond, The
Nasli and Alice Heeramaneck Collection, Gift of
Paul Mellon (68.8.157)

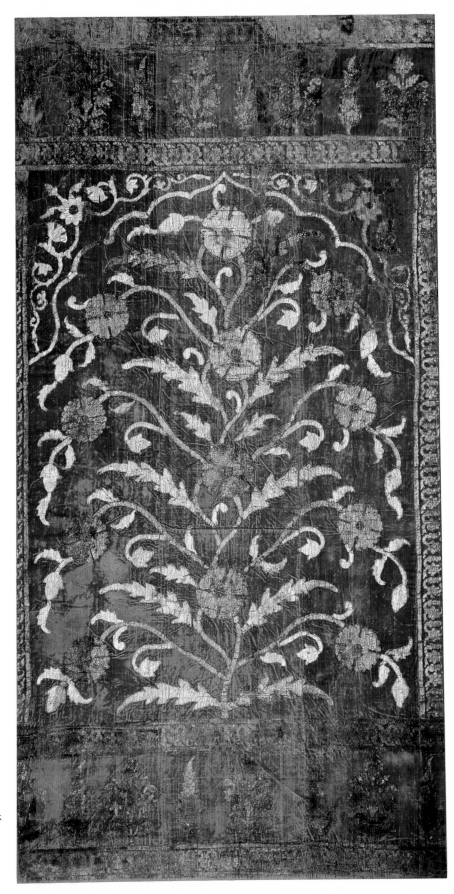

193 Tent hanging
India, c. 1700–1725
Velvet, stencilled and painted
104 × 53 in. (264 × 162.5 cm.)
Doris Wiener Gallery, New York

warps while the other passed beneath the second warp and came to the front beyond it. After one or more rows of knots were tied, several weft threads were shot through the warp. This basic procedure was repeated over and over again until the rug was completed. The warp and weft provided the foundation for the rug; the ends of the many knots collectively formed the soft pile.

The earliest known Mogul knotted rugs date from the reign of Akbar, who established carpet workshops under the supervision of Persian masters in Agra, Lahore, and Fatehpur Sikri. By the seventeenth century, the production of pile rugs was firmly established in Mogul India and seems to have flourished in several different centers. Tavernier mentions that "carpets of silk and gold, others of silk, gold and silver, and others altogether of silk" were made in Surat, while woolen carpets were produced at Fatehpur.[29] Francis Pelsaert, the Dutch East India Company's agent in Agra from 1620 to 1627, notes that carpets at that time were produced at Lahore, Agra, Fatehpur, Jaunpur, and Gujarat: the Jaunpur carpets, he says, were coarse; those from Agra and Fatehpur were "woven in moderate quantities and can be obtained to order, fine or coarse as required"; and the Gujarati rugs were woven of gold and silk.[30]

These rugs were made for domestic consumption, and they were also produced for export by the Portuguese, English, and Dutch to the West. Sometimes this trade was not particularly successful. When British East India Company agents, for example, recognized that carpets from Agra and Lahore would be suitable for the English market, they immediately had a group shipped from Surat in 1615. Although at first popular, the rugs eventually presented problems: on the one hand, English clients preferred large carpets that had to be specially commissioned and were, therefore, costly; on the other hand, the impoverished Indian weavers, knowing that a sale was guaranteed, often skimped on materials. Eventually the East India Company abandoned its pile carpet trade, but not before several fine rugs, commissioned by English agents and bearing their coats-of-arms, had been completed.[31] One of them, known as the "Girdlers' Carpet," was woven with the arms of the Worshipful Company of Girdlers in London and of Robert Bell, the donor: it was ordered in Lahore by Bell, a Director of the East India Company, in 1631, and presented in 1634. The second, now known as the "Fremlin Carpet," was commissioned by William Fremlin and bears his family coat-of-arms.

Although it is difficult today to connect extant seventeenth-century Indian rugs with specific weaving centers, at least four different carpet types[32] are known to have evolved during the reigns of Jahangir, Shah Jahan, and Aurangzeb: (1) carpets made in Lahore, which fall into two subgroups; (2) the so-called "fine-weaves"; (3) the "Indo-Persian" or "Indo-Isfahan" rugs; and (4) the "Portuguese" carpets of Gujarat. The type which can be attributed to Lahore includes rugs with structures and designs that can be linked either to the Girdlers' Carpet or to a group of rugs in the Jaipur Palace Collection. The former has a repeating floral field with palmettes and spiky, leaf-like blossoms. A number of other carpets, including a spectacular mid-seventeenth-century medallion rug now in the Gulbenkian Museum in Lisbon, can in various ways be linked to the Girdlers' Carpet, and therefore form one group attributable to Lahore. The other group of Lahore carpets is that which can be associated with some seventeenth-century rugs in or from the Jaipur Palace Collection that bear inventory labels, a few of which include the phrase "Lahori gilim" or "Lahore rug." These pieces and others like them are decorated with rows of colorful flowering plants; some of the carpets are rectangular, but others are irregularly shaped [Fig. 194].[33] Also associated with this group are certain pictorial rugs with flowering plants such as the fragment of an elephant combat seen here [Fig. 197].

The second major type of seventeenth-century carpets comprises those known as "fine-weaves" because of their exceptionally high quality. Woven with silk wefts on silk warps dyed in bands of three or four different colors, these rugs have a very soft pile made of either undercoat wool or goat hair with high knot counts that range from about 450 to an extraordinary 2,500 per square inch. Their designs include cartouche repeats and floral and trellis patterns [Fig. 195]. One of the most complete extant "fine-weaves," a superb early Shah Jahani prayer carpet now in a private collection [Fig. 199], is woven with almost 2,000 knots per square inch. The finely detailed design of this rug, like those of almost all Islamic prayer carpets, reproduces the shape of the *mihrab*, an arched niche in a mosque that indicates the direction to Mecca. The field contains a typical Shah Jahani flowering plant rising with measured dignity from the flower-scattered

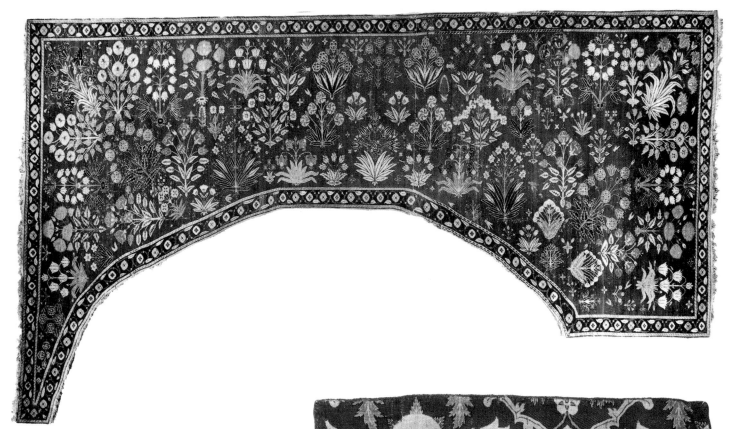

194 Shaped carpet
Mogul, c. 1640–50
Cotton warp and weft, wool pile
176 × 101 in. (447 × 256.5 cm.)
Cincinnati Art Museum,
Gift of Mrs. Audrey Emery (1952.201)

195 Fragment of a rug with a
blossom and trellis design
Mogul, c. 1625–50
Cotton warp and weft, wool pile
26½ × 27½ in. (67.3 × 69.9 cm.)
The Textile Museum, Washington,
D.C. (R 63.00.5)

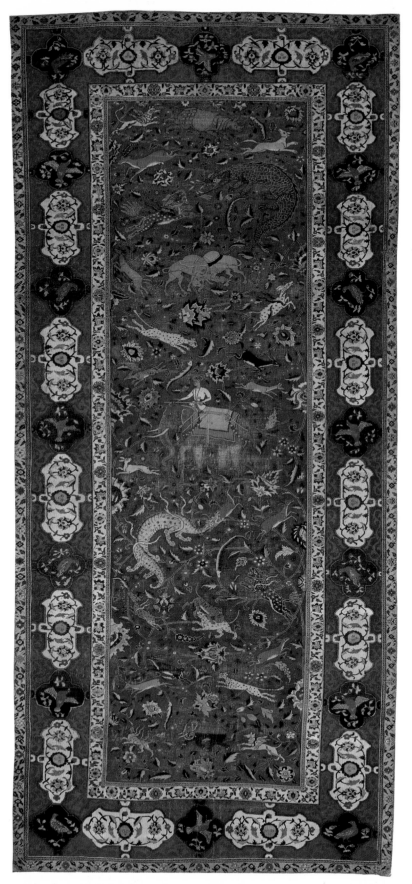

196 Animal carpet
Mogul, c. 1630
Cotton warp and weft, wool pile
159 × 75¼ in. (403.9 × 191.1 cm.)
National Gallery of Art, Washington, D.C.,
Widener Collection (1942.9.475)

197 Fragment of a rug with an elephant
combat
Mogul, c. 1625–50
Cotton warp and weft, wool pile
34¾ × 32¼ in. (88.3 × 81.9 cm.)
The Textile Museum, Washington, D.C.
(R 63.00.13)

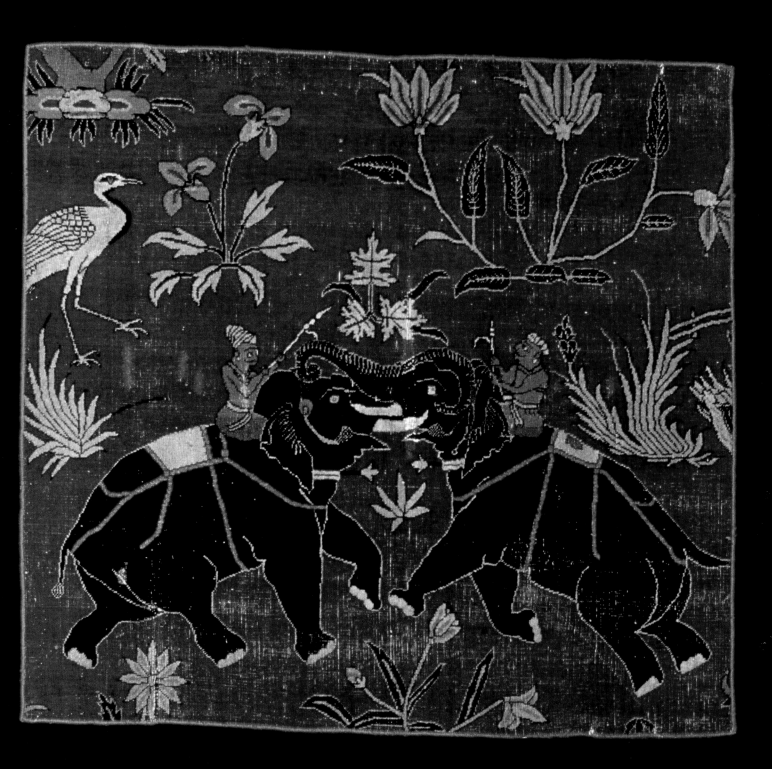

ground to the apex of the arch; two smaller flowers flank it. In many areas, for example the foliage and blossoms, related but different shades of the same color are juxtaposed without separating lines, thus enhancing the design's naturalism. Color patterning is also employed to unify the composition: the red in the border, for instance, is repeated in the edges of the arch and in the blossoms of the small flanking flowers; the orangish hue of the central plant's flowers is also found in those on the spandrels, etc.

Although Kashmir has been suggested as the place of manufacture for the "fine-weaves,"[34] it seems likely that most if not all of those exquisite rugs were made in Lahore. As Daniel Walker has pointed out, the designs of the "fine-weaves" are often related to those from the Lahore groups.[35] This may be seen by comparing the prayer carpet discussed above [Fig. 199] to another well-known Shah Jahani rug, the McMullan Prayer Carpet [Fig. 200], which Walker assigns to Lahore.[36] The two rugs have similar designs and basic colors, though they differ in the range of hues, knot count, quality of wool, and in the nature of the foundation. Quite possibly, the Lahore rug weavers produced both a high, imperial grade of carpet (i.e., "fine-weaves") and a lower commercial one for general domestic and foreign markets.

The third type, known as the "Indo-Persian" or "Indo-Isfahan," is characterized by rather darkly colored designs showing lotuses, palmettes, and cloud bands symmetrically organized within coiling vines. The foundation weave is cotton and the pile wool, though smaller examples sometimes have silk warps or silver-wound brocadings, and may, therefore, represent a more refined level of the general production. At one time, many of these rugs were assigned to eastern Iran, especially sixteenth-century Herat, but it is now thought that some of them were probably made in India. Walker believes that they were produced in a number of centers,[37] while Ellis tentatively attributes them to Agra.[38]

Carpets of the fourth type—the so-called "Portuguese" rugs of Gujarat—were once thought to have been woven in Iran, but recently they have been assigned to India. Their fields are filled with large, concentric diamond medallions of irregular shape and various colors. On either end of the field appear small maritime scenes consisting of Portuguese sailing ships, a man and various animals in the water, and a crew

member on the mast; frequently figures in European-like garb are shown in the boats. These carpets may have been produced for Western markets.

TEXTILES FROM IRAN, TURKEY, EUROPE, AND CHINA

Besides acquiring fabrics and floor coverings produced in Indian workshops, Shah Jahan also collected rare weavings from Iran, Turkey, Europe, and the Far East. Some of these textiles were presented by foreign ambassadors and guests; others were probably purchased from foreign traders who reached India by overland and sea routes. Most of these choice weavings seem to have been regarded as exotic novelties and as necessary parts of the "Ruler of the World's" imperial display. Muhammad Amin Qazvini, a court historian, for example, describes the use of various foreign textiles in Shah Jahan's palace at Agra during a festival in 1628: "The doors and walls of the public and private hall were decked out with cloth-of-gold from Gujarat, and European curtains, and brocades from Turkey and China, and cloth-of-gold from Iraq . . ."[39]

One of the greatest suppliers of foreign weavings to Shah Jahan's court was Iran, a land that had in earlier years furnished master craftsmen for Akbar's textile *karkhanas*. Persian fabrics, especially those with figural designs, are frequently depicted in Shah Jahani paintings [Fig. 27]. So closely related, in fact, were the weaving traditions of the two countries that it is often difficult to tell whether a fabric was made in Iran for export to India, or in India under strong Iranian influence. Two such weavings are illustrated here. One [Fig. 203] is a velvet fragment woven with a design consisting of staggered alternating rows of cypresses flanked by pairs of female figures accompanied by small dogs. The trees are intertwined with prunus saplings, a motif traditional in Iran, while the women's eclectic costumes seem to have been copied from Deccani chintzes. This velvet, as Skelton and Crill have noted, may have been produced by Persian weavers who adapted figural designs that they thought would appeal to their Indian customers;[40] it is also possible that it was made by Persian-influenced Indian craftsmen.

The other example [Fig. 198], a floral silk with rows of what S. C. Welch has described as "boldly masculine curving stems enlaced by graceful, lady-like smaller flowers and culminating in blossoms with flowerlike

198 Fragment of furnishing or dress fabric
India or Iran, c. 1650
Silk and foil-wrapped silk yarns
37¾ × 29½ in. (95.9 × 74.9 cm.)
Virginia Museum of Fine Arts, Richmond, The
Nasli and Alice Heeramaneck Collection,
Gift of Paul Mellon (68.8.156)

petals,"[41] is even more difficult to place geographically. The arrangement of motifs is somewhat similar to that found in mid-seventeenth-century Mogul floral textiles, but the strong, abstract rhythm of the heavy design as well as the composite flowers recall Persian and Ottoman textiles of the same period. Although recently attributed to mid-seventeenth-century Mogul India,[42] it would be difficult to say whether this fragment is Indian, Persian, or Turkish.

Certainly more exotic to the Moguls than Persian textiles, European weavings were also valued in the court of Shah Jahan. Western luxury fabrics are known to have reached India from at least as early as the fifteenth century: Italian brocades were on sale in Calicut when Vasco da Gama arrived; and European velvets could be found in the markets of Vijayanagar before its destruction in 1565.[43] As John Irwin has written, "In fact, there is abundant evidence to show that independently of the Portuguese, Dutch, and

English influence, there flourished a regular trade in European luxury fabrics to India, starting from Venice and reaching the western seaports via Alexandria, Cairo, Jidda, and Aden."[44]

Amongst the most notable seventeenth-century European textiles exported to India were velvets, tapestries, and broadcloth (woolen cloth). Most of these weavings enjoyed initial success as novelties, but later they swiftly declined in popularity. Flemish and English tapestries depicting classical themes ("Vulcan and Venus," etc.), first presented in 1617 to a very pleased Jahangir, for example, proved difficult to sell later when exported in quantity; by the mid 1630s, mention of them disappears in English trade accounts.[45] Similarly, English broadcloth was quite popular when it reached Surat in 1608, but three years later the East India Company's London Directors were told: "Concerning the cloth, which is the main staple commodity of our land . . . it is so little regarded by the people of this

199 The Paravicini Prayer Carpet
Mogul, c. 1625–50
Silk warp and weft, wool (*pashm*) pile
43$\frac{5}{16}$ × 59 in. (110 × 150 cm.)
Private Collection

200 The McMullan Prayer Carpet
Mogul, c. 1625–50
Cotton warp, cotton and silk weft, wool pile
61 × 40½ in. (155 × 103 cm.)
The Metropolitan Museum of Art, New York,
Bequest of Joseph V. McMullan, 1973
(1974.149.2)

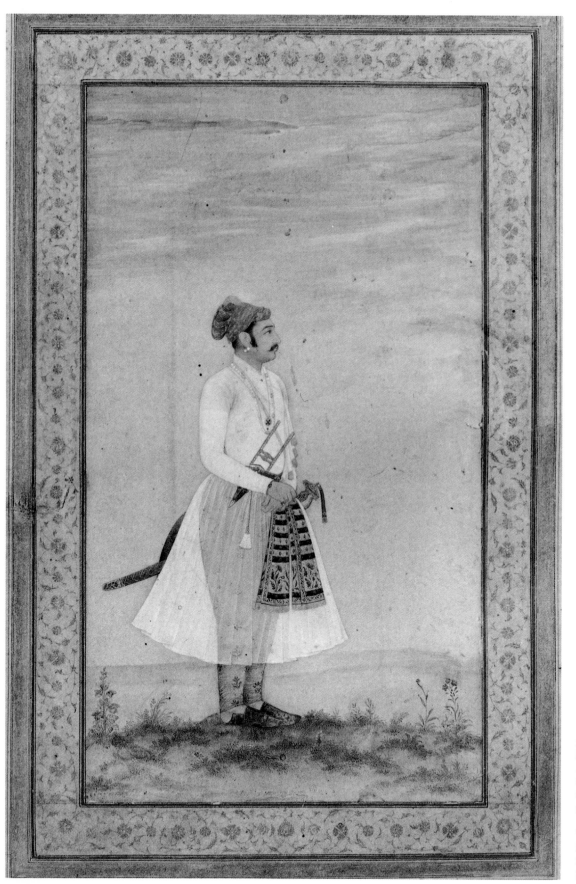

201 *A Rajput Nobleman*
Page from the Late Shah Jahan
Album
Mogul, c. 1640
Opaque watercolor, ink, and gold
on paper
$15\frac{1}{8} \times 10\frac{3}{4}$ in. (38.4 × 27.3 cm.)
Virginia Museum of Fine Arts,
Richmond, The Nasli and Alice
Heeramaneck Collection, Gift of
Paul Mellon (68.8.64)

country that they use it but seldom. Only the King Jahangir doth help us a little, because he taketh some years about a hundred pieces . . ."[46]

COSTUMES

The delightful silks, cottons, woolens, and embroideries available to Shah Jahan and his courtiers were also used to make spectacular robes and garments. Unlike much twentieth-century apparel, in which fairly clear distinctions are made between genders, the male and female costumes worn by Shah Jahan's entourage were equally sumptuous, made of fabrics dyed in the richest possible range of hues, and often woven with highly contrasting patterns. The coordination of colors, designs, and types of fabrics seems to have been done with considerable selectivity. Even normally inconspicuous items, such as shoes, were carefully matched with the rest of the costume.

Although dress was varied, men and women of the court wore fairly standardized garb. The basic attire for a courtier, such as that seen in a portrait of a Rajput nobleman [Fig. 201], consisted of a *pyjama* or *salvar*, a *jama*, a *patka*, and a *pagree*.[47] The *pyjama* or *salvar* was a pair of trousers with long legs, the lower portions of which were tight-fitting and pushed up at the ankles; they were made of various types of material, which might be plain, decorated, or striped. The *salvar* was partially covered by the *jama*, a long-sleeved, full-skirted gown that fell below the knees. When worn, the *jama* was crossed over and tied on one side of the torso—left for Hindus and right for Muslims [see Fig. 26]—with as many as seven or eight ribbons; it was cinctured at the waist by a *patka* or sash. The length of the *jama* was subject to changes of personal and period tastes: in Shah Jahan's day, the most fashionable *jama* fell slightly more than midway between the knees and the feet. The ribbon ties, some of which were purely ornamental, often contrasted or complemented the color of the *jama*. Only the first and last ties were fastened, while the rest hung down in an elegant cascade.

The *patka* was a long single piece of fabric that was wound several times around the body and then tied, the ends hanging down the front of the *jama*. Its decoration, the length of its hanging ends, and the manner of tying it also varied according to period and personal tastes. In Akbar's time, the sash, usually made of cotton, was

202 *Patka* (sash)
Mogul, c. 1675–1725
Brocade twill fabric; silk and gilt yarns
$97\frac{7}{8} \times 19\frac{1}{3}$ in. (248.6 × 49 cm.)
Los Angeles County Museum of Art, From the Nasli and Alice Heeramaneck Collection, Museum Associates Purchase (M.71.1.36)

either plain or patterned with geometric motifs; its ends were very long. During the Jahangir period, the *patka* was made of heavier, more sumptuous fabrics decorated with floral scrolls and arabesques; sometimes it was supported by a second sash of fine muslin. Late in Jahangir's reign a new *patka* appeared. Its ends were decorated with a band containing one or more flowering plants of the type discussed earlier in this chapter. Although geometric, floral scroll, and arabesque *patkas* continued to be used during Shah Jahan's reign, the flowering plant sash became very popular in the later years of the emperor's rule. Two *patkas* pictured here [Figs. 202, 204], though probably woven in Ahmedabad during the late seventeenth or early eighteenth century, offer an idea of the elegant appearance of such sashes in the Shah Jahan period.

The standard Shah Jahani noble dress was topped off with a colorful, elaborate, and rather formal *pagree* or turban—a long piece of cloth, usually silk or cotton, wound around the head. Like the *jama* and the *patka*, the method of wrapping it varied according to taste and period. In the time of Shah Jahan, the most fashionable men wore a band of fabric that, passing behind the head above the neck, held the *pagree* tight to the head; its two ends were joined together on top.

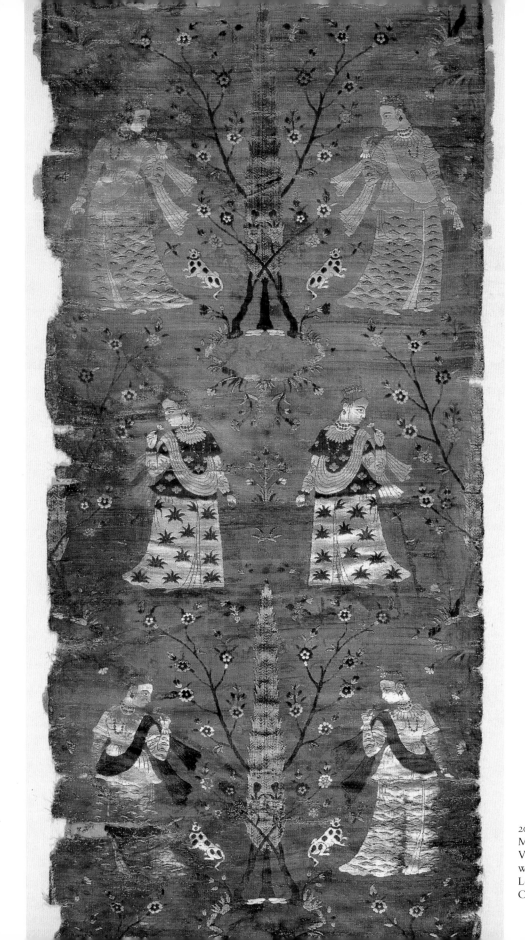

203 Detail of dress or furnishing fabric
Mogul, c. 1650–1700
Velvet
W: 23 in. (58.4 cm.)
Los Angeles County Museum of Art, Costume
Council Fund (M.71.13)

204 *Patka* (sash)
Mogul, c. 1675–1725
Brocade twill fabric; silk yarns
147⅝ × 20⁵⁄₁₆ in. (375 × 51.5 cm.)
The Textile Museum, Washington, D.C. (6.29)

No courtier's attire was complete without accessories. In Shah Jahan's day these items were, of course, quite showy. The *jama, patka,* and *pagree* not only clothed a person, but also supported a splendid array of personal effects, including necklaces and armlets of gems and pearls, turban ornaments, and jeweled daggers (see Chapter Four). Slipper-like shoes, somewhat resembling the modern Indian *chappal,* were made of leather or velvet and frequently embroidered and bejeweled [see Fig. 22]. These accessories, set off by the elegant simplicity of plain fabrics or the colorful designs of patterned textiles, must have made even the plainest courtier look like a rare tropical bird and a suitable attendant to the "Ruler of the World."

Court women wore equally beautiful clothes that often skillfully combined transparent and opaque fabrics in very enticing ways.[48] The favored female costume consisted of a tight-fitting *pyjama* or *salvar,* either plain or patterned; a *choli* or bodice to cover the breasts; and a *pesvaj* or long, usually transparent, coat that fell almost to the feet [see Figs. 21, 29, 31, 95]. The *pesvaj* had a v-neck and was fastened over the breasts, but remained open from the fastening to the ankles, thus revealing the *salvar.* A long *patka,* either plain or patterned, was tied around the waist and an *odhni* or scarf, usually transparent, was draped over the head and shoulders.

The men and women who wore these glittering costumes did so to call attention to their status, wealth, and importance. Such had not always been the case in Mogul India. Paintings from the Akbar period indicate that very few courtiers, including the emperor, were attired in exceedingly elaborate robes. In these pictures "an occasional member of the court, a high dignitary, like a minister, sometimes an ambassador, and oddly enough sometimes even a . . . personal attendant of the emperor, wears these richly patterned dresses; but these are so few that they stand out in a large group of people who dress elegantly, but not with ostentation."[49]

Thirty years later, under the rule of Shah Jahan, tastes had changed. In one painting after another, rows of courtiers dressed in exotically colored robes shimmering with gold, silver, pearls, and precious stones are shown hovering like hierarchies of angels around the enthroned "Ruler of the World" [see Figs. 36, 130]. Cushions richly upholstered with flowered fabrics lie on gilded settees; lustrous carpets cover the floors; and spectacular velvet hangings, suspended from rings in the walls, fall almost to the ground. Far removed from the energetic simplicity and understated elegance of Akbar's court, the world these paintings reveal is one of grandeur, formality, and almost paradisiacal splendor. They vividly document the role that textiles played in helping Shah Jahan to create his imperial image, his "heaven on earth."

CHAPTER SIX

Romance of the Taj Mahal

Pratapaditya Pal

I shall finish this letter with a description of the two wonderful mausoleums which constitute the chief superiority of *Agra* over *Delhi*. One was erected by *Jehan-Guyra* in honor of his father *Ekbar*; and *Chah-Jehan* raised the other to the memory of his wife *Tage Mehala*, that extraordinary and celebrated beauty, of whom her husband was so enamoured that it is said he was constant to her during life, and at her death was so affected as nearly to follow her to the grave.[1]

François Bernier

EUROPE AND THE MOGULS

Bernier ends his comments on the mausoleum with an even more forceful encomium:

It is possible I may have imbibed an Indian taste; but I decidedly think that this monument deserves much more to be numbered among the wonders of the world than the pyramids of *Egypt*, those unshapen masses which when I had seen them twice yielded me no satisfaction, and which are nothing on the outside but heaps of large stones piled in the form of steps one upon another, while within there is very little that is creditable either to human skill or to human invention.[2]

Bernier visited India between 1656 and 1668, which roughly coincided with Shah Jahan's internment in the Agra Fort. He was not exactly partial to Shah Jahan, but that did not prejudice his opinion about the Taj, which having been finished over a decade before his visit must have been in pristine condition at the time.

A fellow countryman of his, the jewel merchant Jean-Baptiste Tavernier, had arrived in Agra in 1641 when the Taj was still being constructed. Though less effusive than Bernier, he too was impressed even by the unfinished mausoleum and wrote, "Of all the tombs which one sees at Agra, that of the wife of Shah Jahan is the most splendid." He goes on to say that Shah Jahan had selected that particular site "so that the whole world should see and admire its magnificence."[3]

And so began the story of the romance of the Taj, even before its completion. But significantly, it is a romance that seems to have captured the Western imagination rather than the Indian. Although the Indians have always been interested in the Moguls, only in the last few decades have they taken to the Taj with the same zeal as tourists from abroad. And as this essay will demonstrate, few eminent Indians have written about the Taj and still fewer eminent artists have painted it. The best-known symbol of Indian civilization is essentially a creation of Western enthusiasm. The observations of the two French visitors quoted above remained typical of the European reaction through the eighteenth century. By comparison, Indian literature of the period seems hardly aware of the monument as a special building, although, as has been mentioned, in the nineteenth century some books about it were written in Persian, primarily to satisfy European curiosity.

Notwithstanding the generally glowing descriptions and assessments, for over a century after the Taj was built no artist, either Indian or European, attempted to sketch or paint it. At least, if they did, nothing has survived. Nevertheless, there was a good deal of curiosity in Europe about the Moguls in general, particularly from the time of Shah Jahan onward. By then both the Dutch and the British were trading extensively in India, while the Portuguese had become well settled at Goa and elsewhere on the subcontinent. The Dutch and the British were largely interested in trade, but the Portuguese were both traders and evangelists. Of the several Catholic orders that sent out missionaries to convert the barbarians in Mogul India, the Jesuits were the most visible as well as the most intellectually curious. When they returned home, if they survived, most must have recounted their experiences and excitement to their acquaintances, but a large number also published accounts of their sojourn. While on the whole these texts, as well as others by English travelers, do not appear to us today as riveting travelogues, they do often provide us with interesting

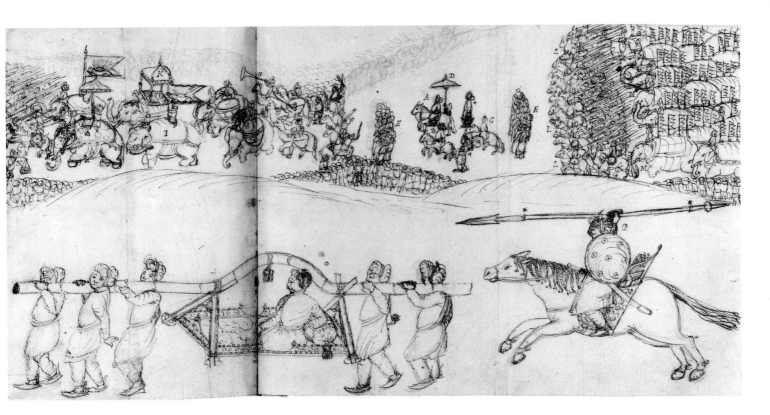

information about and psychological insights into the country and its people. They also reveal how curious the Europeans were about the Great Moguls, who certainly loomed larger in the seventeenth-century Western imagination than did their European counterparts in contemporary Indian minds.

Although a number of Europeans either worked for the Mogul court or were employed elsewhere in India, few of their drawings or sketches are known. One of the earliest to make his own sketches was the Englishman Peter Mundy (1608–67), who as we have seen was in India during Shah Jahan's reign, but left when construction of the Taj had only begun. He was not a great artist, but his drawings are lively, and afford fascinating glimpses of various aspects of Mogul India, as in the panoramic view of the emperor's journey in 1632 [Fig. 205]. Among the monuments that attracted Mundy were Sher Shah's tomb at Sasaram in Bihar and that of Akbar near Agra [Fig. 58], which until the Taj was completed was generally regarded as the finest Mogul building in India.

By the mid-seventeenth century, objects of various kinds such as carpets, textiles, furniture—especially made in Goa for the Portuguese market—and paintings in considerable quantity began to arrive in Europe from India.[4] One of the earliest collectors was Bishop Laud

(1573–1645), who was Chancellor of Oxford University from 1635 to 1641. He was interested both in Persian calligraphy and in Mogul paintings, among which an incomplete *Ragamala* set is probably a product of the Jahangiri period. Laud bequeathed his entire collection to the Bodleian Library at Oxford, where the Indian paintings remained unknown until the early twentieth century.

If there is no evidence of any interest on the part of British artists of the period, a few Dutch artists were more wide-ranging in their tastes. The most distinguished collector of Mogul paintings in the seventeenth century was Rembrandt. Many of his drawings based on them have survived, and three are included here [Figs. 206–208]. As they make clear, all the paintings he owned date from Shah Jahan's reign. It is generally thought that Rembrandt's drawings are copies made when he was forced to sell his art collection in 1656–57 to pay his debtors; but this seems unlikely. For one thing, they are not precise copies, but rather studies. Secondly, as Otto Benesch notes, "the style of

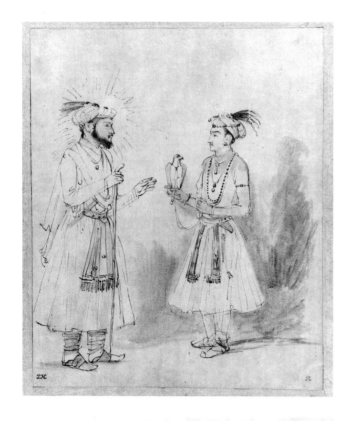

206 Rembrandt van Rijn, *Shah Jahan and Dara Shikoh*
Netherlands, c. 1654–56
Ink and wash on paper
8⅜ × 7 in. (21.2 × 17.9 cm.)
The J. Paul Getty Museum, Malibu, Calif. (85 GA.44)

207 Rembrandt van Rijn, *Indian Warrior with a Shield*
Netherlands, c. 1654–56
Ink and wash on paper
7¹¹⁄₁₆ × 6¹³⁄₁₆ in. (19.6 × 15.8 cm.)
The Pierpont Morgan Library, New York (No. I, 207)

208 LEFT Rembrandt van Rijn, *Shah Jahan*
Netherlands, c. 1654–56
Ink and wash on paper
8⅞ × 6¾ in. (22.5 × 17.1 cm.)
The Cleveland Museum of Art, Leonard C. Hanna, Jr., Fund

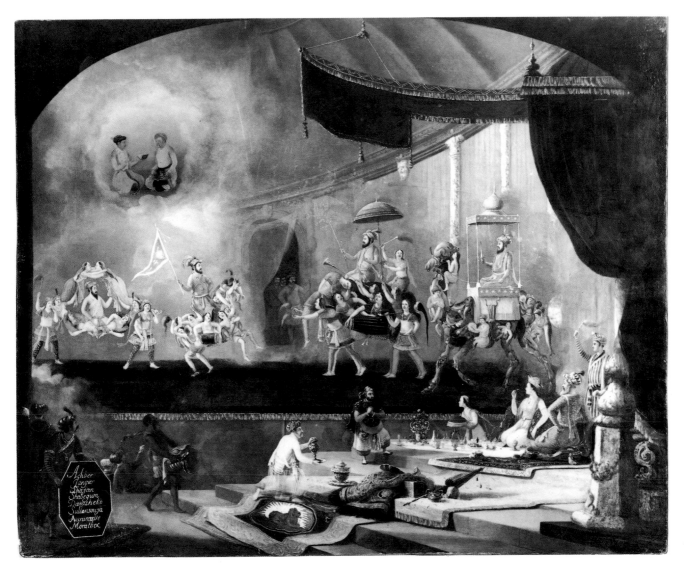

209 Willem Schellinks, *Shah Jahan and His Four Sons*
Netherlands, late 17th C.
Oil on wood
$27\frac{1}{2}$ in. × 35 in. (70 × 89 cm.)
Musée National des Arts Asiatiques—Guimet, Paris

the drawings does not allow us to limit them to such a brief period."[5] Art historians have also generally been reticent about the influence exerted by Rembrandt's Mogul pictures. One of the few exceptions is Benesch, who after pointing out specific instances writes, "such deep influence proves that the drawings were copied by Rembrandt not just on a particular occasion and for a particular purpose, but that he studied them apparently over a prolonged period in which he became engrossed with the delicate spirit of those Eastern works of art."

It is very likely that while the Mogul paintings were in Rembrandt's possession they were seen by members of his studio. If Rembrandt did admire the skills of the Mogul artists, especially for details of garments and jewelry, then it is not improbable that he would discuss them with his pupils. That some members of his circle

were indeed exposed to his collection is evident from the works of at least one of his Dutch contemporaries, Willem Schellinks (c. 1627–78). Among the several fantastic compositions showing Shah Jahan and his children that he painted, a picture now in the Musée Guimet in Paris is a fascinating version [Fig. 209]. The emperor and his daughter Jahanara are seated on a carpeted platform in the foreground and are watching a parade across a stage, where the four males riding

extraordinary mounts are the emperor's four sons. The palanquin or litter and the horse, elephant, and camel are formed out of human bodies. The idea of these composite figures (recalling the confections of the Italian painter Arcimboldo), as well as their forms and the attire of the participants are all clearly based on Mogul paintings [cf. Fig. 113], but the theatrical setting is Schellinks' own conception. No less interesting are the inset figures of Jahangir and Akbar floating in the clouds. One of Rembrandt's sketches does show the two emperors seated together in a similar position, and as Robert Skelton has suggested, he may have "had access to a picture of them in apotheosis such as one now in the Bodleian Library"[6] or such as the one included here [Fig. 212]. Schellinks might have known the image independently of Rembrandt. Interestingly, while he represented Jahangir and Akbar truthfully, the portraits of Shah Jahan and his sons are more generalized. Least convincing is Jahanara, who is clearly a figment of Schellinks' imagination.

In addition to travelers and merchants, the Jesuits were also responsible for the transmission of Indian works of art to Europe. For instance, a Jesuit may well have been the source for a group of Mogul paintings and drawings, some of them apparently unfinished, which were once in the Barberini Collection and are now in the Vatican Library. Most of the pictures are of Mogul rulers, princes, and courtiers. With one exception, which may have been rendered while Jahangir was still alive, all were done in Shah Jahan's Agra. Although none is signed, they are of good quality and very likely were executed for a European visitor, perhaps a Jesuit, by a court painter. Especially attractive is a fine portrait of a princess whose face is shown unusually in a three-quarter view. Although Otto Kurz,[7] who published these pictures, agreed with Manucci that Mogul princesses were not portrayed from life, so distinguished and individualistic is this portrait that the sitter must have been a Mogul princess even if we cannot identify her today.

By and large seventeenth-century European collectors seem to have been interested in pictures of great men rather than any other type of paintings. Most surviving albums of the period, such as that brought back by Manucci or another by Laurens Pit, the Dutch ambassador to Golconda in 1686, which was acquired by Nicholas Witzen, the Dutch scholar and traveler and at one time Burgomaster of Amsterdam, consist of portraits of Mogul and other rulers and nobles of India. One of the earliest European collectors to acquire a group of Mogul pictures of diverse subjects was the Italian Conte Abbate Giovanni Antonio Baldini (1654–1725). While most other seventeenth-century collectors acquired art from Asia incidentally and as a curiosity, Baldini may well be regarded as the first serious Western connoisseur of Asian material. He traveled a good deal in Europe, and it appears that while living in Amsterdam and attending the Congress of Utrecht he came across Asian objects and "applied himself entirely to putting together his remarkable Museum of Indian and Chinese things."[8] Baldini's Indian paintings were engraved by the Frenchman Bernard Picart (1673–1733); interestingly, the subjects were wrongly identified, and one of them, perhaps representing a musical theme (ragini), was called a portrait of Jahanara.

In fact, throughout the seventeenth and for much of the eighteenth century Europeans were chiefly interested in the Great Moguls themselves. All travel accounts invariably contained observations about the rulers and their fabulous wealth. By the end of the seventeenth century, the expression "Mogul" (with several variations) must have been quite familiar in European parlance. Had this not been the case it is unlikely that John Dryden would have written a play about Aurangzeb which was performed at the Theatre Royal, London, in the spring of 1675 and was a favorite at the court of Charles II. From a description published in 1697 we know that Charles Perrault and his brother Claude had devised a scheme for a room "à la manière du Mogol" for the Louvre in Paris, but the idea was abandoned.

Neither the Taj nor the other Mogul monuments, however, seem to have particularly excited Europeans. Certainly there are no surviving sketches or drawings by European artists, whether professional or amateur. This is somewhat surprising considering that "Orientalism" was well on the rise, trade between India and Europe was flourishing, and certainly in England "the rich Indian taste became a favorite indulgence of the Restoration court."[9] Until the end of the eighteenth century, when India became better known in Europe because of the firm establishment of British rule, the term "Indian" was used generically in England for all things Eastern. How vague the idea of Oriental art and architecture was is evident from William and John Halfpenny's *Rural Architecture in the Chinese Taste*,

published in London in 1752. Two designs for garden houses, described as "Indian temples," are clearly pastiches and are neither Indian nor Chinese.[10] Or again in a wool and silk tapestry made in London at the end of the seventeenth century by John Vanderbank "after the Indian manner" one sees a curious combination of motifs from Indian miniatures and japanned lacquer cabinets, with architecture largely derived from East Asia.[11] The prevailing attitude towards things Indian is best expressed in the preface to *The Ladies' Amusement*, published in London in 1760:

With the *Indian* and *Chinese* subjects, greater Liberties may be taken, because Luxuriance of Fancy recommends their Productions more than Propriety, for in them is often seen a Butterfly supporting an Elephant, or Things equally absurd; yet from their . . . airy Disposition [they] seldom fail to please.[12]

For countless future visitors, the Taj Mahal would provide the perfect example of both "Luxuriance of Fancy" and "airy Disposition."

EUROPE AND THE TAJ

While for most of the seventeenth century and the first half of the eighteenth only serious travelers, merchants, and zealous missionaries visited India, it became a much more accessible and inviting country once the British had consolidated their power after Clive's victory at the battle of Plassey in Bengal in 1757. Before the end of the eighteenth century not only would the Taj become a principal attraction of all visitors to India with an interest in the country's culture, but thanks to a number of artists who flocked to the land of the nabobs in search of their fortunes, it would become the best known of all Indian buildings. Thus, both the romance and the image of the Taj were largely a creation of the British in the last quarter of the eighteenth century.

The first noteworthy English artist to have worked in India was Tilly Kettle (1735–86), who was there between 1769 and 1776. As he returned home with a considerable fortune a number of others followed, but none appears to have visited the Taj, which is not surprising since most were portrait painters and not too curious about the country. William Hodges (1746–97), in India between 1780 and 1783, was the first British artist to visit Agra: not only did he draw and paint the monument, but he made no bones about the fact that he

was smitten by its beauty. "The whole," he wrote, "appears like a most perfect pearl on an azure ground. The effect is such, I confess, I never experienced from any work of art."[13] Indeed, how rapidly the fame of the Taj spread among visiting Europeans may be gleaned from the fact that before the end of the century another British artist, Thomas Daniell (1749–1840), observed:

The Taje Mahel has always been considered as the first example of Mahomedan architecture in India, and consequently, being a spectacle of the highest celebrity, is visited by persons of all rank, and from all parts. This high admiration is however not confined to the partial eye of the native Indian; it is beheld with no less wonder and delight by those who have seen the productions of art in various parts of the globe.[14]

Along with his nephew William (1769–1837), Thomas Daniell visited the Taj in 1789. The entry in William's diary for 21 January reads: "Crossed the Jumna abt 7 o C. & breakfasted with Major Palmer in one of the Mosques in the Tage. After breakfast we all visited the inside of the Tage & were much struck with its Magnificent Workmanship." They spent the whole of the next day at the Taj, Thomas drawing the "View from the Garden in the Camera"—the camera obscura, a drawing aid—and in the evening "went upon the Dome" to enjoy a repast of "some Apples Pears & Grapes of Persia from Major Palmers table."[15]

The "garden view of the Taje Mahel . . . taken immediately on entering it by the principal gate" that the Daniells drew [Fig. 210] has remained to this day the most classic and stereotyped view of the monument, particularly with photographers both amateur and professional. More often than not this is the photograph that is reproduced in most commercial representations of the building [see, for example, Figs. 2 and 4]. The Taj had so impressed the Daniells that apart from including it in *Oriental Scenery*, their great collection of aquatint views of India, they published a separate booklet devoted to it. While the prints in that volume are well known, less familiar is a charming drawing rendered from a distance along the river showing the ruins of the township around the Taj and the Agra Fort in the distance on the right [Fig. 211].

The most whimsical representation of the Taj by Thomas Daniell is a large capriccio that juxtaposes it with a South Indian Hindu temple gateway or *gopuram* and other Indian monuments [Fig. 216]. This unique

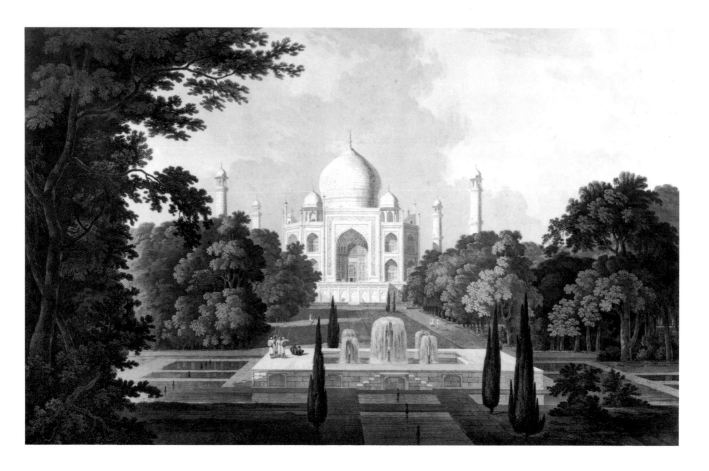

210 Thomas and William Daniell, *The Taje Mahel, Agra, Taken in the Garden*†
England, 1801
Aquatint with hand coloring, from *Views of the Taje Mahel at the City of Agra in Hindoostan taken in 1789*
The British Library (India Office Library and Records), London

211 William Daniell, *Drawing of the Taj Mahal*
England, 1820(?)
Pencil on paper
$12\frac{1}{2} \times 19\frac{1}{2}$ in. (31.8 × 49.5 cm.)
Robert L. Hardgrave, Jr., Austin, Texas

subject was commissioned by the connoisseur Thomas Hope probably in 1799 for the principal drawing room in his mansion in London. There it hung opposite a similarly large picture of the Roman Forum by the Italian artist Pannini. While the *gopuram* looks completely at home against the background of hills, the Taj, dissociated from its flat setting, looks like a model in this "composition picture." Nevertheless, the painting does capture the pearl-like effect of the monument admired a

few years earlier by Hodges. The Daniells' pictures and prints of Indian buildings had a profound effect on the taste for "Orientalism" that developed in English architecture at the time. Among the architects who were influenced by *Oriental Scenery* were Edmund Aiken, S. P. Cockerell, John Nash, and Humphry Repton. Seeing the Daniells' aquatints, a contemporary British critic had observed, "The plates are at once a profound study for the architect or antiquary and a new

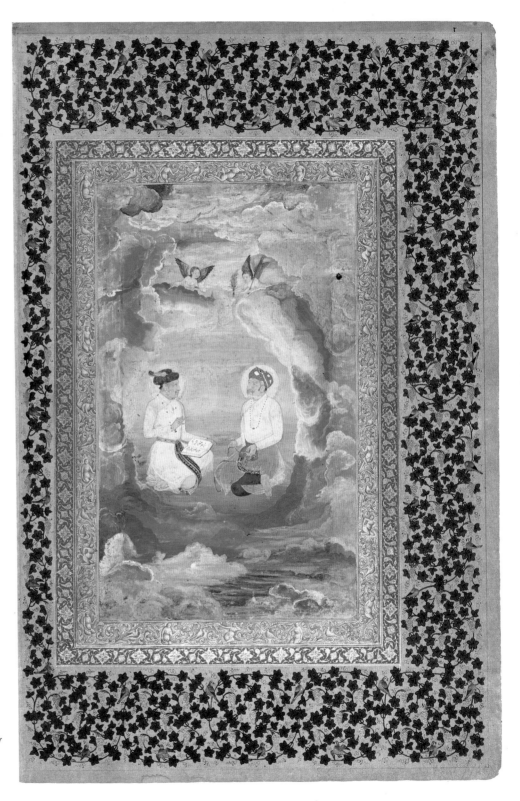

212 *Seated Jahangir and Akbar*
Mogul, 17th C.
Opaque watercolor on paper
Robert Hatfield Ellsworth

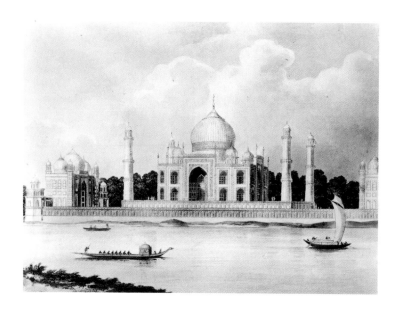

213 Charles Ramus Forrest, *The Taj Mahal, Tomb of the Emperor Shah Jahan and His Queen*
England, 1824
Aquatint with hand coloring
8 × 10¾ in. (20.3 × 27.3 cm.)
Max and Peter Allen

214 Plate with picture of the Taj Mahal
England, c. 1825
Staffordshire earthenware; imprinted: T. Hall and Sons; Oriental
Scenery: Tomb of the Emperor Shah Jahan
14⅛ × 18¼ in. (35.9 × 46.4 cm.)
Paul F. Walter

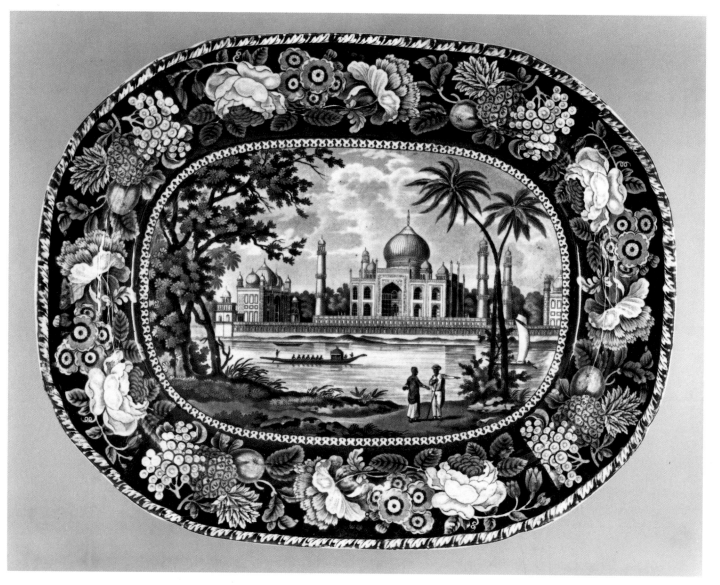

source of delight to the lover of the picturesque," while Repton commented that "architects who have access to them can be at no loss for the minutiae." Cockerell designed Sezincote in Gloucestershire around 1805 for his brother Sir Charles Cockerell, one of the East India Company nabobs who could not forget the magnificent Mogul buildings he had seen in India. As Raymond Head has summed up, "Fundamentally Sezincote is based upon the classical villa designs of Cockerell's tutor, Sir Robert Taylor. . . . Onto this classical structure Cockerell was to drape another classic design, that of the Taj Mahal."[16] Both Repton and Nash were involved with the design of the Brighton Pavilion, which remains the most familiar of all Indian-style buildings raised in Europe. It was the Daniells' aquatints of Mogul architecture that inspired both men and instilled in them such an admiration of Indian architecture that Repton was led to comment that "it was only a matter of time before the Indian style would become a national style."[17] Apart from architecture, motifs from the Daniells' aquatints found their way into British homes in the forms of wallpaper or Staffordshire crockery. The blue-and-white serving platter with a view of the Taj Mahal reproduced here [Fig. 214], however, was not copied from a Daniell aquatint. Rather, as the accompanying print [Fig. 213] shows, it was based on an illustration in Charles Ramus Forrest's *A Picturesque Tour Along the Rivers Ganges and Jumna, In India*, published in 1824. Forrest did military service in the country between 1802 and 1826, and was one of the gifted amateur artists whose impressions are among the many admirable legacies of British presence in India.

Another such amateur was James Forbes (1749–1819), who was one of the early group to admire and draw the Taj. Already in 1781 he was on the spot making his sketches, which were engraved and colored by hand. Not only are his meticulous renderings of details [Fig. 215] among the finest of the genre, but they were done at a time when the Mogul monuments, including the Taj, were less vandalized than they would be in the nineteenth century—ironically enough during the very period when the romance of the Taj continued to grow in its intensity.

The almost instant fascination with and adulation of the Taj by British artists of the last quarter of the eighteenth century was due less to their love of the picturesque than to their admiration of the sublime and

215 James Forbes, *Fac-Simile of the Inlaid Work on the Tomb at Agra, Called Taje-Mahal, or Crown of the Seraglio*
England, 1781
Engraving with hand coloring
$8\frac{3}{4} \times 11$ in. (22.2 × 27.2 cm.)
Anonymous

their romantic sensibilities. Undoubtedly the search for the picturesque inspired most artists to come to India, but if that expression meant a preference for "romantic disorder" in both nature and art as opposed to classical formalism, then certainly the Taj did not fit the bill. However, to those who like the Earl of Shaftesbury and Edmund Burke were interested in the concept of the sublime as an alternative to the more classical idea of beauty, the Taj was the monument *par excellence*. In fact, in the context of the prevailing aesthetic attitudes of the time, the Taj could be placed in all categories. Its symmetry and geometric formalism, as well as the gleaming white marble, made it particularly appealing to those who admired the classical world. To those whose taste was for the sublime, the Taj was certainly capable of arousing strong emotional responses, a necessary ingredient of this particular "mode of vision." As to the romantic concern, what other monument in the world embodied such a tragic story as that of the love between Shah Jahan and Mumtaz Mahal? For those who arrived in search of the romantic India, the Taj was the quintessential building by all standards. So it is easy to understand how that incurably romantic traveler in British India Fanny Parks could write in 1835: "And now adieu, beautiful Taj, adieu! In the far, far west I shall rejoice that I have gazed upon

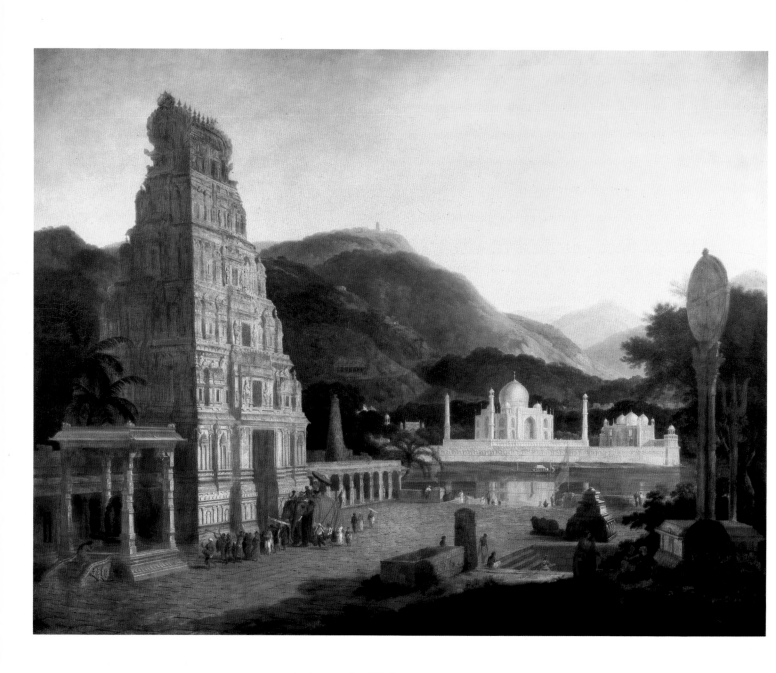

216 Thomas Daniell, *Composition, Hindu and Muslim Architecture†*
England, 1799
Oil on canvas
$43\frac{3}{4} \times 89\frac{1}{2}$ in. (112×229 cm.)
Niall Hobhouse

217 Hercules Brabazon Brabazon, *The Taj Mahal, Agra*
England, late 19th C.
Watercolor and opaque watercolor on paper
11 × 14 in. (27.9 × 35.6 cm.)
Chris Beetles Ltd., St. James's, London

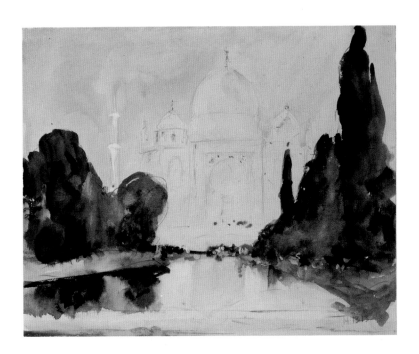

218 Hercules Brabazon Brabazon, *Delhi, the Great Mosque*
England, late 19th C.
Watercolor and opaque watercolor on paper
20 × 27 in. (50.8 × 68.6 cm.)
Chris Beetles Ltd., St. James's, London

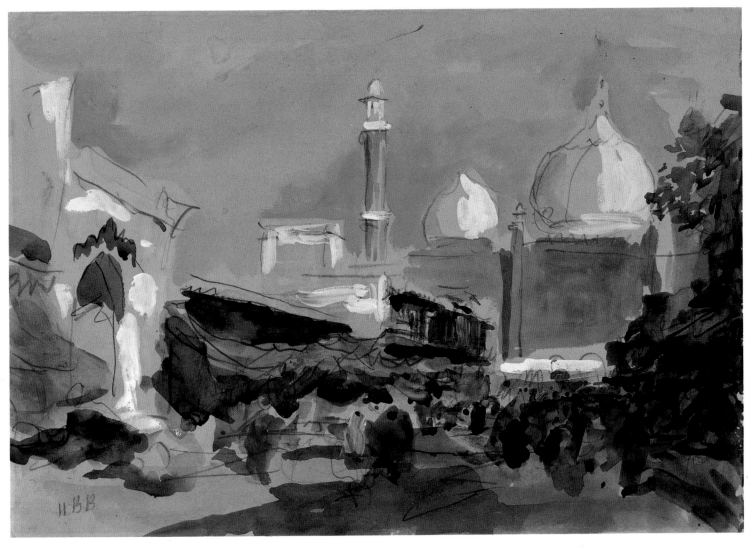

219 William Simpson, *The Taj Mahal, Agra*
England, 1864
Watercolor on paper
$13\frac{1}{2} \times 20$ in. (34.3 cm. × 50.8 cm.)
Trustees of the Victoria and Albert
Museum, London (1130–1869)

your beauty nor will the memory depart until the lowly tomb of an English gentlewoman closes on my remains." A few years later another English lady, the wife of Major W. H. (later Sir William) Sleeman of the Bengal Army, is reported to have exclaimed in a similar vein: "I cannot tell you what I think for I know not how to criticize such a building, but I can tell you what I feel. I would die tomorrow to have such another over me."

Even a sampling of the innumerable studies of the Taj undertaken by European artists throughout the nineteenth century could fill a volume larger than the present one. Most are adequate representations, of little aesthetic merit. They are, however, of great topographical and archaeological interest, as they provide us with fairly accurate descriptions of the building. The views of the Taj by the British artist William Simpson (1823–99) introduce a refreshing sensibility to a subject that was already becoming hackneyed [Fig. 219]. He is less self-conscious, and his sketches have an uncontrived subtlety about them. He may be regarded as the first of a generation of artists who would attempt to convey their impressions of the Taj rather than its jewel-like quality.

By the time Edward Lear (1812–88) arrived in India in 1873, the Taj had become a must on the itinerary of every traveler to the subcontinent. And all those who wrote about it invariably were surprised at how well it lived up to its reputation. Like the stereotyped frontal view of the Taj that continues to assault our eyes, it became commonplace for every writer, as was said by Edward, Prince of Wales, who visited India in 1875–76, "to set out with the admission that it is indescribable, and then proceed to give some idea of it."

Sir William Sleeman was one of the most eloquent nineteenth-century admirers of the Taj, and his *Rambles and Recollections of an Indian Official*, published in 1844, was a considerable success. He had waited a quarter of a century to see the Taj, and having seen it he expressed his reactions with sentimental eloquence in keeping with the romantic taste of the period.

After my quarter of a century of anticipated pleasure, I went on from part to part in the expectation that I must by-and-by come to something that would disappoint me; but no, the emotion which one feels at first is never impaired. . . . One returns and returns to it with undiminished pleasure; . . . and he leaves it with a feeling of regret, that he could not have it all his life within his reach; and of assurance that the image of what he has seen can never be obliterated from his mind "while memory holds her seat."

Over a century later another visitor from another continent was to echo the same sentiments. In *India and the Awakening East*, published in 1953, Eleanor Roosevelt concluded her fulsome tribute to the Taj by writing: "As long as I live I shall carry in my mind the beauty of the Taj, and at last I know why my father felt

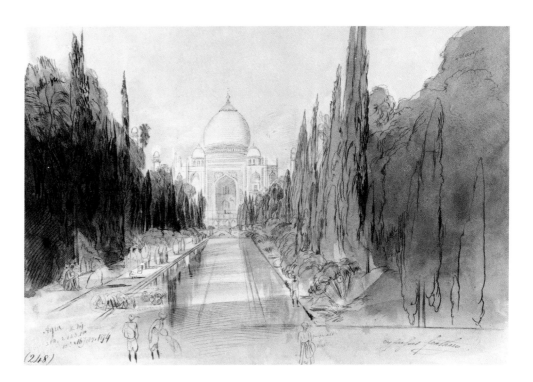

220 Edward Lear, *Agra: The Taj*†
England, 1874
Watercolor on paper
13½ × 19½ in. (34.3 × 49.5 cm.)
The Houghton Library, Harvard
University, Cambridge, Mass.

it was the one unforgettable thing he had seen in India. He always said it was the one thing he wanted us to see together."

Confronted by the Taj, Lear exclaimed in exasperation, "*What* can I do here? Certainly not the architecture, which I naturally shall not attempt, except perhaps in a light sketch of one or two direct garden views." Although his views of the Taj and its gardens are somewhat conventional, they reveal a sensitivity and gentle eloquence that characterize many of his Indian watercolors [Fig. 220]. The soft, muted hues of his rapid washes vividly capture the alluringly mysterious qualities of the monument in the early morning light of winter. But more than his sketches of "the most beautiful of all earthly buildings," his description of the ambience is one of the most poetic of the numerous impressions left by countless visitors. Anticipating the Prince of Wales by more than a generation Lear wrote, "Descriptions of this wonderfully lovely place are simply silly, as no words can describe it at all;" and then he promptly moved on to describe the surrounding gardens, and being an ardent admirer of nature composed the following passage, which is remarkably visual in its descriptive and evocative powers:

What a garden! What flowers! . . . What gorgeously dressed and be-ringed women! Men mostly in white, some with red shawls . . . the Great Centre of the Picture being ever the vast glittering Ivory-white Taj, and the accompaniment and contrast of the dark green cypresses, with the rich yellow green trees of all sorts! And then the effect of the innumerable flights of bright green Parrots flitting across,—like live Emeralds;—and of the scarlet poinsettias and countless other flowers—"beaming" bright off the dark green!! . . . The garden is indescribable.[18]

Hercules Brabazon Brabazon (1821–1906), a British watercolorist of eminence, arrived in India in 1875, two years after Lear. He was probably the most accomplished of all the Victorian artists who visited the country and drew the Mogul monuments. Of his many Indian sketches, the two illustrated here depict the Taj and Shah Jahan's Jami Masjid in Delhi seen from a back alley—a rarely painted view [Figs. 217, 218].

Brabazon has been characterized as a "painter of painters" and in 1892 was proclaimed the "best watercolor painter" since Turner.[19] A man of independent means, he was largely self-taught as an artist, learning from such masters as Turner, who remained a life-long influence, and Velásquez. He was also a friend of John Ruskin and John Singer Sargent. He occasionally showed his pictures with Corot and Whistler, and after his first one-man show, which took place in 1892 when he was seventy-one, a critic wrote: "Impressionism can be exquisitely beautiful as Mr. Whistler and Mr. Brabazon have taught us." Both his Indian pictures

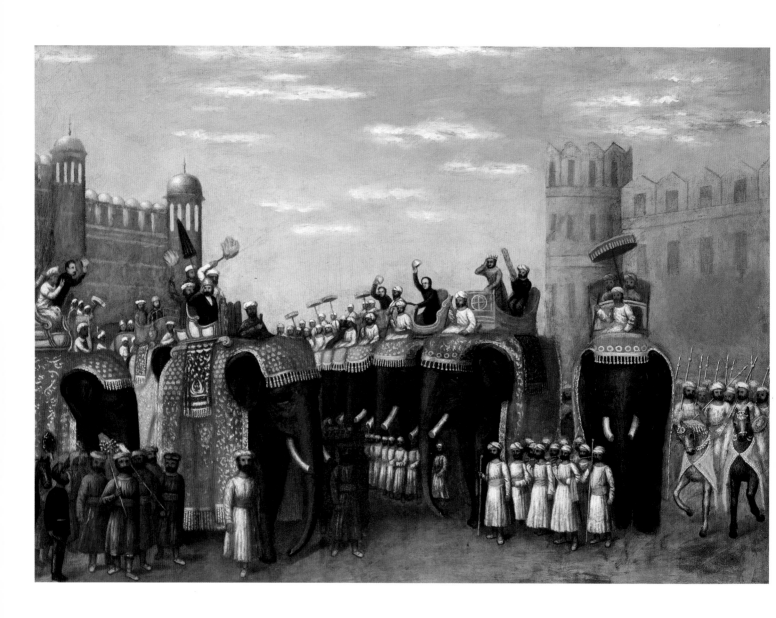

221 Erastus Salisbury Field, *The Visit of Ulysses
S. Grant to India* (copied from James R. Young's
Around the World with General Grant)
United States, c. 1880
Oil on canvas
34 × 45½ in. (87 × 115.5 cm.)
Museum of Fine Arts, Springfield, Mass., The
Morgan Wesson Memorial Collection (63.19)

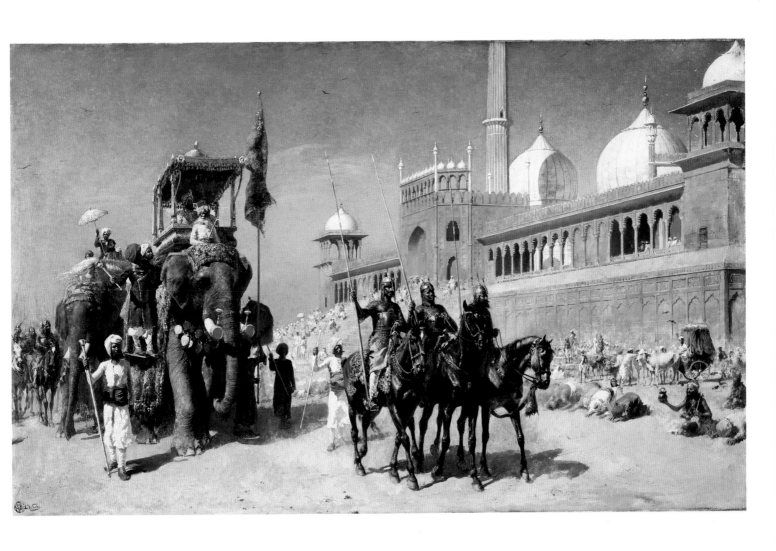

222 Edwin Lord Weeks, *The Great Mogul and
His Court Returning from the Great Mosque at
Delhi, India*
United States, c. 1890
Oil on canvas
$33\frac{5}{8} \times 54\frac{1}{4}$ in. (85.4 × 137.8 cm.)
Portland Museum of Art, Portland, Maine, Gift
of Miss Marion Weeks, in memory of
Dr. Stephen Holmes Weeks, 1918

223 Vasili Vasilievich Vereshchagin,
Pearl Mosque, Delhi†
Russia, c. 1878
Oil on canvas
155⅞ × 197⅝ in. (396 × 502 cm.)
Courtesy, Museum of Fine Arts, Boston
Gift by Contribution, 1892 (92.2628)

shown here are indeed "impressions," sketched with the utmost economy, and yet they successfully capture the atmospheric essence and have a sparkle and spontaneity not always apparent in more meticulous renderings. Enclosed in the bright sunlight, only the rough outline of the Taj emerges from the background, while the vegetation and the reflection in the pool are only evanescent suggestions. In the other picture, with a few deft strokes he has admirably captured the bustle and mystery of the crowded street behind the majestic mosque. Even though the technique is impressionist, the picture conveys the atmosphere of the place with uncanny realism.

While much is known about the British reaction to the Taj, little has been published concerning the responses of nineteenth-century artists and travelers from the Continent of Europe. It almost seems as if they had decided to leave India to the British and concentrate more on the regions known as the Near East and the Far East.[20] One notable exception was the Russian artist Vasili Vasilievich Vereshchagin (1842–1904). He had studied at the Ecole des Beaux Arts in Paris under J. L. Gérôme, one of the greatest exponents of Orientalism in the nineteenth century, and was a genuine admirer of

Asia and its peoples. Indeed, he was proud of the fact that he was partly Oriental, as his grandmother had been a beautiful Tartar woman. He traveled through India between 1874 and 1876, dates which partly overlapped with Brabazon's and Lear's visits. His trip also coincided with that of the Prince of Wales, who invited him to join the royal entourage. Vereshchagin, however, politely refused, and in general avoided the British in India as he wanted to see the real country.

He traveled widely, and was generally interested in the people, the natural landscapes, and the architecture. Although not well known today, he was much admired in his time as a "painter both essentially modern and essentially original, whose work should prove epoch-making in our modern history with its unmodern Art."[21] Predictably, he visited both Agra and Delhi and painted many of the Mogul monuments, including the Taj. The picture reproduced here has a less familiar subject, the Pearl Mosque in the Red Fort at Delhi, built by Aurangzeb [Fig. 223]; it clearly reveals the artist's acute power of observation, sympathy for his subject, and flawless technique. His realism is remarkably precise and pure, and yet it is both poetic and abstract.

NINETEENTH-CENTURY AMERICA AND THE TAJ

By one of those curious coincidences, the first known American artist to paint the Taj on the spot, Edwin Lord Weeks (1849–1903), was not only a contemporary of Vereshchagin but also a student of Gérôme in Paris at about the same time. Weeks had joined the Ecole in 1869, while Vereshchagin arrived either the same year or the year before. We do not know how well they knew each other, but as both were keenly interested in the Orient one would imagine that they would have been friends.

The story of the American romance with the Taj, however, had begun much earlier. As was the case in Europe, merchants and travelers rather than artists were the first to be smitten. One of the earliest "Americans" to visit India was Elihu Yale (1649–1721), the benefactor of the well-known university that now bears his name. Although born in Boston, he lived in England from the age of three. He was in India from 1672 to the end of the century, becoming governor of Madras (1687–92) and then a director of the East India Company. We do not know whether he visited the Taj, though it is unlikely, but he may well be considered the first American collector of Mogul miniatures, which were later sold in London in 1721–22. Some of them were used by the weaver John Vanderbank for tapestries that are now at Yale University. Another noteworthy American to visit India was Charles Eliot Norton (1827–1908). Soon after his graduation he visited the Taj and admired it, with New England restraint, although later as a member of the Harvard faculty he would be an influential figure in the art world.

Far more effusive is Bayard Taylor's account of his visit to the Taj as included in his *A Visit to India, China and Japan*, published in 1855. A novelist and journalist, he had accompanied Commodore Matthew Perry on his successful naval expedition to Japan. Taylor visited India some time in the early 1850s. He was one of the few observers to discount the theory that the monument was designed by an Italian architect. "One look at the Taj," he wrote, "ought to assure any intelligent man that this was false—nay, impossible, from the very nature of the thing." Like many others who have marveled at the buoyancy of the solid marble edifice, Taylor was much impressed by its apparent weightlessness. "So light it seems, and so airy," he went on, "and

when seen from a distance, so like a fabric of mist and sunbeams, with its great dome soaring up, a silvery bubble, about to burst in the sun, that even after you have touched it, and climbed to its summit, you almost doubt its reality." He concluded: "The Taj truly is, as I have already said, a poem. It is not only a pure architectural type, but also a creation which satisfies the imagination, because its characteristic is Beauty."[22]

It is remarkable how visitor after visitor to the Taj commented on its ethereal insubstantiality. Another American, Robert Ogden Tyler, a military man rather than a literary figure, viewed the Taj in 1873 and wrote, "Seen by moonlight, the darker inlaid-work and the discoloration disappear, and all is pure white. The lines and tracery are softened and blended, and it seems so delicate and intangible that one would hardly be surprised if at some moment it should melt like a cloud into 'thin air'."[23] These sentiments were repeated some four decades later by the German philosopher Count Hermann Keyserling when in a more metaphysical vein he attempted to explain the mystery and mystique of the Taj Mahal's aesthetic appeal:

I could not have believed that there could be anything like it. A massive marble structure without weight, as if composed of ether.... Here the rational elements have been melted into the decorative, which means that gravity, whose exploitation is the real principle of all other architecture, has lost its weight.[24]

Curiously, perhaps unbeknownst to Keyserling, some contemporary artists were in fact trying to capture this evanescent quality of the Taj, but more of that later.

Although Weeks was the first known American artist to visit India, he was not the first to paint the Taj. That dubious honor may belong to Erastus Salisbury Field (1805–1900). Field came from Massachusetts, like Elihu Yale and Charles Eliot Norton, but nothing is known about his Oriental inclination or Indian connection. Apart from portraits and landscapes, he was interested in historical and allegorical subjects, which he painted with an idiosyncratic fusion of fantasy and mystical vision, for instance in his vast *The Historical Monument of the American Republic*. It seems almost natural that he should have read and been inspired by John Russell Young's *Around the World with General Grant*, published in 1879. To a man who had hardly gone beyond Massachusetts, Ulysses Grant's trip around the world must have seemed no less spectacular

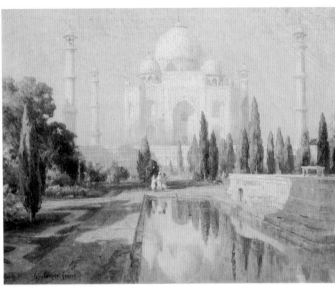

224 Colin Campbell Cooper, *Taj Mahal*
United States, early 20th C.
Oil on canvas
43 × 36¾ in. (109.2 × 93.3 cm.)
Sherrill Helene Seeley Henderson

225 Albert Goodwin, *The Jasmine Tower,
Agra Fort*
England, 1918
Watercolor, opaque watercolor, and oil on
board
10¼ × 14 in. (26 × 35.6 cm.)
Chris Beetles Ltd., St. James's, London

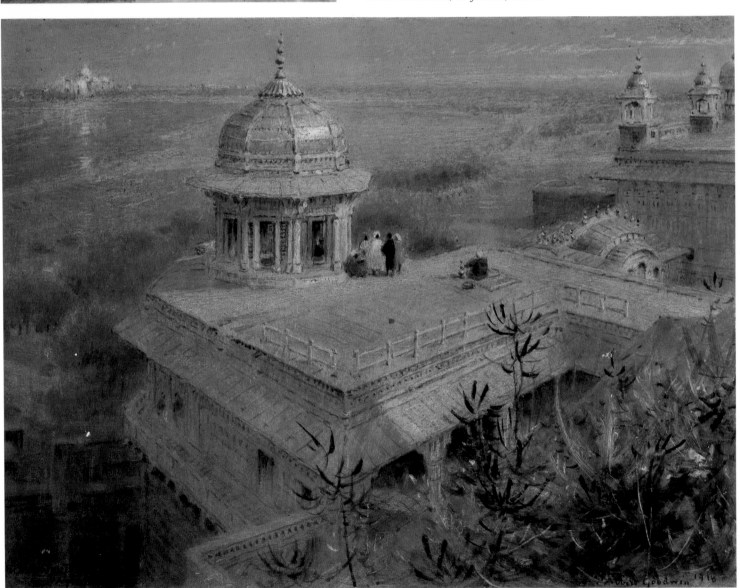

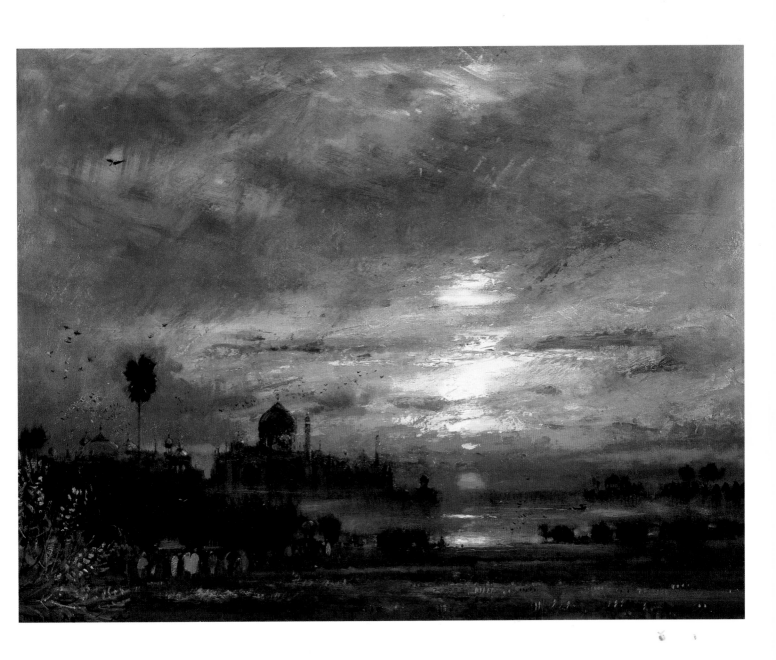

226 Albert Goodwin, *Taj Sunset*
England, c. 1918
Oil on board
$17\frac{1}{2} \times 23\frac{1}{2}$ in. (44.5 × 59.7 cm.)
Chris Beetles Ltd, St. James's, London

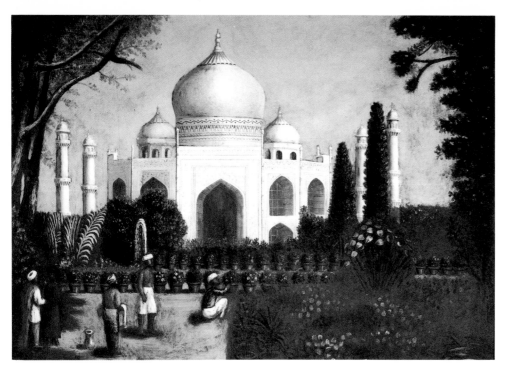

227 Erastus Salisbury Field, *The Taj Mahal and Its Gardens*
United States, c. 1880
Oil on canvas
35 × 45 in. (88.9 × 114.3 cm.)
Museum of Fine Arts, Springfield, Mass., The Morgan Wesson Memorial Collection (63.14)

than that of Homer's Ulysses. In any event, Field was so impressed by at least one of the engravings illustrating Young's book that he painted the same subject as a triumphant commemoration of Grant's visit to India [Fig. 221]. The immediate occasion may have been Grant's visit in 1880 to Hartford where Stephen Ashley, a cousin of Field, was in charge of the ceremonial arrangements. It was a fitting subject for both Field's style and his rich imagination.

Less easy to explain is Field's preoccupation with the Taj Mahal, of which several pen, ink, and pencil sketches as well as oil paintings exist. Nor is it easy to determine the sources of these works, except that he must have seen some English prints or book illustrations, or even drawings of the monument by Indian artists which might have reached the eastern ports through traders. The view of the Taj illustrated here [Fig. 227] is rather a strange composition, for neither is the impressive platform visible nor does the garden conform to reality. The arrangement of the garden, with rows of plants in pots, and the foliage seem to have been lifted from another source, perhaps from a picture of an early nineteenth-century British Indian mansion. Field also painted the screen and one of the cenotaphs inside the tomb. Apart from the account of General Grant's voyage around the world, Field must have read other, earlier accounts by travelers in India, such as Bayard

Taylor's mentioned previously. It has been suggested that his fascination with the Taj Mahal, "the temple to a beloved wife's memory, may be associated with the deaths of family and friends."[25] However, Field was essentially a romantic at heart, even though unlike Weeks he did not physically set out in search of the exotic Orient. He may simply have been moved by the universal pathos underlying the story of the Taj Mahal.

Like Edward Lear, Edwin Lord Weeks wielded the pen and the brush with equal facility. Although he was primarily a painter, he was also a prolific writer, explorer, collector, and photographer. Because of his training with Gérôme and interest in photography, like his Russian contemporary Vereshchagin he too painted in a super-realistic style, capturing both the details and the atmosphere of his subjects with compelling veracity and subtle sensitivity. In a historical picture in Portland [Fig. 222], he has evoked the grandeur and the lavish pageant of Mogul India with photographic precision, as if he was watching the imperial procession. Another of his works is less ambitious in its subject [Fig. 228], but no less admirable for his masterly rendering of the figures, especially those engaged in various activities, and the different effects of light that accentuate the textures and the colors within the composition. This luminous painting clearly demonstrates how well Weeks had learned from Gérôme to make use of light to

228 Edwin Lord Weeks, *The Hour of Prayer at Muti Mushid (Pearl Mosque) Agra*
United States, 1889
Oil on canvas
79 × 119 in. (201 × 302 cm.)
Alexander R. Raydon, Raydon Gallery, New York

emphasize "the juxtaposition of internal and external surfaces."

Weeks apparently made three trips to India between 1882 and 1892. Not only did he write a book about his last trip, but he frequently contributed articles to *Harper's Magazine* and *Scribner's Magazine*. Although he has been accused of displaying "a lack of cultural understanding," his extensive observations about Indian art and architecture, of the past as well as of his own times, are fascinating to read and of historical interest as well. His reaction to the Taj reveals his extraordinary sensitivity to light, which was his artistic forte.

Seen from across the Jumna [he wrote in 1895] it rises like a summer cloud against the clear sky, and its inverted mirage trembles in the deep blue of the water. There is no blackness in the shadows on the sunlit faces, and even under the deeply recessed arches the color is luminous and opalescent, while on the shadowed side it borrows the cool reflected tones of the sky, and is as full of transparent tints and hues of mother-of-pearl as the lining of a shell.[26]

While wandering through the narrow streets of Ahmedabad and admiring the richly carved woodwork of the windows and balconies of ordinary houses, Weeks came across a workshop owned and operated by a fellow American. That American was Lockwood de Forest (1850–1932). A painter, collector, and decorator, de Forest may well be regarded as the most ardent admirer of Indian art and crafts America has ever produced. Indeed, in his enthusiasm he may well be regarded as the American equivalent of Sir George Birdwood, that great nineteenth-century British champion of traditional Indian decorative arts. With Birdwood, de Forest shared an antipathy to Western industrialized society. Birdwood's *The Industrial Arts of India* was published in 1880, the very year de Forest sailed out on the first of several visits. Like Weeks a year or so later, he was enchanted by the extraordinary skill of the Indian carvers, whether seen in the Mogul stone monuments or in the streets of Ajmer or Ahmedabad. Both would have agreed with Birdwood when he wrote that every house was "a nursery of the beautiful . . . which must have its effect in promoting the unrivalled excellence of the historical arts and handicrafts of India."[27]

Although de Forest is not now regarded as an artist in the same light as his mentor Frederick Church, in his own day he was admired for his "suprapersonal objectivity on canvas"; commenting on some of his studies of the Near East inspired by a trip in 1875–76, a critic wrote, "We have before us color and form such as would persuade the beholder that the ruins themselves are before him."[28] Better known as an admirer and

229 Charles Bartlett, *Taj Mahal from the Desert*
England, early 20th C.
Color woodblock print
10 × 14½ in. (25.4 × 36.8 cm.)
Honolulu Academy of Arts, Gift of Mrs. Charles
M. Cooke, 1927 (5364)

230 Lockwood de Forest, *Study for the Taj Mahal*
United States, c. 1893
Oil on board
$12\frac{7}{16} \times 7\frac{7}{8}$ in. (31.5 × 20 cm.)
Santa Barbara Museum of Art, Gift of Mr. and Mrs. Kellam
de Forest (86.30.2)

promoter of Indian design and ornament, he did sketch extensively in the country during his travels. And like all the others, he too inevitably tried his hand at drawing the Taj [Fig. 230], though not quite as successfully as his contemporaries Weeks or Cooper.

TWENTIETH-CENTURY ARTISTS AND THE TAJ

Colin Campbell Cooper (1856–1937) studied at the Pennsylvania Academy under Thomas Eakins, then went to Paris where, along with several other American artists associated with the Impressionist style, he was attracted to Julian's, the most independent of the French academies of the time. Unlike many of his better-known compatriots, however, Cooper did not remain abroad: he returned home to teach for a time at the Drexel Institute in Philadelphia and to become one of the most successful painters of American city scenes.

Cooper visited India in 1913, traveling and sketching extensively. Later in life, in *Palette and Pen in India*—an account of his impressions, which remains unpublished—he wrote that "India had always been one of my dreams." A considerable number of his sketches and paintings have survived, including several studies of the Taj [Fig. 224]. They are less dramatic than some of his other architectural compositions, but his impressionistic style was particularly suited for capturing the shimmering effects of light mentioned by so many visitors but rarely expressed adequately in pictures, and combining "the flickering effects of sunlight, using an impressionist palette, with a sense of solidity of form."[29]

The English watercolorist Albert Goodwin (1845–1932), who visited India in 1917, was one of the most successful of all artists who attempted to paint the Taj. The two pictures included here perfectly evoke the magical effect that the mausoleum has had upon countless visitors [Figs. 225, 226]. Goodwin's long life spanned both the Pre-Raphaelite and the Impressionist ages. He studied with Arthur Hughes, numbered Ford Madox Brown and Ruskin among his intimate friends, and like Brabazon was an admirer of Turner. As Andrew Wilton has written, "his technical and formal disciplines" were "invigorated at the hands of Ruskin and in the fresh air of Turner's achievements," but his work also belongs to the self-indulgent symbolism of Odilon Redon (1840–1916), or the quasi abstraction of Whistler (1834–1903). Such men as these more nearly approximate to the self-obsession, the spiritual dandyism, that is manifest in Goodwin's Diary and which, in a different form, is equally apparent in his work as an artist.[30]

It is not surprising, therefore, that Goodwin's pictures of the Taj reflect both a Turnerian sublimity and a stilted theatricality that are essential ingredients in the average person's reaction to the mausoleum. One might well have expected him to paint the evanescent view of the Taj as seen by the hapless emperor for the last eight years of his life from the Jasmine Tower in the Agra Fort [Fig. 225]. As he wrote in his diary,

Painted today small replica of an outline of the Taj Mahal, Agra Fort. This, when I saw it from the top of the Fort,

231 Hiroshi Yoshida, *Approach to Agra*
Japan, 1930s
Color woodblock print
9¾ × 14¾ in. (24.8 × 37.5 cm.)
Anonymous

232 OPPOSITE William Congdon,
exhibition announcement for Betty
Parsons' Gallery illustrating the Black
Taj, c. 1954†

overlooking the Jasmine Tower, I remember thinking it worth all the travail to see that alone. I can hear still the Georgian sort of chanting that came up from the natives below who were washing the clothes of Agra in the Jumna River.[31]

He was obviously so entranced with this view, since it was the hour of sunset, that he decided to stay on and was locked in the fort. His rendition of the Taj enveloped in the red and orange of a tropical sunset remains one of the most haunting images of the monument ever painted [Fig. 226]. Commenting on "a study of sunset light burning like fire on a low hillside in Kent" that Goodwin painted when he was only fourteen, Andrew Wilton writes, "It is a precocious externalization of a sudden emotion in the presence of nature."[32] How much more inspiring and spiritually moving the sight of the tropical sun sinking behind the Taj must have been to the mature artist in 1917!

Less well known than Goodwin is a younger compatriot of his who must have been very much impressed with the Taj, as he has left a large corpus of studies. Charles William Bartlett (1860–1940) traveled extensively in Asia absorbing many influences and worked in all media. He was much influenced by Japanese woodblock prints, as were many of the Impressionists at the turn of the century, and he executed a charming series on the Taj, one of which is

illustrated here [Fig. 229]. It is almost uncanny how a dozen years or so later the only Japanese artist ever to draw the Taj should have coincidentally echoed Bartlett's composition with camels [see Fig. 231].

On the whole the Taj proved to be less popular with twentieth-century artists from abroad than it had been in the previous century. Among the few who did recreate it was Yoshida Hiroshi (1876–1950). Regarded as outstanding among the Japanese artists who became interested in Western art movements, Yoshida came to the United States when he was twenty-three years old and appears to have been an immediate success. He did not go to India until he was fifty-five. He traveled extensively across the country, and produced twenty-one prints. Of these, four are devoted to the Taj Mahal, capturing the monument in different lights both during the day and at night. In *Approach to Agra* [Fig. 231] he has beautifully expressed the contrasting play of light on the white and pink stones, while the other print included here remains one of the most ethereal representations of the Taj on a moonlit night [Fig. 239]. It is a theme that has repeatedly been extolled by all visitors who have published their impressions. Yoshida's rendering of the subject is at once restrained and yet pregnant with the scene's mysterious and mystical atmosphere.

The story of Western civilization's continuing fascination with the Taj can be brought closer to our own

times with two studies of the Taj done in the 1950s by William Congdon (b. 1912). Born in Providence, Rhode Island, Congdon studied art in Provincetown and in Boston. During the Second World War he served as a voluntary ambulance driver in North Africa and Europe and continued to sketch and draw. After the war his work was exhibited in Betty Parsons' gallery, and he began to travel frequently, including a visit to India. As he himself stated in 1955, "Why do I travel? Because only in Italy, India, etc. do I feel a whole experience and so can do a whole painting." In 1959 he settled permanently in Italy.

With regard to his *Taj Mahal No. 3* [Fig. 244], Congdon commented in 1955,

The Taj Mahal is not a building. It is a prayer, breathing in the night like the moon. At dusk it glows, whole swollen gold against the nighting sky, while in the river flats the vultures rip at a carcass and thread the current with blood. In the distance glimmer the cupolas of Akbar, the city of Agra.[33]

Congdon also made another painting of the Taj, which was used for the announcement of an exhibition [Fig. 232]. Apart from the vigorous, lively delineation, it is interesting because it depicts the "black Taj" and is the only known reaction by an artist to the myth that Shah Jahan intended to build a black replica of the Taj to serve as his own tomb.

PHOTOGRAPHY AND THE TAJ

After the invention of photography in 1839, increasingly the camera began to usurp the painter's role as a recorder of topography. The early photographers in India demonstrated an enthusiasm for the same sights and monuments, including of course the Taj Mahal, as Hodges and the Daniells had done in the last quarter of the eighteenth century.

Coming from diverse backgrounds and by no means always practicing as professionals, some intrepid pioneers were not daunted by the complex techniques or cumbersome equipment that were necessary in the early days. Even the difficulties that the Indian climate caused did not dampen their excitement. The earliest known pictures of Agra were made by John Murray (1809–98), who was a medical officer and cholera specialist in charge of the medical college at Agra. Murray made large paper negatives (15 × 18 inches, or c. 38 × 46 cm.) that produced beautifully detailed images when printed [Fig. 233]. In 1857, the year of the Mutiny in India, thirty-five of these photographs were exhibited in London by the publisher J. Hogarth, and in the following year Hogarth issued thirty of them in a work entitled *Photographic Views of Agra and its Vicinity*. Five depicted the Taj Mahal.

The publication of Murray's work especially underscored the valuable role that photography could play in documenting the artistic remains of earlier times. An accurate means of rendering the fascinating monuments of India had been, in fact, a much desired and long sought after goal. It had led the Daniells in the late eighteenth century to travel around with a camera obscura, in order to record more accurately the perspective and details of the buildings they would feature in their highly acclaimed series of aquatints. The fine quality of Murray's prints confirmed that the detail of photographs could surpass even the most meticulous drawings. The early photographs of the Taj included views that replicated the standard depictions of this famous monument as well as unique panoramas made by carefully combining a series of images [see Fig. 39, which may also be by Murray]. He also exploited particularly dramatic vantage points by photographing the mausoleum from a position downriver on the same bank. The contrast thus achieved between the pristine white monument and the surrounding ruins heightens the romantic and picturesque qualities of the scene.

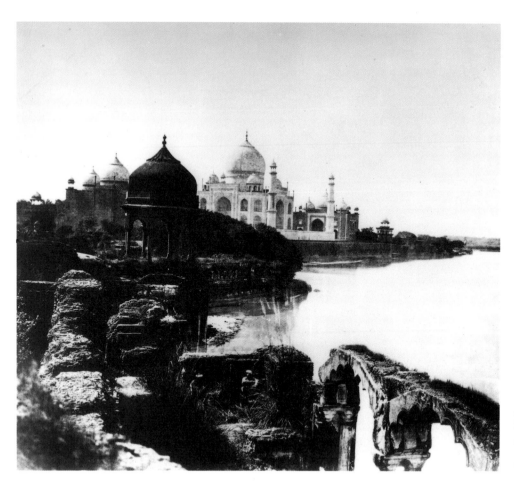

233 John Murray, *View of the Taj Mahal*
England, c. 1857
Albumen print from waxed-paper negative
$15\frac{3}{4} \times 17\frac{15}{16}$ in. (40 cm. × 45.5 cm.)
Collection of Howard and Jane Ricketts

234 Felice Beato, *Entrance View of the Taj Mahal*
From a photograph album of Major Riboul
England, c. 1860
Albumen print
$9\frac{15}{16} \times 12\frac{1}{16}$ in. (24.9 × 30.6 cm.)
The J. Paul Getty Museum, Malibu, Calif.
(84.XO.421.61)

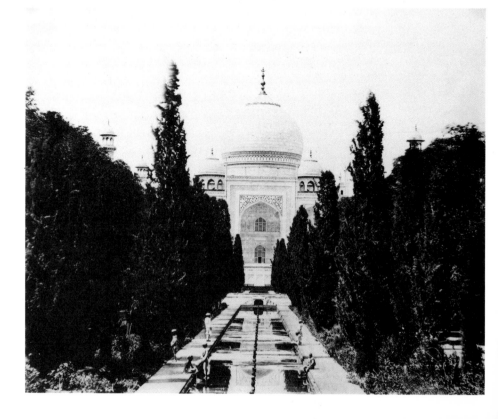

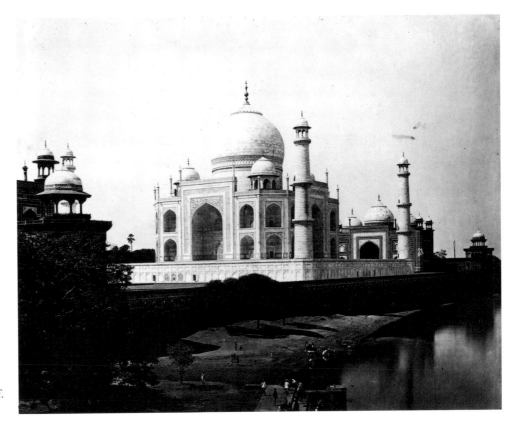

235 Samuel Bourne, *The Taj Mahal,
Agra*
From a photograph album entitled *Tour
du Monde par J. F. H.*
England, c. 1865
Albumen print
$9\frac{1}{8} \times 11\frac{15}{16}$ in. (23.2 × 30.3 cm.)
The J. Paul Getty Museum, Malibu, Calif.
(84.XA.910.170)

Two of the five images of the Taj Mahal included in Hogarth's publication are of this type.[34] Subsequently such views became more popular, and Indian painters added them to their repertoire for foreign patrons.

Other photographers—both Indian and foreign—in the nineteenth century operated in a similar spirit of exploration. One example is Felice Beato, who went to India in the late 1850s in order to record the Mutiny, and traveled there in partnership with James Robertson, a Scotsman. Several of their pictures of the Taj survive; their view of Indians in the overgrown garden presents an evocative image of modern India encumbered by its past [Fig. 234].

The best-known exponent of nineteenth-century photography in India is the Englishman Samuel Bourne. In Calcutta in 1864 he formed a partnership with Charles Shepherd which developed into a firm that became the leading supplier of views of the country, and is still in business today. In the late 1860s the firm was already able to issue a catalogue called *A Permanent Record of India* with more than 1,500

available views listed. For the majority of visitors in the nineteenth century, the photographic process was too cumbersome and complex to allow them to make their own records of what they saw, quite unlike the situation today in the age of simple automatic cameras, and Bourne and Shepherd provided a valuable service. Often the purchased views would be mounted in albums, much like our modern scrapbooks but on a much more lavish scale. One particularly extravagant album now in the collection of the J. Paul Getty Museum contains more than 200 photographs, each measuring approximately 8 × 10 inches (c. 20 × 25 cm.) and mounted on a separate page. Interestingly, only on a page with a photograph of the Taj did the owner of the album write any comments. Predictably, the marginal notes consist of effusive praise of the sublime building. This particular view [Fig. 235] is a variation on the dramatic riverside view first made by Murray [see Fig. 233]. Bourne made a number of studies of the Taj, as well as other buildings at Agra and Delhi, which proved quite popular [see, for example, Figs. 38 and 70].

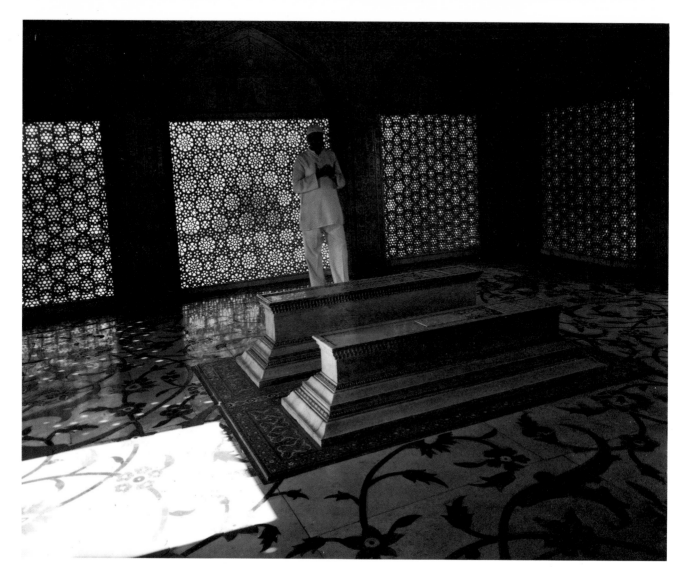

236 Linda Connor, *Man Paying Respects Inside Itimad-ud-daula's Tomb*
United States, 1979
Silver gelatin print
8 × 10 in. (20.3 × 25.4 cm.)
Linda Connor, San Francisco

In the nineteenth century, photographs of India were as important for their documentary value as their aesthetic effect. They were often viewed by the photographers as well as by their audience as faithful records of the country's wonders. Such seemingly "straightforward" images of the Taj Mahal have continued to be made in the twentieth century by large numbers of admiring tourists as their own documents, and by professional photographers for various purposes.

But there were and are other individuals who have made more personal, subjective explorations, a result both of changes in the role of the modern artist and of the greater acceptance of photography as a legitimate art form. Although several, such as the acclaimed Indian photographer Raghu Rai, have focused some of their creative energies on the mausoleum, for many the fact that the image of the Taj Mahal has become a visual cliché has diminished its appeal as a subject. Photographers who do deal with such monuments generally attempt to go beyond documenting the subject.

Two contemporary Americans whose work includes images of Mogul monuments are Linda Connor and Mitch Epstein. Using a camera that produces large negatives with rich detail (as in the nineteenth century), Connor's view of the interior of Itimad-ud-daula's

tomb at Agra [Fig. 236] captures not only the surface detailing but also the way sunlight transforms the space inside, making it seem a separate world. The photograph is evocative without becoming simply picturesque, as we are confronted too directly by the scene to feel removed from it. Mitch Epstein's view of the riverside terrace of the Taj Mahal also confronts us with poignant immediacy [Fig. 245]. Presenting only a slice of the mausoleum and its vast marble terrace on which the movement of two Indian visitors has been captured, the image celebrates the magnificence of India's heritage in terms of experiencing its space and setting. By exploring the feelings engendered by visits to India, rather than just its sights, such artists convey in their work something similar to the emotional effect Shah Jahan intended when he created the grandest of Mogul monuments.

INDIAN ARTISTS AND THE MYSTIQUE OF THE MOGULS

As was the case with literature, Indian artists seem to have largely ignored the Taj until the Europeans "discovered" it and began to admire it. It should be noted that even though Mogul patrons preferred naturalistic pictures and as a result Indian painters began to show increasing awareness of their surroundings, they had no interest in painting existing buildings, either for documentary purposes or for the sake of "picturesqueness." The creators of those buildings, however, continued to fascinate Indian artists and their patrons. As far as we know, no scholar has yet made a study of the interest that various Muslim and Hindu courts maintained throughout the eighteenth century in the personalities and the histories of the imperial Moguls. Not only did patrons (European as well as Indian) continue to put together albums which contained both earlier pictures and contemporary portraits of past rulers, but they also had works like the *Padshahnama* of Shah Jahan copied and illustrated.

While the Muslims have always been interested in the past, it is less easy to explain the nostalgia among Rajput patrons for Mogul emperors. Certainly the last great Mogul, Aurangzeb, could not have been the object of adulation among the Hindus in general: being an orthodox Muslim, he was less tolerant of the infidels than his predecessors. However, both during and after his long reign (1658–1707), for almost the entire eighteenth century, until the consolidation of British authority and power, much of India was in political turmoil. The Mogul empire continued to collapse as one inept ruler after another displayed political incompetence as well as moral decrepitude. Under the circumstances, to both Muslim nabobs and Hindu maharajas, as well as to their subjects, the reigns of Akbar, Jahangir, and Shah Jahan must have seemed like the days of wine and roses.

Several of the pictures representing scenes from Shah Jahan's life reproduced in Chapter One are eighteenth-century copies of paintings made during the emperor's life. One of these, made probably toward the end of Aurangzeb's reign, depicts a court scene in a tent with a young enthroned Shah Jahan [see Fig. 36]. Extremely faithful to the original, the painting must have been done by a very competent artist, perhaps for a copy of the *Padshah-nama* or for the family of one of the nobles present at the court. Another of these later replicas is the famous wedding procession of Dara Shikoh, which has already been discussed [see Fig. 34]. Clearly the wedding was one of the most festive even by Shah Jahan's luxurious standards, and one can imagine that it was talked about in Agra for generations. In any event, Dara Shikoh certainly became a legendary figure in the Indian consciousness, not only because of his sympathy for Hinduism but also for his tragic end. Various romantic stories about this philosopher-prince became current all over India, and he remained a popular theme among artists as well.

A sampling of a variety of pictures included here [Figs. 237, 238] demonstrates how much of a popular figure Shah Jahan became. The tragic loss of his wife and his ultimate dethronement by one of his sons must have made him an especially appealing figure to the Hindus. Even in the twentieth century he inspired the great Bengali poet Rabindranath Tagore to compose a long poem about his fate, a part of which has been quoted as the epigraph to the Introduction. He was also the subject of a successful play written by the well-known Bengali dramatist D. L. Ray.

One of the earliest Rajput pictures of Shah Jahan may have belonged to a series of posthumous portraits of Mogul emperors done around 1690 for the ruler of Basohli, a small state in the western Himalayas [Fig. 237]. Two of Basohli's rulers, Bhupat Pal and Sangram Pal, were particularly close to Shah Jahan. Bhupat Pal was not only given a robe of honor by the emperor but

may also have received a large pendant that adorned the chests of several rulers of Basohli until Medini Pal (d. 1736). Sangram Pal was at the imperial court in 1640 and was a friend of Dara Shikoh.

A second portrait [Fig. 254] from the same region was probably painted not much later for the ruler of Nurpur. Jahangir and Nur Jahan visited Nurpur in 1622, and the name of the capital bears witness to the close, if short-lived, relationship between them and Jagat Singh. Shah Jahan himself never forgave Jagat Singh for murdering his friend Bhupat Pal of Basohli in 1635, although Jagat Singh had supported Shah Jahan when he rebelled against his father. His grandson Man Dhata was the last Nurpur ruler to serve in the Mogul army, and this portrait of Shah Jahan may well have been done for him.

What is interesting is that had the portraits not been inscribed with the emperor's name we would have been hard pressed to identify the figures. Neither really looks like Shah Jahan, and in fact the standing figure looks more like Aurangzeb [see Fig. 18]. While it is unusual for a ruler to hold a fly-whisk, there are one or two pictures of Shah Jahan in which he is seen holding the object.

Pictures of the Moguls also circulated in the Rajput courts of Rajasthan. A typical eighteenth-century painting, perhaps from Udaipur, depicts Shah Jahan charging a lion with his bare sword while attendants stand by with guns and a dagger [Fig. 238]. The raw courage of the early Mogul emperors had become

237 *Shah Jahan*
Basohli, c. 1690
Opaque watercolor on paper
8¼ × 6 in. (21 × 15.2 cm.)
Jane Greenough

238 *Shah Jahan Hunting*
Rajasthan, Udaipur(?), 18th C.
Opaque watercolor on paper
9 × 11¾ in. (22.9 × 28.9 cm.)
Kapoor Galleries Inc.

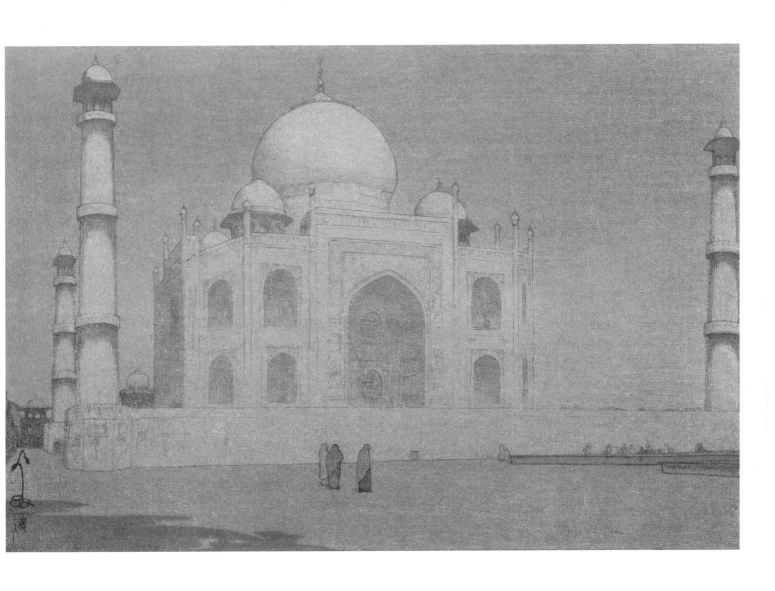

239 Hiroshi Yoshida, *Moonlight of Taj Mahal,*
No. 4
Japan, 1930s
Color woodblock print
$15\frac{3}{4} \times 10\frac{3}{4}$ in. (40 × 27.3 cm.)
Terence McInerney, New York

240 *Nur Jahan†*
Mogul, c. 1650–1700
Opaque watercolor on paper
$7\frac{1}{8} \times 4\frac{3}{4}$ in. (18.1 × 12.1 cm.)
Kapoor Galleries Inc.

241 *Babur, Humayun, and other Grandees†*
Mogul, 17th C.
Drawing
The Art Institute of Chicago, Gift of Mrs. Joseph Valentine
(1945.312)

Nur Jahan appears in the lower right, at an angle to the main figures.

legendary even during their lifetimes. It is no wonder that stories of their bravery and skill while hunting should have been recalled at Rajput courts long afterward, perhaps with the help of such paintings. While Jahangir preferred to use the gun, Shah Jahan, like his grandfather, often attacked both lions and tigers with only his sword (see p. 94).

The Mogul personality who seems to have carved a permanent niche in the Indian memory is Nur Jahan. More portraits of this woman have survived, rendered in both Mogul and Rajput style, than of any other lady of the imperial family. While some of them are not inscribed, others are. Two representations from what appears to have been an eighteenth-century album are identified as "Nur Jahan Begum," even though they don't look alike [Figs. 30 and 240]. In one she is engaged

at her toilet, and in the other she is seated on a terrace listening to a female musician. Both are romanticized images of this extraordinary woman. That she was the only female member of the imperial family to have been regarded on the same level as the rulers and important princes is clear from an eighteenth-century or earlier drawing that was used for pouncing (a stenciling process) [Fig. 241]. In a galaxy of males, she is the only female included. Interestingly, she is shown in the distinctive turban which appears to have become the hallmark of her later portraiture, as in a beautiful Rajput picture showing her drinking wine [see Fig. 8].

There is no gainsaying the fact that Indian artists became interested in the Taj towards the end of the eighteenth century due to the European interest in the building. Once the Taj was discovered and became a

242 *The Taj Mahal with European Sightseers*†
From a manuscript of *Amal-i-Salih*, a history of Shah Jahan
India, c. 1815
Opaque watercolor on paper
The British Library, London (Ms. Or. 2157, fol. 612a)

243 Mihr Chand, *Woman Looking at the Taj Mahal through a Window*†
India, c. 1790
Opaque watercolor on paper
Staatliche Museen zu Berlin, Islamisches Museum (I 4597, fol. 20)

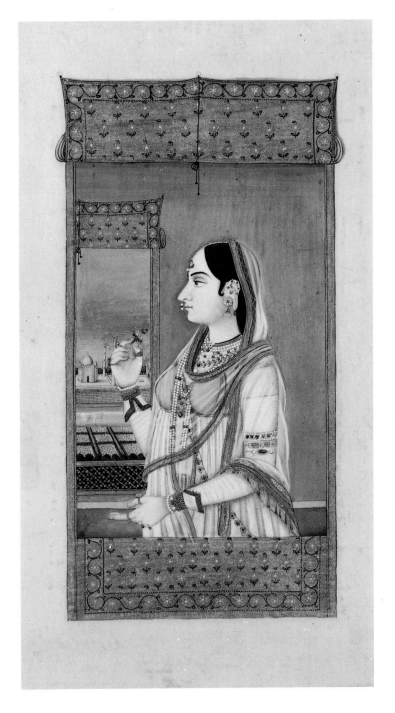

favorite picnic spot for Europeans, mostly British, the demand for general views as well as for details of its much admired inlay work increased by leaps and bounds. A rare picture from an early nineteenth-century manuscript in the British Library provides vivid evidence of the boisterous parties held on the terrace [Fig. 242].

One of the earliest representations of the Taj by an Indian artist is a unique composition by the painter Mihr Chand [Fig. 243], which formed part of an album put together for Antoine Polier (1741–95), a French-Swiss nabob who spent a good deal of time in the kingdom of Oudh. Mihr Chand was one of the leading painters at the court of Shuja-ud-daula at Faizabad. The

244 William Congdon, *Taj Mahal No. 3 (1954)*
United States, 1954
Oil and metallic paint on masonite
50 × 56 in. (125 × 140 cm.)
William Congdon, Milan

245 Mitch Epstein, *Taj Mahal, India*
United States, 1970s
Ektacolor print
$21\frac{7}{8} \times 14\frac{3}{4}$ in. (55.6 × 37.5 cm.)
Mitch Epstein, New York

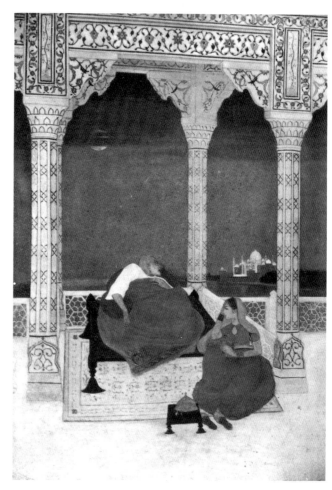

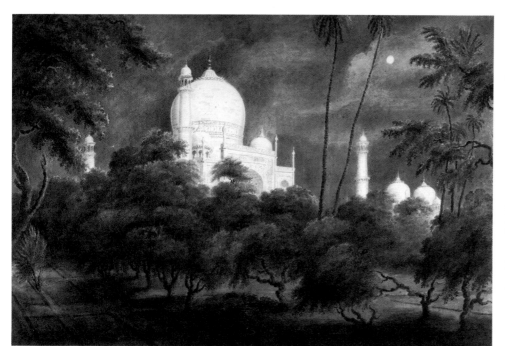

246 ABOVE LEFT *Taj Mahal*
Rajasthan, Kotah, late 18th/early 19th C.
Ink and color on paper
$7\frac{1}{2} \times 6\frac{5}{16}$ in. (19 × 16 cm.)
Jan Vlug, Brussels

247 Abanindranath Tagore, *The Passing
of Shah Jahan*†
India, early 20th C.

248 Sita Ram, *Taj Mahal by Moonlight*
India, c. 1815
Opaque watercolor on paper
16 × 24 in. (40.6 × 61 cm.)
Arthur M. Sackler Museum, Harvard
University, Cambridge, Mass.,
Anonymous Loan

picture shows a beautiful lady holding a rose as she offers us her striking profile, with a distant view of the Taj through the window. We do not know who this lady was, and although she is placed in Agra she is unlikely to be a Mogul princess. Mihr Chand painted at least one other version of the same portrait with a different background. That picture, strangely, flanks a portrait of Shuja-ud-daula that was copied by Mihr Chand from an original by Tilly Kettle, who was visiting the court in 1771–72. The mysterious lady may well have been a famous singer and a mistress of Shuja-ud-daula.

One of the earliest known drawings of the Taj by an Indian artist is a charming freely drawn sketch, probably by a painter from Kotah in Rajasthan [Fig. 246]. As the accompanying notation indicates, it was done on the spot. Whether it was a study for a painting to be done for a European or an Indian patron cannot be determined. The use of correct perspective does demonstrate, however, that the artist was familar with European style drawings of architecture.

Among the most poetic representations of the Taj are two paintings by Sita Ram done in the early years of the nineteenth century [Figs. 248, 249]. One depicts the monument by daylight and the other at night. Apart from their topographical interest, especially for the layout of the gardens and the vegetation which differ even from other contemporary views, the pictures reveal how brilliantly Sita Ram had mastered European techniques. In fact, he had gone farther than his British contemporaries, and anticipated the more illusionistic and impressionist renderings of the Taj that were preferred by Western artists half a century later. Sita Ram was adept at altering his brushstrokes and modulating his pigments to express the enormously contrasting effects of light during the day and at night. The harsh sun is obviously less flattering to the white marble, but on a moonlit night it shines like a dazzling pearl, especially in contrast to the ghostly vegetation in front.

Another unusual view of the Taj is a watercolor by an unknown nineteenth-century Indian artist that provides a panoramic view of the complex as a royal procession is on its way to the monument [Fig. 250]. For some reason, however, the party has halted on the rough stone terrain. While the palanquin bearers have put down their load, the royal visitor has alighted from the elephant and stands a little closer to the center of the picture, flanked by an umbrella bearer and a bodyguard. More bodyguards stand almost in the middle of the foreground, and look in the same direction as their master. There seems little doubt that the scene represents a specific occasion. The most likely explanation is that the author of this picture was accompanying a British artist engaged in sketching the Taj, and the princely party stopped out of curiosity, or for a break, or both. Even though we cannot identify the painter or his curious visitors, the picture remains a rare depiction of a very specific historical moment and affords an unusual view of the monument.

Among twentieth-century Indian artists who have been inspired by the Taj and its legends, the most notable is Abanindranath Tagore (1871–1951), a nephew of the poet Rabindranath Tagore. Abanindranath did at least two pictures of Shah Jahan with the Taj a shimmering image in the distance. In one the emperor rides a horse, perhaps dreaming about the building he was planning to raise. In the other [Fig. 247] the artist was obviously moved by the pathos of Shah Jahan's last years, for the frail, aged emperor is stretched out on his bed in the Jasmine Tower and is sustaining himself with his daily dose of the Taj.

No artist of Indian origin, however, has been as inspired by the Great Moguls as was the Indo-Pakistan artist Abdur Rahman Chughtai (1895–1975).[35] Apart from his firm belief that he was a descendant of Ustad Ahmad, the presumed architect of the Taj (see Chapter Two), he appears to have been motivated by Tagore's *Passing of Shah Jahan* [Fig. 247], which was much acclaimed when first published in 1918. By 1922 Chughtai completed his own version of the theme and thereafter he executed several paintings with Mogul subjects, including some romantic interpretations of the Taj. He also painted a picture of the architect presenting the design of the monument to Shah Jahan, entitled *The Story Teller*, which is a curious composition with the building in the background partially obscured by a clearly Art Deco peacock perched on a branch of a nonexistent tree. The symbolic meaning of the peacock's presence remains obscure.

Throughout the nineteenth century and even into the twentieth, until the invention of easily portable, inexpensive cameras by Eastman Kodak, there continued to be a demand among foreign visitors for pictures, particularly of the Moguls and their monuments. While some patrons preferred larger images

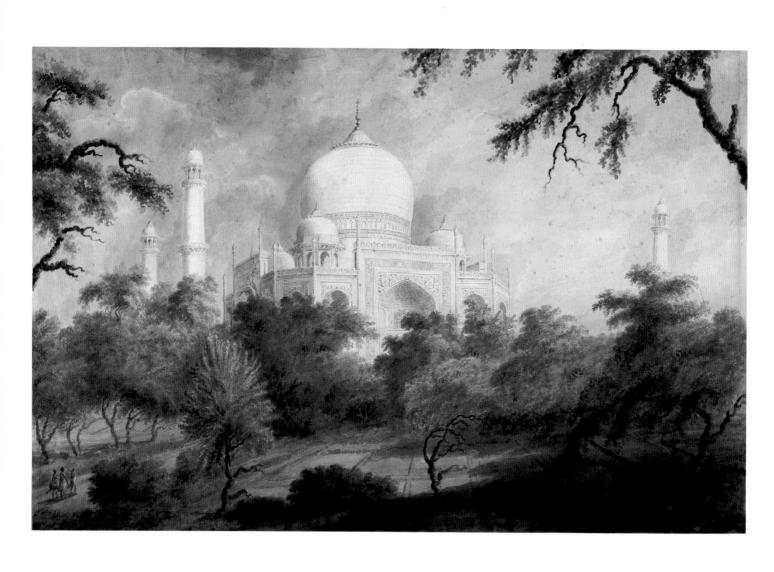

249 Sita Ram, *Taj Mahal in Morning Light*
India, c. 1815
Opaque watercolor on paper
16 × 24 in. (40.6 × 61 cm.)
Paul F. Walter

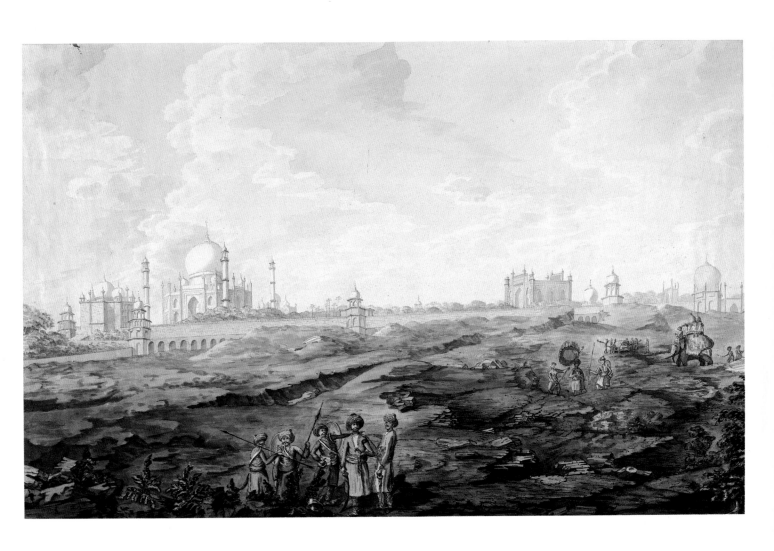

250 *View of the Taj Mahal*
India, early 19th C.
Opaque watercolor on paper
13¾ × 21¾ in. (34.8 × 55 cm.)
Los Angeles County Museum of Art, Purchased
with funds provided by The Smart Family
Foundation through the generosity of Mr. and
Mrs. Edgar G. Richards (M.86.123)

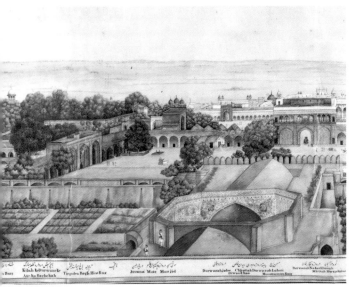
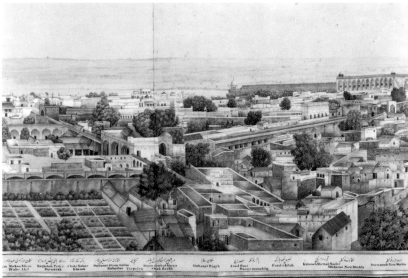

such as the panoramic view of the Delhi Fort [Fig. 252], there was also quite a demand for accurate paintings of the rich ornamental designs, particularly those of the Taj. Most were done by Indian artists, who are remarkable for the quality and precision of their renderings [see Figs. 53–55, 60–62, 132].

Apart from watercolors on paper, the Taj was also painted on other media for popular consumption, particularly for foreign visitors. Among these glass, mica, and ivory were the most common, ivory being the most popular, probably because of its greater durability. These miniature paintings on ivory could be used in a variety of ways, as may be seen from three typical examples illustrated here [Figs. 251, 253, 255]. Few Indian monuments other than the Islamic buildings around Delhi and Agra seem to have had a ready market. Whether framed to be hung on a wall [Fig. 253] or mounted for the mantelpiece or the dresser, there is no ambiguity about which building was considered the most important. In other examples, the Taj is surrounded by the early Mogul emperors and empresses, while in a finely inlaid box of c. 1900 which once belonged to a maharani of Indore, it is flanked by stereotyped portraits of Shah Jahan and Mumtaz Mahal [Figs. 14, 255]. A brooch which combines a view of the monument alone with an elaborate gold setting [Fig. 251] would have been an exquisite gift—perhaps a memento for a bride.

251 Brooch with image of the Taj Mahal
India, c. 1865
Etched ivory in gold setting
$2\frac{3}{8} \times 3$ in. (6 × 7.6 cm.)
Janice Jocelyne Gibson, Los Angeles

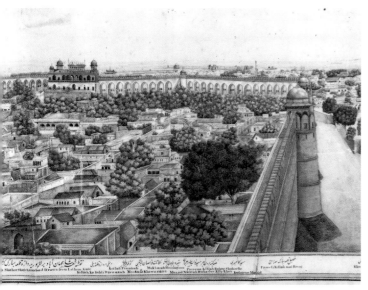

252 Mazhar Ali Khan, *Panorama of Delhi Fort and City* (detail)
India, 1846
Opaque watercolor on paper
26 × 193¹³⁄₁₆ in. (66 × 491 cm.) (overall)
The British Library (India Office Library and Records), London
(Ms. Add. Or. 4126)

We are standing on the Lahore Gate and looking toward the river (cf. Fig. 72, looking the other way). The bazaar inside the gate appears on the left; beyond it is the Naubatkhana. Part of the arcaded Diwan-i-am (Hall of Public Audience) appears beyond that to the right, and the three domes of the Pearl Mosque stand off to the left. At the far right are the walls facing the city, angling round to the tall Delhi Gate.

253 Plaque with North Indian monuments
India, 19th C.
Oil on ivory
8¼ × 12½ in. (21 × 31.8 cm.)
Paul F. Walter

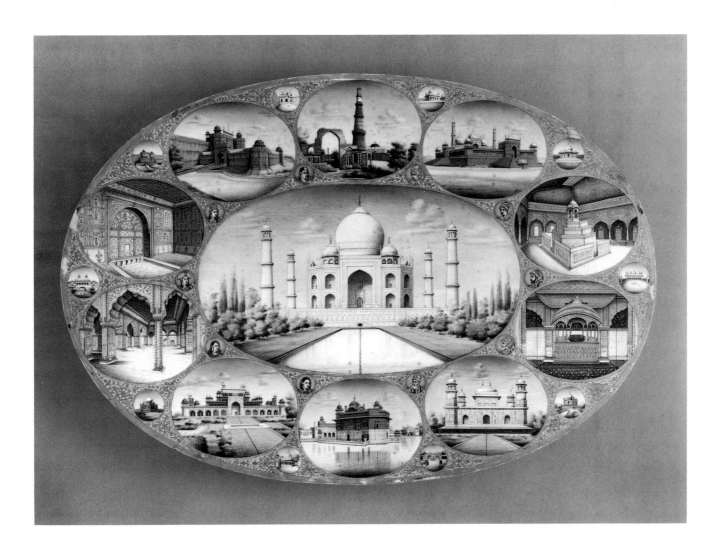

254 *Shah Jahan*
Nurpur, 18th C.
Opaque watercolor on paper
$8\frac{3}{4} \times 6\frac{3}{8}$ in. (22.2 × 16.2 cm.)
Kapoor Galleries Inc.

255 Box with images of Shah Jahan, Mumtaz
Mahal, and the Taj Mahal
North India, c. 1900
Sandalwood inlaid with ivory, silver, and green
quartz; opaque watercolors on ivory
L: $16\frac{1}{4}$ (41.3 cm.)
Charles Wolfe Masters, Jr., and Family Trusts

CONCLUSION

These were not the only means whereby the image of the Taj continued to be disseminated in the West. A rare object is a piece of nineteenth-century embroidery which exactly copies the inlaid design on top of Shah Jahan's cenotaph [Fig. 256]. It is not unlikely that this impressive piece was done in India, perhaps following one of the innumerable drawings such as those illustrated here [see Figs. 62, 132]. Although we do not know exactly why the embroidery was made, other than the attraction of the design, it remains an unusual testimony to the nineteenth-century romance with the Taj.

All who have visited the Taj Mahal must have noticed the dozens of shops that continue to do brisk business with models of the mausoleum in all sizes, and marble plates and boxes of various sizes and shapes, inlaid in the *pietra dura* technique that has become synonymous with the building. Indeed, there is literary evidence that models of the Taj were being shipped to Britain before 1850 as exhibits. Several nineteenth-century models gather dust in various ethnological museums in Europe and America. Most were made of alabaster, because the material is both lighter than marble and more transparent, allowing it to be romantically lit. One such model was given to Columbia University as far back as 1897, while the Peabody Museum in Salem, Massachusetts, has an even older example. Much larger and more unusual, however, is a spectacular replica in wood that was carved in Agra for a jeweler. After being displayed in a Paris exhibition it crossed the Atlantic in 1939 especially for the New York World's Fair [Fig. 257], and was subsequently acquired by an expatriate Indian, who used it as the showpiece for his Indian restaurant in Florida. One can imagine how exciting it must have been for the restaurant's patrons to come in from the humid climate of Florida, very much like that of India, and eat a hot curry while admiring the dramatically lit model, thereby vicariously re-experiencing the candle-lit suppers enjoyed at the real Taj by nineteenth-century

256 Copy of the design from the top of Shah Jahan's cenotaph
India, c. early 19th C.
Embroidery on silk
$68\frac{1}{8} \times 19\frac{11}{16}$ in. (173 × 50 cm.)
Trustees of the Victoria and Albert Museum, London
(IS 34–1987)

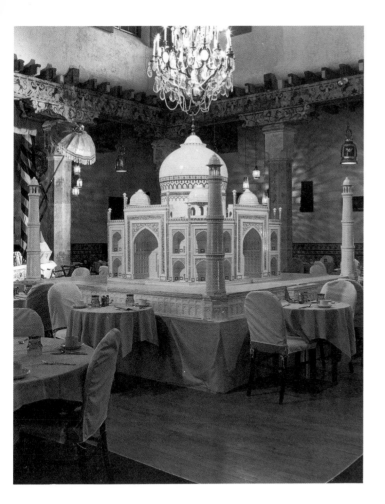

258 Vase
India, 19th C.
Marble with inlay
H: 10¾ in. (27.3 cm.)
Seattle Art Museum, Gift of Friends of the Margaret E. Fuller
Memorial (54.180)

257 Model of the Taj Mahal from the 1939 World's Fair
India, early 20th C.
Painted wood
9 × 9 × 9 ft. (274.5 × 274.5 × 274.5 cm.)
Mrs. Sajjan Singh Sarna

259 Ted Engelbart, *Indian Heat*, cartoon for the *Los Angeles
Times*
United States, 1987
Ink on paper
5¾ × 7½ in. (14.6 × 19.1 cm.)
Ted Engelbart

visitors. In a similar vein, a cartoonist for the *Los Angeles
Times* recently used the Taj to create an amusing
illustration for an appraisal of some Indian restaurants
[Fig. 259].

Pietra dura decoration increased in popularity across
Northern India with the growth of the Taj Mahal's
appeal to the Indians. It became particularly fashionable
among wealthy Indians, especially the ruling classes, to
use inlaid marbles for buildings and furnishings. While
a few architectural panels did go out of the country [Fig.
261], most objects that traveled were smaller and more
easily portable, such as a luxuriantly inlaid vase and very
fine marble plate inlaid with a flowering plant [Figs.
258, 260]. The sumptuously inlaid architectural panel,
continuing the type of ornamentation that is the
hallmark of the Taj Mahal's *pietra dura* work, must have
adorned an eighteenth-century palace. A marble throne
[Fig. 262] not only demonstrates how widespread was
the influence of the Taj's ornament, but also displays the
Indian craftsmen's continued skill with both inlaying

260 Plate
India, 18th C.
White marble with carnelian, lapis lazuli, jade,
and black marble inlay
D: 12 in. (30.5 cm.)
Mr. and Mrs. John Gilmore Ford

261 Panel
India, 18th C.?
Marble with inlay
$18\frac{1}{2} \times 36\frac{5}{8}$ in. (47 cm. × 93 cm.)
Dar al-Athar al-Islamiya, Kuwait National
Museum (LNS 70 s[c])

262 Throne
Agra, 18th–19th C.
Marble with inlay
H: 43$\frac{5}{16}$ (110 cm.)
Collection Joseph Uzan, Paris

and marble carving. Indeed, it is because of this continuity of tradition that the Taj Mahal and other Mogul monuments could be restored: as Edwin Weeks noted toward the end of the nineteenth century,

While in Persia we found that the splendid monuments of its former glory have been abandoned to picturesque but lamentable decay, and the public buildings now erected have little if anything of the ancient spirit; in India, on the contrary, the native architects and artisans are still doing admirable work, not inferior in respect to artistic detail and finish to the work of past centuries.[36]

The few examples of *pietra dura* included here amply corroborate Weeks's observations. The tradition is still alive today, thanks to the millions of tourists who year after year flock to Shah Jahan's mausoleum for his beloved Mumtaz.

For most individuals the Taj Mahal will always be a personal experience, a sentimental journey, a new thrill, or a memorable event. Millions more will stand before it and have their pictures taken to grace family albums as in the past. No matter how familiar the image becomes, it is unlikely that in this case familiarity will breed contempt.

This brief account of the romantic saga of the unique experience, or the state of mind, known as the Taj Mahal may be brought to a close by quoting a recent communication from the American artist William Congdon. He first visited the Taj in the 1950s, and yet the impression etched on his memory was so strong that in 1988 he wrote:

The Taj Mahal, as if it were not a building of exact measurements and restricted definitions, is rather a vision, as unmeasurable and as all-embracing as a dream. It is not terrestrial architecture, but heavenly architecture, not of material but of the spirit. . . . One does not approach its limits, but immerses oneself into its no limits. This is the dynamic of the greatest art.[37]

Notes to the Text

Chapter 1: Ruler of the World (pp. 14–52)

1 *Tuzuk-i-Jahangiri*, vol. 1, pp. 19–20.
2 For this and other quotations in this paragraph in connection with the birth, see M. Lal, pp. 1–4.
3 M. Lal, p. 13.
4 *Tuzuk-i-Jahangiri*, vol. 1, p. 306.
5 Ibid.
6 Ibid., p. 395.
7 Ibid., vol. 2, p. 27.
8 Ibid., vol. 1, p. 159.
9 Ibid., p. 397.
10 The quotation from Asaf Khan is taken from M. Lal, p. 99. For the dating of Fig. 12, see below, Chapter 3, n. 9.
11 *The Indian Heritage*, p. 42, no. 53.
12 *Shahjehan Namah*, trans. Lieut. Fuller, pp. 55–60.
13 Ikram, pp. 187–88.
14 *Tuzuk-i-Jahangiri*, vol. 1, p. 48.
15 See Gangoly, pp. 33–34.
16 *Shahjehan Namah*, pp. 375–76.
17 Chowdhuri, pp. 374–75.
18 Manucci, vol. 1, p. 194.
19 Ignatieff, p. 16.
20 Kurz, pl. 30(c).
21 Hasrat, p. 84.
22 Mundy, vol. 1, p. 202.
23 Yazdani, p. 40.
24 *Tuzuk-i-Jahangiri*, vol. 2, pp. 78–79.
25 Ibid., pp. 68–69.
26 Ibid., p. 114.
27 Lall, p. 52.

Chapter 2: Mausoleum for an Empress (pp. 53–87)

1 Chaghatai, 1957, p. 82.
2 Gurner, pp. 149–50.
3 Gupta, p. 13. See also pp. 29–31.
4 Moreland and Geyl, p. 2.
5 Nath, 1987, pp. 149–53.
6 Chaghatai, 1957, p. 83. It is after the description of this ceremony that the histories by Kanbo and Lahori give a detailed description of the various structures of the empress's tomb. See also Begley, 1978–79, pp. 17–18.
7 Hodgson, p. 56.
8 Gupta, p. 56.
9 Begley, 1978–79, pp. 8–11.
10 For a discussion of the general importance of calligraphy in Islam, see A. Welch, 1979.
11 Begley, 1978–79, pp. 6–8. See also Begley, 1979, pp. 12–13.
12 Begley, 1979, p. 13.
13 Moynihan, pp. 131–32. For other discussions of Mogul gardens, see Crowe et al., 1972; Brookes, pp. 116–61; Dickie, pp. 128–37.
14 Hodgson, p. 56.
15 Chaghatai, 1957, p. 88.
16 Schimmel, pp. 13–39, especially pp. 29–31.
17 Koch, 1988, pp. 12–14.
18 Translated in Koch, 1982A, p. 258.
19 Skelton, 1972A, pp. 147–52.
20 Koch, 1988, especially p. 39, n. 24.
21 The two different techniques of inlay used in this tomb have been discussed by Koch, 1988.
22 Golombek, p. 43. See also Hoag, pp. 246–48.
23 Chaghatai, 1957, pp. 86–87.
24 Nath, 1972, p. 45.
25 Bernier, p. 290; Tavernier, vol. 1, pp. 90–91.
26 Chaghatai, 1957, p. 89. Translations of the calligraphic inscriptions on the cenotaphs are given in Latif, 1896, pp. 110–11 and Moin-ud-din, pp. 47–78.
27 Manrique, pp. 173–77.
28 Sleeman, p. 181. See also Kanwar, 1986, pp. 37–45 for a discussion of Austin de Bordeaux.
29 Even in 1910 Hosten (pp. 281–88) published an article supporting the contention that the architect was Veroneo, but many also strongly argued against such claims, noting that the architectural form of the Taj Mahal was a logical conclusion of earlier Mogul buildings. One example of an argument supporting an Indian architect is Havell, 1903, pp. 1039–49.
30 There are a number of articles concerning Ustad Ahmad: see Begley, 1982, pp. 39–42 for a general discussion. See also Chaghtai, 1937, pp. 200–209; Nadvi, pp. 75–110; Ahmad, pp. 330–50; Kanwar, 1974, pp. 11–32.
31 Chaghatai, 1937, p. 202.
32 Ahmad, pp. 338–39.
33 Begley, 1979, p. 7, n. 7.
34 Translated in Koch, 1982A, p. 259.
35 Quoted in Dickie, p. 128.
36 Golombek, p. 48.
37 Lowry, 1987, pp. 136–37.
38 Golombek, pp. 44, 49.
39 Ibid., p. 48.
40 Lowry, 1987, pp. 140–41. Lowry notes that although these materials were common in the fourteenth century for Islamic buildings, they all but disappear in the fifteenth century. Thus, their revival in the sixteenth century may indicate a desire on the part of the Moguls to be identified with earlier Islamic kingdoms of India.
41 Begley, 1978–79, p. 12.
42 Ibid., pp. 25, 34–35.
43 Nath (1972, p. 44) suggests that these were chosen to underscore the family's origin in Iran.
44 Thompson, pp. 12–30.
45 Begley, 1979, especially p. 16.
46 Ibid., p. 27.
47 Ibid., p. 28.
48 Tavernier, vol. 1, p. 91.
49 Koch, 1988, especially pp. 21–23.
50 Saksena, p. 263.
51 Husain, p. 21.
52 Ibid., p. 52.
53 Bernier, p. 285.
54 Koch, 1988, p. 14.
55 Ibid., pp. 34–35. Koch discusses the possibility that the most unusual Italian plaque, which depicts Orpheus, might have been used to equate Shah Jahan's just rule with Orpheus' ability (with his music) to make beasts live peacefully together. This theory might also be the explanation for the popularity in paintings of the period of a similar theme depicting "Majnun in the Wilderness." See below, p. 109.
56 Bernier, p. 266.
57 Husain, pp. 56–57.
58 Begley, 1981, p. 8.
59 Husain, p. 60.
60 Sleeman, p. 322.
61 Their absence is discussed by Begley, 1981, p. 11. See also Husain, pp. 42–43.
62 Begley, 1981, pp. 8–9.
63 Begley notes that the overt political orientation of this mosque is mitigated slightly by some of the inscribed Koranic passages, which suggest that the building was raised by piety. See Begley, 1981, p. 11.
64 Nath, 1969, pp. 29–36.
65 Tillotson, 1987.
66 Vats, 1946, p. 5.
67 Hogarth, p. 511; Gurner, pp. 150–53.
68 Raleigh, pp. 198–99.
69 Spear, pp. 180–87.
70 Koch, 1982B, pp. 331–39, identifies part of this bath as now in the collection of the Victoria and

Albert Museum, London.

71 Vats, 1946, pp. 6–7; Vats, 1950, pp. 91–99. For a discussion of whether or not the Taj is sinking, see Nath, 1972, pp. 79–82.

72 P. N. Oak's book has been published in three editions, the latest in 1974. For discussion of Oak's arguments, see Tillotson, 1986, pp. 266–69.

73 D'Monte, pp. 48–49.

74 He published these in several elaborate books and also exhibited models in Newport and Washington, D.C. (at the National Gallery). See Remey, 1927.

Chapter 3: **Artists for the Emperor** (pp. 88–127)

1 S. C. Welch, 1987, see especially pp. 96, 119, 122, 129, 137; Beach, 1978, pp. 90, 135.

2 Several artists, however, seem to have left the atelier. Bishndas, whose eccentric style may not have appealed to the emperor, probably departed to work for patrons such as Zafar Khan, the governor of Kashmir (see pp. 124–25). It is also possible that Abul Hasan, who may not have received the enthusiastic support from Shah Jahan that he had from Jahangir, went elsewhere: although he was still a relatively young man at the time, his name disappears from any records after the first years of the emperor's reign.

3 Several of these compilations remain more or less intact (Minto, Wantage, and Kevorkian Albums), but much controversy rages over the degree of their "virginity," later additions, and so forth.

4 Beach, 1978, p. 28.

5 Beach, 1981, p. 169.

6 For a discussion of this work and its inscriptions, see S. C. Welch, 1987, pp. 206–09.

7 Goswamy and Fischer, p. 90.

8 Beach, 1978, p. 78. For a discussion of the court histories produced under Shah Jahan, see Komala, pp. 49–57.

9 This page, rendered in the Shah Jahani style, has been traditionally assigned to that period (Beach, 1978, p. 84), though it might be somewhat later.

10 S. C. Welch, 1987, p. 290, fig. 18. For a cameo of the same subject, see below, p. 145.

11 Beach, 1978, p. 112.

12 At least one other version of this painting is known.

13 Falk and Archer, p. 65.

14 Gadon, p. 156.

15 A. Welch and S. C. Welch, pp. 217–20; S. C. Welch, 1985, pp. 245–47.

16 S. C. Welch, 1987, p. 178.

17 Losty, pp. 97–99.

18 Koch, 1988, pp. 31–33. Cf. also the choice of Orpheus as a subject to ornament the imperial *jharoka* in the Red Fort at Delhi: above, Chapter 2, n. 55.

19 S. C. Welch has suggested that this volume may have been damaged when on a summer evening in 1644 Shah Jahan's daughter Jahanara's dress was ignited by a candle flame (see S. C. Welch, 1985, p. 242; and, for Jahanara's accident, above, p. 48).

20 Linda Leach provides an illuminating discussion of the Mogul "pastiche picture" (Leach, pp. 51–53).

21 Very little is known about the lives and artistic development of these men. Fortunately, some Shah Jahani pictures are inscribed with the name of the artist who painted them in the form of signatures or scribal attributions. When correct, it is often possible to assign a coherent and distinctive body of work to a given painter. The discussions of some Shah Jahani painters in this chapter owe much to the fine work of Milo Beach (see Beach, 1978).

22 Beach, 1978, p. 98.

23 Several versions of this painting are known.

24 Goswamy and Fischer, p. 20.

25 Gadon, p. 157.

26 Falk and Archer, p. 82.

27 Ibid., pp. 72–73.

28 Ibid., pp. 73–74.

29 S. C. Welch, 1987, p. 201, n. 4.

30 Losty, p. 101.

31 Ibid.

32 Ibid., p. 94.

Chapter 4: **Jades, Jewels, and Objets d'Art** (pp. 128–69)

1 Bernier, p. 298.

2 Blavatsky, pp. 427–28.

3 *Tuzuk-i-Jahangiri*, vol. 2, pp. 143–44; and Skelton, 1972A, pp. 150–51.

4 *Tuzuk-i-Jahangiri*, vol. 1, pp. 5–7.

5 Ibid., p. 215.

6 Jauhar, p. 43; cited by Beach, 1987, p. 26.

7 Brown, pp. 564–65.

8 *Tuzuk-i-Jahangiri*, vol. 1, p. 322.

9 *Shah Jahan as a Prince, Holding a Jewel*; Victoria and Albert Museum, London (IM 14–1925). The painting has been illustrated in several publications, including *The Indian Heritage* (front cover). The central table diamond of this turban ornament has perhaps been recently rediscovered: see *Islamic and Hindu Jewellery*, lot no. 48, pp. 64–65.

10 *Darbar of Shah Jahan*, Mogul, c. 1655–60; Bharat Kala Bhavan, Varanasi (3474). The painting is published in the American Committee for South Asian Art Color Slide Set: "Bharat Kala Bhavan: Mughal Paintings," nos. 3892–97.

11 Terry, p. 373.

12 Tavernier, vol. 2, pp. 100–101.

13 Ibid., vol. 1, p. 295.

14 *Babur-nama*, p. 522.

15 Abul Fazl, *A'in-i-Akbari*, p. 15.

16 Fraser; cited by Aziz, 1942, pp. 555–56. The amounts of rupees and dollars are derived from computations based on information given in Aziz, 1942, p. 541.

17 Foster, 1909, pp. 195–96. The President was Thomas Kerridge and the Council members were Richard Wylde, John Skibbow, Joseph Hopkinson, William Martin, and George Page.

18 Al-Biruni, *Kitab al-jamahir fi ma'rifat al-jawahir* (Book on Precious Stones), an early eleventh-century text, cited by Spink, p. 9.

19 Foster, 1926, p. 225.

20 Tavernier, vol. 1, p. 246.

21 See Hughes, p. 149, for the injunction (6:86) in the *Hidayah*, a twelfth-century work on Islamic religious law.

22 Foster, 1921, p. 112.

23 The reading of the date inscribed with the name of Aurangzeb is uncertain. For the suggested variations, see Ball, p. 381; and *The Indian Heritage*, cat. no. 297, p. 108.

24 Tavernier, vol. 1, p. xviii.

25 Stronge, 1983–84, p. 51; and Stronge, 1986, pp. 311–13.

26 Mumme, pp. 62–63.

27 Tavernier, vol. 2, pp. 82–83.

28 Keller, 1981, p. 85; and Ringsrud, pp. 68–70.

29 *Sweat of the Sun, Tears of the Moon: Gold and Emerald Treasures of Colombia*.

30 *Tuzuk-i-Jahangiri*, vol. 1, p. 400.

31 Ibid., vol. 2, p. 26.

32 *Emperor Jahangir Weighs Prince Khurram*, attributed to Manohar, c. 1610–15; British Museum, London (1948.10–9609). The painting was most recently published in S. C. Welch, 1985, cat. no. 118, p. 189.

33 Manucci, vol. 1, p. 140.

34 Quoted in Hosten, 1922, p. 147.

35 Latif, 1982, pp. 119–22.

36 *The Indian Heritage*, cat. no. 376, pp. 122–23.

37 *Antique Jewellery, Including a Collection of Cameos*, lot no. 88, p. 16.

38 For a discussion of the cameo, see *The Indian Heritage*, cat. no. 377, p. 123. The name of the officer is given as Anup Ray in *Tuzuk-i-Jahangiri*, vol. 1, pp. 184–88, Anup Singh in the Windsor Padshah-nama, fol. 134r (see above, p. 94).

39 *Akbar-nama*, vol. 2, pp. 301–02, n. 6. For the inscribed object, an archer's thumb ring engraved as belonging to Shah Salim (Jahangir's name while a prince) in the Bharat Kala Bhavan, Varanasi, see Irwin, 1968, fig. 1, p. 63. Another jade object, a small fluted vessel in the Brooklyn Museum (lent by Robin Martin, L. 79.19), has also been attributed to the period: see Brand and Lowry, cat. no. 75, pp. 116 and 155.

40 Skelton, 1969, pp. 2–4. For the collection of Timurid jades by Jahangir, see *Tuzuk-i-Jahangiri*, vol. 1, p. 146; and Skelton, 1972B, p. 102.

41 One cup is in the British Museum, London (1945.10–17–259). The other was formerly in the collection of Sir Isaac and Lady Wolfson, Great Britain: see *The Indian Heritage*, cat. no. 355a, p. 118.

42 For the documentation of several such presents, see Sainsbury, pp. 313–19.

43 Tavernier, vol. 1, pp. 309–10.

44 Vases made of agates from Cambay and Broach are mentioned by the first-century Roman author Pliny the Younger, cited in Watt, p. 562.

45 Tavernier, vol. 1, p. 56.

46 Desai, cat. no. 113, p. 136.

47 *Islamic Works of Art, Carpets and Textiles*, lot no. 90, p. 37; and *Islamic and Hindu Jewellery*, lot no. 29, pp. 47–48.

48 De Laet, p. 91.

49 Bernier, p. 110. The gold box was first published in *Islamic Jewellery*, lot no. 78, pp. 72–73. At that time, the body of the box was assigned to the eighteenth century or later by Michael Spink. He has recently said that he now considers it to be earlier and closer in date to the lid of c. 1625. Personal communication to the author, 30 March 1988.

50 See Koch, 1982A, pp. 251–62.

51 Desai, p. 142.

52 Latif, 1982, p. 65. See also Varney, pp. 31–39. The historical claim is based on records in the state archives of Jaipur.

53 The hilt was dated c. 1640 in S. C. Welch, 1985 (cat. no. 177, p. 271) on the basis of its quality and similarity to the Shah Jahan wine cup; but if this particular pistol-grip hilt form entered the Mogul artistic vocabulary under Aurangzeb and if the hilt was carved by an imperial craftsman working for the new emperor who seized power in 1658, then its date would seem to fall closer to 1660.

54 The painting is in the Victoria and Albert Museum, London. See *The Indian Heritage*, cat. no. 160, pp. 63–64.

55 *Tuzuk-i-Jahangiri*, vol. 1, pp. 90–91.

56 Pant, vol. 2, p. 163.

57 See Lieut. Fuller's translation of the *Shahjehan Naman* of Inayat Khan, passim.

58 Manucci, vol. 2, pp. 358–59.

59 *The Indian Heritage*, cat. no. 428, p. 133.

60 Pant, vol. 2, p. 116.

61 Manucci, vol. 2, p. 359.

62 Abul Fazl, *A'in-i-Akbari*, p. 119.

63 *The Indian Heritage*, cat. no. 439, p. 135.

64 Hunt, pp. 50–56.

65 *Babur-nama*, p. 407.

66 *Tuzuk-i-Jahangiri*, pp. 132, 206, and 323.

67 See Aziz, 1942, pp. 397 and 418.

68 Foster, 1926, pp. 99, 400, 445, and 459.

69 Bernier, p. 359.

70 Foster, 1921, pp. 109–10.

71 For a discussion of fragments found in a fourteenth-century Tughluq palace in Delhi, see Smart, 1975–77, pp. 199–230. For a brief notice and illustrations of fragments found at Fatehpur Sikri, see Brand and Lowry, pp. 115–16, fig. 14.

72 See, for example, the painting mentioned in n. 32 above.

73 Guy, p. 28.

Chapter 5: **Fabrics, Carpets, and Costumes** (pp. 170–93)

1 Tavernier, vol. 1, pp. 83–84.

2 So prized were textiles that the moment they passed into royal hands (by order, gift, or purchase) they were taken to the imperial storehouses, labeled, and arranged according to the day, month, and year of entry into the imperial collections; sometimes their colors, weight, price, and place of acquisition were also noted. The promptness with which such textile records were made is indicated in a Mogul painting of Prince Khurram being weighed on his sixteenth birthday (see above, Chapter 4, n. 32): carefully folded fabrics, jewelry, daggers, and other sumptuous objects presented by the young prince to his father Jahangir on that occasion fill the foreground; an efficient steward or clerk is shown making an inventory of these treasured gifts on the spot!

3 Smart and Walker, p. 87.

4 Abid, like most Shah Jahani painters, idealizes his subject, but the depiction is probably accurate, at least in a general sense.

5 A description of a "good house" in Delhi written by Bernier in the mid-seventeenth century (see Bernier, pp. 247–48) succinctly indicates that the extensive use of textiles by Shah Jahan and his predecessors was largely a grandiose version of common Indian and Middle Eastern practices.

6 Almost insurmountable problems face anyone attempting to provide a truly detailed, comprehensive analysis of Shah Jahani textiles, particularly with regard to the types of weavings, dating, technical developments, and specific places of manufacture. Very few bear dated or datable inscriptions or markings; attempts to develop chronologies based upon the similarity of textile designs to those on more firmly dated works of art can be misleading, especially in a country where ornamental vocabularies frequently have long and repetitive lives. Although representations of fabrics and carpets in Mogul paintings are useful in a general sense, the specific types depicted are often difficult to determine (velvet, silk, etc.); and, of course, the pictorial fantasy of the Shah Jahani artists as well as their strong tendency to "perfect" must be taken into account. Even contemporary accounts of textiles and their production, often written by enthusiastically romantic European travelers or fawning Mogul courtiers, are not always reliable, thorough, or consistent.

7 Bernier, pp. 258–59.

8 Most of these silk fabrics, either pure or mixed, were made of ordinary silk (mostly *Bombyx mori*), but a few textiles from Eastern India were woven from other varieties. Near the Bengal–Orissa border, for example, mixed fabrics were produced from cotton and a wild silk derived from the silkworm *Anthereap aphia* and known as "Tussur." Another wild silk—*muga* from Assam—was used for embroidering muslin piece-goods, and, probably, for weaving some fabrics (see Irwin, 1957, p. 62).

9 Tavernier, vol. 2, p. 2.

10 Bernier, p. 439.

11 Tavernier, vol. 2, pp. 2–3, 21–22.

12 Controversy exists over the metal-ground fabrics' place of manufacture. Some of them may have been woven in Iran and others in India. (See Bier, pp. 236–37.)

13 Irwin, 1955A, p. 21.

14 Bernier, p. 139.

15 Tavernier, vol. 1, pp. 46–47.

16 Bernier, p. 270.

17 Smart and Walker, pp 88–89; Smart, 1986, pp. 9–10.

18 Irwin, 1955A, pp. 22–24; Irwin, 1956, pp. 35–36; Irwin, 1957, pp. 64–65.

19 Irwin, 1955A, p. 23, pp. 25–30.

20 Not every cotton weaver or merchant was honest. Tavernier, who viewed India with a businessman's eye, carefully recorded many of the frauds perpetrated by local textile producers. Sometimes, he writes, they skimped on the number of threads used in a fabric, a fraud that could only be detected by meticulously counting each strand. The weight of textiles and, therefore, the price was often increased by storing them in damp places. Occasionally, too, five or ten coarser, thinner, shorter, or narrower fabrics were hidden in the middle of a bale of almost two hundred separate pieces and thereby escaped detection by the unwary buyer. (See Tavernier, vol. 2, pp. 22–25).

21 Irwin, 1955B, pp. 2–5. Two grades of fleece were used: the first and finest was collected from rocks and shrubs against which wild Central Asian goats had rubbed themselves; the second, a lower grade, was taken from domesticated goats of the same species.

22 Moreland and Geyl, pp. 19 and 36.

23 Manrique, vol. 1, pp. 428–29.

24 Bernier, pp. 402–03.

25 Manrique, vol. 2, p. 147.

26 Irwin and Hall, pp. 5–6.

27 Irwin, 1955A, pp. 16–17.

28 Irwin, 1957, pp. 62–64.

29 Tavernier, vol. 2, pp. 2 and 22.

30 Moreland and Geyl, pp. 7, 9, 19.

31 Irwin, 1955A, pp. 17–20. The Girdlers' Carpet is still in the possession of the Girdlers' Company in

London; the Fremlin Carpet is in the Victoria and Albert Museum, London.

32 The following discussion of Indian knotted carpets owes much to the work of Daniel S. Walker (Walker, pp. 252–57).

33 The exact function of the irregularly shaped carpets is unknown. They were, however, woven in the loom and not cut or pieced.

34 Ellis, 1988, p. 211.

35 Walker, pp. 255–56.

36 Ibid.

37 Ibid., p. 256.

38 Ellis, p. 211.

39 Andrews, p. 151.

40 S. C. Welch, 1985, p. 250.

41 Ibid.

42 *The Indian Heritage*, p. 87.

43 Irwin, 1959, p. 62.

44 Ibid.

45 Ibid., pp. 62–63.

46 Irwin, 1955A, p. 7.

47 Khandalavala, p. 287.

48 Ibid., p. 293.

49 Goswamy and Fischer, p. 20.

Chapter 6: **Romance of the Taj Mahal**
(pp. 194–242)

1 As quoted in Carroll, p. 40.

2 Ibid., p. 141.

3 Ibid., p. 139.

4 Lightbown, pp. 228–79.

5 Benesch, p. 319, also for the next quotation.

6 Skelton, 1985, p. 279. A good article for those interested in early European collections of Indian artworks.

7 Kurz, pp. 251–71.

8 Lightbown, p. 266. It should be noted that while European fascination with "Orientalism" generally concerned the Near East, the French artist Eugène Delacroix (1798–1863), the greatest of the Orientalists, did copy Mogul pictures, including a portrait of Shah Jahan (see Rosenthal, pp. 3–33).

9 Weinhardt, Jr., p. 209.

10 Ibid.

11 Head, fig. 1.

12 As quoted in Weinhardt, Jr., p. 208.

13 As quoted in Archer, 1980, caption to Pl. 29.

14 Ibid., caption to Pl. 28.

15 Ibid., caption to Pl. 27.

16 Head, p. 39.

17 Ibid., p. 49.

18 R. Murphy, pp. 78–79.

19 For Brabazon, see Beetles, 1986, an exhibition catalogue that is the source for this brief discussion.

20 A Dutch colonial officer, J. H. W. Le Clercq (1809–85), visited in 1847 and made a large number of drawings and paintings including the Taj which are preserved in the Royal Institute of Linguistics and Anthropology in Leiden.

21 Zimmern, p. 9.

22 As quoted in Carroll, p. 148.

23 Ibid., p. 146.

24 Ibid., p. 153.

25 Black, 1984, p. 52. Field's paintings of the cenotaph and the screen were wrongly identified in this catalogue.

26 Weeks, 1896, p. 322.

27 Mitter, p. 237.

28 Gatling and Lewis, p. 9.

29 J. M. Hansen, n.p.

30 Beetles, n.d., p. 5.

31 Ibid., p. 89.

32 Ibid., p. 2.

33 *Contemporary American Painting and Sculpture*, pp. 187–88, pl. 94.

34 See Haworth-Booth, pp. 104–07 for other images of the Taj by Murray. The photograph illustrated in Fig. 39 might be by Murray because details of the scene are similar to those in other photographs by him and it seems to have been made with paper negatives.

35 I am grateful to Dr. Janice Leoshko for bringing to my attention Dr. Marcella Nesom's dissertation (see Bibliography), which she was kind enough to share with us. Unfortunately, we were unable to acquire photographs of any of Chughtai's works.

36 Weeks, 1895, p. 570.

37 From a letter written to Dr. Janice Leoshko.

Bibliography

Abul-Fazl. 1873. *The A'in-i Akbari.* Vol. 1. Trans. H. Blochmann, ed. D. C. Phillott. Calcutta: Bibliotheca Indica; 2nd edn. Calcutta: Asiatic Society of Bengal, 1927; reprint Lahore: Qausain, 1975.

———. 1897–21. *The Akbarnama.* 3 vols. Trans. H. Beveridge. Calcutta: Asiatic Society, Bibliotheca Indica.

Ahmad, N. 1956–57. "Imam-ud-Din Husain Riadi, the Grandson of Nadir-ul-'Asr Ahmad, the Architect of the Taj Mahal, and his *Tadhkira-i-Baghistan,*" *Islamic Culture,* vol. 30, pp. 330–50; vol. 31, pp. 61–87.

Al-Biruni. *Kitab al-jamahir fi ma'rifat al-jawahir* (Book on Precious Stones). Ed. Krenkow. Hyderabad, 1936.

Anderson, Col. R. P. 1873. "The Taj: A Translation from the Persian." *The Calcutta Review,* vol. 57, pp. 233–37.

Andrews, P. 1987. "The Generous Heart on the Mass of Clouds: The Court Tents of Shah Jahan." *Muqarnas,* vol. 4, pp. 149–65.

Antique Jewellery, Including a Collection of Cameos. 1982. Auction cat. London: Christie's, 7 Dec.

Appasamy, J. 1968. *Abanindranath Tagore and the Art of His Times.* New Delhi: Lalit Kala.

Archer, M. 1960. "The Daniells in India and Their Influence on British Architecture." *Journal of the Royal Institute of British Architects,* Sept., pp. 439–44.

———. 1972, *Company Drawings in the India Office Library.* London: Her Majesty's Stationery Office.

———. 1980. *Early Views of India.* London/New York: Thames and Hudson.

Archer, M. and W. G. 1955. *Indian Painting for the British, 1770–1880.* Oxford: Oxford University Press.

Archer, M., et al. 1987. *Treasures from India: The Clive Collection at Powis Castle.* London: Herbert in association with the National Trust/New York: Meredith Press.

Art of Edwin Lord Weeks, 1849–1903. Exh. cat. Durham, N. H.: University Art Galleries, University of New Hampshire, 1976.

Atil, E., et al. 1985. *Islamic Metalwork in the Freer Gallery of Art.* Exh. cat. Washington, D.C.: Freer Gallery of Art, Smithsonian Institution.

Auboyer, J. 1955. "Un Maître hollandais du XVIIᵉ siècle s'inspirant des miniatures mogholes." *Arts asiatiques,* vol. 2, 4, pp. 251–73.

Aziz, A. 1942. *The Imperial Treasury of the Indian Mughuls.* In *The Mughal Indian Court and Its Institutions,* vol. 2. Lahore; reprint Delhi: Idarah-i Adabiyat-i Delhi, 1972.

———. 1947. *Arms and Jewellery of the Indian Mughals.* In *The Mughal Indian Court and Its Institutions,* vol. 3. Lahore: the author.

The Babur-nama in English (Memoirs of Babur). 1922. Trans. and ed. A. S. Beveridge. London; reprint London: Luzac, 1969.

Ball, V. 1893–96. "A Description of Two Large Spinel Rubies, with Persian Characters Engraved upon Them." *Proceedings of the Royal Irish Academy,* vol. 3, no. 3, pp. 380–400.

Beach, M. C. 1966. "Mughal and Rajput Minor Arts." In *The Arts of India and Nepal: The Nasli and Alice Heeramaneck Collection,* pp. 161–67. Exh. cat. Boston: Museum of Fine Arts.

———. 1978. *The Grand Mogul: Imperial Painting in India, 1600–1660.* Williamstown, Mass.: Sterling and Francine Clark Art Institute.

———. 1981. *The Imperial Image: Paintings from the Mughal Court.* Exh. cat. Washington, D.C.: Freer Gallery of Art, Smithsonian Institution.

———. 1987. *Early Mughal Painting.* Cambridge: Harvard University Press.

Beetles, C. n.d. *Albert Goodwin R.W.S., 1845–1932.* London: Chris Beetles.

———. 1986. *Hercules Brabazon Brabazon (1821–1906) and the New English Art Club.* London: Chris Beetles.

Begley, W. E. 1978–79. "Amanat Khan and the Calligraphy of the Taj Mahal." *Kunst des Orients,* vol. 12, pp. 5–60.

———. 1979. "The Myth of the Taj Mahal and a New Theory of its Symbolic Meaning," *The Art Bulletin,* vol. 61, pp. 7–37.

———. 1981. "The Symbolic Role of Calligraphy on Three Imperial Mosques of Shah Jahan." *Kaladarsana: American Studies in the Art of India,* pp. 7–18. New Delhi: American Institute of Indian Studies.

———. 1982. "Ustad Ahmad." *Macmillan Encyclopedia of Architects,* vol. 1, pp. 39–42. New York: Free Press.

———. 1983. "Four Mughal Caravanserais Built during the Reigns of Jahangir and Shah Jahan." *Muqarnas,* vol. 1, pp. 167–79.

———. 1985. *Monumental Islamic Calligraphy from India.* Villa Park, Ill.: Islamic Foundation.

Benesch, O. 1973. *The Drawings of Rembrandt.* 6 vols. London: Phaidon Press.

Bernier, F. 1891. *Travels in the Mogul Empire A.D. 1656–1668.* Trans. A. Constable. London: Oxford University Press; reprint New Delhi: S. Chand, 1972.

Bhavani, E. 1978. *Decorative Designs on Stone and Wood in India.* Bombay: Taraporevala.

Bier, C. 1987. *Woven from the Soul, Spun from the Heart: Textile Arts of Safavid and Qajar Iran, 16th–19th Centuries.* Washington, D.C.: Textile Museum.

Black, M. 1963. "Erastus Salisbury Field and the Sources of his Inspiration." *Antiques Magazine,* vol. 83, no. 2 (Feb.), pp. 201–04.

———. 1984. *Erastus Salisbury Field, 1805–1900.* Springfield, Mass.: Museum of Fine Arts.

Blavatsky, H. P. 1883–86. "From the Caves and Jungles of Hindostan." *Moskovskiya Vedomosty* (Moscow Chronicle). First English edn. London, 1892. Reprinted in *H. P. Blavatsky: Collected Writings.* Trans. and compiled by B. de Zirkoff. Wheaton, Ill.: Theosophical Society, series no. 5, 1950; reprint Wheaton, Ill.: Theosophical Publishing House, 1975.

Born, W. 1942. "Ivory Powder Flasks from the Mughal Period." *Ars Islamica,* vol. 9, pp. 93–111.

Brand, M., and G. D. Lowry. 1985. *Akbar's India: Art from the Mughal City of Victory.* Exh. cat. New York: The Asia Society Galleries.

Brandenburg, D. 1969. *Der Taj Mahal in Agra.* Berlin: Verlag Bruno Hessling.

Brookes, J. 1987. *Gardens of Paradise: The History and Design of the Great Islamic Gardens.* London: Weidenfeld and Nicolson/New York: Meredith Press.

Brown, P. 1957. "Monuments of the Mughal Period." In *The Cambridge History of India,* vol. 4, *The Mughal Period,* pp. 523–76. London: Cambridge University Press; reprint New Delhi: S. Chand, 1963.

Bruhn, T. P. 1987. *A Journey to Hindoostan: Graphic Art of British India, 1780–1860.* Storrs, Conn.: William Benton Museum of Art.

Caplan, A. 1968. "An Important Carved Emerald from the Mogul Period of India." *Lapidary Journal,* vol. 22, pp. 1336–37.

Carroll, D. 1953. *The Taj Mahal.* New York: Newsweek.

Chaghatai, M. A. 1957. "The Description of the

Taj Mahal of Agra." *Iqbal*, vol. 5, pp. 82–95.

Chaghtai, M. A. 1937. "A Family of Great Mughal Architects." *Islamic Culture*, vol. 11, pp. 200–09.

———. 1938. *Le Tadj Mahal d'Agra*. Brussels: Editions de la Connaissance.

———. 1941. "Pietre-Dura Decoration of the Taj." *Islamic Culture*, vol. 15, pp. 465–72.

Chandra, M. 1939. "The Art of Cutting Hardstone Ware in Ancient and Modern India." *Journal of the Gujarat Research Society*, vol. 1, no. 4, pp. 71–85.

———. n.d. "Mugal Yug ke Begari aur unki Kala" (Mughal Period Jewellers and their Art). *Kala-Nidhi*, vol. 4, pp. 6–14.

Chowdhuri, J. N. 1937. "Mumtaz Mahall." *Islamic Culture*, vol. 11, pp. 373–81.

Clements, T. 1941. "The Emerald Mines of Muzo, Colombia, South America." *Gems & Gemology*, vol. 3, no. 9, pp. 130–34.

Contemporary American Painting and Sculpture. Urbana: University of Illinois College of Fine and Applied Arts, 1955.

Crowe, S., et al. 1972. *The Gardens of Mughal India*. London: Thames and Hudson.

Dam-Mikkelsen, B., and T. Lundbaek, eds. 1980. *Ethnographic Objects in the Royal Danish Kunstkammer 1650–1800*. Copenhagen: National Museum.

de Forest, L. 1912. *Illustrations of Design*. Boston: Athenaeum Press.

Dehejia, V., and A. Staley. 1988. *Impossible Picturesqueness*. New York: Columbia University Press.

De Laet, J. E. 1631. *The Empire of the Great Mogol*. Dutch edn. Leiden; English edn., trans. J. S. Hoyland, Bombay: D. B. Taraporevala Sons, 1928.

Desai, V. N. 1985. *Life at Court: Art for India's Rulers, 16th–19th Centuries*. Exh. cat. Boston: Museum of Fine Arts.

A Descriptive List of Farmans, Manshurs and Nishans Addressed by the Imperial Mughals to the Princes of Rajasthan. 1962. Bikaner: Directorate of Archives.

Desmond, R. 1974. *Photography in India During the Nineteenth Century*. London: India Office Library and Records Annual Report.

Diba, L. S. 1983. "Glass and Glassmaking in the Eastern Islamic Lands: Seventeenth to Nineteenth Century." *Journal of Glass Studies*, vol. 25, pp. 187–93.

Dickie, J. 1985. "The Mughal Garden: Gateway to Paradise." *Muqarnas*, vol. 3, pp. 128–37.

Digby, S. 1962–64. "A Seventeenth Century Indo-Portuguese Writing Cabinet." *Bulletin of the Prince of Wales Museum of Western India*, vol. 8, pp. 23–28.

———. 1973. "A Corpus of 'Mughal' Glass." *Bulletin of the School of Oriental and African Studies*, vol. 36, no. 1, pp. 80–96.

———. 1986. "The Mother-of-Pearl Overlaid Furniture of Gujarat: The Holdings of the Victoria and Albert Museum." In *Facets of Indian Art: A Symposium Held at the Victoria and Albert Museum on 26, 27, 28 April and 1 May 1982*, ed. R. Skelton et al., pp. 213–22. London: Victoria and Albert Museum.

Dikshit, M. G. 1969. *History of Indian Glass*. Bombay: University of Bombay.

D'Monte, D. 1984. "Pollution Imperils the Taj Mahal." *Sierra*, vol. 69, no. 3, pp. 48–49.

The Estelle Doheny Collection, from the Edward Laurence Doheny Memorial Library, St. John's Seminary, Camarillo, California. n.d. [1987]. Pre-auction cat. New York: Christie's.

Ellis, C. G. 1988. *Oriental Carpets in the Philadelphia Museum of Art*. Philadelphia: Philadelphia Museum of Art.

Falk, T., and M. Archer. 1981. *Indian Miniatures in the India Office Library*. London: Sotheby Parke Bernet.

Felix, Rev. 1916. "The Mughal Seals." *Journal of the Panjab Historical Society*, vol. 5, no. 2, pp. 100–25.

Foster, W. 1909. *The English Factories in India, 1624–1629: A Calendar of Documents in the India Office, etc.* Oxford: Clarendon Press.

———, ed. 1921. *Early Travels in India, 1583–1619*. London: Oxford University Press.

———, ed. 1926. *The Embassy of Sir Thomas Roe to India, 1615–19*. London: Hakluyt Society, 1899; rev. edn. London: Oxford University Press.

Fraser, J. 1742. *The History of Nadir Shah, formerly called Thamas Kuli Khan*. 2d edn. London: Printed for A. Millar; reprints Westmead, England: Gregg, 1971 and Delhi: Mohan, 1973.

Gadon, E. W. 1986. "Dara Shikuh's Mystical Vision of Hindu–Muslim Synthesis." In *Facets of Indian Art: A Symposium Held at the Victoria and Albert Museum on 26, 27, 28 April and 1 May 1982*, ed. R. Skelton et al., pp. 153–57. London: Victoria and Albert Museum.

Gangoly, O. C. 1928. "On the Authenticity of the Feminine Portrait of the Moghul School." *Rupam*, pp. 33–34.

Gascoigne, B. 1971. *The Great Moghuls*. New York: Harper & Row; reprint New York: Dorset Press, 1987.

Gatling, E. I., and A. S. Lewis. 1976. *Lockwood de Forest: Painter, Importer, Decorator*. Huntington, N.Y.: Heckscher Museum.

Golombek, L. 1981. "From Tamerlane to the Taj Mahal." *Islamic Art and Architecture (Essays in Islamic Art and Architecture In Honor of Katharina Otto Dorn*, ed. Abbas Daneshvari), vol. 1, pp. 43–52.

Goswamy, B. N., and E. Fischer. 1987. *Wonders of a Golden Age: Painting at the Court of the Great Mughals*. Zurich: Museum Rietberg.

Gray, B. 1964–66. "The Export of Chinese Por-

celain to India." *Transactions of the Oriental Ceramic Society*, vol. 36, pp. 21–37.

Gunther, R. T. 1932. *The Eastern Astrolabes*. In *The Astrolabes of the World*, vol. 1, pp. 109–302. London, 1932; reprint London: Holland Press, 1976.

Gupta, I. P. 1986. *Urban Glimpses of Mughal India: Agra, the Imperial Capital*. New Delhi: Discovery Publishing House.

Gurner, C. W. 1924. "Lord Hastings and the Monuments of Agra." *Bengal, Past and Present*, vol. 27, pp. 148–53.

Guy, J. S. 1986. *Oriental Trade Ceramics in South-East Asia Ninth to Sixteenth Centuries*. Singapore/Oxford: Oxford University Press.

Hambly, G. 1968. *Cities of Mughal India*. New York: G. P. Putnam's Sons.

Hansen, J. M. 1981. *Colin Campbell Cooper*. Santa Barbara, Calif.: James M. Hansen.

Hansen, W. 1972. *The Peacock Throne: The Drama of Mogul India*. New York: Holt, Rinehart and Winston.

Hasrat, B. J. 1953. *Dara Shikoh*. Santiniketan: Visra Bharati.

Hasson, R. 1987. *Later Islamic Jewellery*. Jerusalem: L. A. Mayer Memorial Institute for Islamic Art.

Havell, E. B. 1903. "The Taj and Its Designers." *The Nineteenth Century and After*, pp. 1039–49. New York: Leonard Scott Publishers.

Haworth-Booth, M. 1984. *The Golden Age of British Photography, 1839–1900*. New York: Aperture in association with the Philadelphia Museum of Art and the Victoria and Albert Museum.

Head, R. 1986. *The Indian Style*. London: Allen & Unwin/Chicago: University of Chicago Press.

Hendley, T. H. 1892. *Damascening on Steel and Iron, as Practiced in India*. London: W. Griggs & Sons.

———. 1909. *Indian Jewellery. Journal of Indian Art and Industry*, vol. 12; reprint (2 vols.) Delhi: Cultural Publishing House, 1984.

Hoag, J. D. 1968. "The Tomb of Ulugh Beg and Abdu Razzaq at Ghazni, a Model for the Taj Mahal." *Journal of the Society of Architectural Historians*, vol. 27, pp. 234–48.

Hodgson, J. A. 1843. "Memoir on the Length of the Illahee Guz, or Imperial Land Measure of Hindostan.' *Journal of the Royal Asiatic Society*, pp. 42–63.

Hogarth, D. G. 1925. "George Nathaniel Curzon, Marquess Curzon of Kedleston, 1859–1925." *Proceedings of the British Academy*, vol. 11, pp. 502–24.

Hosain, M. H. 1941. "Contemporary Historians During the Reign of Shah Jahan." *Islamic Culture*, vol. 15, pp. 64–79.

Hosten, Rev. H. 1910. "Who Planned the Taj?" *Journal and Proceedings of the Asiatic Society of Bengal*, vol. 6, pp. 281–88.

———. 1922. "European Art at the Moghul Court."

Journal of the Uttar Pradesh Historical Society, vol. 3, no. 1, pp. 110–84.

Hughes, T. P. 1885. *A Dictionary of Islam*. London; reprint Lahore: Premier Book House, 1965.

Hunt, E. H. 1916. "Old Hyderabad China." *Journal of the Hyderabad Archaeological Society*, vol. 1, pp. 48–87.

Husain, Muhammed Ashraf. 1937. *An Historical Guide to the Agra Fort*. Delhi: Manager of Publications.

Ignatieff, M. 1988. "Freud's Cordelia." *The New York Review of Books*, vol. 25, no. 18, p. 16.

Ikram, S. M. 1964. *Muslim Civilization in India*. New York: Columbia University Press.

Imaduddin, S. M. 1966. "Mughal Swords in the Dacca Museum." In *Nalini Kanta Bhattasali Commemoration Volume*, ed. A. B. M. Habibullah, pp. 161–65. Dacca: Dacca Museum.

The Indian Heritage: Court Life and Arts under Mughal Rule. 1982. Exh. cat. London: Victoria and Albert Museum.

Irwin, J. 1955A. "Indian Textile Trade in the Seventeenth Century; [1] Western India." *Journal of Indian Textile History*, no. 1, pp. 5–33.

———. 1955B. *Shawls: A Study in Indo-European Influences*. London: Her Majesty's Stationery Office.

———. 1956. "Indian Textile Trade in the Seventeenth Century; [2] Coromandel Coast." *Journal of Indian Textile History*, no. 2, pp. 24–42.

———. 1957. "Indian Textile Trade in the Seventeenth Century; [3] Bengal." *Journal of Indian Textile History*, no. 3, pp. 58–74.

———. 1959. "Indian Textile Trade in the Seventeenth Century; [4] Foreign Influence." *Journal of Indian Textile History*, no. 4, pp. 52–64.

———. 1968. "Mughal Jades." *The Times of India Annual*, pp. 63–70.

Irwin, J., and M. Hall. 1973. *Indian Embroideries*. (Historic Textiles of India at the Calico Museum, vol. 2.) Ahmedabad: Calico Museum of Textiles.

Islamic Arms and Armour from Private Collections. 1982. Exh. cat. Copenhagen: The David Collection.

Islamic and Hindu Jewellery. 1988. Auction cat. London: Spink and Son, 13 April–6 May.

Islamic Jewellery. 1986. Auction cat. London: Spink and Son, 15 April–9 May.

Islamic Works of Art, Carpets and Textiles. 1988. Auction cat. London: Sotheby's, 12 Oct.

Ivanov, A. A., et al. 1984. *Oriental Jewellery. From the Collection of the State Treasury, the State Hermitage Oriental Department*. Moscow: Art.

Jauhar, 1970. *Tezkereh al Vakiat* (Relation of Occurrences). Trans. C. Stewart. Reprint Delhi: Kumar Brothers.

Jenkins, M., and M. Keene. 1982. *Islamic Jewelry in the Metropolitan Museum of Art*. New York: Metropolitan Museum of Art.

Juynboll, G. H. A. 1986. "The Attitude towards Gold and Silver in Early Islam." In *Pots & Pans: A Colloquium on Precious Metals and Ceramics in the Muslim, Chinese and Graeco-Roman Worlds, Oxford 1985*, ed. M. Vickers, pp. 107–15. Oxford: Oxford University Press.

Kahlenberg, M. H. 1972. "A Study of the Development and Use of the Mughal *Patka* (Sash) With Reference to the Los Angeles County Museum of Art Collection." In *Aspects of Indian Art*, ed. P. Pal, pp. 153–66. London: E. J. Brill.

———. 1973. "The Relationship Between a Persian and an Indian Floral Velvet in the Los Angeles County Museum of Art Collection." *Los Angeles County Museum of Art Bulletin*, vol. 19, no. 2, pp. 22–27.

Kanwar, H. I. S. 1974. "Ustad Ahmad Lahori." *Islamic Culture*, vol. 48, pp. 11–32.

———. 1986. "Austin Hiriat de Bordeaux." *Indica*, vol. 23, pp. 37–45.

Keene, M. 1981. "The Lapidary Arts in Islam: An Underappreciated Tradition." *Expedition*, vol. 24, no. 1, pp. 24–39.

Keller, P. C. 1981. "Emeralds of Colombia." *Gems & Gemology*, vol. 17, no. 2, pp. 80–92.

Khandalavala, K. 1958. *Pahari Miniature Painting*. Bombay: New Book Company.

Koch, E. 1982A. "The Baluster Column—A European Motif in Mughal Architecture and its Meaning." *Journal of the Warburg and Courtauld Institutes*, vol. 45, pp. 251–62.

———. 1982B. "The Lost Colonnade of Shah Jahan's Bath in the Red Fort of Agra." *Burlington Magazine*, vol. 124, no. 951, pp. 331–39.

———. 1982C. "The Influence of the Jesuit Mission on Symbolic Representations of the Mughal Emperors." In *Studies and Commentaries on Islam in India*, ed. Christian Troll. New Delhi: Vikas.

———. 1988. *Shah Jahan and Orpheus: The Pietre Dure Decoration and the Programme of the Throne in the Hall of Public Audience at the Red Fort of Delhi*. Graz, Austria: Akademische Druck.

Komala, W. 1982. *The Windsor Castle "Badhshah Nama" and its Place in the Development of Historical Painting During the Reign of Shah Jahan, 1628–1658*. Ph.D. diss. University of Iowa.

Kurz, O. 1967. "A Volume of Mughal Drawings and Miniatures." *Journal of the Warburg and Courtauld Institutes*, vol. 30, pp. 251–71.

Lal, K. S. 1987. *The Mughal Harem*. New Delhi: Aditya Prakashan.

Lal, M. 1986. *Shah Jahan*. New Delhi: Vikas Publishing.

Lall, J. 1982. *Taj Mahal and the Glory of Mughal Agra*. New Delhi: Lustre Press.

Latif, M. 1982. *Bijoux Moghols*. Exh. cat. Brussels: Musées Royaux d'Art et d'Histoire.

Latif, S. M. 1896. *Agra: Historical and Descriptive*. Calcutta: Calcutta Central Press.

Leach, L. Y. 1986. *Indian Miniature Paintings and Drawings*. (Cleveland Museum of Art Catalogue, Part 1.) Cleveland: Cleveland Museum of Art.

Lightbown, R. W. 1969. "Oriental Art and the Orient in Late Renaissance and Baroque Italy." *Journal of the Warburg and Courtauld Institutes*, vol. 42, pp. 228–79.

Little, S. 1980. "Cross-cultural Influences in Asian Ceramics." *Apollo*, vol. 112, no. 222, pp. 124–29.

Losty, J. 1982. *The Art of the Book in India*. London: British Library.

Lowry, G. 1981. "Foreign Emissaries to the Mughal Court: Did They Influence Indian Art?" *The India Magazine*, Dec., pp. 34–39.

———. 1987. "Humayun's Tomb: Form, Function, and Meaning in Early Mughal Architecture." *Muqarnas*, vol. 4, pp. 133–47.

Manrique, S. 1927. *Travels of Fray Sebastien Manrique, 1629–1643*. 2 vols. Trans. C. E. Quard and H. Hosten. Oxford: Hakluyt Society.

Manucci, N. 1907–08. *Storia do Mogor*. 4 vols. Trans. W. Irvine. London: John Murray.

Markel, S. 1987. "Carved Jades of the Mughal Period." *Arts of Asia*, vol. 17, no. 6, pp. 123–30.

Marshal, P. 1980. "Agra: Atmospheric Pollution Threatens Taj Mahal." *Architectural Record*, vol. 168, p. 35.

Maynard, A. 1963. "Chinese and Indian Jade Carvings in the Collection of Sir Isaac and Lady Wolfson." *The Connoisseur*, vol. 153, no. 616, pp. 85–89.

Meen, V. B., and A. D. Tushingham. 1968. *Crown Jewels of Iran*. Toronto: University of Toronto Press.

Mehta, R. J. 1980. *Masterpieces of Indian Craftsmanship in Marble and Sandstone*. Bombay: Taraporevala.

Michell, G. ed. 1978. *Architecture of the Islamic World*. London: Thames and Hudson.

Millar, A. T. 1977. *Old Goa and the Trade in Chinese Porcelain*. Bombay: Ruby Printers.

Mirror of Princes: The Mughals and The Medici. 1988. Bombay: Marg.

Mitter, P. 1977. *Much Maligned Monsters*. Oxford: Clarendon Press.

Moin-ud-din, M. 1905. *The History of the Taj and the Buildings in its Vicinity*. Agra: Moon Press.

Moreland, H., and P. Geyl (trans.) 1972. *Jahangir's India: The Remonstratie of Francisco Pelsaert*. Delhi: Idarah-i Adabiyat-i Delhi.

Morley, G. 1971. "On Applied Arts of India in Bharat Kala Bhavan." In *CHHAVI: Golden Jubilee Volume*, ed. A. Krishna, pp. 107–29. Varanasi: Bharat Kala Bhavan, Banaras Hindu University.

Moynihan, E. 1979. *Paradise as a Garden in Persia and Mughal India*. New York: Braziller.

Mughal Silver Magnificence (XVI–XIXth C.). 1987. Exh. cat. Brussels: Antalga.

Mumme, I. A. 1982. *The Emerald: Its Occurrence, Discrimination, and Valuation.* Port Hacking, Australia: Mumme Publications.

Mundy, P. 1914. *The Travels of Peter Mundy in Europe and Asia, 1608–1667.* Vol. 2, ed. R. C. Temple. London: Hakluyt Society.

Murphy, R., ed. 1953. *Edward Lear's Indian Journal.* London: Jarrolds.

Murphy, V. 1987. "Origins of the Mughal Flowering Plant Motif." In *Vastra: The Fabric of Indian Art,* pp. 3–11. London: Indar Pasricha Fine Arts.

Nadelhoffer, H. 1984. *Cartier: Jewelers Extraordinaire.* London: Thames and Hudson/New York: Abrams.

Nadvi, S. S. 1948. "The Family of the Engineers Who Built the Taj Mahal and the Delhi Fort." *Journal of the Bihar Research Society,* vol. 34, pp. 75–110.

Nath, R. 1967. "Important Christian Tombs at Agra." *Indica,* vol. 4, pp. 19–34.

———. 1969. "Hessing's Tomb at Agra: A Taj in Miniature." *Indica,* vol. 6, pp. 29–36.

———. 1972. *The Immortal Taj Mahal: The Evolution of the Tomb in Mughal Architecture.* Bombay: D. B. Taraporevala.

———. 1976. *Some Aspects of Mughal Architecture.* New Delhi: Abhinav.

———. 1985. *The Taj Mahal and Its Incarnation (Original Persian Data on Its Builders, Material, Costs, Measurements, etc.).* Jaipur: The Historical Research Documentation Programme.

———. 1987. "The Land of the Taj Mahal." *Indologica Jaipurensia (Dr. Mulk Raj Anand Felicitation Volume),* vol. 1, pp. 149–53.

Nesom, M. B. 1984. *Abdur Rahman Chughtai: A Modern South Asian Artist.* Ph.D. diss. Ohio State University.

Nicolson, N. 1977. *Mary Curzon.* London: Weidenfeld and Nicolson/New York: Harper & Row.

Nigam, M. L. 1976–77. "A Rare Jade Book-Stand of Sultanate Period." *Salar Jung Museum Research Journal,* vols. 9–10, pp. 15–20.

———. 1978. "Souvenirs from Indian Jade (Salar Jung Collection)." *Marg,* vol. 31, no. 2, pp. 51–58.

———. 1979. *Jade Collection in the Salar Jung Museum.* Hyderabad: Salar Jung Museum.

———. 1983. "The Mughal Jades of India." In *An Age of Splendour—Islamic Art in India,* ed. K. Khandalavala, pp. 76–83. Bombay: Marg.

Oak, P. N. 1965. *Taj Mahal Was a Rajput Palace.* Delhi: Asiatic Printers (for the author).

Pant, G. N. 1980. "Swords and Daggers." In *Indian Arms and Armour,* vol. 2. New Delhi: Army Educational Stores.

Pare, R. 1982. *Photography and Architecture 1839–1939.* Montreal: Canadian Center for Architecture.

Pinder-Wilson, R. H. 1957. "Three Illustrated Manuscripts of the Mughal Period." *Ars Orientalis,* vol. 2, pp. 413–22.

Pope, J. A. 1970. *Fourteenth-Century Blue-and-White: A Group of Chinese Porcelains in the Topkapu Sarayi Müzesi, Istanbul.* (Occasional Papers, vol. 2, no. 1.) Washington, D.C.: Freer Gallery of Art, Smithsonian Institution, 1952; rev. edn.

———. 1981. *Chinese Porcelains from the Ardebil Shrine.* Washington, D.C.: Freer Gallery of Art, Smithsonian Institution, 1956; rev. edn.

Puri, S. 1983. "Mughal Jewellery." In *An Age of Splendour—Islamic Art in India,* ed. K. Khandalavala, pp. 84–87. Bombay: Marg.

Rai, R. 1986. *Taj Mahal.* New York: Vendome Press.

Raleigh, Sir T. 1906. *Lord Curzon in India.* London: Macmillan.

Rawson, P. S. 1968. *The Indian Sword.* London: Herbert Jenkins.

Rembrandt Drawings from American Collections. 1986. Exh. cat. New York: The Pierpont Morgan Library.

Remey, C. M. 1927. *A Nonagonal Temple in the Indian Style of Architecture.* Italy: privately published.

Ringsrud, R. 1986. "The Coscuez Mine: A Major Source of Colombian Emeralds." *Gems & Gemology,* vol. 22, no. 2, pp. 67–79.

Rosenthal, D. A. 1982. *Orientalism.* Rochester: Memorial Art Gallery of the University of Rochester.

Rubin, I. E., ed. 1975. *The Guennol Collection.* Vol. 1. New York: Metropolitan Museum of Art.

Sainsbury, W. N. 1864. "The Fine Arts in India in the Reign of King James I." *The Fine Arts Quarterly Review,* vol. 2, pp. 313–19.

Saksena, B. P. 1932. *History of Shah Jahan of Dilhi.* Allahabad; reprint Allahabad: Central Book Depot, 1962.

Sanderson, G. 1937. *A Guide to the Buildings and Gardens, Delhi Fort.* Delhi: Manager of Publications.

Sarda, H. 1911. *Ajmer, Historical and Descriptive.* Ajmer: Scottish Mission Industries.

Schimmel, A. 1976. "The Celestial Garden in Islam." In *The Islamic Garden,* pp. 11–40. Washington, D.C.: Dumbarton Oaks.

Schumann, W. 1977. *Gemstones of the World.* Trans. E. Stern. London: N. A. G. Press/New York: Sterling; reprints 1979 and 1984.

Shahjehan Namah of Inayat Khan, unpublished trans. by Lieut. Fuller. India Office Library, London, Ms. Add. 30,777, fols. 1–562.

Shellim, M. 1979. *Oil Paintings of India and the East by Thomas Daniell RA and William Daniell RA, 1769–1837.* London: Inchcape/Spink and Son.

Skelton, R. 1962. "Jades Moghols." *L'Oeil,* vol. 96, pp. 42–47 and 89.

———. 1969. *The Shah Jahan Cup.* London: Victoria and Albert Museum.

———. 1970. "The European Impact on Mughal Art." In *Europe and the Indies, the Era of the Companies 1600–1824,* pp. 32–35. London: British Broadcasting Corporation.

———. 1972A. "A Decorative Motif in Mughal Art." In *Aspects of Indian Art,* ed. P. Pal, pp. 147–52. Los Angeles: Los Angeles County Museum of Art.

———. 1972B. "The Relations Between the Chinese and Indian Jade Carving Traditions." In *The Westward Influence of the Chinese Arts from the 14th to the 18th century,* ed. W. Watson, pp. 98–110. (Colloquies on Art and Archaeology in Asia, no. 3.) London: University of London, Percival David Foundation of Chinese Art, School of Oriental and African Studies.

———. 1978. "Characteristics of Later Turkish Jade Carving." In *Proceedings of the Fifth International Congress of Turkish Art,* ed. G. Feher, pp. 795–807. Budapest: Akademiai Kiado.

———. 1985. "Indian Art and Artifacts in Early European Collecting." In *The Origins of Museums,* ed. Oliver Impey and Arthur MacGregor. Oxford: Clarendon Press.

Sleeman, Sir W. H. 1844. *Rambles and Recollections of an Indian Official.* Rev. annotated edn. ed. V. A. Smith, 1915; reprints Karachi: Oxford University Press, 1973 and 1980.

Smart, E. S. 1975–77. "Fourteenth-Century Chinese Porcelain from a Tughlaq Palace in Delhi." *Transactions of the Oriental Ceramic Society,* vol. 41, pp. 199–230.

———. 1986. "A Preliminary Report on a Group of Important Mughal Textiles." *The Textile Museum Journal,* vol. 25, pp. 5–23.

———, and D. S. Walker. 1985. *Pride of the Princes: Indian Art of the Mughal Era in the Cincinnati Art Museum.* Cincinnati: Cincinnati Art Museum.

Smith, V. A. 1915. "The Treasure of Akbar." *Journal of the Royal Asiatic Society of Great Britain and Ireland,* pp. 231–43.

Spartano, F. 1987. *Charles Mason Remey and the Baha'i Faith.* New York: Carlton Press.

Spear, P. 1949. "Bentinck and the Taj." *Journal of the Royal Asiatic Society of Great Britain and Ireland,* pp. 180–87.

Speight, E. P. 1928. "The Spiritual Value of Islamic Architecture." *Islamic Culture,* vol. 2, pp. 611–21.

Spink, M. 1988. "Some Aspects of Islamic Jewellery." In *Islamic and Hindu Jewellery* (cit. above), pp. 5–16.

Sprague, S. 1977. "Samuel Bourne, Photographer of India in the 1860s." *British Journal of Photography,* pp. 28–32.

Steube, I. 1973. "William Hodges and Warren Hastings: A Study in Eighteenth-Century

Patronage." *Burlington Magazine*, Oct.–Dec., pp. 659–76.

Stronge, S. 1983–84. "Mughal Jewellery." *Jewellery Studies*, vol. 1, pp. 49–53.

———. 1985. *Bidri Ware: Inlaid Metalwork from India*. London: Victoria and Albert Museum.

———. 1986. "Jewels for the Mughal Court." *The V&A Album*, vol. 5, pp. 309–17. London: Victoria and Albert Museum.

Sweat of the Sun, Tears of the Moon: Gold and Emerald Treasures of Colombia. 1981. Exh. cat. Los Angeles: Natural History Museum of Los Angeles County.

Sweetman, J. 1988. *The Oriental Obsession: Islamic Inspiration in British and American Art and Architecture 1500–1920*. Cambridge: Cambridge University Press.

Tavernier, J. B. 1925. *Travels in India by Jean-Baptiste Tavernier, Baron of Aubonne*. 2 vols. Trans. V. Ball. 2d edn., ed. William Crooke. London; reprint New Delhi: Oriental Books, 1977.

Teng Shu-ping. 1983. *Catalogue of a Special Exhibition of Hindustan Jade in the National Palace Museum*. Exh. cat. Trans. David M. Kamen. Taipei: National Palace Museum.

Terry, E. 1622. *A Voyage to East-India*. (Presented in manuscript form to Charles Prince of Wales in 1622.) 1st edn., London, 1655; 2d edn., London: Printed for J. Wilkie and others, 1777.

Thomas, E. 1875. "Note on a Jade Drinking Vessel of the Emperor Jahangir." *Journal of the Royal Asiatic Society of Great Britain and Ireland*, vol. 7, no. 2, pp. 384–89.

Thomas, G. 1979. "The First Four Decades of Photography in India." *History of Photography*, pp. 215–26.

Thompson, J. P. 1912. "The Tomb of Emperor Jahangir." *Journal of the Punjab Historical Society*, vol. 1, pp. 12–30.

Tillotson, G. H. R. 1986. "Politics and the Taj Mahal." *Oriental Art*, n.s. vol. 32, no. 3, pp. 266–69.

———. 1987. *The Rajput Palaces: The Development of an Architectural Style, 1450–1700*. New Haven: Yale University.

Titley, N. 1977. *Miniatures from Persian Manuscripts*. Museum cat. and index. London: British Museum Publications.

———. 1979. *Plants and Gardens in Persian, Mughal and Turkish Art*. London: British Library.

Tod, J. 1920. *Annals and Antiquities of Rajasthan or the Central and Western Rajput States of India*. 3 vols. Ed. W. Crooke. London: Oxford University Press; reprint Delhi: Motilal Banarsidass, 1971.

Travel in Aquatint and Lithography, 1770–1860. From the Library of J. R. Abbey, vol. 2. Reprint Folkestone and London: Dawson's of Pall Mall, 1972.

The Tuzuk-i-Jahangiri. 1909–14. 2 vols. in one. Trans. A. Rogers, ed. H. Beveridge. Reprint of 2d edn. Delhi: Munshiram Manoharlal, 1968.

Untracht, O. 1988. "The *Nava-ratna*." In *Islamic and Hindu Jewellery* (cit. above), pp. 17–30.

Varney, R. J. 1958. "Enamelling in Rajasthan." *Roopa-lekha*, vol. 29, nos. 1 and 2, pp. 31–39.

Vats, M. S. 1946. "Repairs to the Taj Mahal." *Ancient India*, vol. 1, pp. 4–7.

———. 1950. "Repairs at Agra and Fatehpur Sikri: 1944–49." *Ancient India*, vol. 6, pp. 91–99.

Voysey, H. 1825. "On the Building Stones and Mosaic of Akberabad or Agra." *Asiatic Researches*, vol. 15, pp. 429–35.

Walker, D. S. 1982. "Classical Indian Rugs." *Hali*, vol. 4, no. 3, pp. 252–56.

Watt, Sir G. 1908. *The Commercial Products of India*. London: John Murray.

Weeks, E. L. 1895. "Notes on Indian Art." *Harper's Magazine*, vol. 91, pp. 567–85.

———. 1896. *From the Black Sea Through Persia and India*. New York: Harper and Brothers.

Weinhardt, C. J., Jr. 1958. "The Indian Taste." *The Metropolitan Museum of Art Bulletin*, vol. 26, no. 7, pp. 208–16.

Welch, A. 1979. *Calligraphy in the Arts of the Muslim World*. Austin: University of Texas Press.

———, and S. C. Welch. 1982. *Arts of the Islamic Book: The Collection of Prince Sadruddin Aga Khan*. Ithaca, N.Y.: Cornell University Press for the Asia Society.

Welch, S. C. 1963. *The Art of Mughal India*. Exhibition cat. New York: Asia House Gallery; reprint New York: Arno Press, 1976.

———. 1978. *Imperial Mughal Painting*. New York: George Braziller.

———. 1985. *India: Art and Culture, 1300–1900*. Exh. cat. New York: Metropolitan Museum of Art.

———, et al. 1987. *The Emperor's Album: Images of Mughal India*. New York: Metropolitan Museum of Art.

Wilkinson, J. V. S. 1934. "Shah Jahan's Drinking Vessel." *Burlington Magazine*, vol. 64, p. 187.

———. 1957. "An Indian Manuscript of the Golestan of the Shah Jahan Period." *Ars Orientalis*, vol. 2, pp. 423–25.

Yazdani, G. 1982. "Jahanara." In *Selections from Journal of the Punjab Historical Society*, vol. 3, *Mughal India*. Ed. Zulfiqar Ahmad. Lahore: Sang-e-meel Publications.

Zebrowski, M. 1982. "Bidri: Metalware from the Islamic Courts of India." *Art East*, vol. 1, pp. 26–29.

———. 1984. "Ornamental Pandans of the Mughal Age." In *Symbols and Manifestations of Indian Art*, ed. S. Doshi, pp. 31–40. Bombay: Marg.

Zimmern, H. 1886. "An Eastern Painter." *The Art Journal* (London), n.s., pp. 9–12.

Zucker, B. 1984. *Gems and Jewels: A Connoisseur's Guide*. London and New York: Thames and Hudson.

List of Lenders

Max and Peter Allen, Boston

Mr. and Mrs. James W. Alsdorf, Chicago

The Art Institute of Chicago

The Asia Society, New York
Mr. and Mrs. John D. Rockefeller 3rd
Collection

Asian Art Museum of San Francisco
The Avery Brundage Collection

Chris Beetles Ltd., St. James's, London

Bibliothèque Nationale, Paris

The British Library, London

The Brooklyn Museum, Brooklyn, New York

Cincinnati Art Museum, Cincinnati, Ohio

The Cleveland Museum of Art, Cleveland, Ohio

William Congdon, Milan

Linda Connor, San Francisco

Gary Crawford, San Francisco

Mrs. J. LeRoy Davidson, Los Angeles

Lois A. Ehrenfeld, San Francisco

Dr. William Ehrenfeld, San Francisco

Robert Hatfield Ellsworth, New York

Ted Engelbart, Santa Monica, Calif.

Mitch Epstein, New York

Mr. and Mrs. John Gilmore Ford,
Baltimore, Md.

The J. Paul Getty Museum, Malibu, Calif.

Janice Jocelyne Gibson, Los Angeles

Jane Greenough, Los Angeles

Robert L. Hardgrave, Jr., Austin, Tex.

M.I. Harman, Martin I. Harman, Inc., Benjamin
Zucker (Precious Stones Company), and J. &
S.S. De Young, Inc.

Harvard Art Museums (Arthur M. Sackler
Museum), Cambridge, Mass.

Sherrill Helene Seeley Henderson, Santa Barbara,
Calif.

Howard Hodgkin, London

Honolulu Academy of Arts

The British Library (India Office Library and
Records), London

Ramesh Kapoor, New York

Gloria Katz and Willard Huyck, Los Angeles

Hashem Khosrovani, Geneva

Navin Kumar, New York

Dar al-Athar al-Islamiya, Kuwait
Kuwait National Museum

D. A. J. Latchford, Bangkok

Dr. and Mrs. Edmund J. Lewis, Chicago

Linden Museum, Stuttgart (West Germany)

Los Angeles County Museum of Art,
Los Angeles

Terence McInerney, New York

Patrick McMahon, Dublin

Mehdi Mahboubian, New York

Peter Marks, New York

Charles W. Masters, Jr., Los Angeles

The Metropolitan Museum of Art, New York

Musée Guimet, Paris

Museum für Indische Kunst, Berlin-West
Staatliche Museen Preussischer Kulturbesitz

Museum of Art, Rhode Island School of Design,
Providence, R. I.

Museum of Fine Arts, Boston

Museum of Fine Arts, Springfield, Mass.

Museum Rietberg, Zurich

National Gallery of Art, Washington, D.C.

National Gallery of Victoria, Melbourne,
Australia

The Nelson-Atkins Museum of Art, Kansas
City, Mo.

The Pierpont Morgan Library, New York

Portland Museum of Art, Portland, Maine

Howard and Jane Ricketts, London

Alexander R. Raydon, Raydon Gallery,
New York

Rijksmuseum, Amsterdam

Royal Asiatic Society, London

Royal Ontario Museum, Toronto

Arthur M. Sackler Gallery, Smithsonian
Institution, Washington, D.C.

Prince Sadruddin Aga Khan, Geneva

San Diego Museum of Art, Edwin Binney, 3rd,
Collection

The Santa Barbara Museum of Art, Santa
Barbara, Calif.

Mrs. Sajjan Singh Sarna, Sarasota, Fla.

Seattle Art Museum, Seattle, Wash.

A. Soudavar, Geneva

Galerie J. Soustiel, Paris

Wim Swaan, New York

Dorothea H. Swope, New York

The Textile Museum, Washington, D.C.

Joseph Uzan, Paris

Victoria and Albert Museum, London

Virginia Museum of Fine Arts, Richmond

Paul F. Walter, New York

Doris Wiener Gallery, New York

Yale Center for British Art, Paul Mellon
Collection, New Haven

and various Private Collectors

Index